COLLECTING THE MULTIVERSE

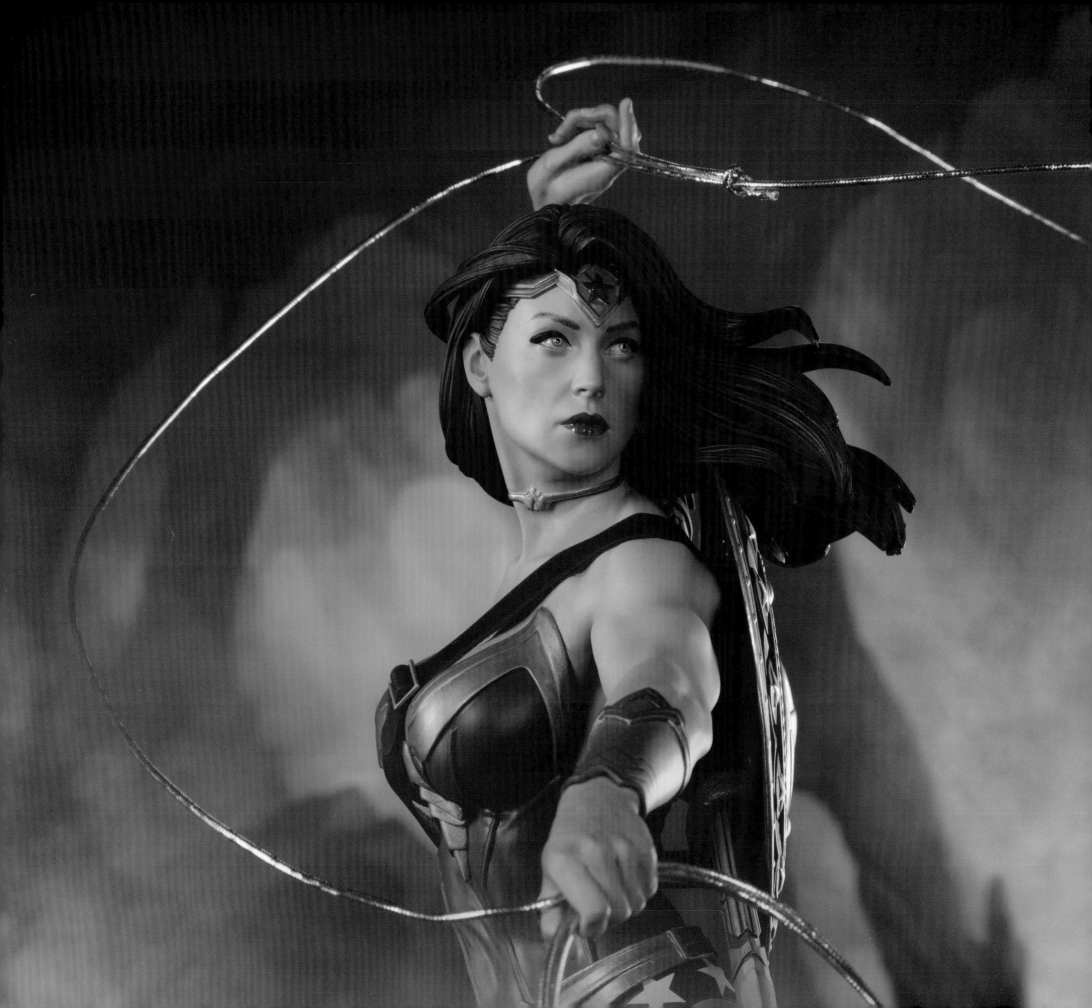

COLLECTING THE MULTIVERSE
THE ART OF SIDESHOW

FOREWORD BY KEVIN CONROY

WRITTEN BY ANDREW FARAGO

INSIGHT
EDITIONS

San Rafael · Los Angeles · London

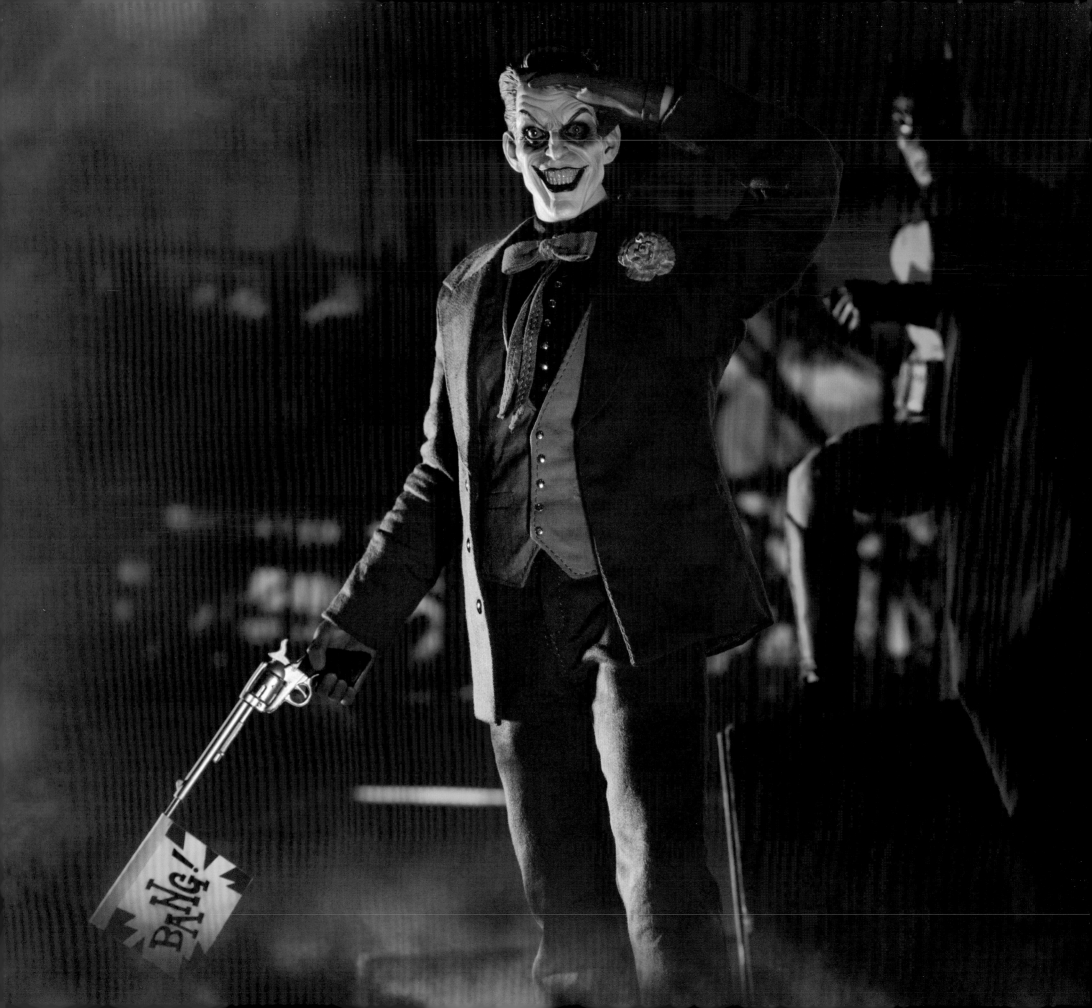

CONTENTS

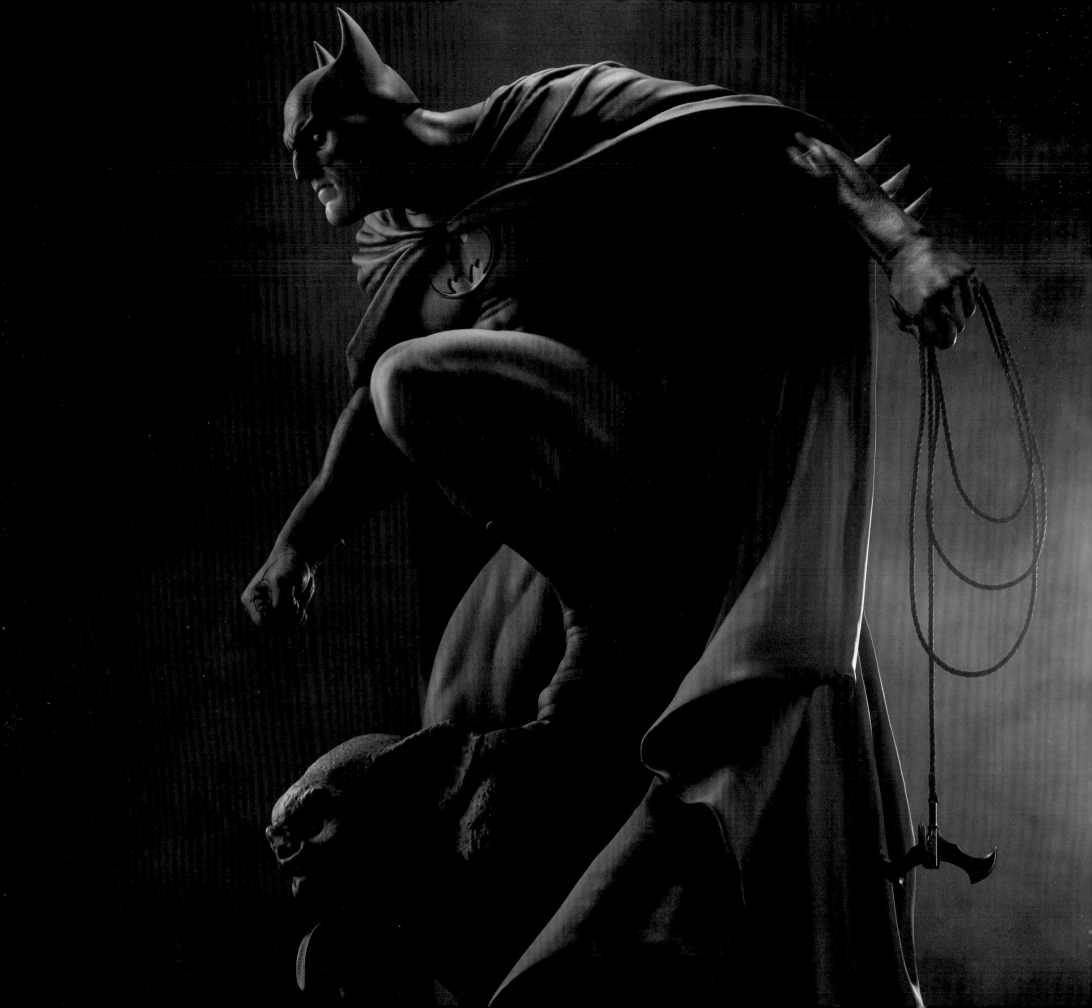

FOREWORD
WHY THE WORLD NEEDS HEROES

There is a wonderful line in a John Lennon song: *Life is what happens while you're busy making other plans.*

As a teenager, I had set out to become a stage actor but was conflicted about whether I should pursue a career that had more impact on people's lives: a doctor or a lawyer, something more essential than acting.

Moving to New York City and entering Juilliard at seventeen, I was largely escaping the misery of an alcoholic household and dissolving family. Juilliard gave me a scholarship, and I worked summer jobs to pay the rent. Soon I was doing summer stock and national tours of classics like *King Lear*, regional Shakespeare theaters with *Much Ado About Nothing*, *Midsummer Night's Dream*, and more *Lear*, playing Orestes in a trilogy of the entire Oresteia. That led to me working for Joe Papp at the New York Shakespeare Festival as Laertes in *Hamlet* and Lysander in *Midsummer*, and then, ultimately, to Broadway. As I was establishing a name in the New York theater community, various casting directors got to know my work.

Branching out, I began to do television. In 1991, on a trip to LA to shoot a new pilot, my agent said Warner Bros. was interested in my reading for a new animated show of *Batman*. I had no background in animation, wasn't a comic book reader, and had never even auditioned for an animated show. It seems one of those New York casting agents who was familiar with my work at the Public Theater knew WB was having trouble casting the role of Batman and suggested Andrea Romano bring me in. Fate.

An actor steeped in playing epic classic heroes onstage meets Bruce Timm, Paul Dini, Eric Radomski, and Andrea Romano, and is introduced to Batman—the most classic, epic, darkly theatrical hero of the entire DC canon. It all just clicked, and a twenty-eight-year partnership was born. But the chances of all those coincidences coming together the same day are about one in a million.

Now in 2020, Batman has brought me from *Batman: The Animated Series* to *The Adventures of Batman and Robin* to *Batman Beyond* to *Justice League*; the movies *Batman: Mask of the Phantasm*, *Batman & Mr. Freeze: SubZero*, *Batman: The Killing Joke*, *Batman and Harley Quinn*; the extraordinary *Arkham* games . . .

Through it all, the amazing Batman fans have been so loyal to the Dark Knight. He inspires such devotion and affection in his fans. I think it's his humanity that gets people. He has no superpowers; he can't fly or bend metal. He's a man. A very flawed and tortured man, trying to right the world. He's our culture's embodiment of that "hero with a thousand faces" that Joseph Campbell wrote about—that hero seen through all cultures, who is tortured by fate or the gods, is destroyed, and resurrects himself, transforming into an avenging angel.

Over the years, those fans have wanted to thank me for helping them through dark times, difficult childhoods, and abusive households. People have an emotional, personal connection to the Dark Knight—and, by extension, my performance.

Recently I've been asked to record personal videos for fans with greetings from Batman. Originally, they were overwhelmingly "Happy Birthday," "Congrats on the new job," or "Happy Anniversary." But at the time of writing this, we find ourselves living through a deadly global pandemic that has devastated lives and ravaged the economy. I was sure the bookings would cease as jobs evaporated and budgets tightened. But the exact opposite has happened. The bookings have multiplied.

It seems people need a hero now more than ever. But the messages have changed. People want words of encouragement for friends who've lost jobs, words of solace to those fighting the virus, or words of inspiration to the front-line workers. Batman continues to mean so much to so many, and I'm just lucky to be a part of it. And it all came to me as I was so busy making other plans. I suppose I ended up pursuing exactly the career I was meant to, and it is essential in its own way.

My experience has taught me that there is more need now for heroes than ever. People need heroes who stand for a clear and honorable truth. Batman and dozens of other heroes created by DC have filled this need, providing hope and inspiration to thousands. And those heroes are so beautifully captured in these figures depicted by Sideshow Collectibles.

Kevin Conroy
2020

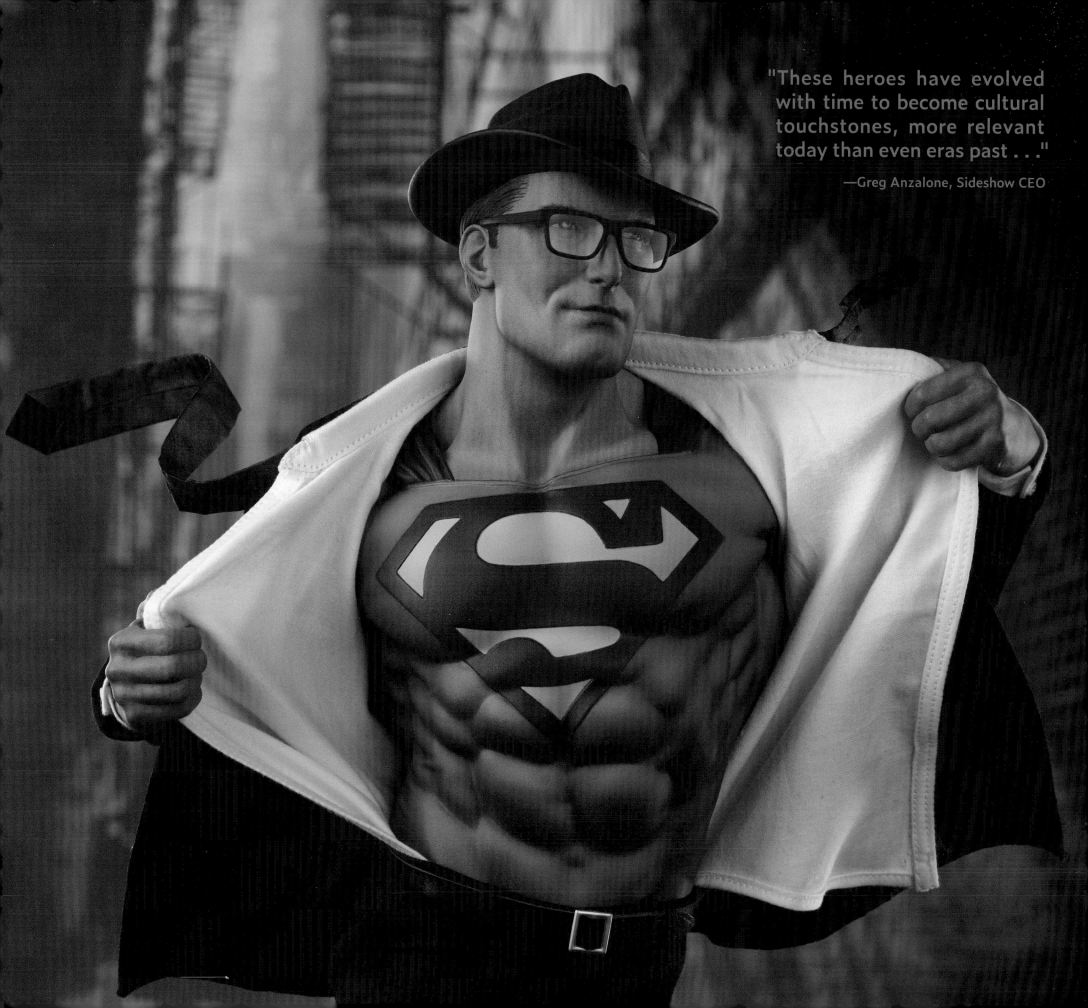

"These heroes have evolved with time to become cultural touchstones, more relevant today than even eras past . . ."

—Greg Anzalone, Sideshow CEO

INTRODUCTION

From the first appearance of Jerry Siegel and Joe Shuster's Superman in 1938—the original costumed Super Hero—in *Action Comics* #1, DC Comics has been synonymous with the World's Greatest Super Heroes. Almost overnight, the Man of Steel inspired a bold, new heroic age and was joined on the newsstand by Batman and Robin, Wonder Woman, The Flash, Green Lantern, Aquaman, and a veritable legion of Super Heroes to follow.

Within two years of his introduction, Superman would star in the nation's top-rated children's radio program. Just over a decade later, he would headline one of the most popular shows on television, *Adventures of Superman*. Hit animated series and a string of blockbuster motion pictures would follow. Along the way, the Man of Steel's iconic red *S* became a symbol of heroism and virtue recognized throughout the DC multiverse, from the high-rises of Metropolis to the farmhouses of Smallville.

Superman's fellow crime fighters Batman and Wonder Woman joined him on the global stage, appearing in best-selling comic books, starring in popular television shows and films, and becoming a big part of our everyday lives, thanks to licensed products ranging from Underoos to breakfast cereals. Whether fans know DC's Trinity from graphic novels, cartoons, or coloring books, the cultural impact of DC is undeniable.

As an essential part of our popular culture, it was inevitable that DC would team up with Sideshow to create an entire universe of premium figures and statues, showcasing the original Super Heroes in a format worthy of their incredible legacy. "As one of the premiere makers of figure collectibles, Sideshow found the DC multiverse a perfect playground to immerse itself in," says Sideshow CEO Greg Anzalone. "These are characters that have helped shape the former comic landscape as well as our current popular culture."

After a long history of mutual admiration, Sideshow and DC joined forces in 2011 to produce their first statue, a Premium Format™ Figure of The Joker.

Sideshow's chilling rendition of the Clown Prince of Crime was an immediate hit, launching a dynamic partnership that continues to this day. "I vividly remember the mutual enthusiasm that Sideshow and the DC creatives shared about our collaboration," says Anzalone. "It was a symbiotic match in temperament, enthusiasm, and vision. There is a high level of trust that has been hard-earned between DC and Sideshow. That trust translates into guidance but not demands, feedback but not overbearing art direction, and that shows in the quality of the work that we produce."

The collaboration has produced astonishing results, and each piece that Sideshow creates, whether bringing a popular movie costume to sixth scale or designing a radical new interpretation of a classic character, represents a series of new and unique challenges—but the Sideshow team wouldn't have it any other way. "We look at each of these characters as a puzzle to solve," adds costume fabrication manager Tim Hanson. "Each of these statues has individual challenges that we have to address. Our techniques will vary from project to project, but bringing life to these characters—that's our primary function."

Over the course of the past decade, Sideshow has worked its creative magic on the iconic heroes of the DC multiverse. And like those iconic heroes, this World's Finest team shows no signs of slowing down. "These heroes have evolved with time to become cultural touchstones, more relevant today than even in eras past," says Greg Anzalone. "Look at Wonder Woman as a prime example. We're in the midst of a renaissance of female empowerment and the creation of a world that encourages and celebrates female leadership. Or Batman, who realizes that his charitable works as billionaire Bruce Wayne are just as important as what he does in costume, if not more so, when it comes to building a better future. And Superman's ideals and heroism are just as inspirational and vital today as they've ever been.

"The world will always need heroes."

SIXTH SCALE
FIGURES

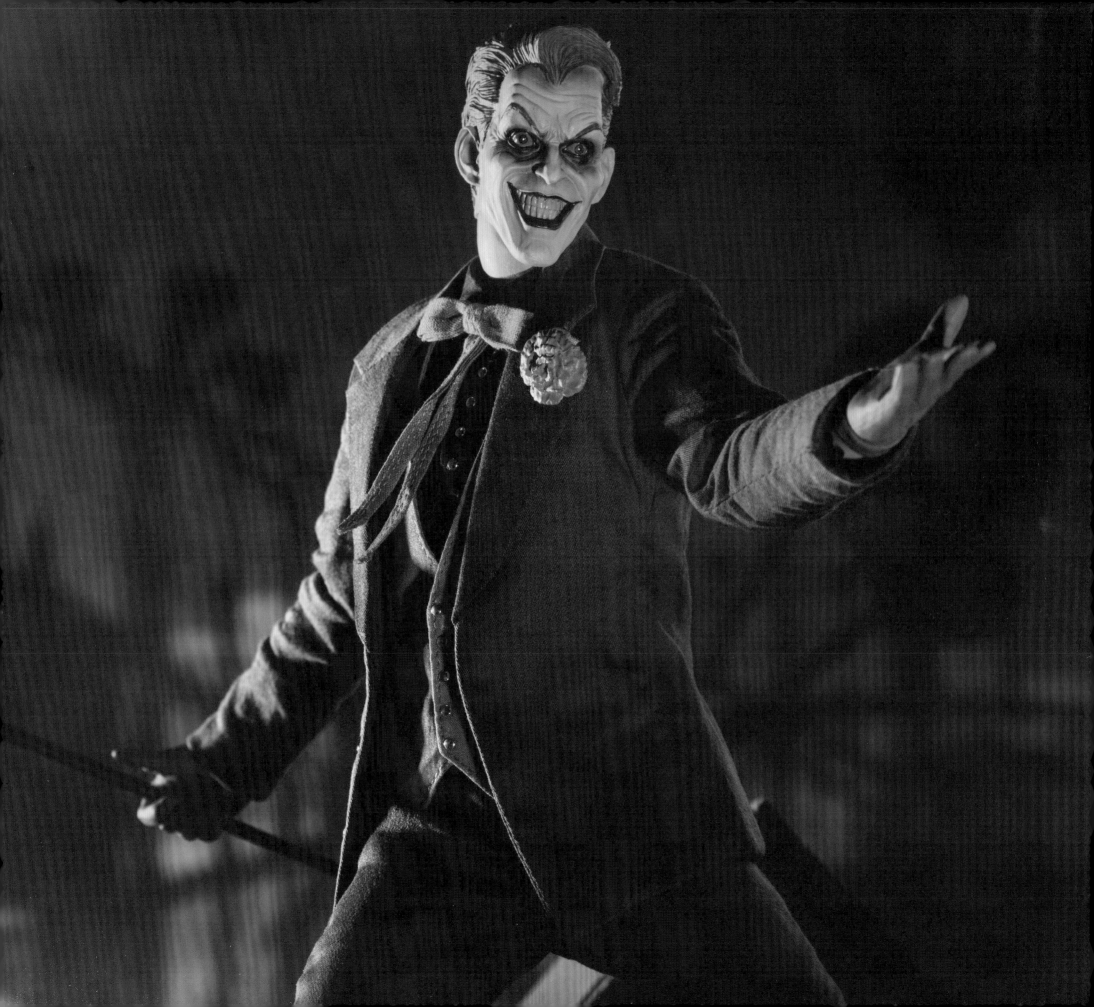

"MY DISGUISE MUST BE ABLE TO STRIKE TERROR INTO THEIR HEARTS. I MUST BE A CREATURE OF THE NIGHT..."
–BRUCE WAYNE, *DETECTIVE COMICS* #33 (1939)

SIXTH SCALE FIGURES

Sixth-scale figures—articulated foot-high figures with changeable clothing and accessories—have been captivating fans and collectors for generations. Although the playscale format had caught on with hobbyists and sculptors earlier, it achieved lasting mainstream popularity with the 1964 introduction of Hasbro's original G.I. Joe, which boasted an attention to detail that had not been seen previously in collectible action figures. Other sixth-scale figures from rival manufacturers would soon follow, including the Ideal Toy Company's Captain Action, an adaptable heroic figure who, with a change of wardrobe, could adopt the guise of any number of Super Heroes, including Superman, Batman, and Aquaman. This was DC's first foray into the action figure market.

The short-lived Captain Action line folded in 1968, just two years after its introduction, but the DC Super Heroes wouldn't disappear from toy stores for long. The Mego Corporation picked up the DC license and produced twenty different figures starting in 1972, with best-selling renditions of Superman, Batman, Robin, and Wonder Woman alongside lesser-known heroes like the Teen Titans—Speedy, Kid Flash,

Aqualad, and Wonder Girl. Mego's World's Greatest Super Heroes! line would end its run in 1983, but its legacy was undeniable, as a generation of comic book fans can attest.

In the following decade, Sideshow would take sixth scale to the next level, bringing an unprecedented level of craft and detail to their figures, first with the award-winning Star Wars line, and later, with other popular licensed characters from the Marvel Universe as well as Indiana Jones and, appropriately enough, G.I. Joe. It was only a matter of time before they turned their attention to the classic, beloved heroes of the DC multiverse and some of the most iconic characters in the history of popular fiction.

Bringing life to these classic heroes is an all-star team of creators, Sideshow's very own Justice League. Bonded together by their love of comics and toys, this crew of visual artists, graphic designers, sculptors, and builders have joined forces to create some of the most visually stunning collectibles in the known universe.

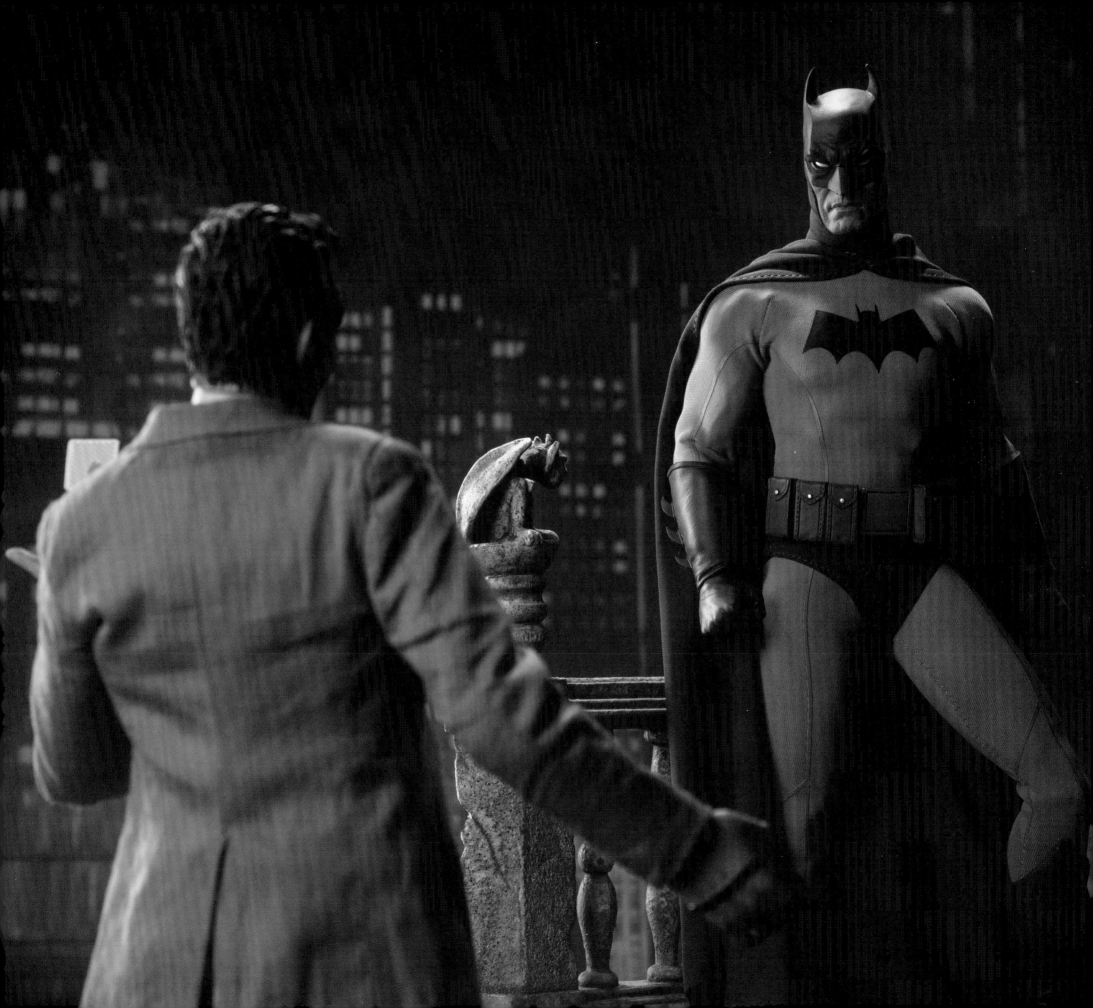

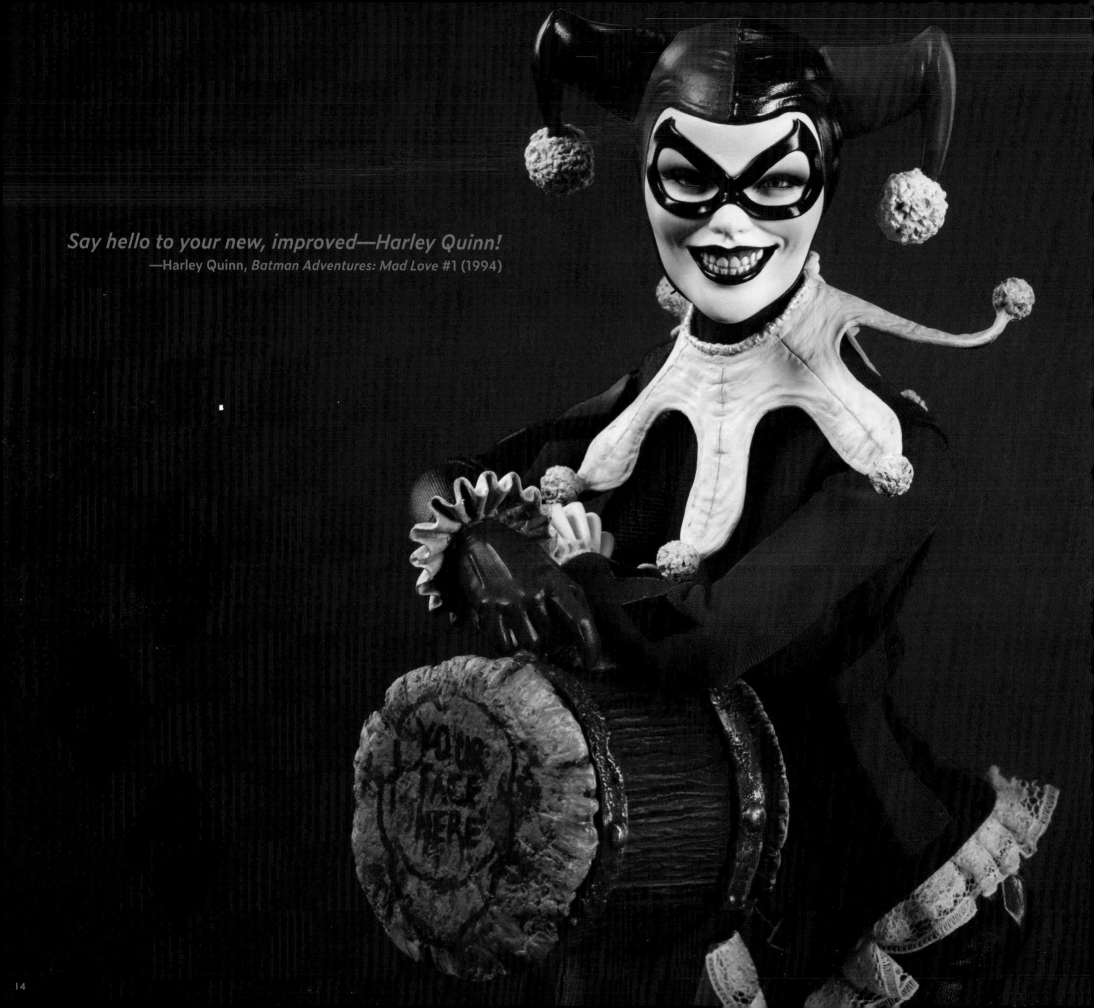

Say hello to your new, improved—Harley Quinn!
—Harley Quinn, *Batman Adventures: Mad Love #1 (1994)*

HARLEY QUINN

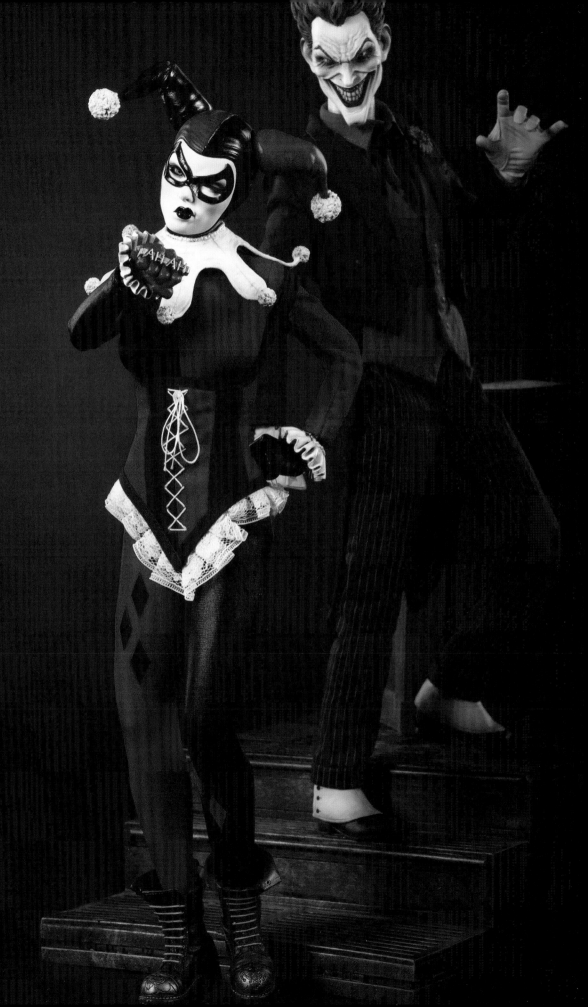

Dr. Harleen Quinzel was an honest, overworked psychiatrist who was driven to help—until she was driven mad by The Joker. No longer bound by society's rules, she would reinvent herself as The Joker's partner, Harley Quinn, and Gotham City would never be the same.

Sideshow's rendition of DC's madcap adventurer highlights Harley Quinn's penchant for getting into trouble, as well as her acrobatic prowess and her incredible arsenal—including a custom cleaver, an oversize popgun, and comically engraved brass knuckles—making her a force to be reckoned with. Whether she's battling alongside The Joker or fighting alongside Gotham City's heroes, Harley never loses her sense of humor—or her giant wooden mallet!

Dressed to kill in a detailed fabric bodysuit, fitted corset, and iconic red-and-black jester tights, Sideshow's Harley features a full array of interchangeable hands and weaponry, plus an alternate head capturing one of her more playful expressions. This attention to detail is found in every one of Sideshow's Sixth Scale Figures. "Research is key!" says costume fabrication artist Esther Skandunas, discussing the care and craft that goes into each character. "Before I can do anything, before I look for fabrics or start the patternmaking process, I have to become a bit of a detective. I need to know every detail of the clothes. If the character is a film or TV character, as in the case of Harley Quinn, I try to find as much visual detail information as possible, so that I can accurately replicate the clothing on a smaller scale."

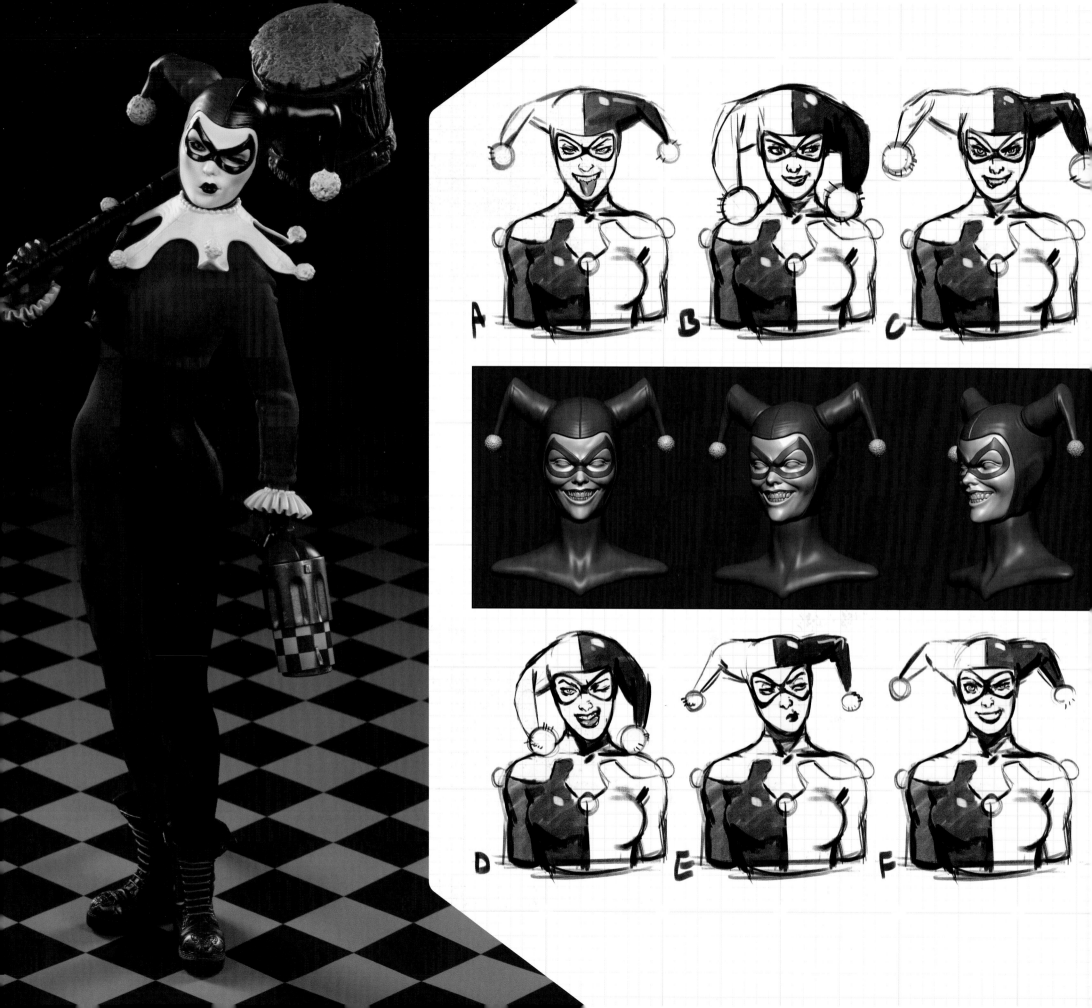

A

B

C

D

E

F

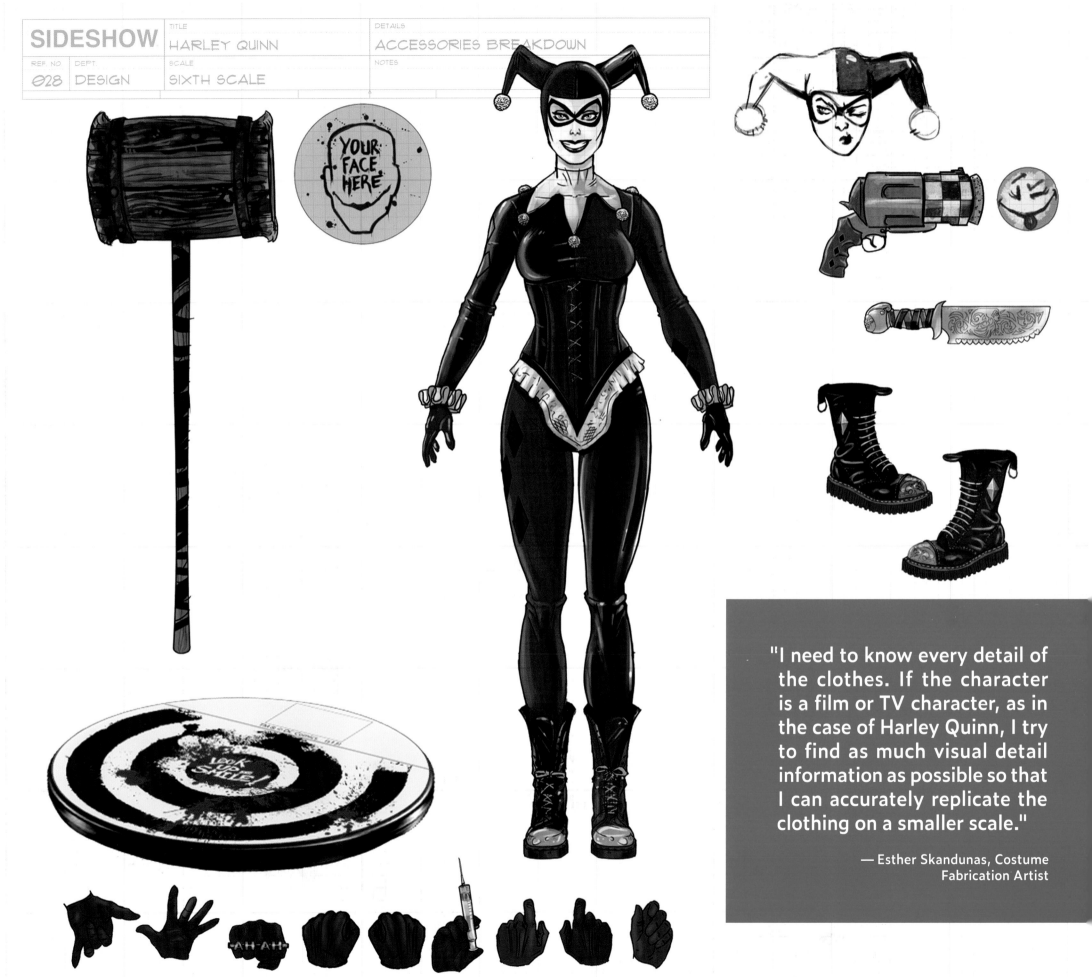

TITLE
HARLEY QUINN

DETAILS
ACCESSORIES BREAKDOWN

REF. NO.
028

DEPT.
DESIGN

SCALE
SIXTH SCALE

NOTES

YOUR FACE HERE

"I need to know every detail of the clothes. If the character is a film or TV character, as in the case of Harley Quinn, I try to find as much visual detail information as possible so that I can accurately replicate the clothing on a smaller scale."

— Esther Skandunas, Costume Fabrication Artist

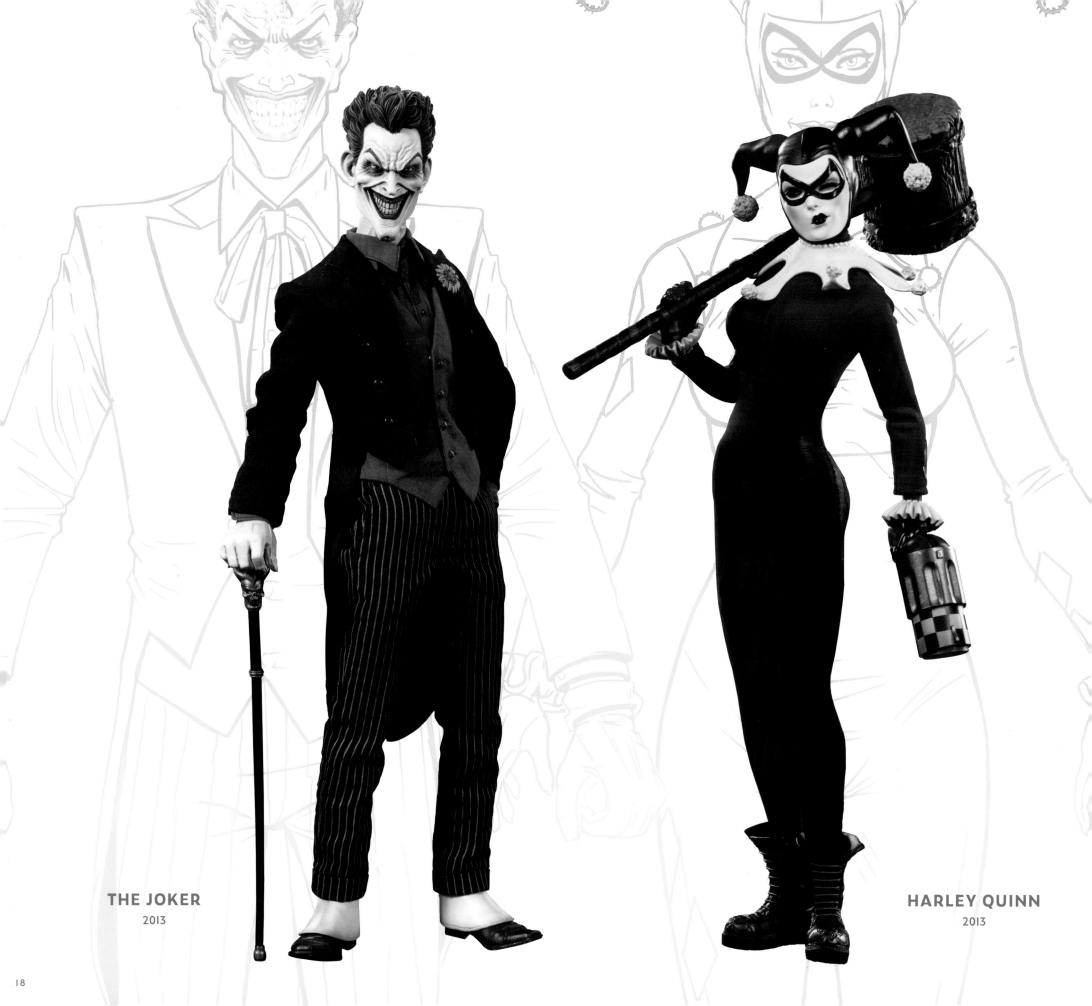

THE JOKER
2013

HARLEY QUINN
2013

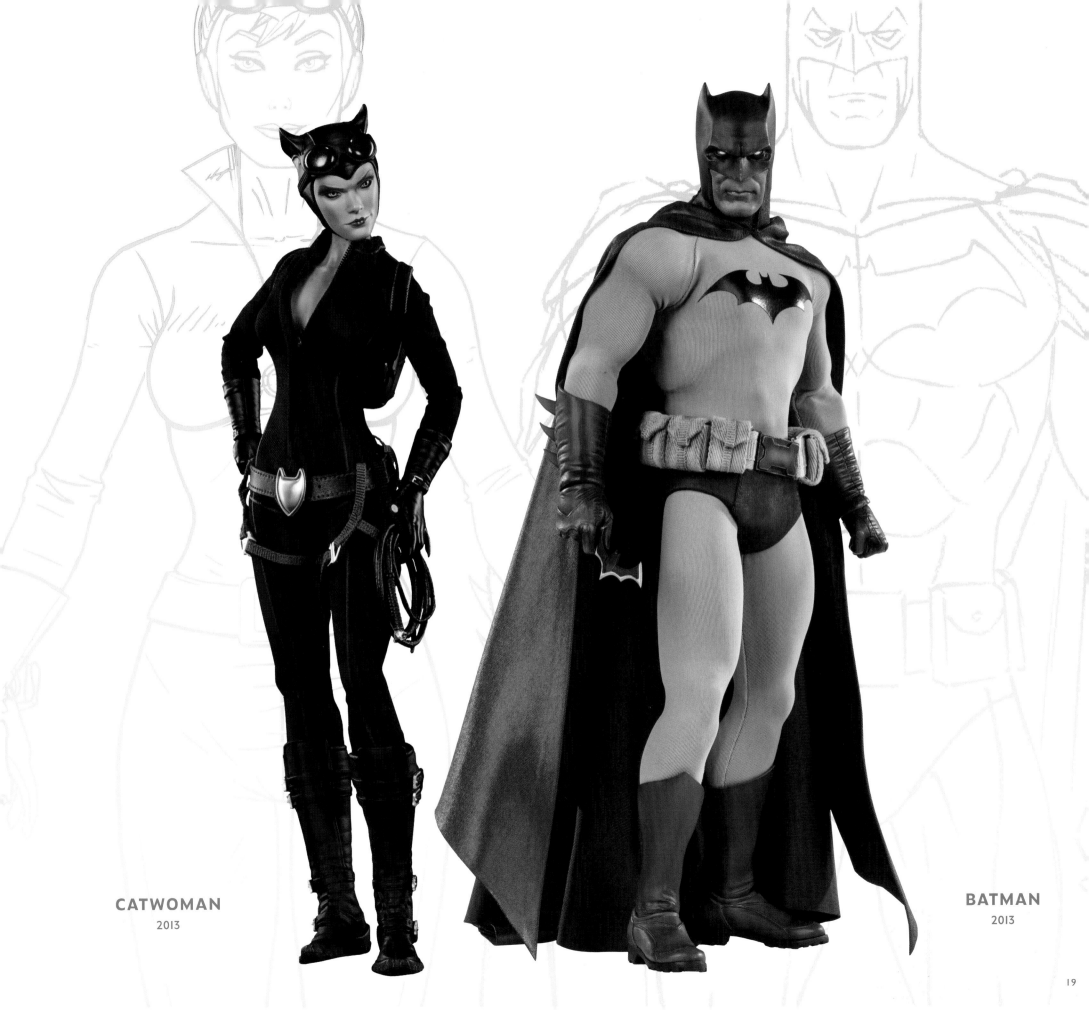

CATWOMAN
2013

BATMAN
2013

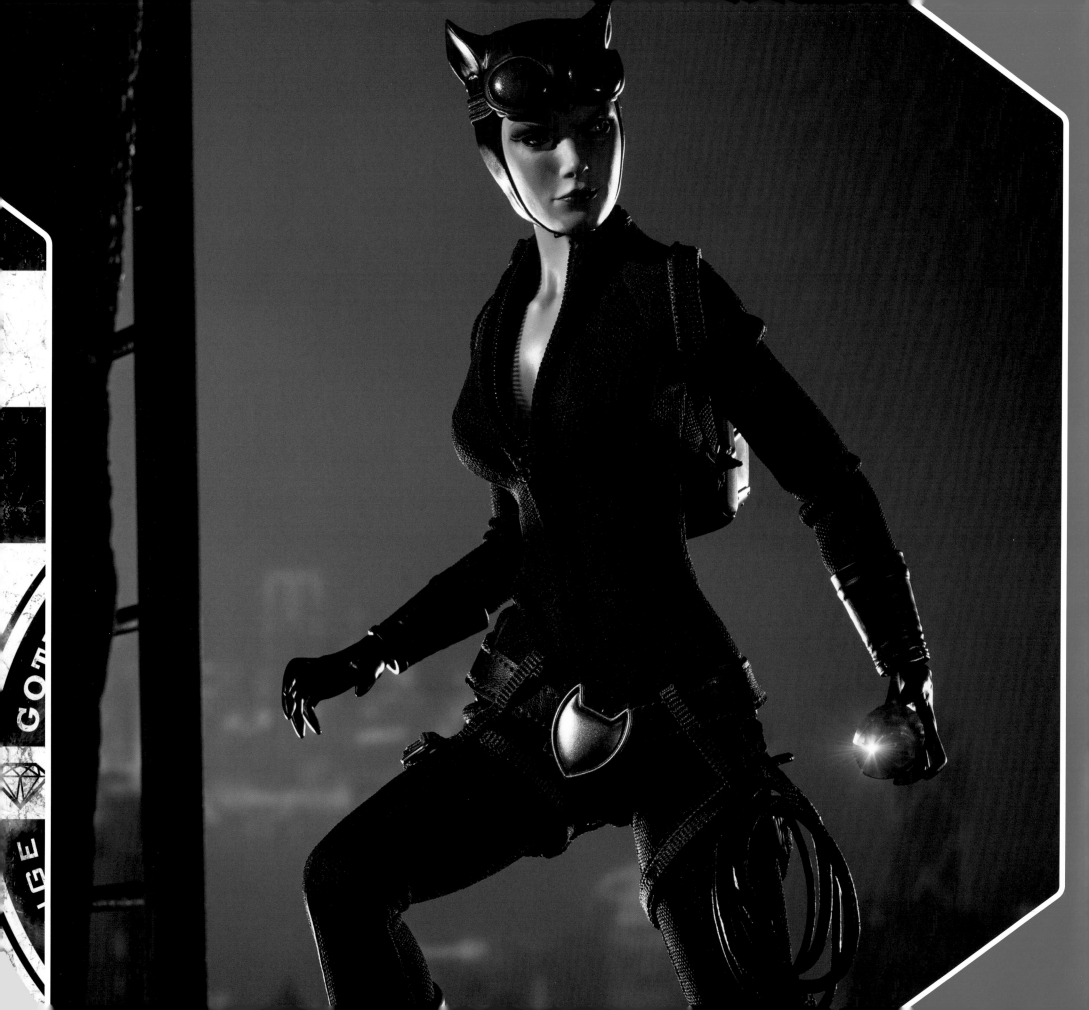

CATWOMAN

They may suspect me, but they'll never see me. They may chase me, but they'll never catch me. Never, never, ever catch me. —Catwoman, *Catwoman,* #19 (1995)

The mysterious Catwoman is Gotham City's most wanted—and most elusive—cat burglar. The infamous Selina Kyle walks the razor's edge between light and darkness, perpetrating an elaborate jewel heist one day, aiding Gotham City's costumed heroes the next. Motivated partly by her own self-interest and partly by the fun of not playing by anyone's rules, Catwoman remains the most unpredictable member of Batman's Rogues Gallery.

Sideshow's Catwoman is fitted with a sleek, modern black bodysuit and all the essential tools of her trade, including her trademark whip, infrared goggles, lockpicks, cat claws, and a climbing harness for making a quick entrance or hasty retreat.

Two interchangeable hand-painted unmasked heads, or portraits, have been created to capture two sides of this feline femme fatale, one with Selina's mischievous smirk and a second that shows off her more ferocious side.

"This is one of the few Sixth Scale Figures that I've had the chance to work on," notes painter Kat Sapene. "I was a freelancer and came on at a time they were willing to give a new painter a try. I dove headlong into painting and got all my training on the job—usually by making mistakes and having to fix them," laughs Sapene. "In the end, I think these turned out great."

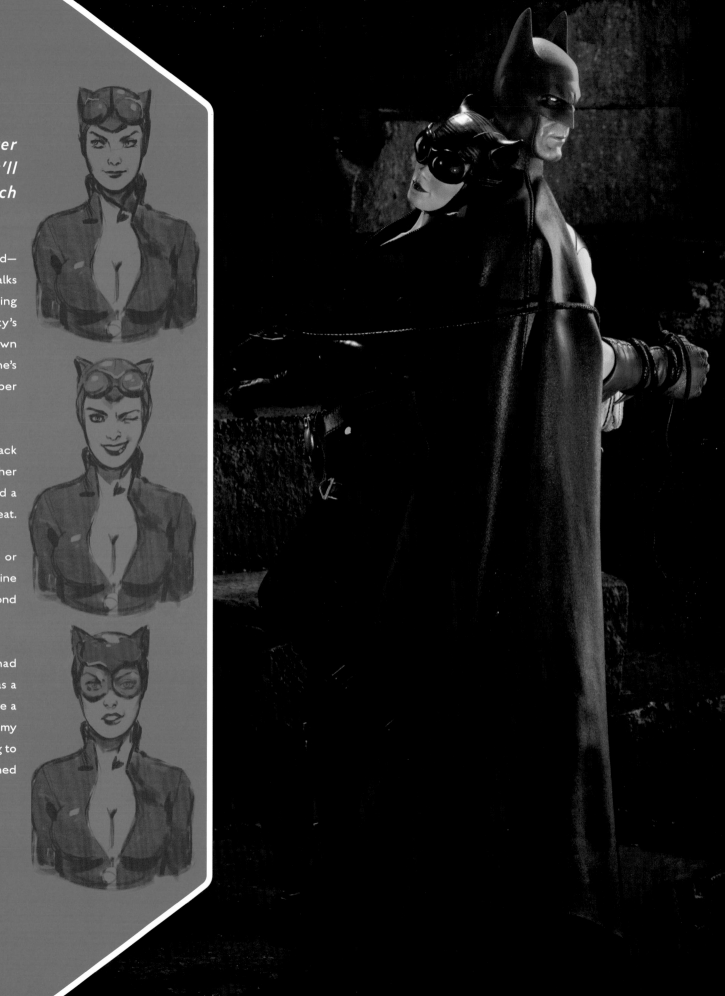

TRANSPARENT LENSES

HAIR PIECE

PARTING LINES
FOLLOW SEAMS

EYE INSERTS

SOFT WHIP

HARD HANDLE

HARD SHELL

FABRIC CORE
WITH ZIPPER

SOFT PLASTIC

HARD PLASTIC

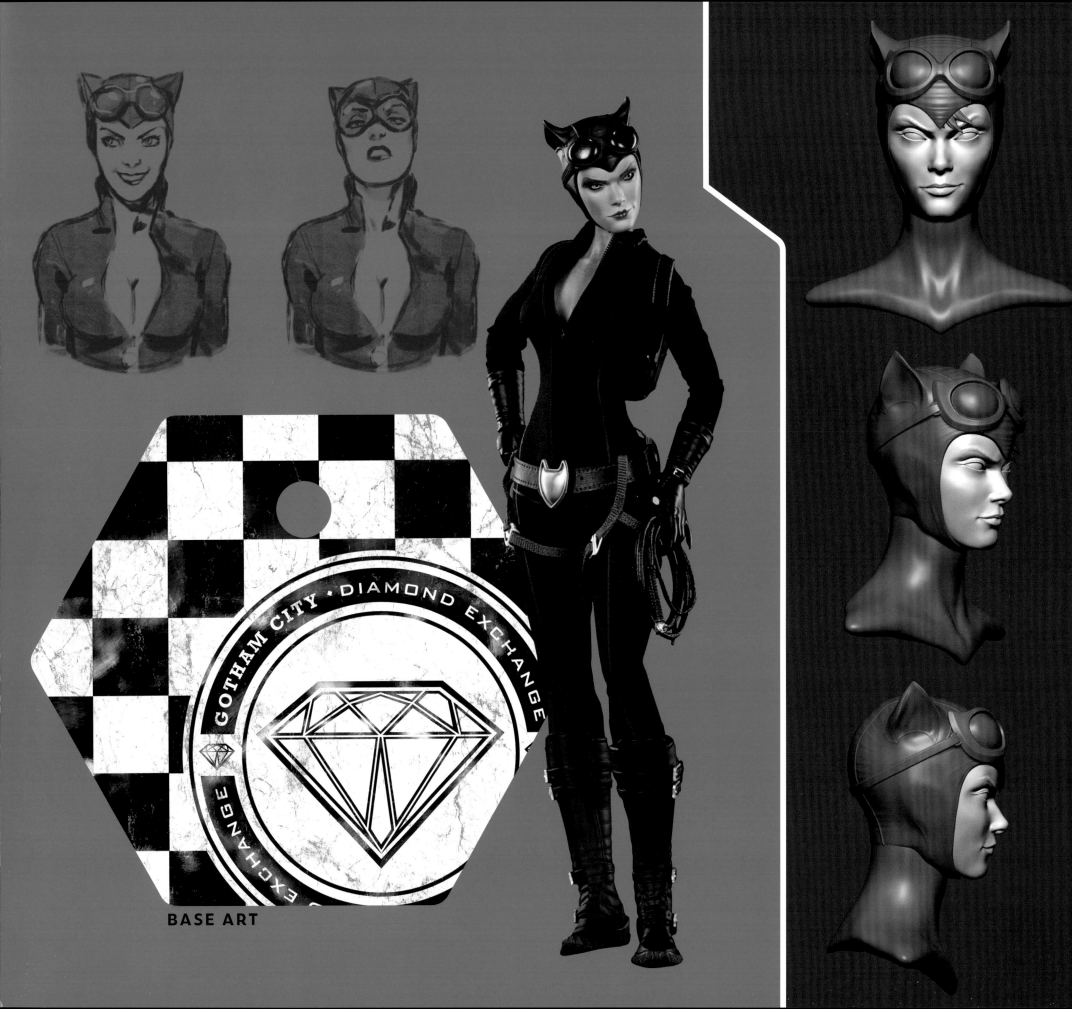

BASE ART

SUPERMAN
2014

BATMAN
GOTHAM KNIGHT
2015

24

GREEN LANTERN

2015

LOBO

2016

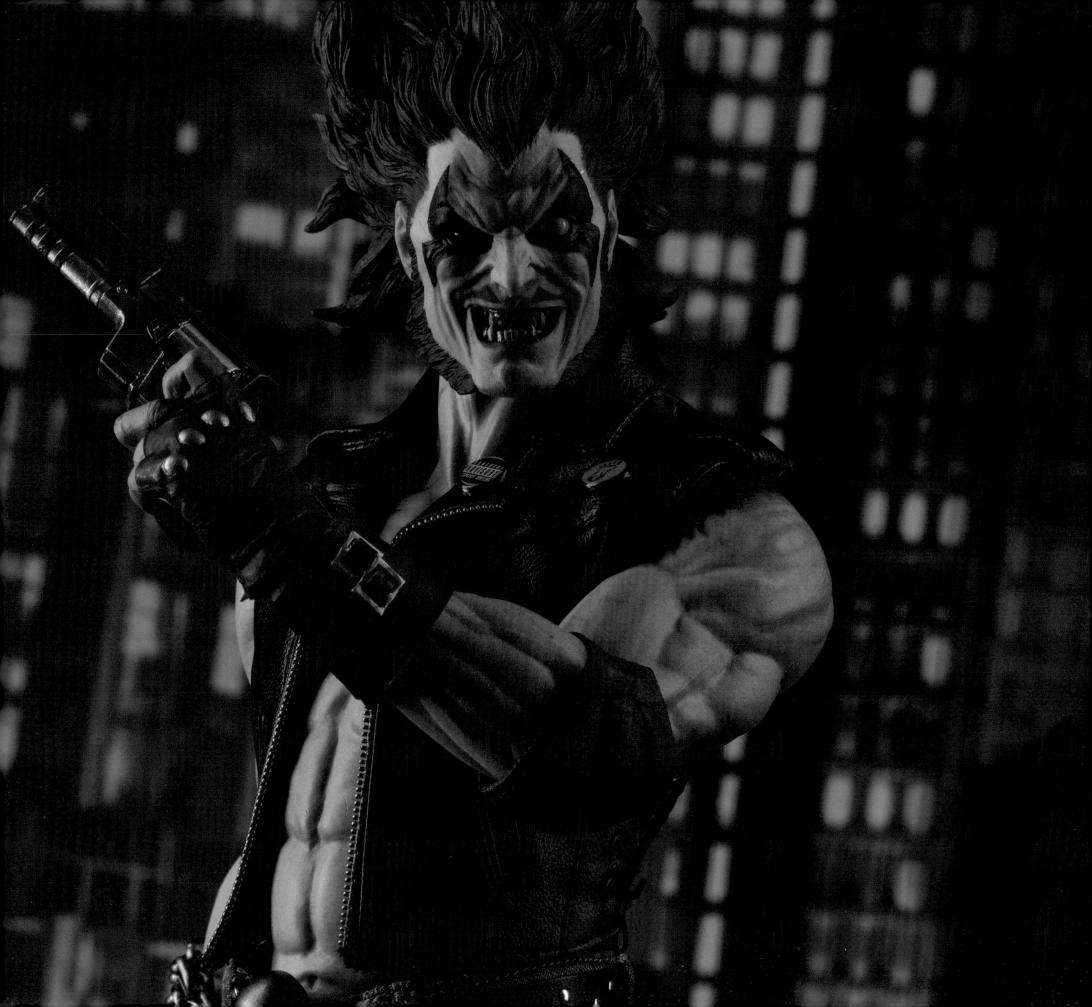

LOBO

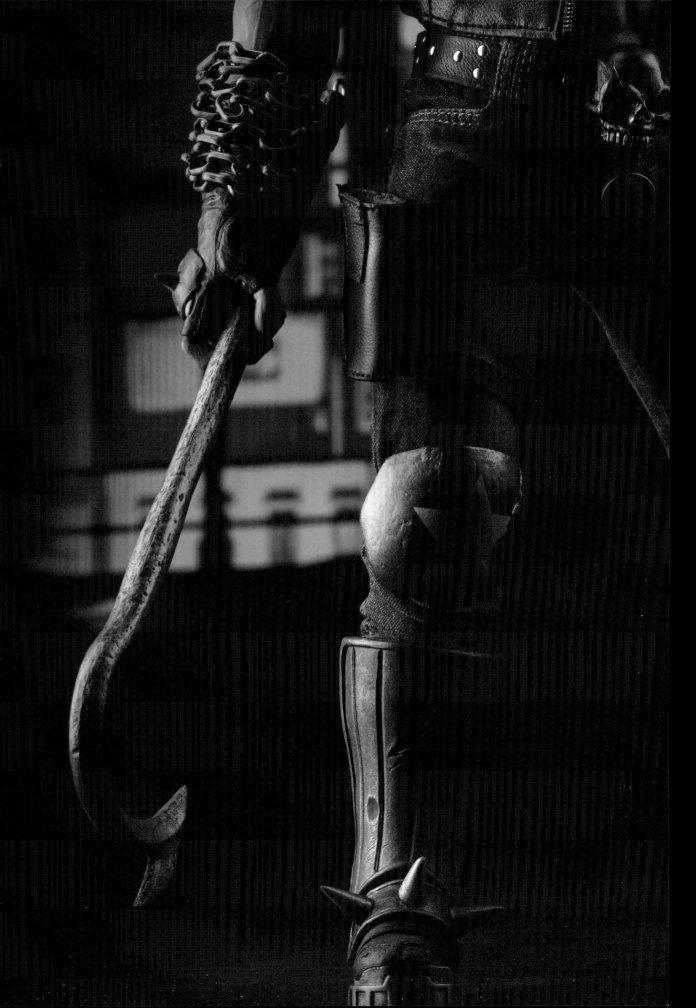

I got one whole heap o' pent-up anger an' frustrated rage just a-beggin' fer a few friendly faces to frag! —Lobo, *Lobo* #1 (November 1990)

Lobo, known as the Main Man to friends and enemies alike, is the most fearsome bounty hunter in the galaxy. This deadly intergalactic biker is the last survivor of the utopian planet Czarnia, a status he earned through his systematic elimination of his entire civilization—not surprising behavior from one whose name means "one who devours your entrails and thoroughly enjoys it."

Armed with his iconic hook and chain, his customized SpazFrag666 spacehog and a penchant for extreme violence, the Last Czarnian's super-strength, advanced healing powers, and creative methods for inflicting pain make him one of the most dangerous characters in the DC multiverse.

Sideshow's rendition of Lobo represents an amazing step forward in product detailing; among its many sculpted pieces are a unique torso and arms, accentuating Lobo's superhuman physique, and all the custom accessories that fans have come to expect from the Main Man, including his classic hook and chain, skull belt buckle, and hero-stomping boots. Lobo's tattered vest includes a custom patch featuring his signature catchphrase, "Bite Me Fanboy."

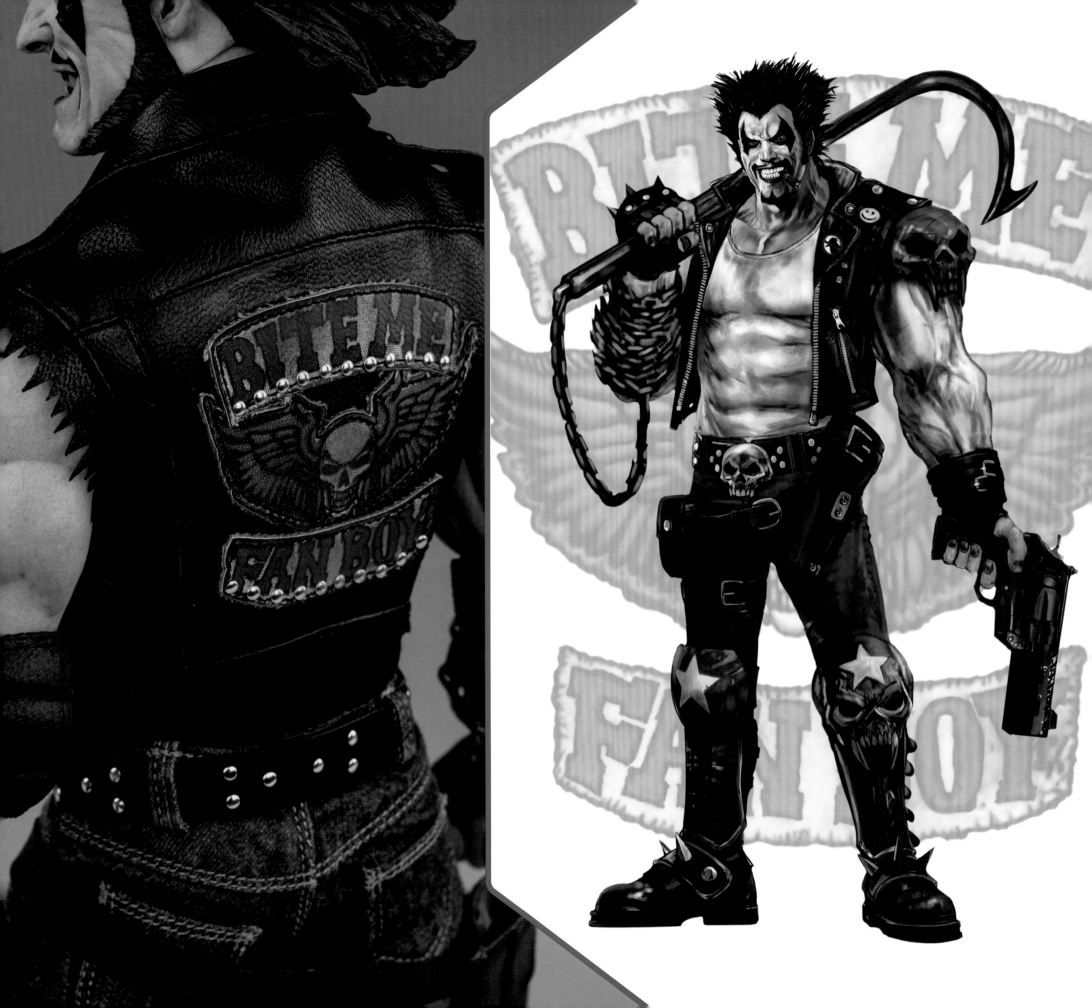

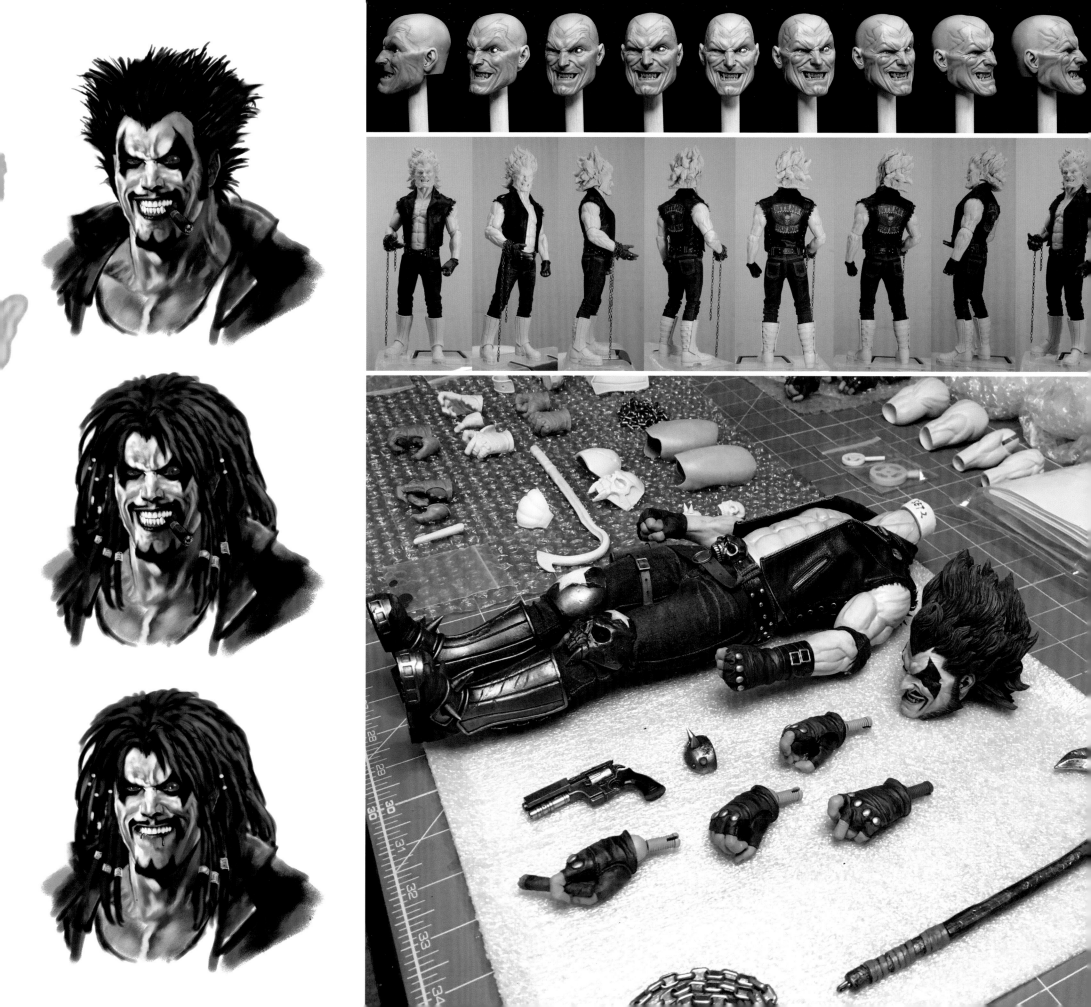

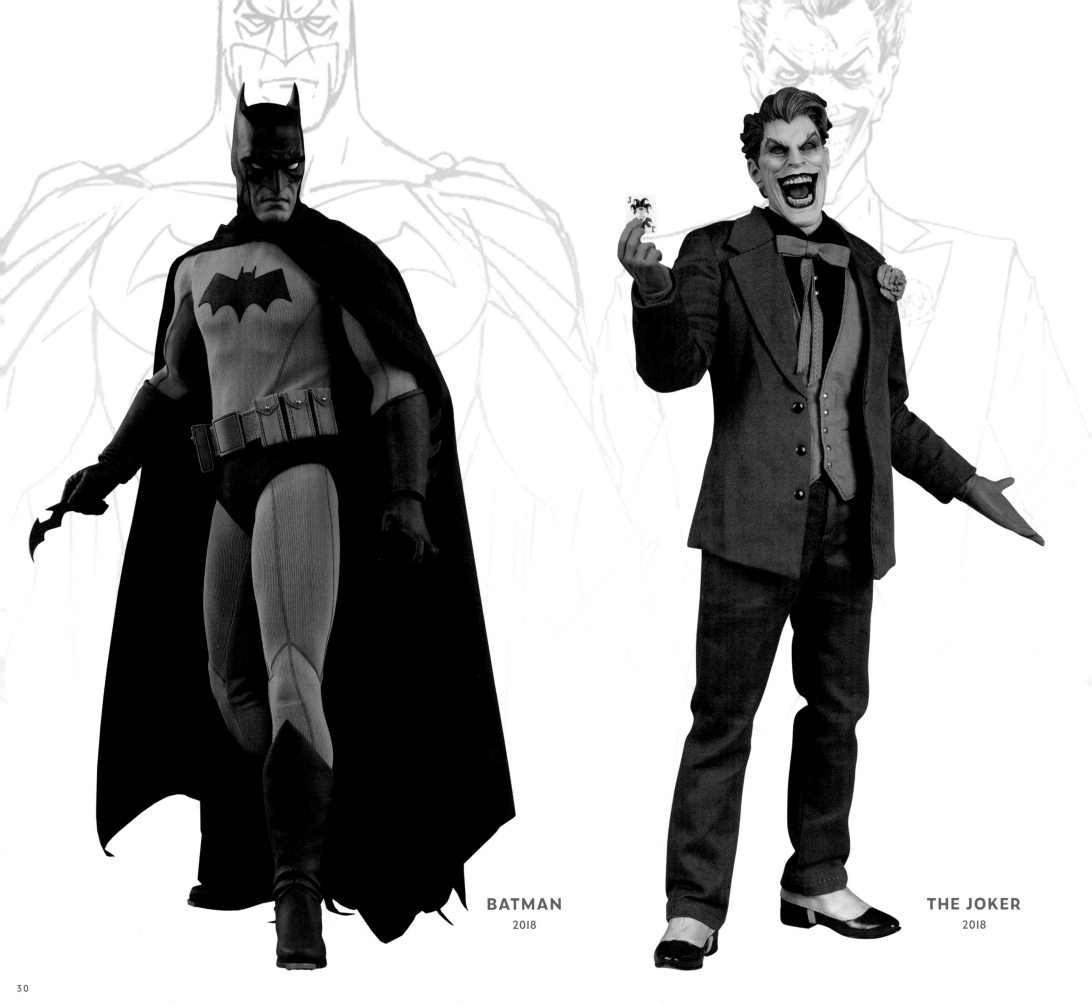

BATMAN
2018

THE JOKER
2018

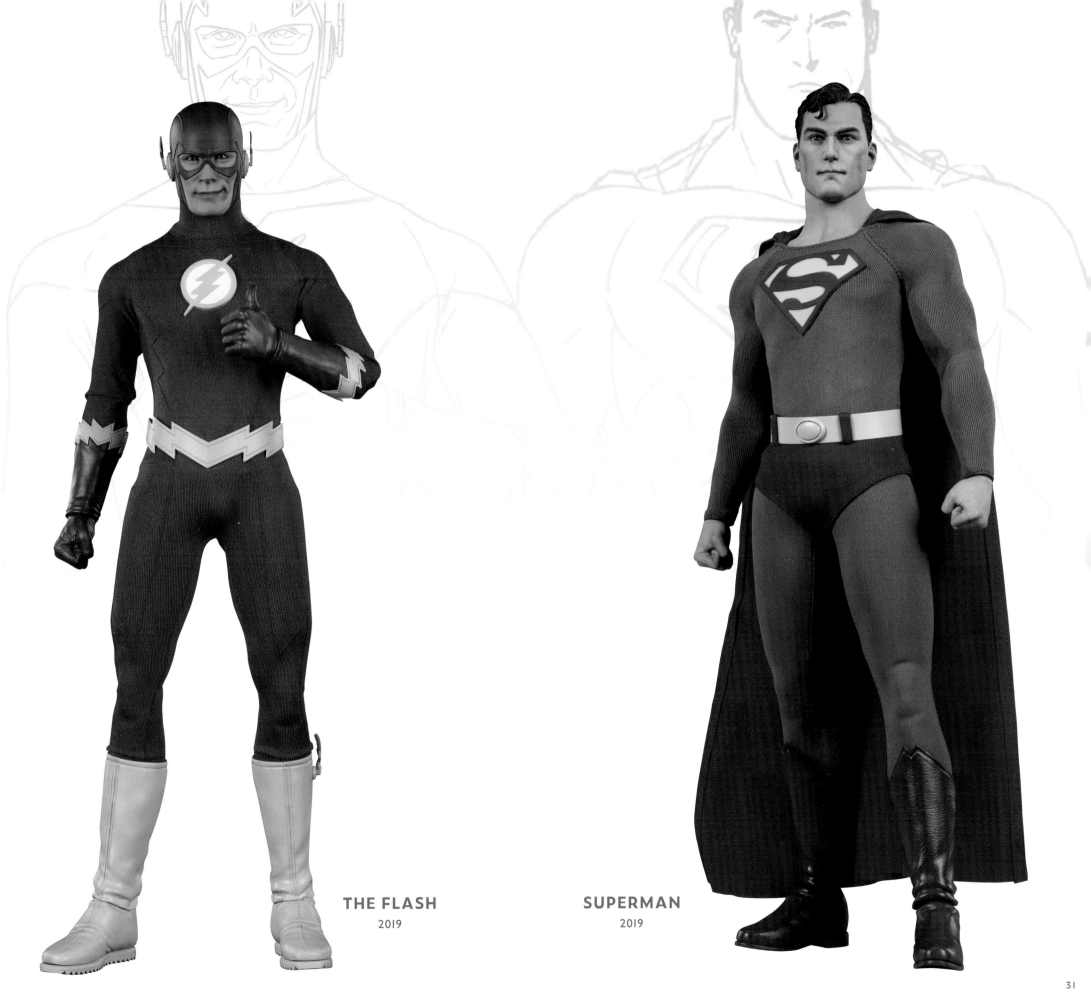

THE FLASH

2019

SUPERMAN

2019

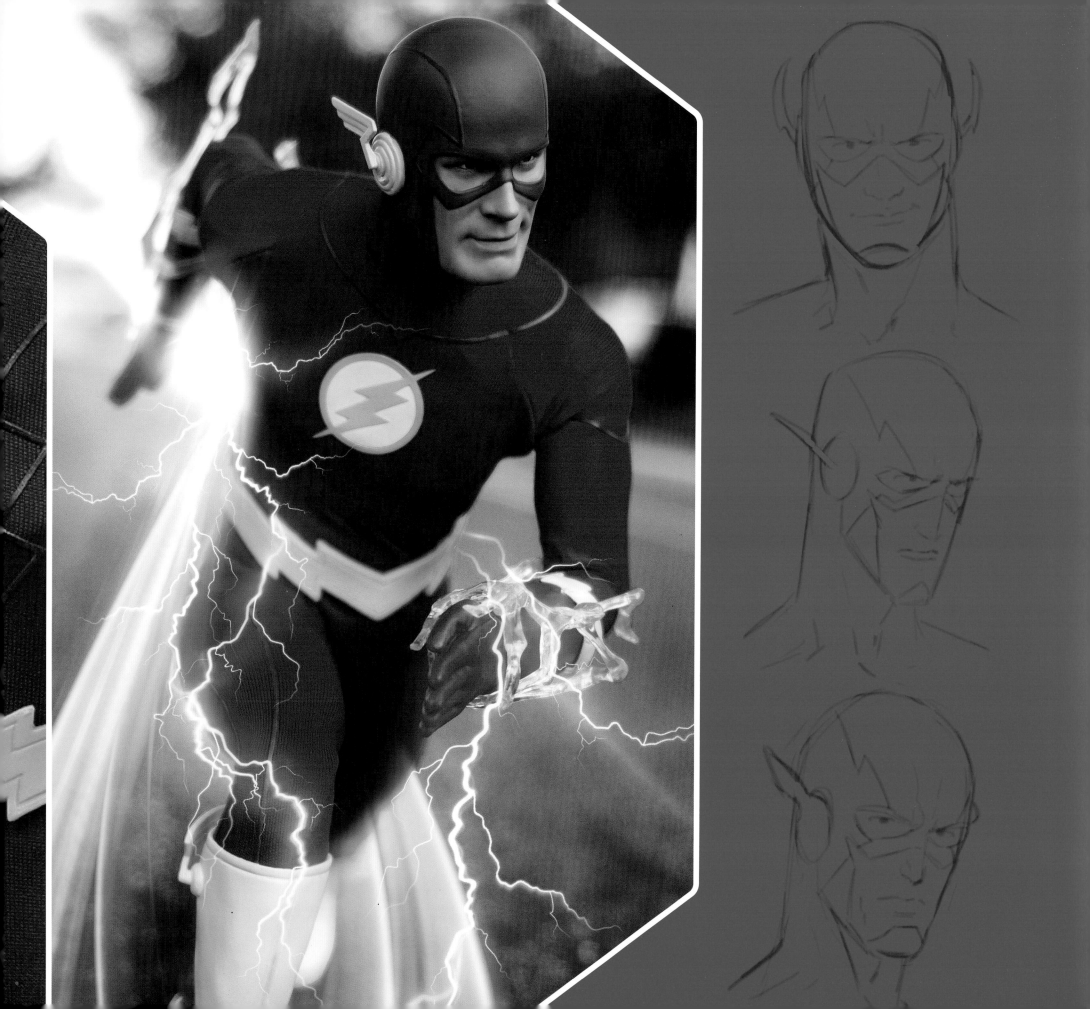

THE FLASH

Maybe I just need to run and see where the Speed Force takes me. —The Flash, *The Flash* #58 (January 2019)

Forensic scientist Barry Allen was working late one night when a lightning bolt struck his laboratory and doused him with a mysterious array of super-charged chemicals, rendering him unconscious. When he awoke, he discovered that the accident had gifted him with super-speed, drawn from the extra-dimensional cosmic energy field called the Speed Force. Vowing to use his newfound powers for good, and drawing inspiration from the beloved Super Hero comics of his youth, he adopted the costumed identity of The Flash—the Fastest Man Alive.

Based on Barry Allen's signature comic book appearance, The Flash Sixth Scale Figure features a tailored red fabric costume with piping detail, yellow accents, and his iconic lightning bolt logo. The cheerful, optimistic hero launched a revival of DC's Super Hero comics upon his introduction, and Allen became the signature character of the era that came to be known as the Silver Age of Comics.

Sideshow's The Flash Sixth Scale Figure captures Barry Allen's heroism, and through its bold sculpture and poseability, this articulated figure is equipped for a variety of dynamic action poses. It includes four sculpted lightning effects, which can be attached around the gloves and boots to show the Speed Force in action.

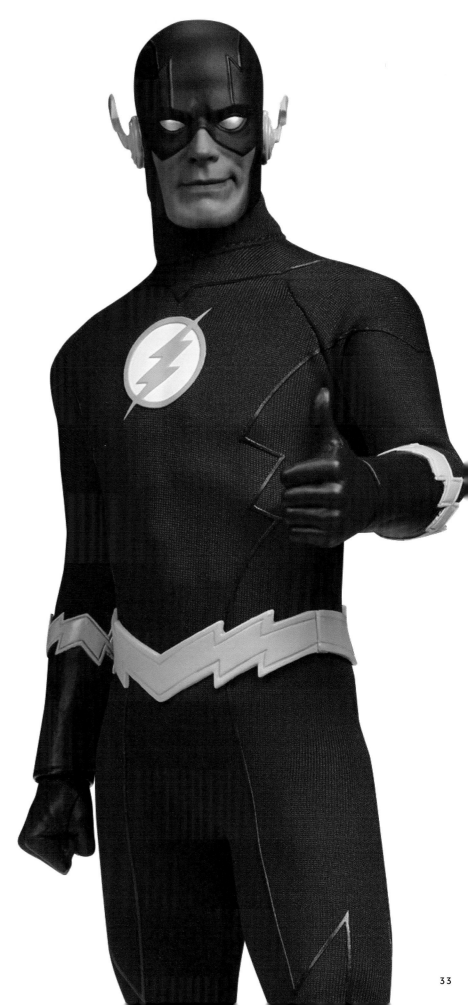

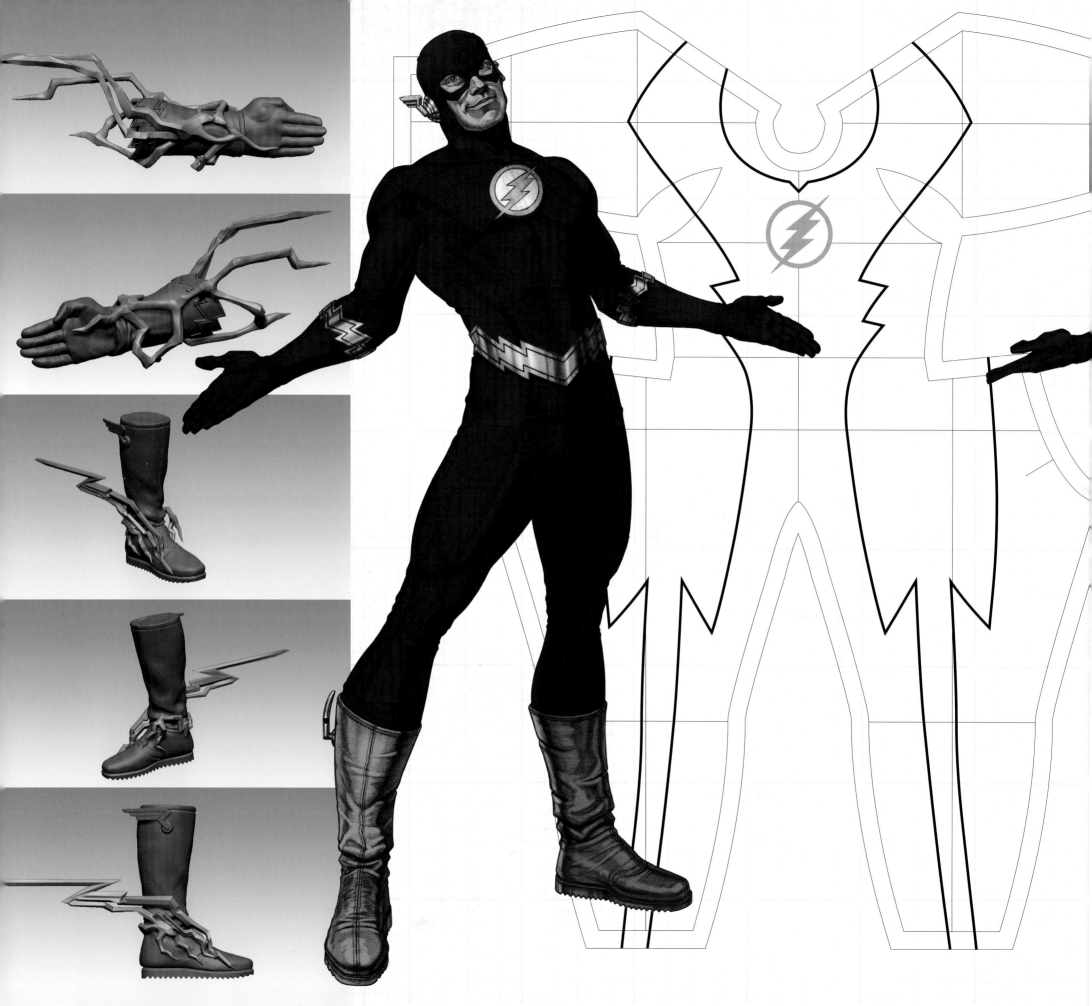

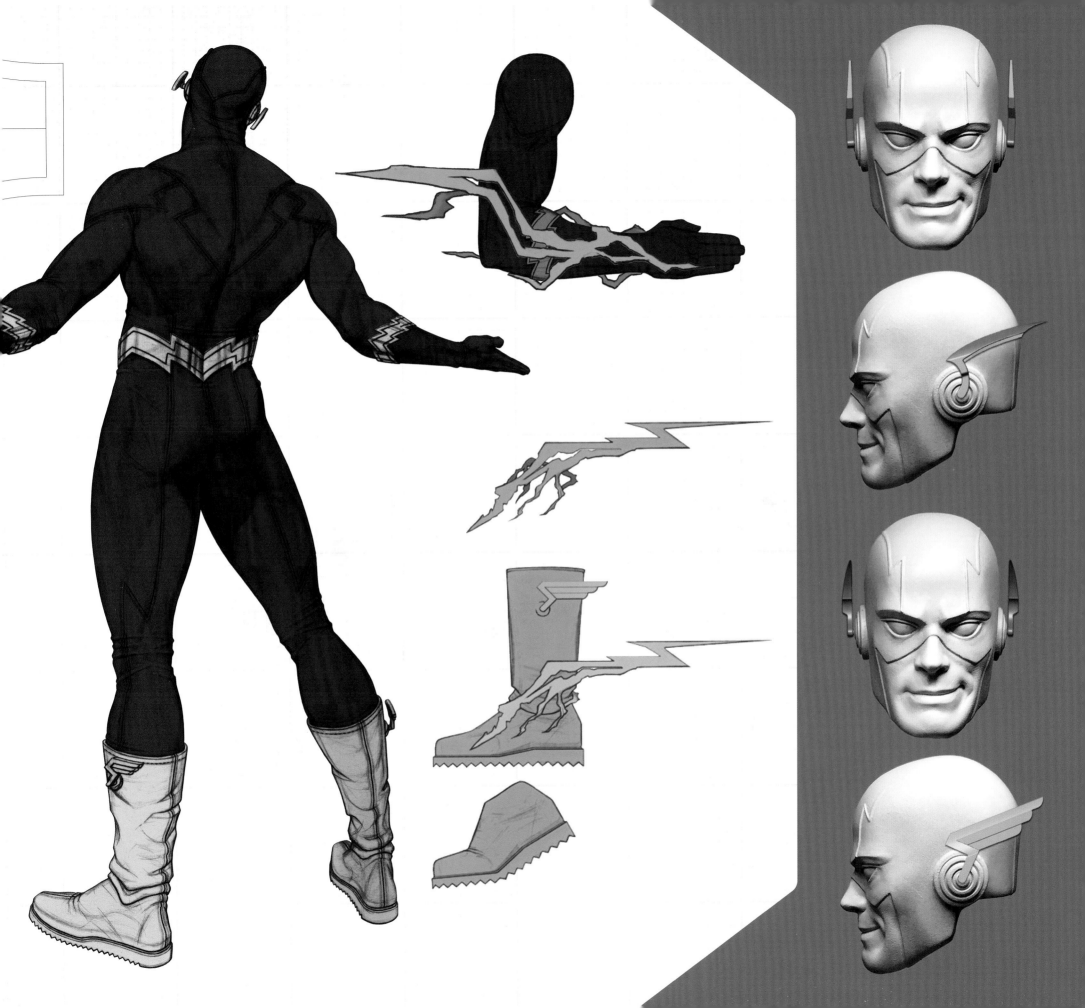

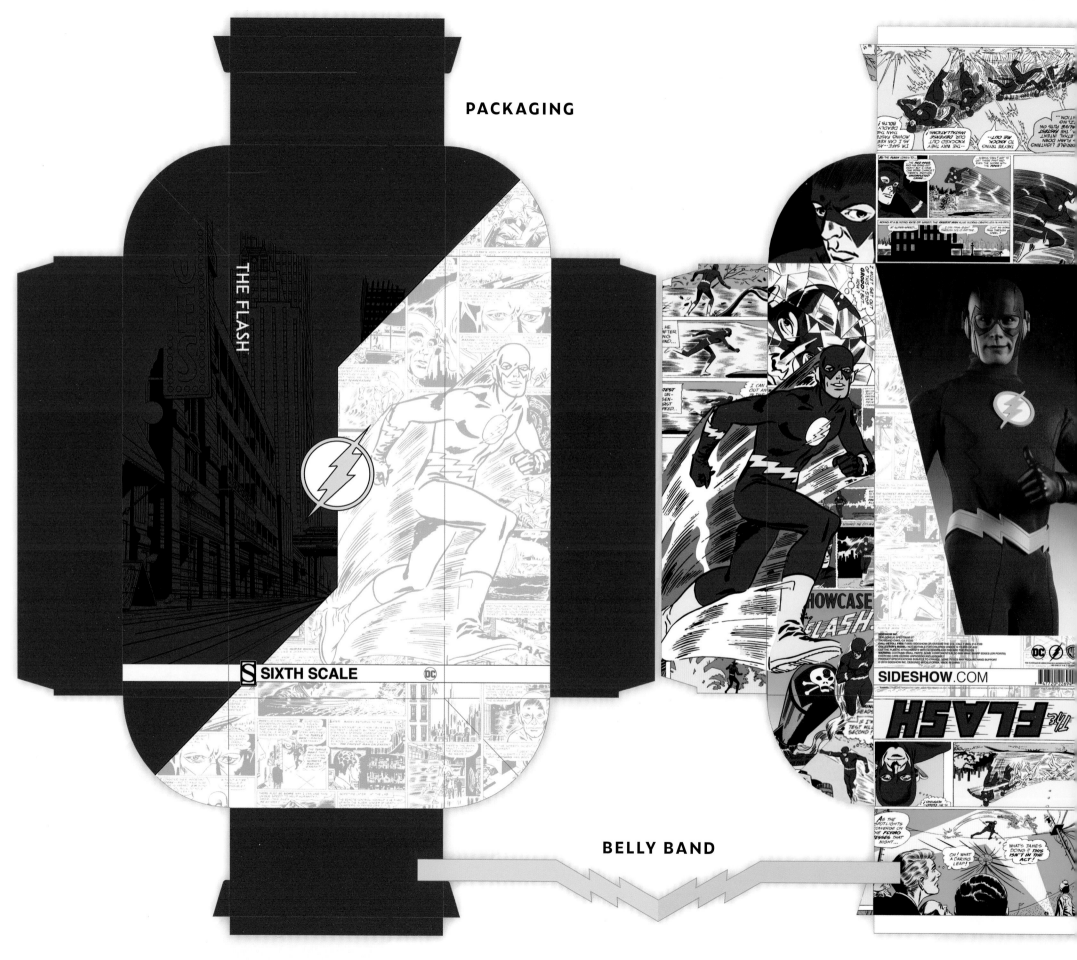

PACKAGING

THE FLASH

SIXTH SCALE

BELLY BAND

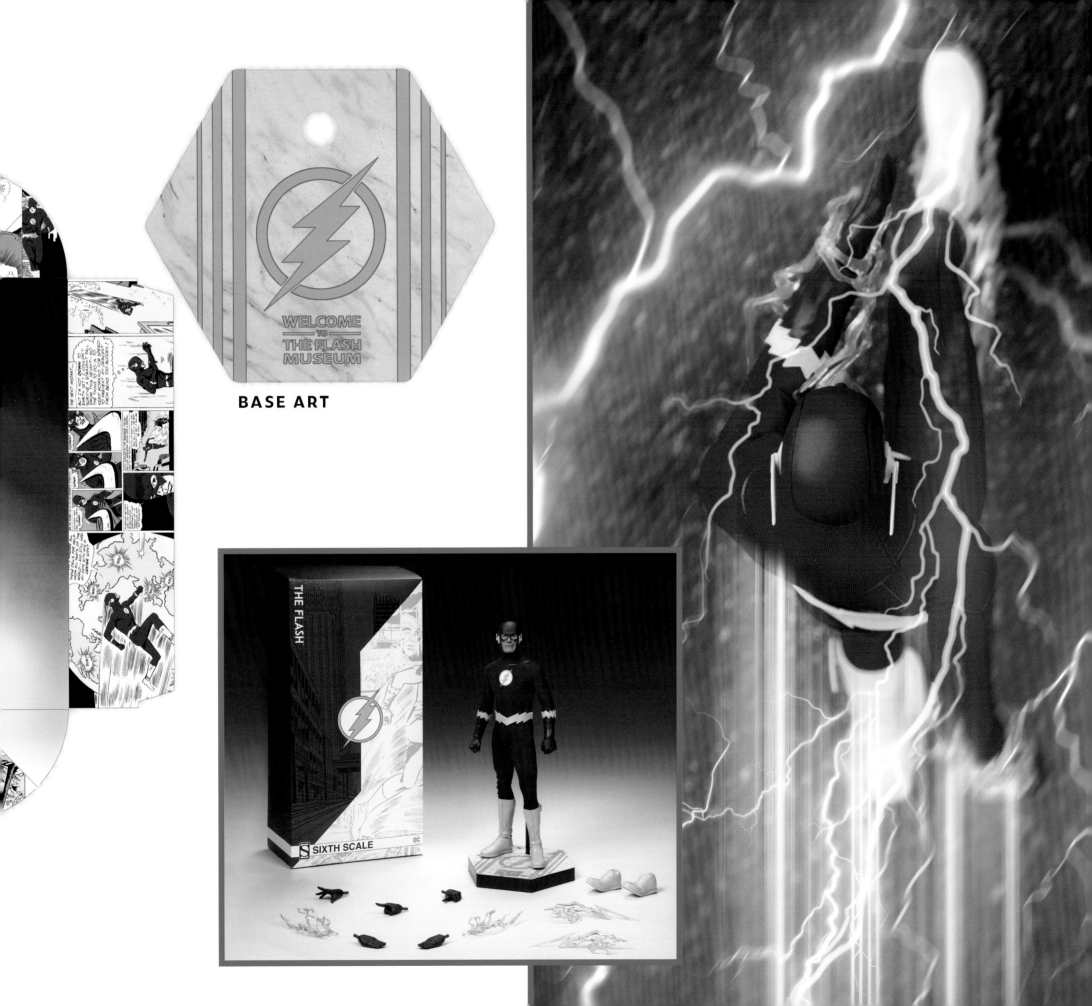

BASE ART

THE FLASH

SIXTH SCALE

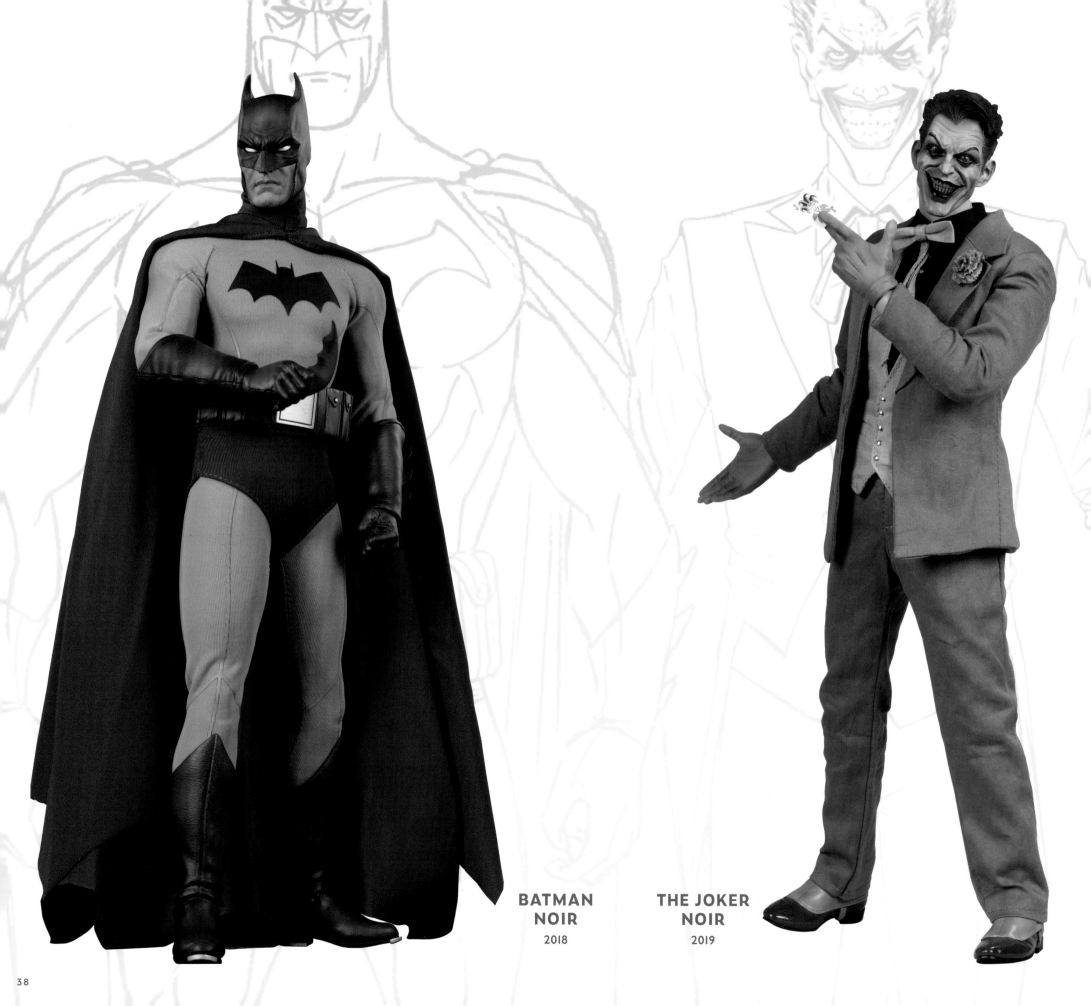

BATMAN
NOIR

2018

THE JOKER
NOIR

2019

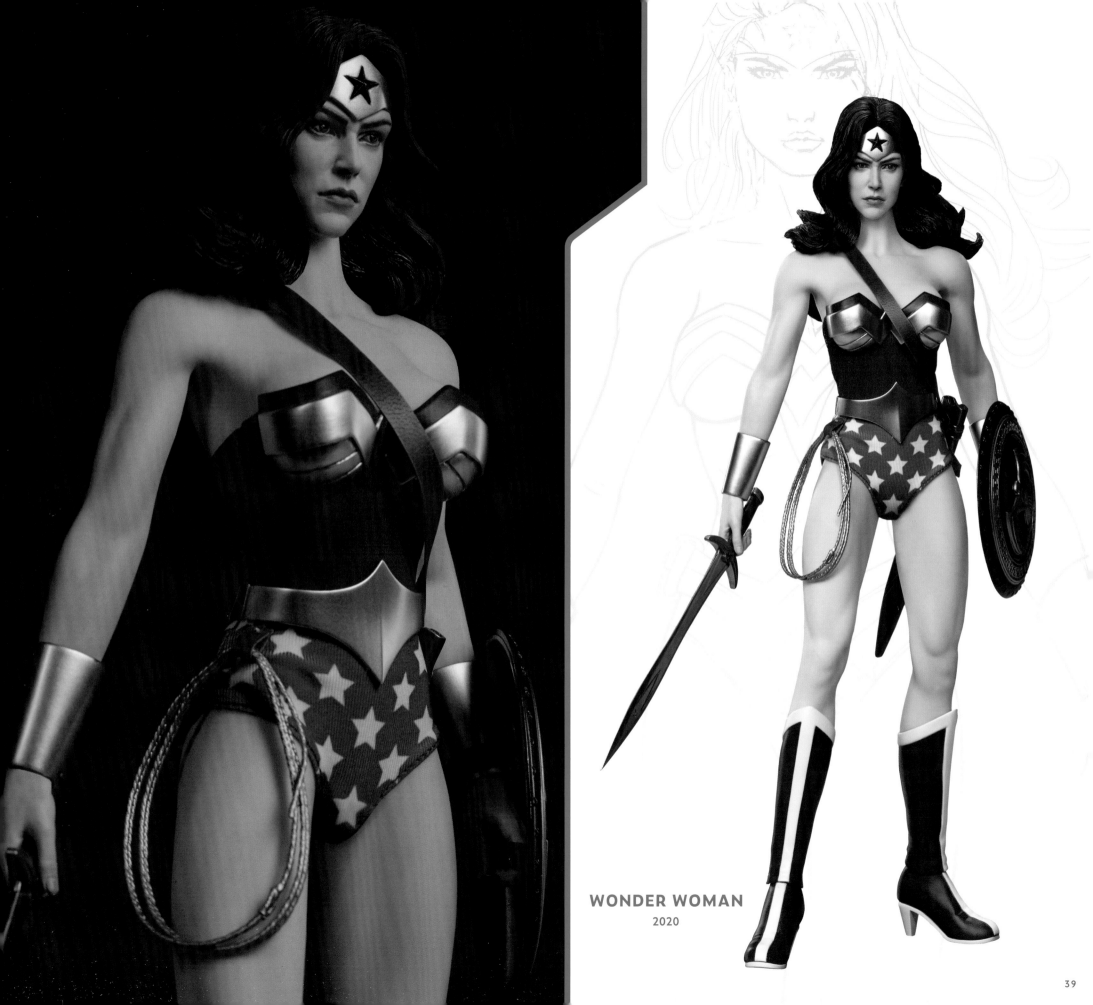

WONDER WOMAN

2020

39

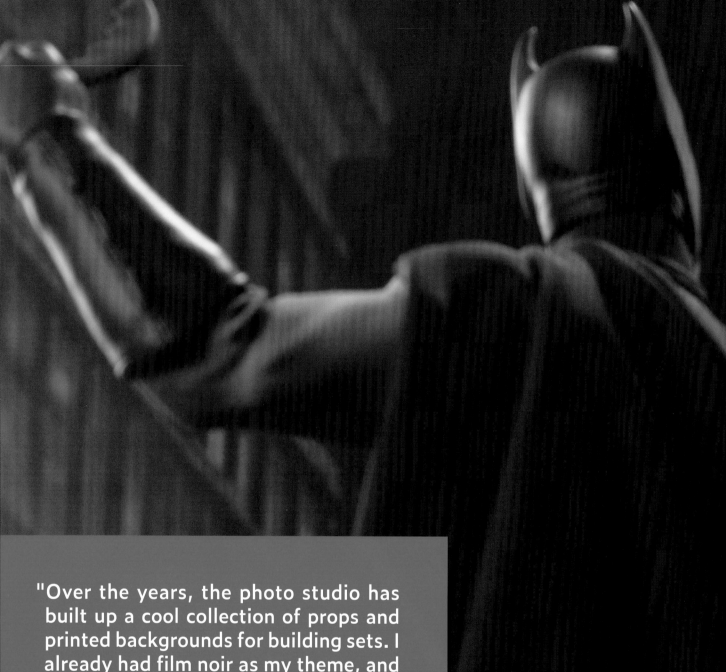

"Over the years, the photo studio has built up a cool collection of props and printed backgrounds for building sets. I already had film noir as my theme, and being a Batman fan, I knew I wanted to have this group shot set on a rooftop. With my tripod at the ready, it didn't take long for the characters to come alive and practically perform in front of my camera."

— Cassie Fuertez, Photographer

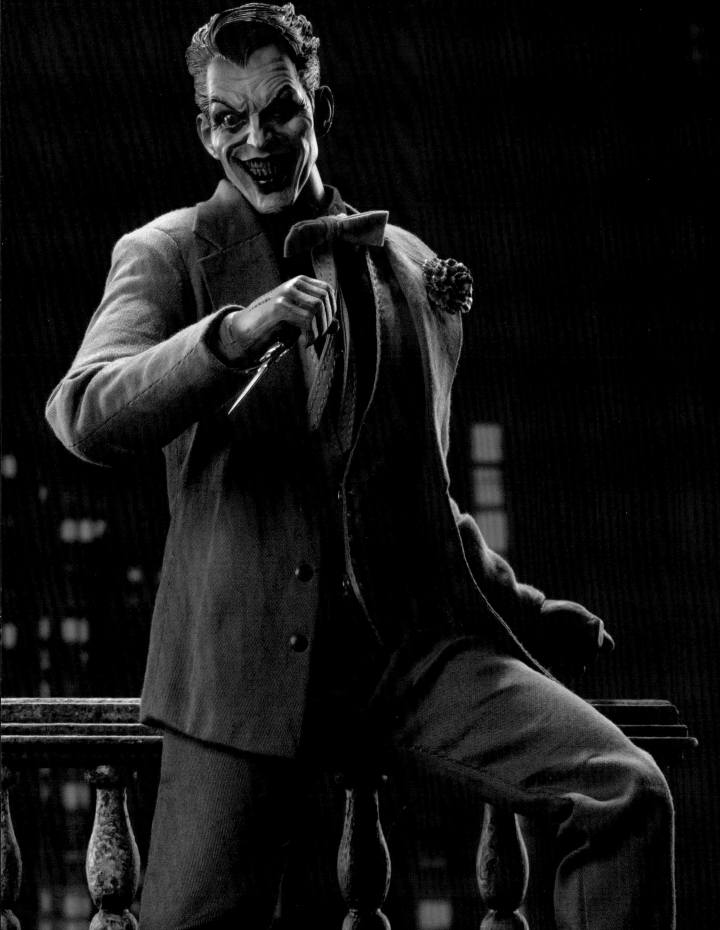

THE JOKER
NOIR VERSION

I don't hate you because I'm crazy . . .
I'm crazy because I hate you! —The Joker,
Batman: Cacophony #3 (January 2009)

Batman's greatest foe takes a classic turn in The Joker (Noir Version) Sixth Scale Figure. This monochromatic rendition of The Joker cuts a dashing figure in a custom vintage-style suit, replete with fabric suit jacket and pants, vest, dress shirt, bow tie, and shoes with sculpted spats. The Joker is literally dressed to kill, with his deadly lapel flower, high-voltage joy buzzer, razor-sharp playing cards, and an array of lethal armaments ready to terrorize Gotham City.

Although The Joker is practically synonymous with his trademark purple-and-green palette, the Clown Prince of Crime is so iconic that he makes an indelible impression even completely devoid of color. "Black-and-white images force viewers to see the subjects for what they are," notes painter Alfred Paredes. "None of the color to distract or create a false sense of mood. When you take away The Joker's garish clown-like colors, all you're left with is the madness. And when it comes to The Joker, he's the ultimate in crazy."

Project manager Kevin Ellis feels that the noir rendition of The Joker fully embraces that absence of color, with astonishing results. "The expression on the figure is what does it for me," says Ellis. "There is something about taking the green hair and red lips out of the equation that really makes the expression even more terrifying. It may sound silly, but I feel that looking at the noir version of The Joker is like recalling a distant memory of a bad dream that still haunts you. It is very chilling compared to the more colorful version of The Joker that we've grown accustomed to."

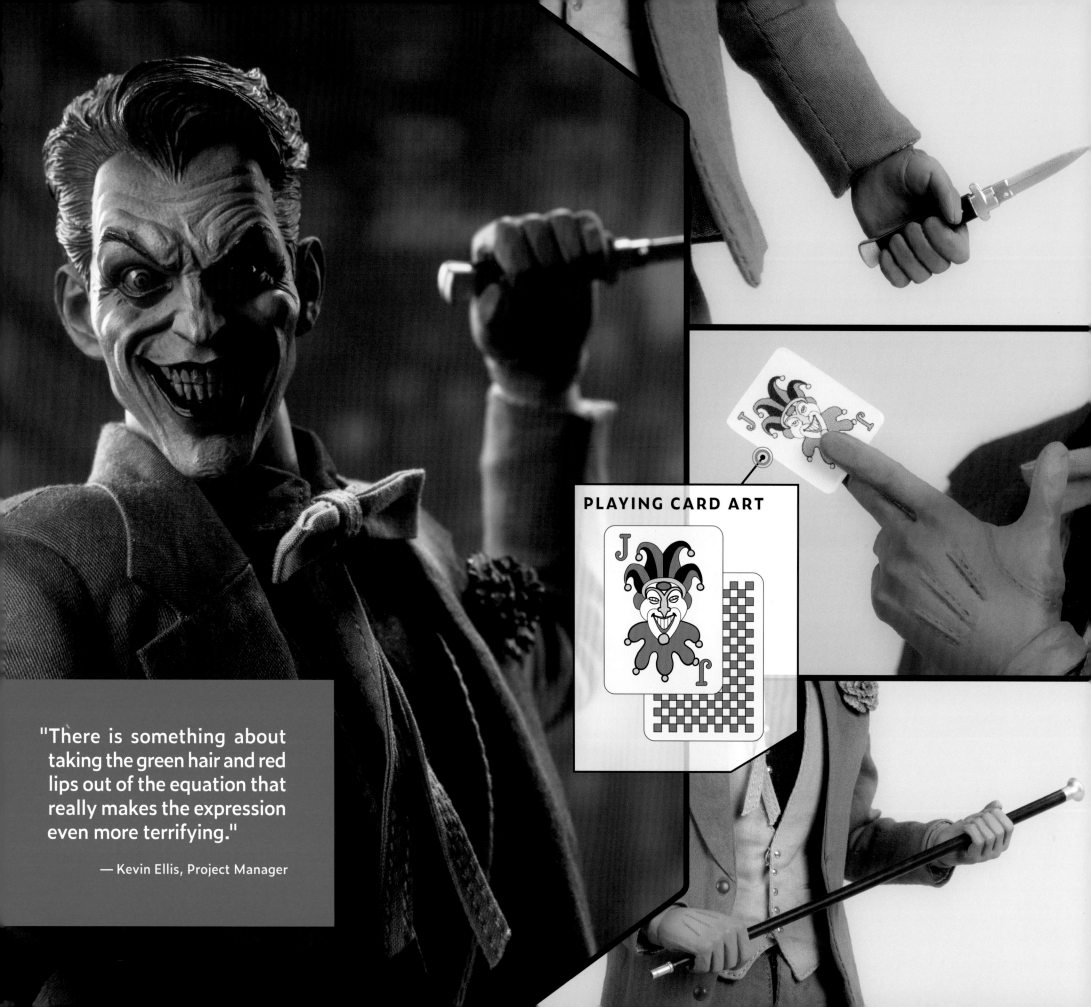

PLAYING CARD ART

"There is something about taking the green hair and red lips out of the equation that really makes the expression even more terrifying."

— Kevin Ellis, Project Manager

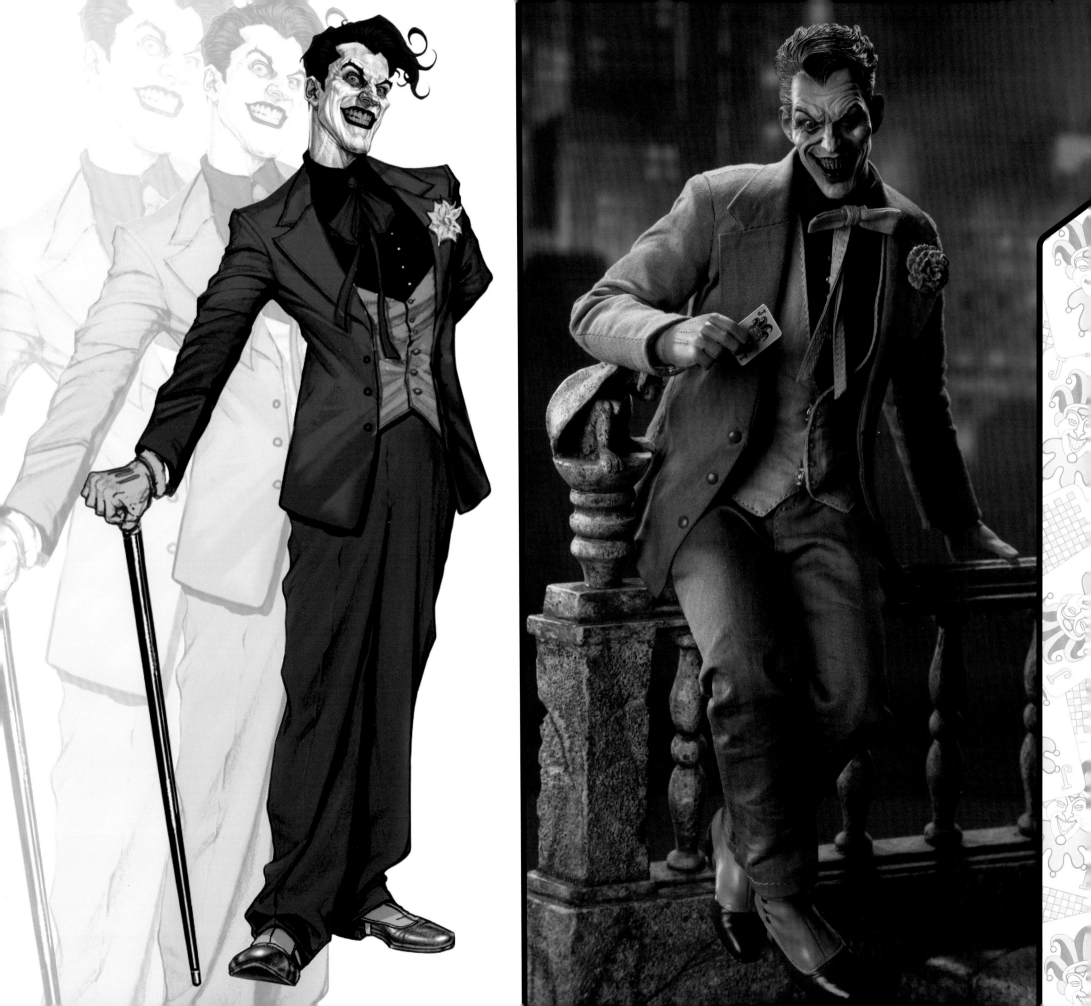

PREMIUM
FORMAT™

F I G U R E S

PREMIUM FORMAT™ FIGURES

While Sideshow's Sixth Scale Figures come from the rich tradition of classic action figures, the Premium Format Figures are designed as bold showcase pieces. Presented in impressive quarter-scale, the hand painted Premium Format Figures are crafted with meticulous detail and represent some of the most ambitious designs and sculpts in Sideshow's entire catalog.

"We're taking a step beyond the 'museum poses,' so while they're not necessarily action poses, they are definitely more dynamic," says costume fabrication manager Tim Hanson. "Wonder Woman in the middle of making a lasso, Superman having his battle with Brainiac, Batman perched and ready to strike."

The Premium Format Figures start at the conceptual stage, with digital artists developing bold, dynamic, two-dimensional renderings of the classic DC characters. A series of sketches—sometimes dozens—are crafted and discussed with the art director and project manager, at which point the 3D design team and sculptors team up to bring the original artist's vision to reality. That development process often employs an intriguing mix of old-school craft and cutting-edge technology. "My essential toolkit would have my Iwata HP-C and CM, a couple of small liner brushes as well as a few larger round brushes, paint, a hairdryer, toothpicks, and cotton swabs. Probably some gloves and paper towels as well," notes painter Kat Sapene. "Meanwhile,

some of the most exciting advances in technology have really been in digital modeling and 3D printing. The amount of detail that a sculptor can add to a project is really amazing. And even though these aren't exactly advancements in paint, they really help, because projects can be engineered to facilitate paint in a way that could never happen when sculptures were done traditionally."

Like most of her fellow team members, costume fabricator Esther Skandunas brings a wealth of knowledge to each Sideshow project. "My most valuable tools are the skills that I have built up over many years and many experiences in creating clothing. Creating these garments is not as simple as having a particular patternmaking book, or a specific curved ruler or set of measurements that I use.

"My skills come from many years of making patterns for theatrical costumes, hundreds of hours of tailoring structured garments for the stage and for myself and others," adds Skandunas. "The many years of sewing that have taught me how to mentally deconstruct a garment and know all the pieces, and the process of how to put the garment back together by just looking at an image. These are the most valuable tools I have, and each project and character I work on adds even more skills to my mental library and techniques. That is the most exciting part of creating these figures . . . there is always something new to learn from each project."

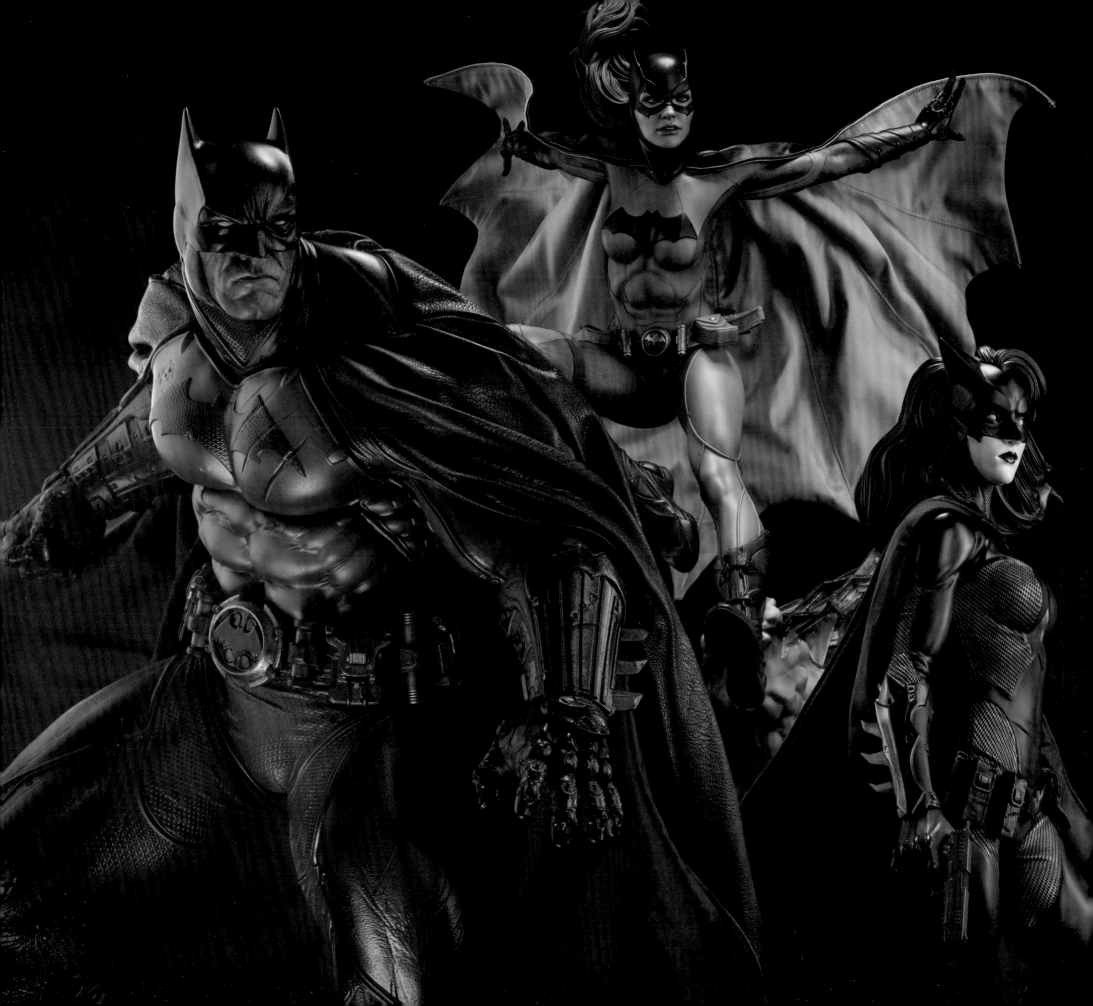

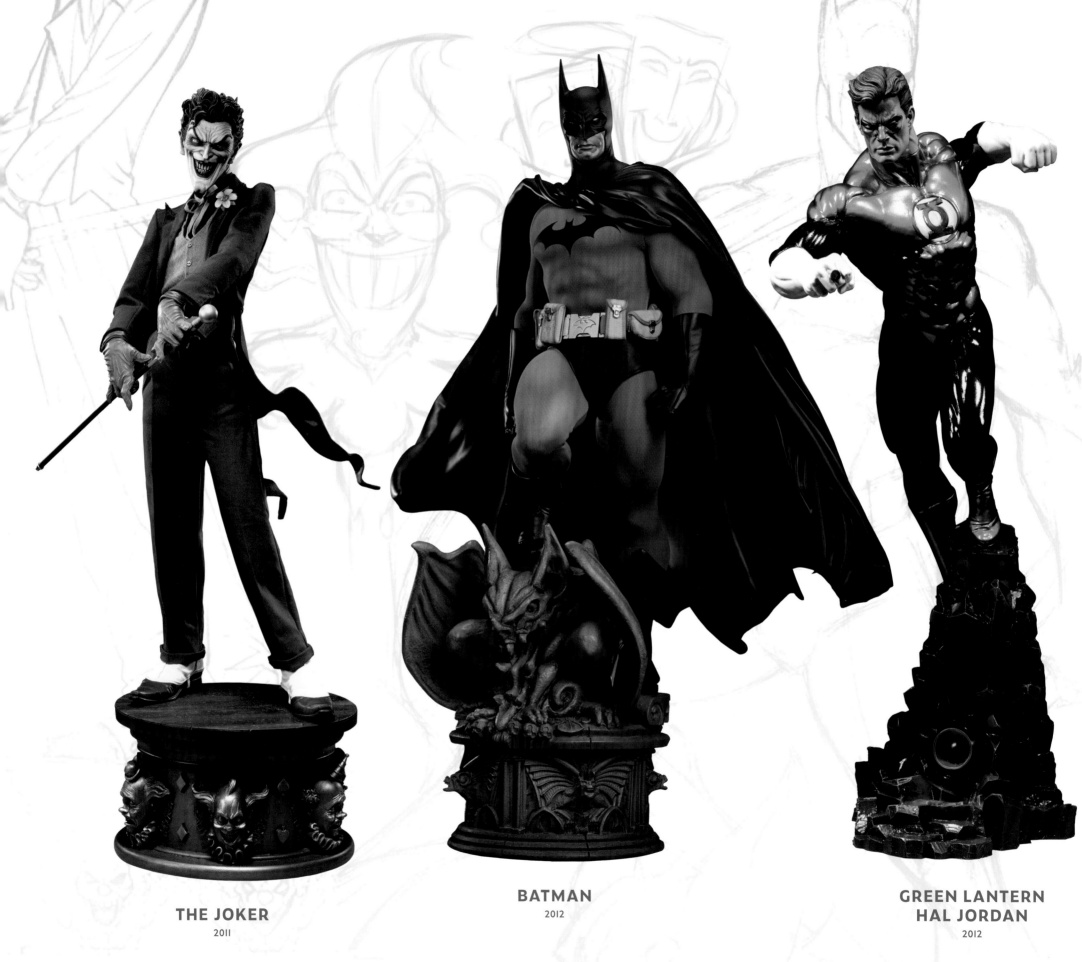

THE JOKER
2011

BATMAN
2012

GREEN LANTERN
HAL JORDAN
2012

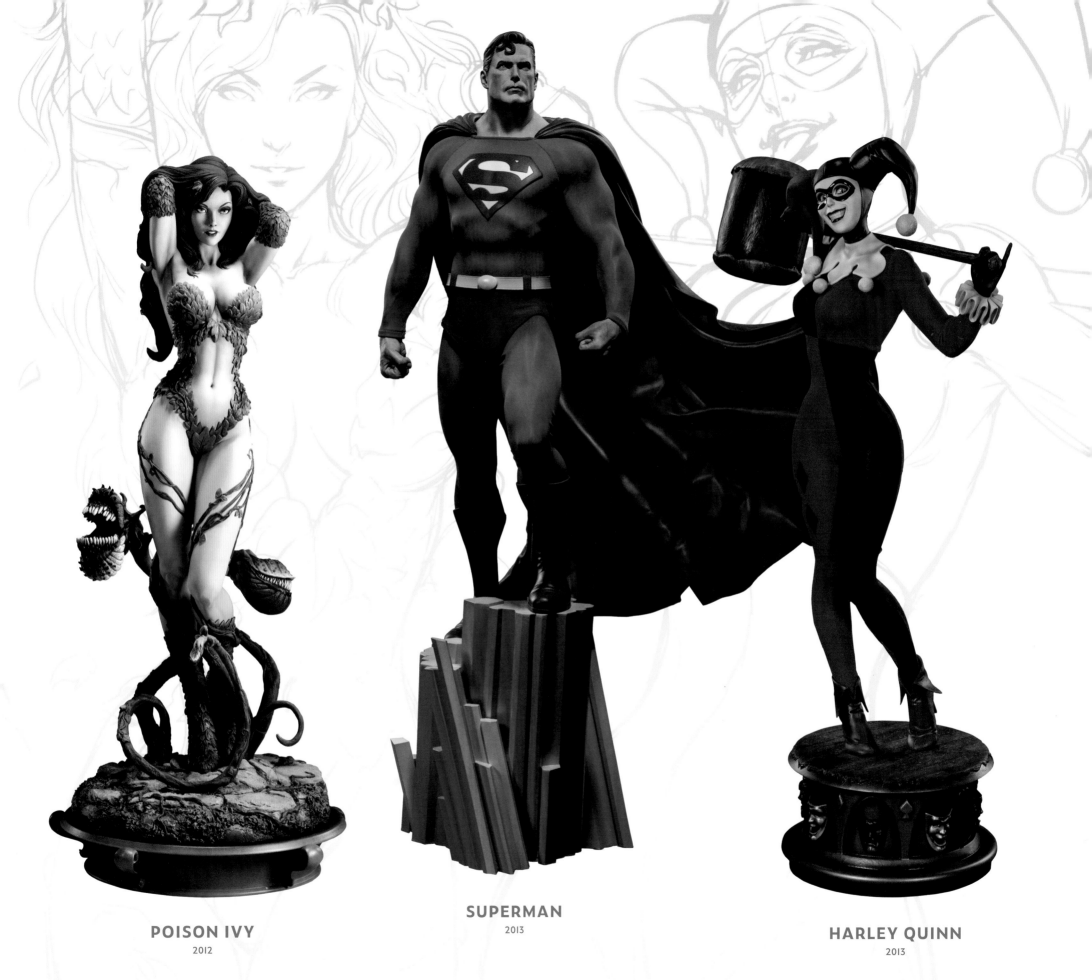

POISON IVY

2012

SUPERMAN

2013

HARLEY QUINN

2013

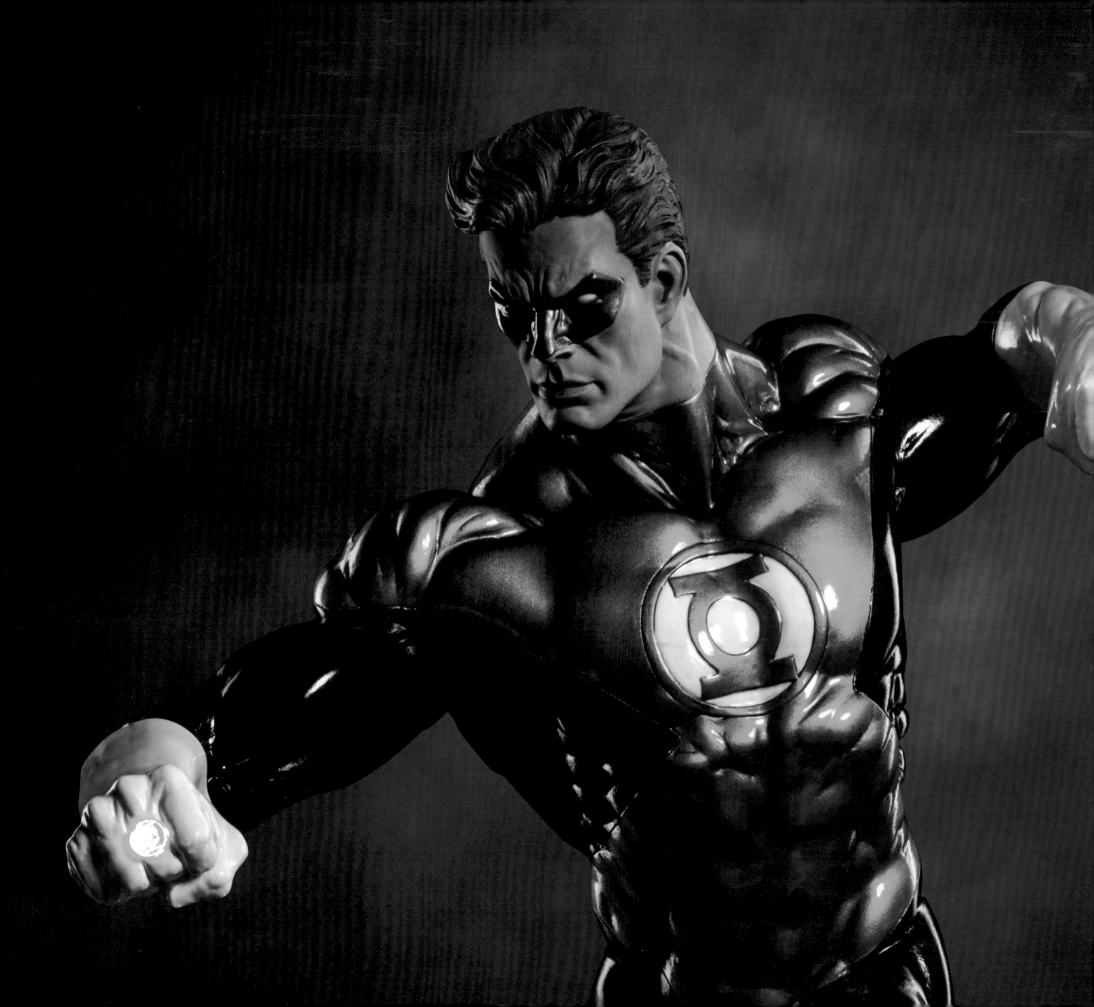

GREEN LANTERN
HAL JORDAN

In brightest day, in blackest night, no evil shall escape my sight. —Green Lantern, *Showcase* #22 (1959)

When dying alien Abin Sur crash-landed on Earth, his power ring sought a worthy successor and ultimately chose Ferris Air's resident test pilot Hal Jordan, based on his strength of will and fearless nature. Jordan accepted the power ring and, with it, membership in the Green Lantern Corps, an intergalactic police force dedicated to keeping peace throughout the universe.

The Green Lantern Premium Format Figure captures the might and majesty of Hal Jordan and his power ring as he uses its awesome energy to create cosmic constructs ranging from a simple utilitarian staircase to a giant, power-packed emerald fist.

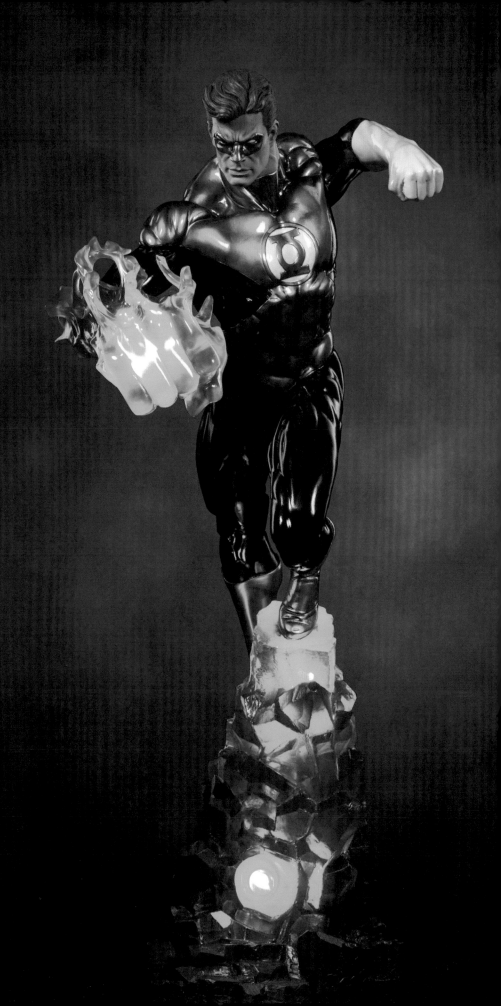

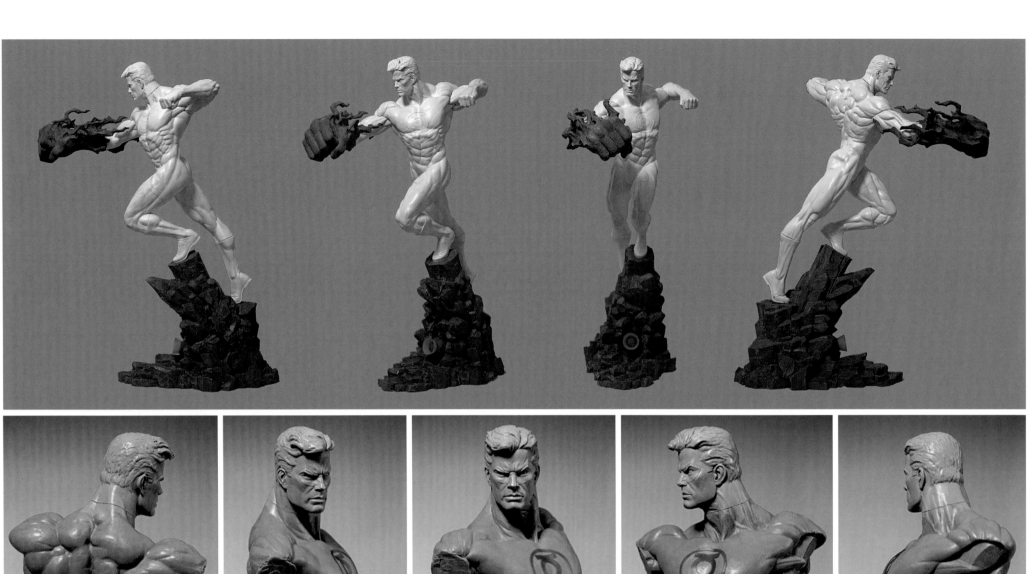

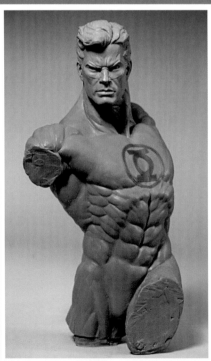
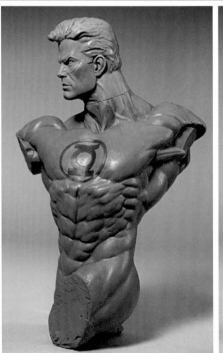
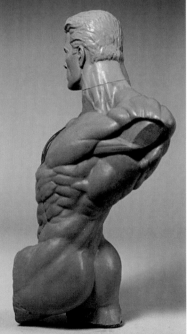

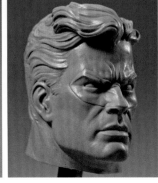
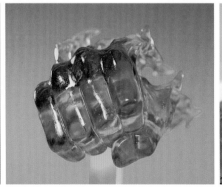

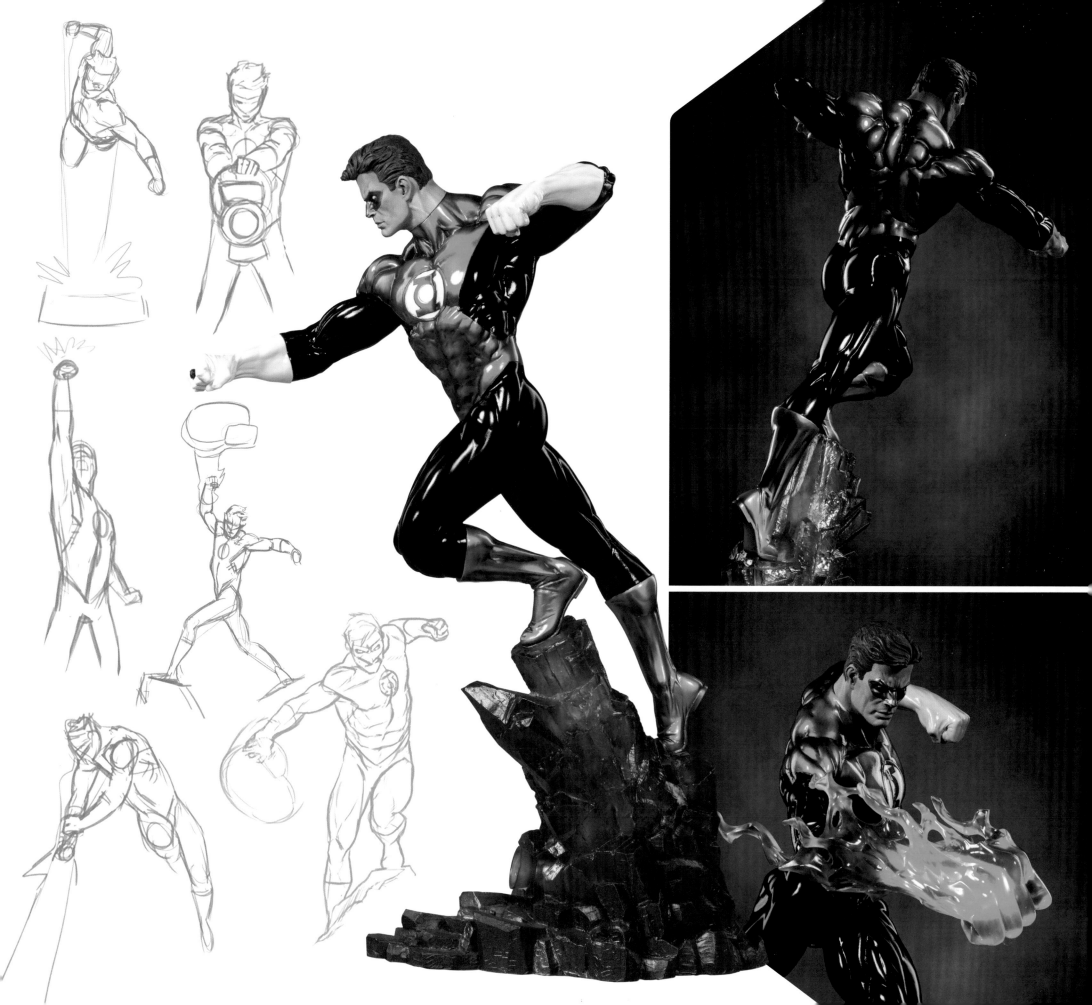

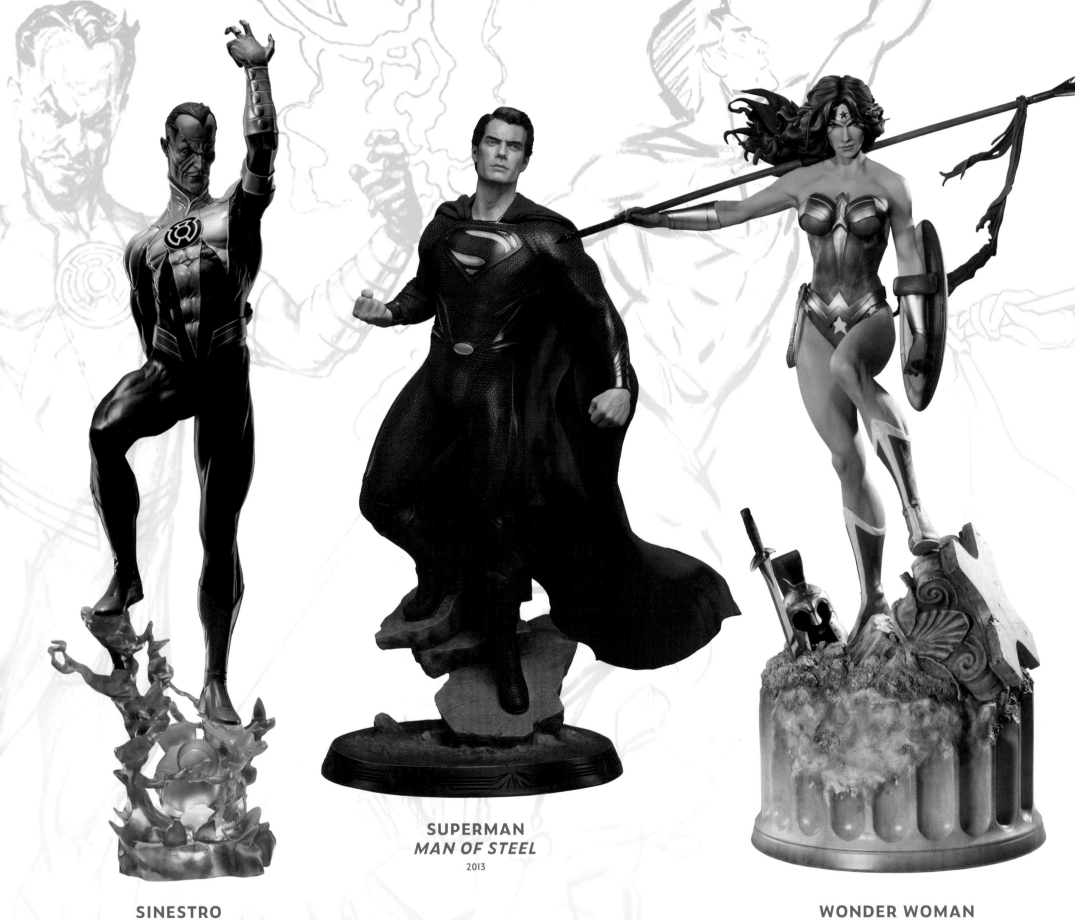

SINESTRO
SINESTRO CORPS

2013

SUPERMAN
MAN OF STEEL

2013

WONDER WOMAN

2014

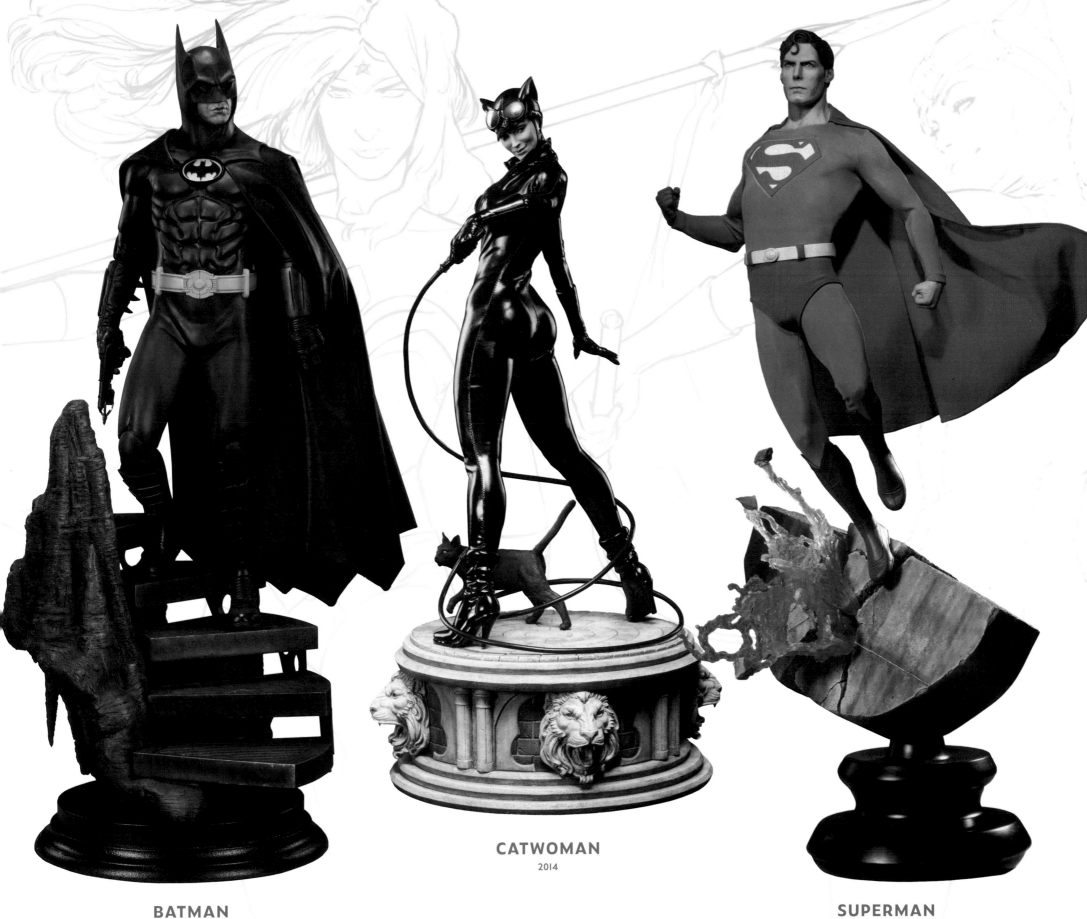

BATMAN
1989 *BATMAN*
2014

CATWOMAN
2014

SUPERMAN
1978 *SUPERMAN: THE MOVIE*
2014

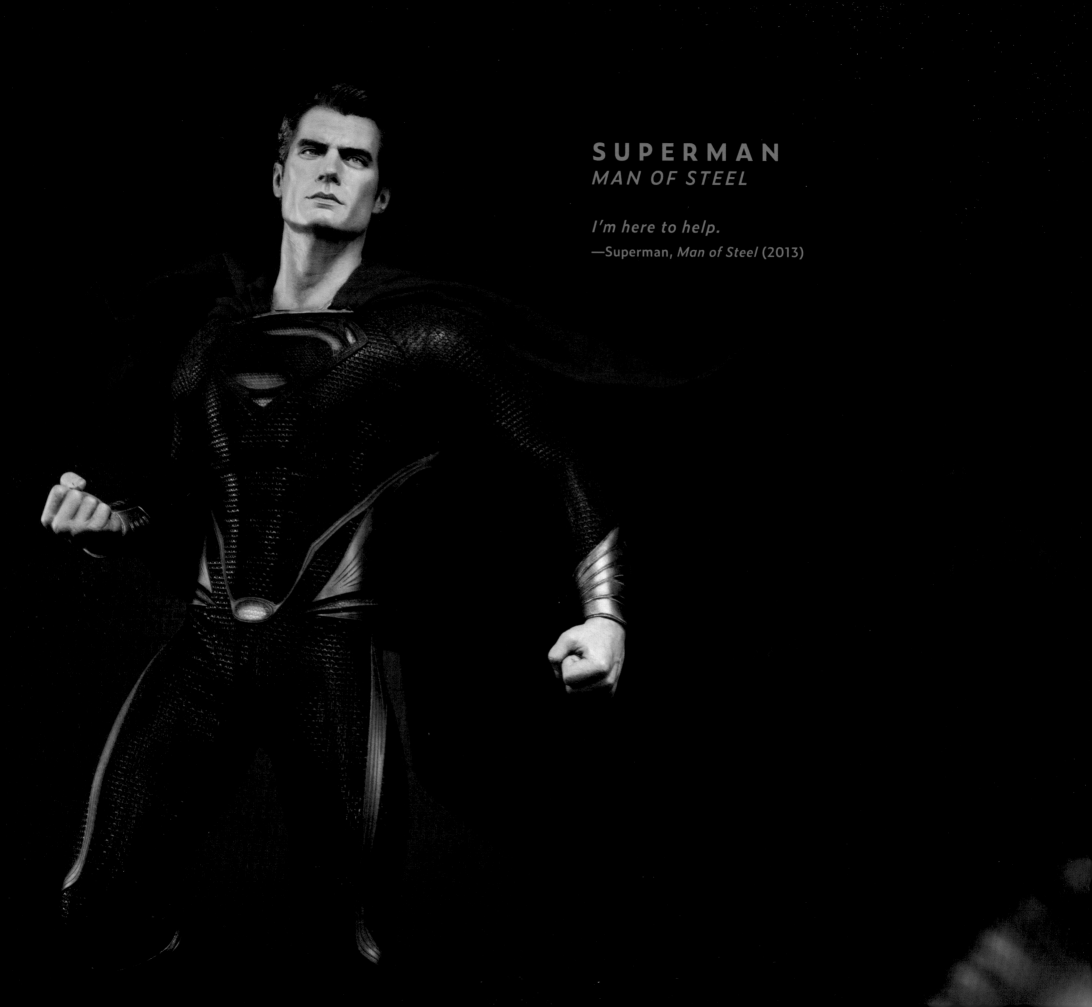

SUPERMAN
MAN OF STEEL

I'm here to help.
—Superman, *Man of Steel* (2013)

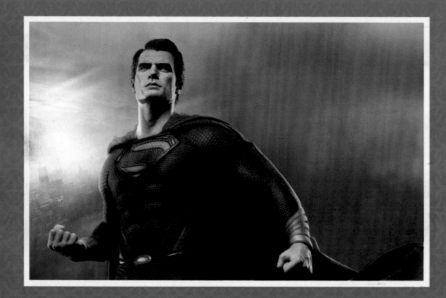

DETAILS AND DESIGN

In 2013, Zack Snyder brought the world his bold new vision of one of its most celebrated heroes with *Man of Steel*. Actor Henry Cavill would bring life to the Last Son of Krypton in that film as well as Snyder's subsequent films, *Batman v Superman: Dawn of Justice* and *Justice League*, as the young hero grew into his role as the World's Greatest Super Hero.

Sideshow's Premium Format Figure is a masterful feat of design, with a hand-tailored replica of his distinctive new suit, complete with a fully poseable fabric cape and stunning likeness of Cavill as Superman, the Man of Steel.

"We are a fortunate group of artists, and our cut and sew team is extremely dedicated to getting costuming details correct right down to the thread color holding the fabric elements together," notes production manager Kellam Cunningham. "When production schedules permit, the team at Warner Bros. Archives has allowed on-site visits and has gotten us up close to some of the most iconic costumes and props in recent movie history. This gives us an actual feel for the costume and allows us to cross-reference fabric colors, materials, patterns, and the minute details of the things, such as buttons, zippers, collars, stitching, etc. Sometimes the translation from life-size costuming efforts to the smaller scale can be quite challenging, but it's an area of Sideshow's expertise that sets us apart from some of our competitors."

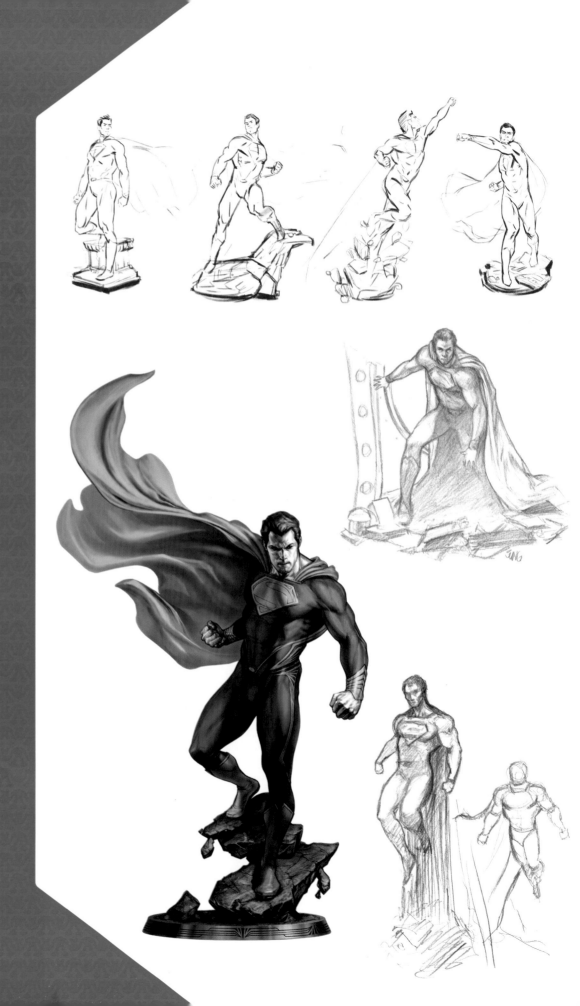

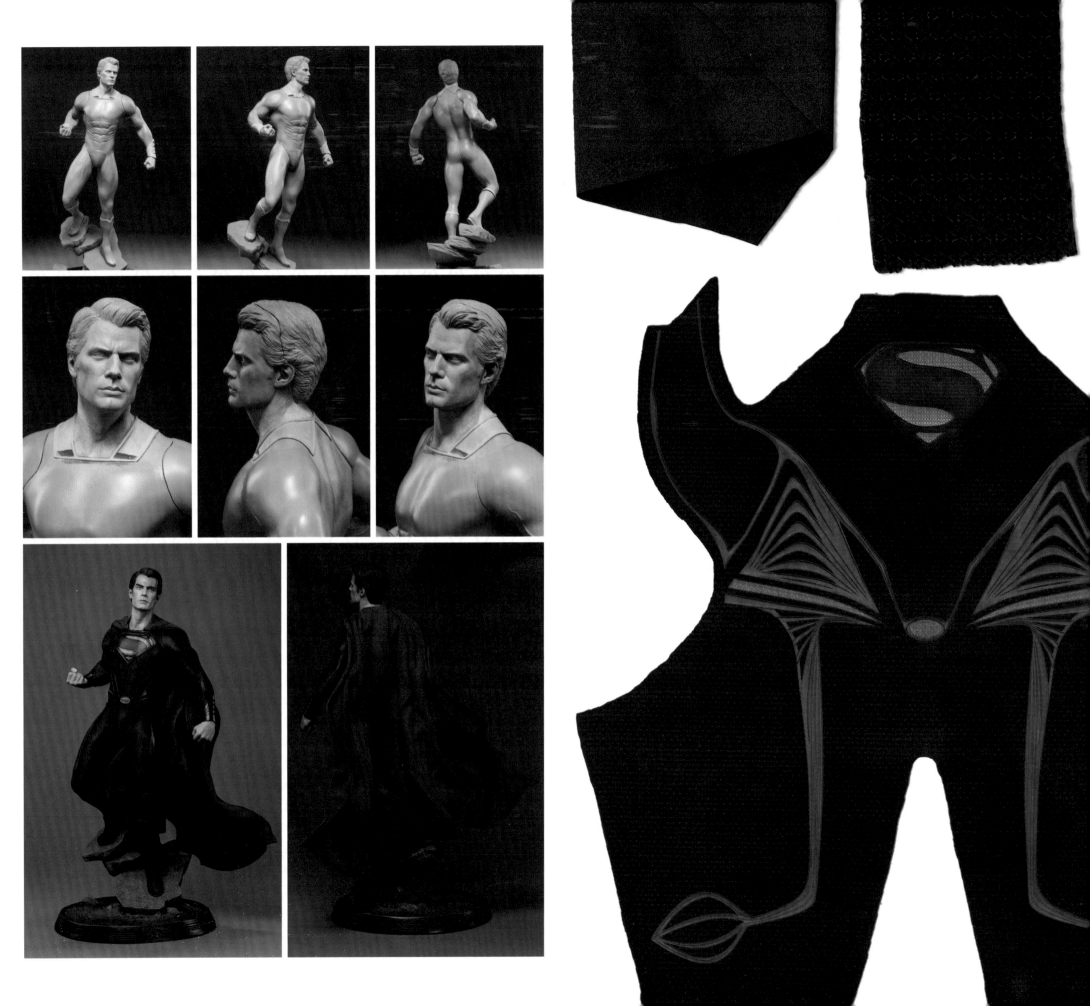

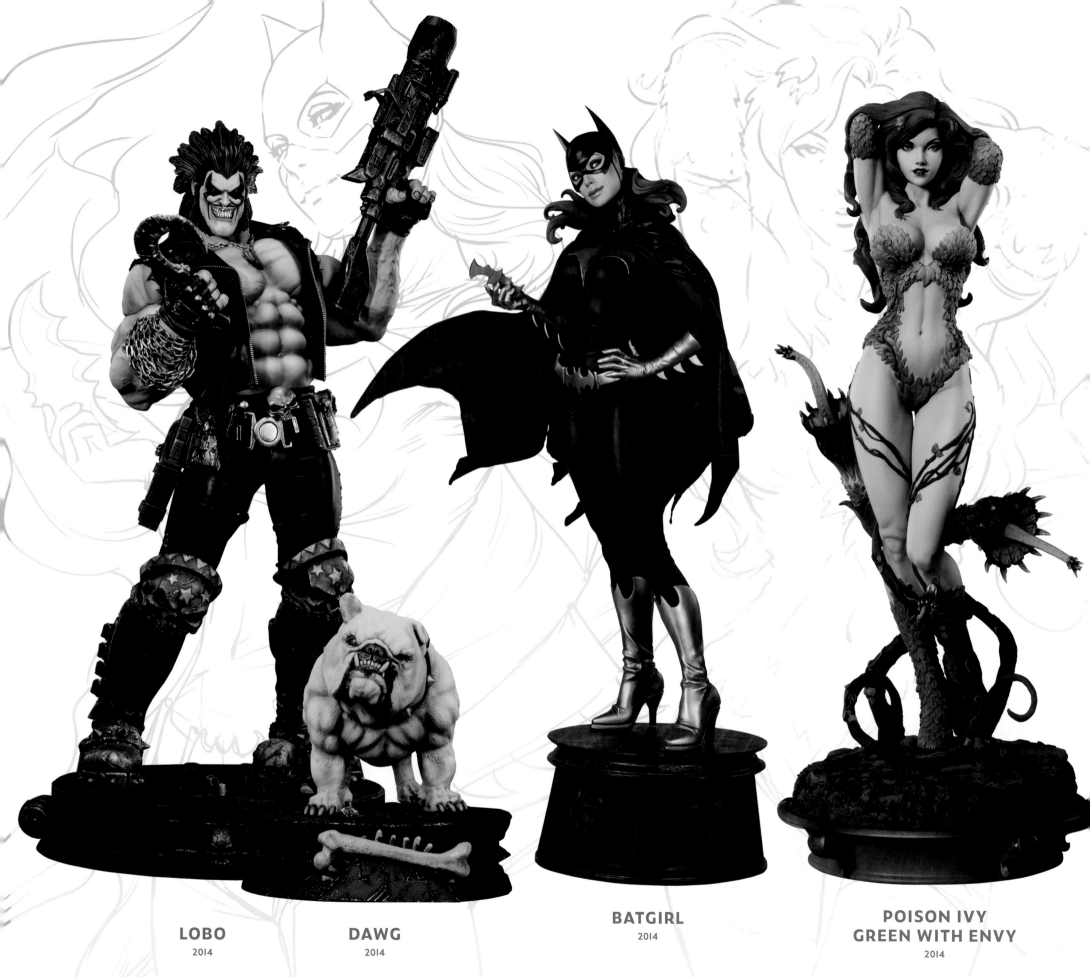

LOBO

2014

DAWG

2014

BATGIRL

2014

**POISON IVY
GREEN WITH ENVY**

2014

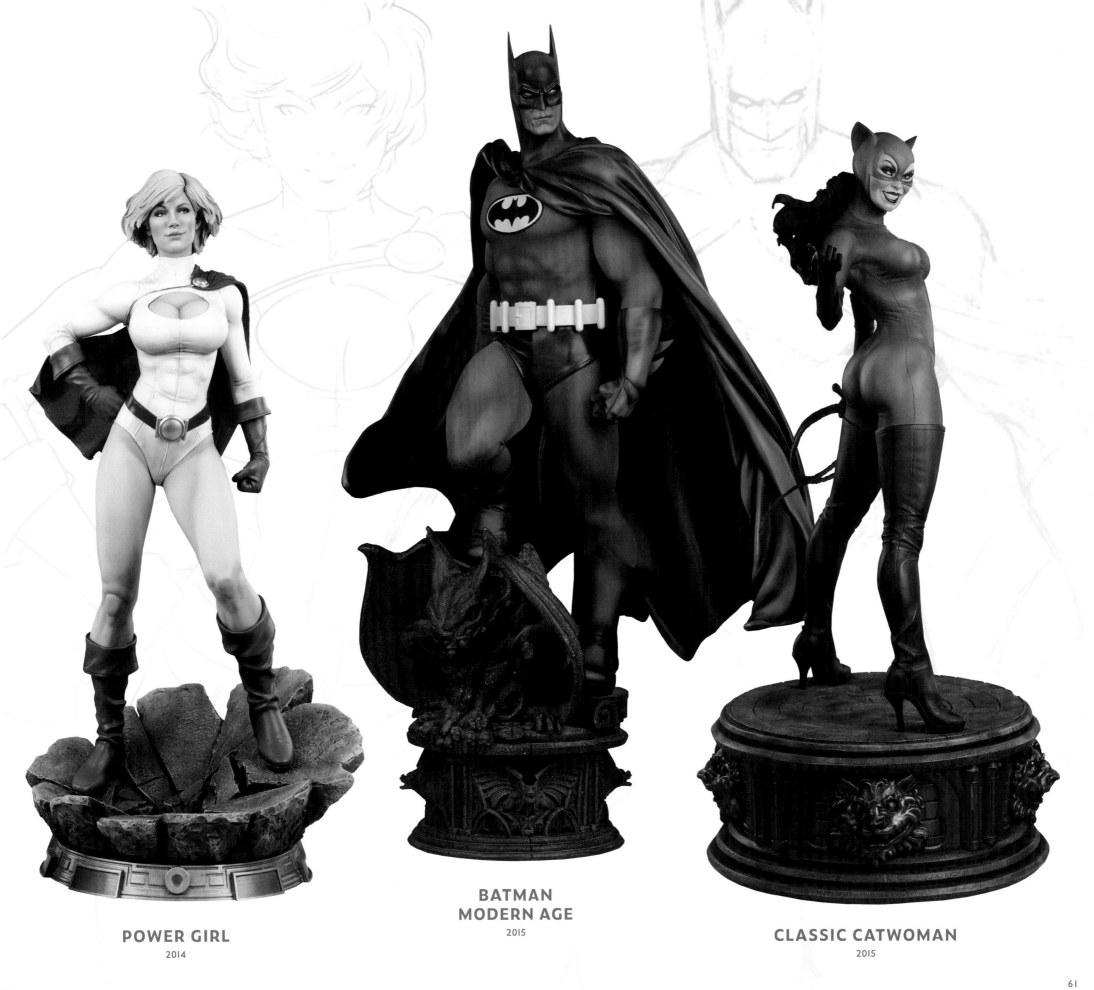

POWER GIRL

2014

BATMAN
MODERN AGE

2015

CLASSIC CATWOMAN

2015

61

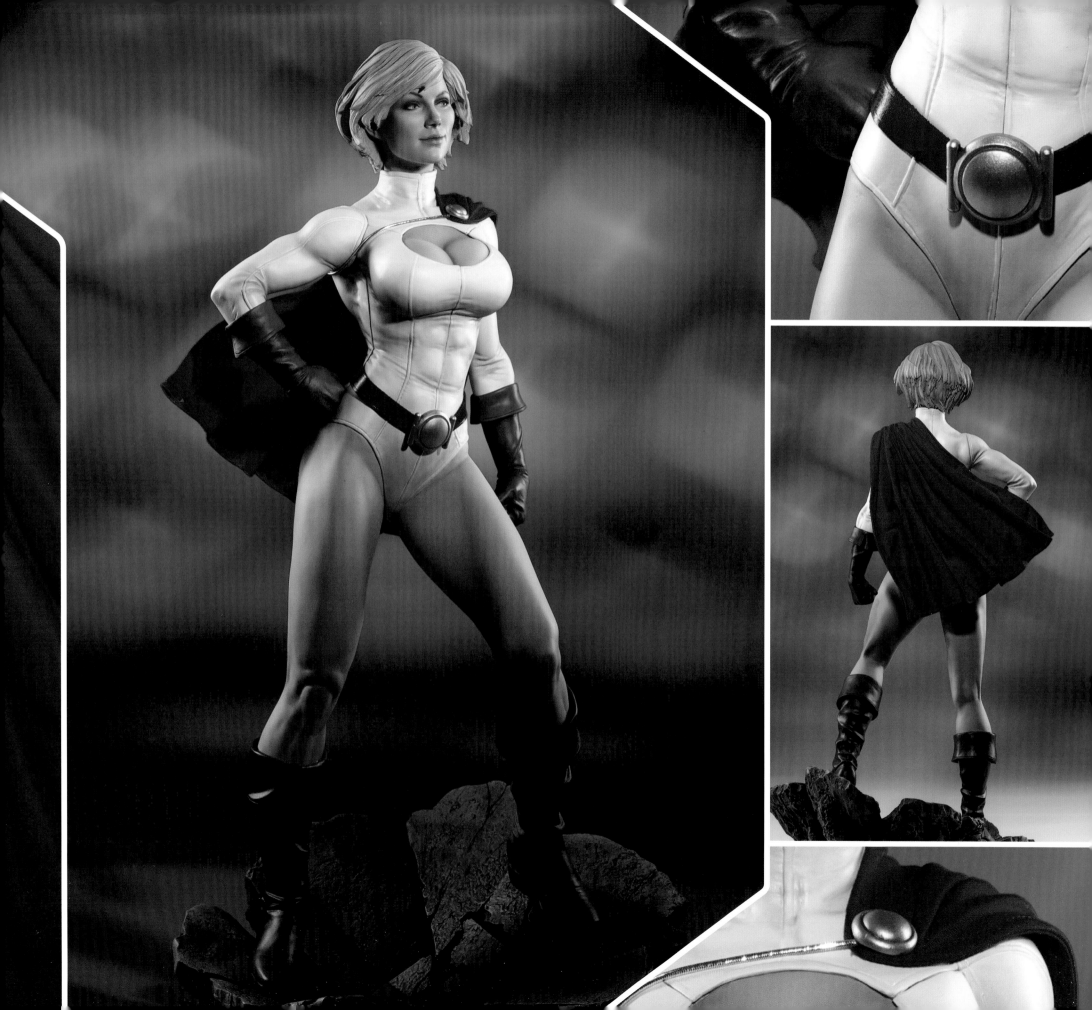

POWER GIRL

You'd be surprised how freeing it is to know that your strength comes from something inside yourself. —Power Girl, *Green Lantern/Power Girl* #1 (October 2000)

Endowed with the powers of Krypton, Superman's strong and sassy cousin is ready to rock, standing tall in her classic red, white, and blue costume. Gifted with powers far beyond those of mortals, the confident Power Girl, aka Karen Starr, uses those abilities to protect the people of the world—alongside the Justice League.

Sideshow's polystone Power Girl Premium Format Figure packs a knockout punch with its unique sculpt and dynamic design.

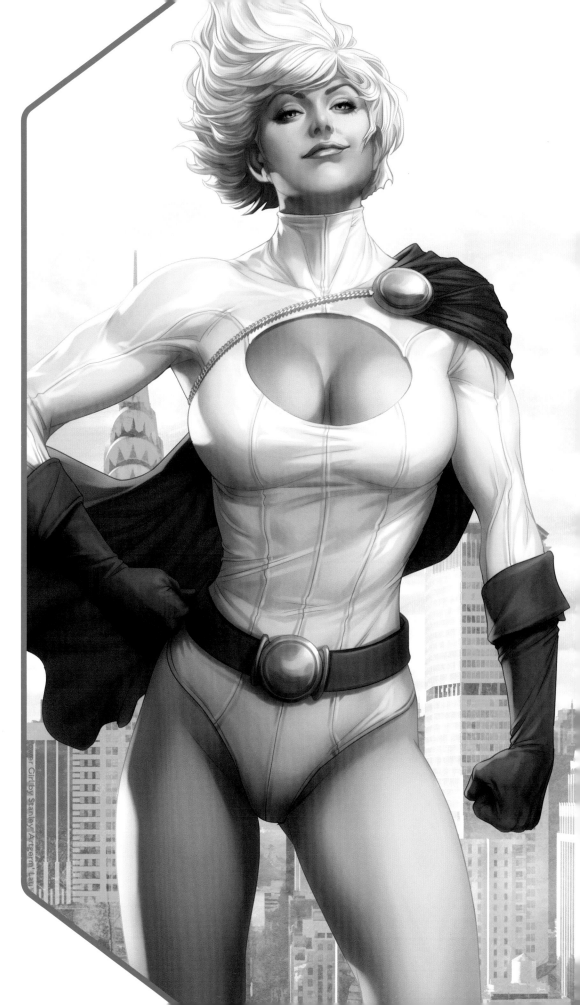

Although Power Girl isn't as well known as her famous cousin, she's got a dedicated fan following, and her popularity has grown steadily over the past decade, thanks to her DC Comics adventures. "To be perfectly honest here, I didn't really know much about Power Girl before working on the sculpture," laughs sculptor Mark Newman. "I do my research, though, before starting on any project—searching out as much info as I can on the personality and other artists' interpretation of the character, as well as picking up notes from the real fans of a character and what they like about them.

"One thing I found quite apparent with Power Girl in past depictions of her, besides her strength and confidence, was her powerful female physique," Newman continues. "Her pose in the sculpt is very confident, strong, and she seems very proud of the crater she just created upon her landing. 'Now who's gonna fix this?' kept creeping into my thoughts as I was sculpting this piece."

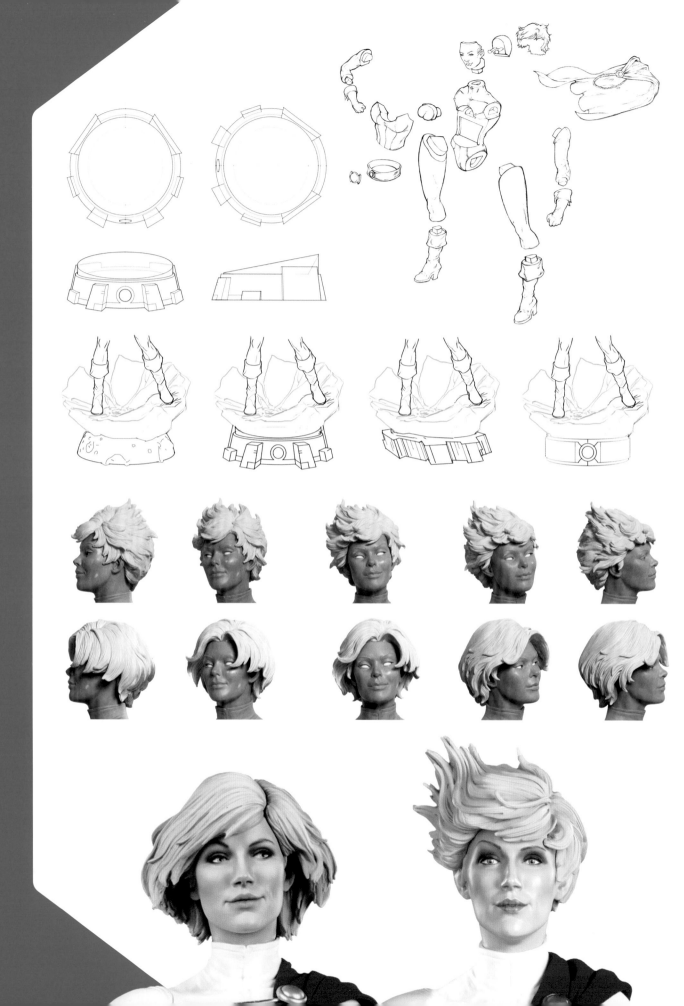

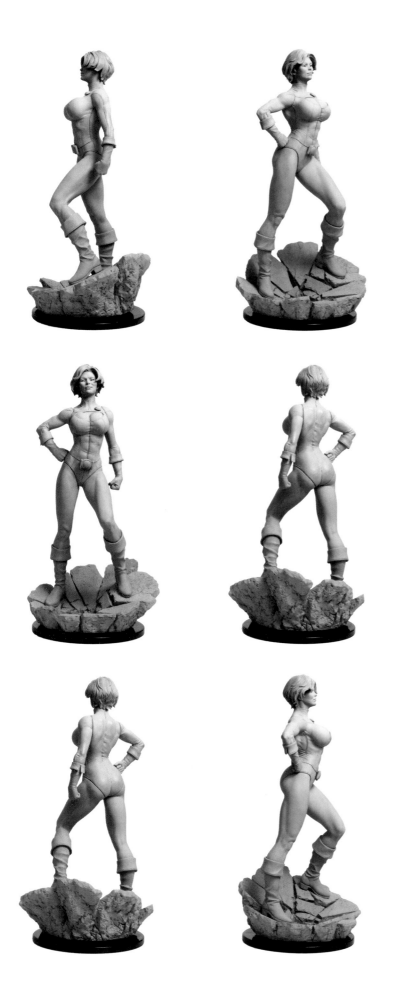

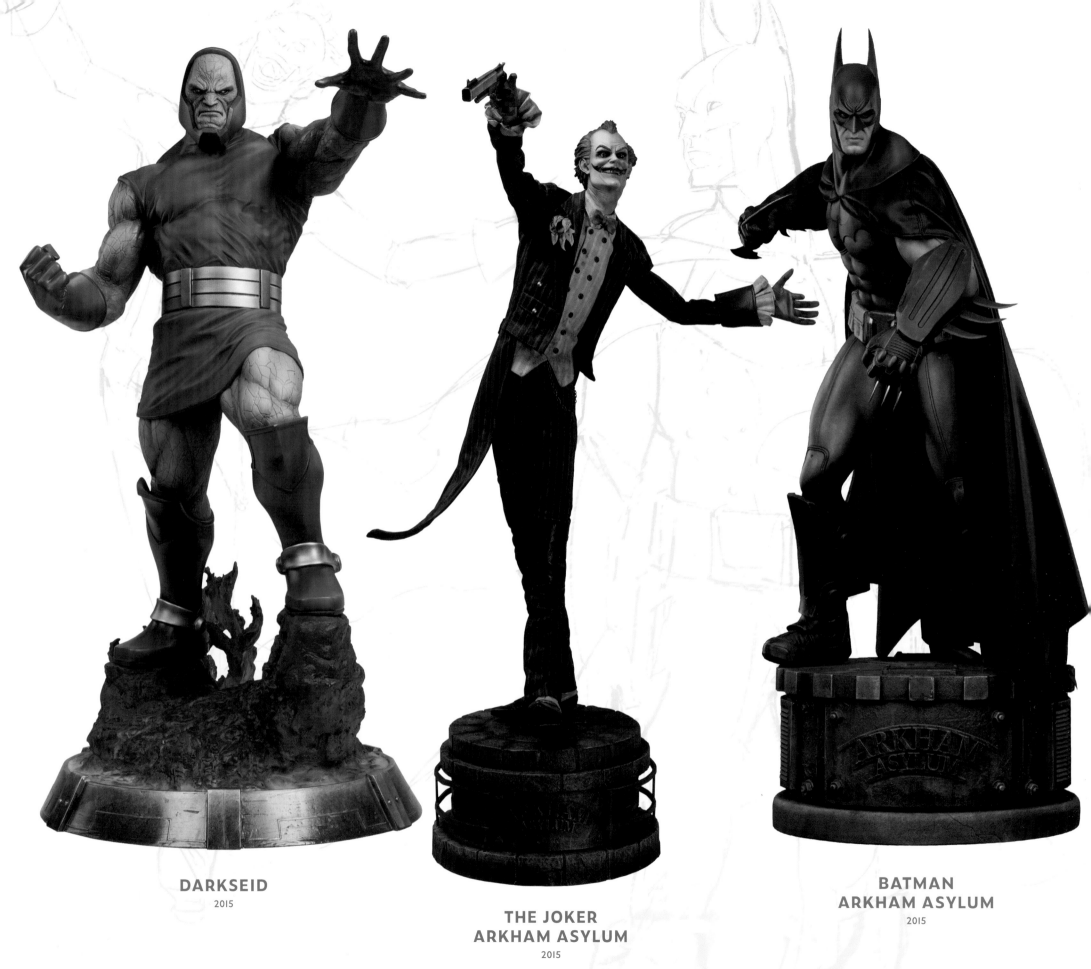

DARKSEID

2015

THE JOKER
ARKHAM ASYLUM

2015

BATMAN
ARKHAM ASYLUM

2015

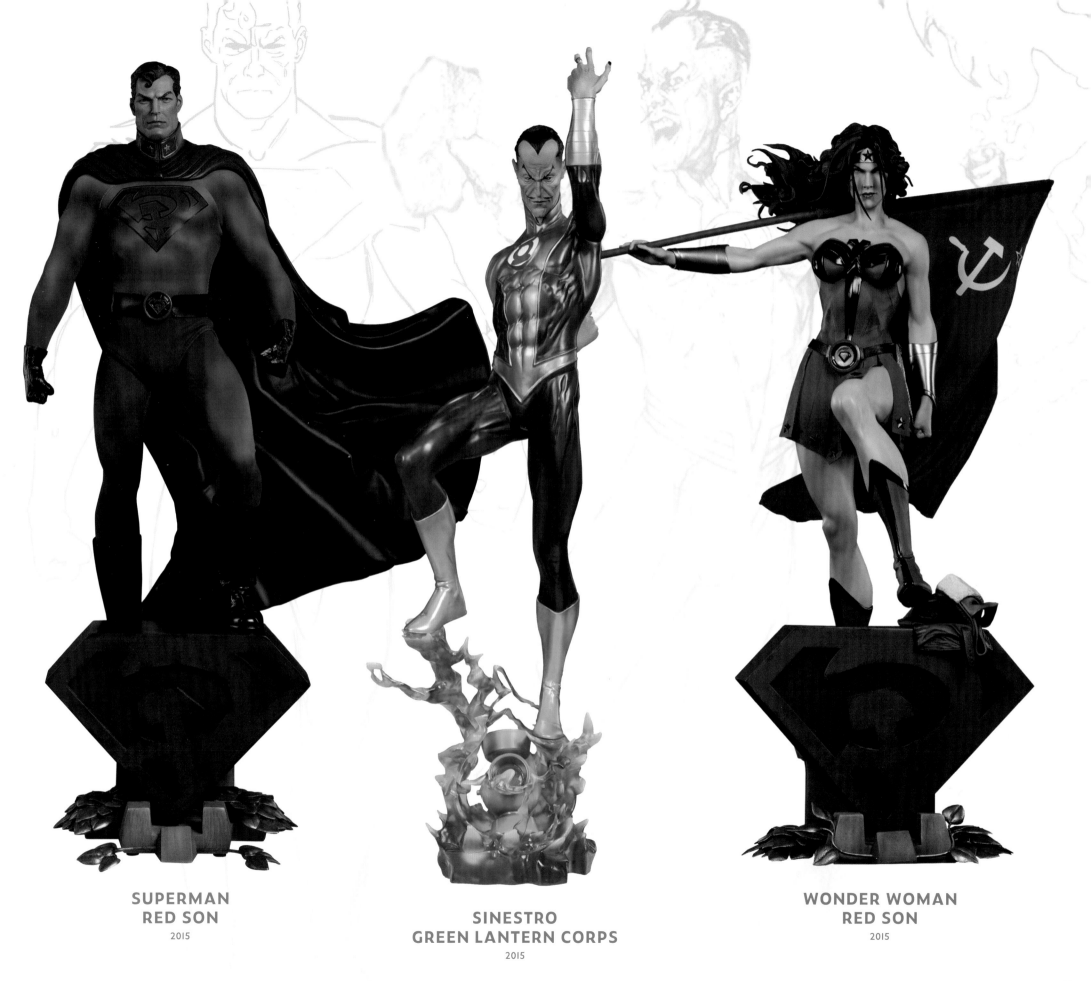

SUPERMAN
RED SON

2015

SINESTRO
GREEN LANTERN CORPS

2015

WONDER WOMAN
RED SON

2015

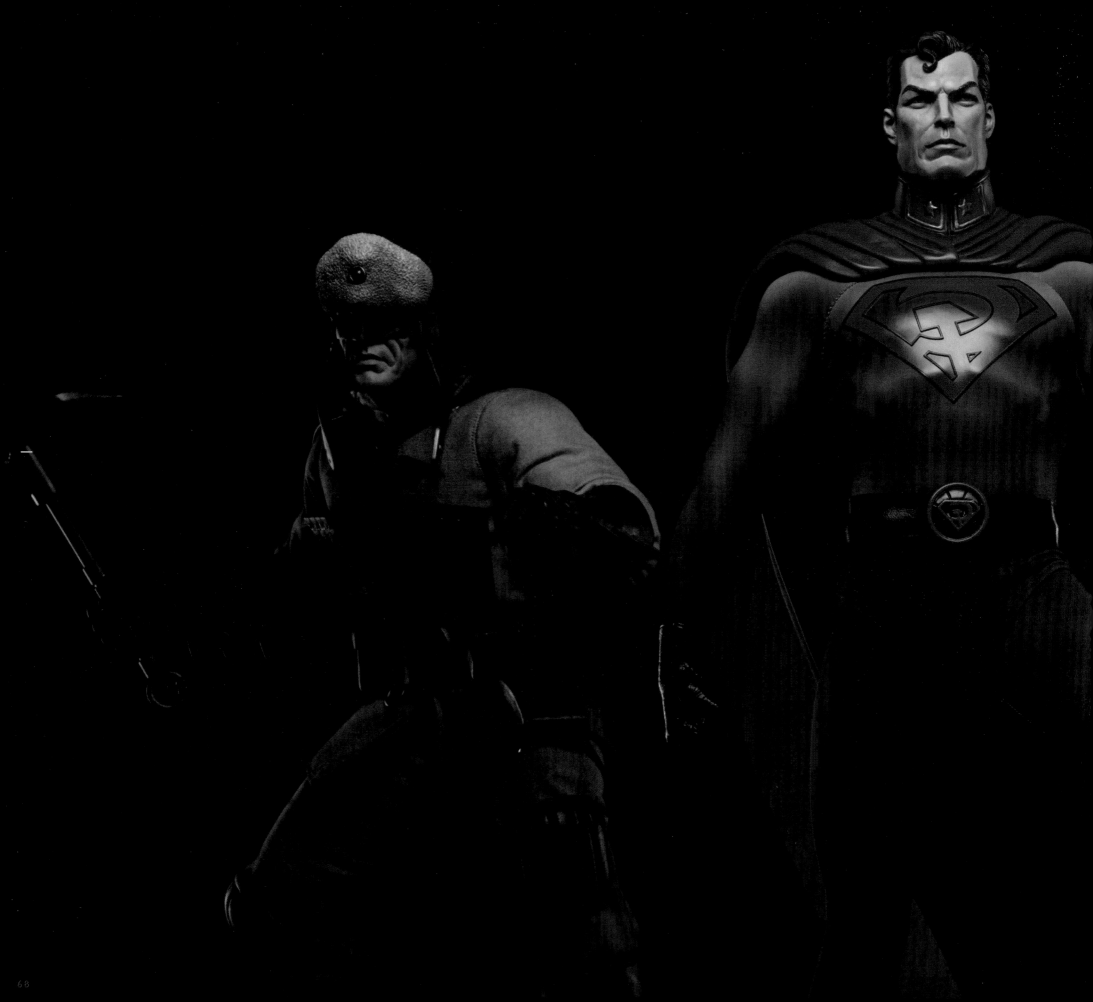

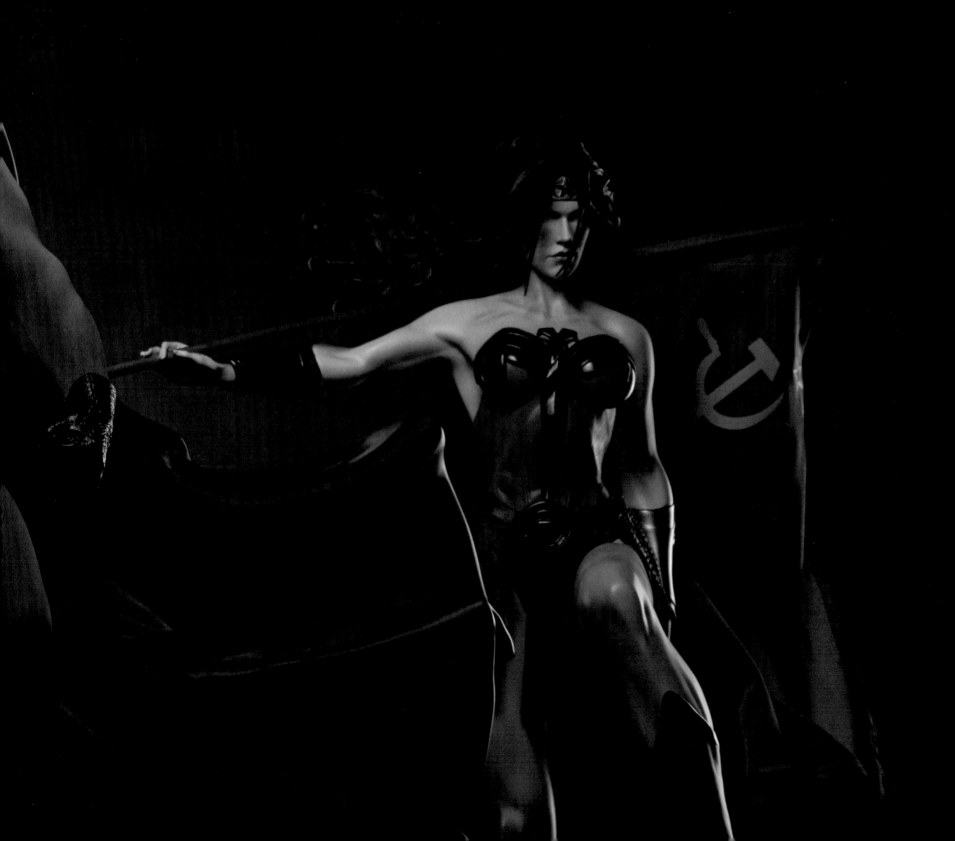

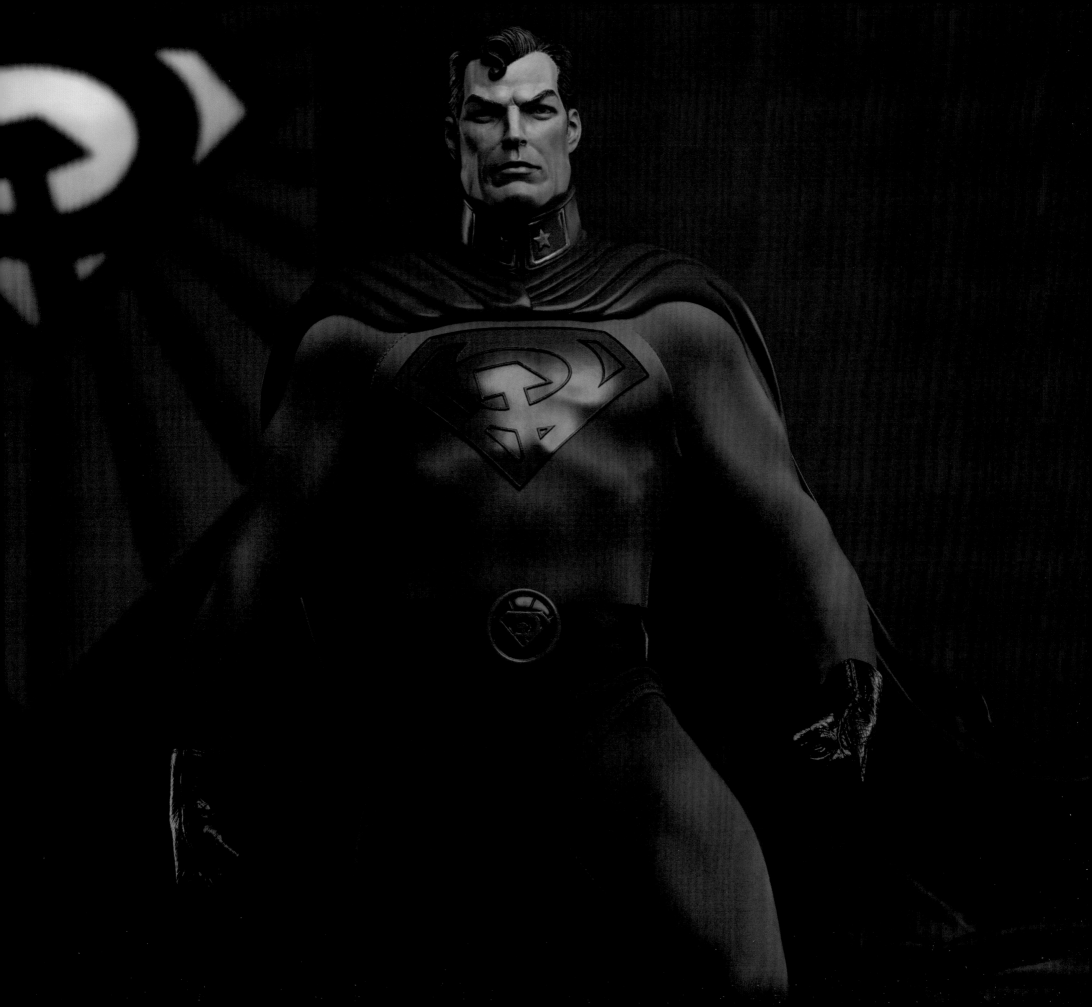

SUPERMAN: RED SON

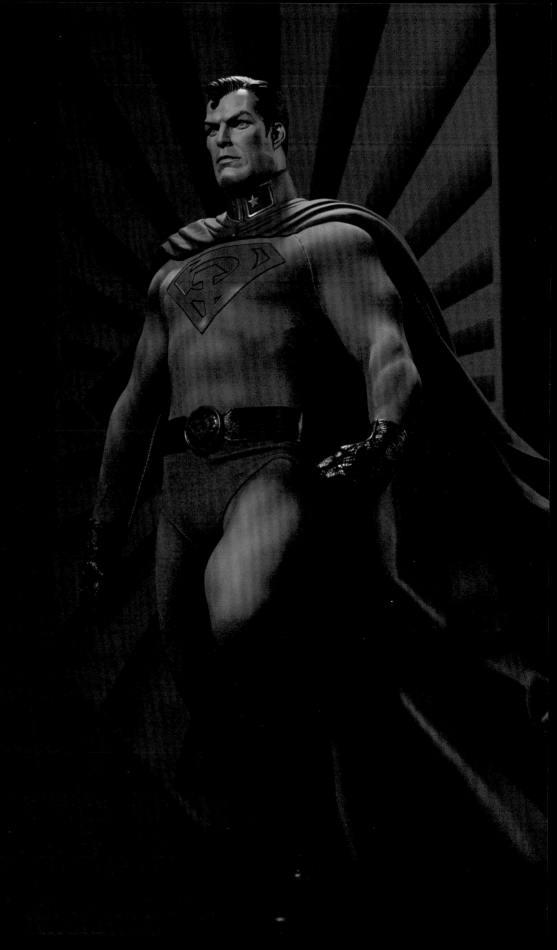

Let our enemies beware, there is only one superpower now. —Soviet Television Announcer, *Superman: Red Son* #1 (June 2003)

The critically acclaimed miniseries *Superman: Red Son* by Mark Millar, Dave Johnson, and Kilian Plunkett was published under DC's Elseworlds imprint, which features stories where DC Super Heroes are taken from their usual settings and put into strange times and places—some that have existed, and others that can't, couldn't, or shouldn't exist.

Superman: Red Son is a tale of Cold War paranoia that imagines a universe that sees Kal-El's rocket crash-land into the heart of the Soviet Union instead of the American Midwest. Raised on a collective, the infant grows up and becomes a symbol to the Soviet people, and the world changes drastically from the one we know.

DETAILS

The Comrade of Steel sports a red-and-grey costume, which reflects the uniforms of the Soviet military during the Cold War era. This champion of the common worker fights the never-ending battle for Stalin, socialism, and the international expansion of the Warsaw Pact.

"The *Red Son* suit resembles the classic Superman look, but with a shift in emblem and color palette, chunkier boots, a chunkier belt, and an added choker," says production manager Kellam Cunningham. "It's got quite a striking appearance, with nods to the classic, but with a design sensibility that reflects Soviet, rather than American, influences."

Cunningham got to employ several innovative techniques for this series, which adapted designs from DC artist Dave Johnson. "With this piece, we actually printed the shading and highlights of the suit directly onto the fabric. This printing technique, called *dye sublimation*, is used to force light onto the figure in order that the contrast of high and low points of the statue's physique are exaggerated. In other words, we're creating an illusion of light that tricks the viewer's eye into seeing details they might not otherwise notice."

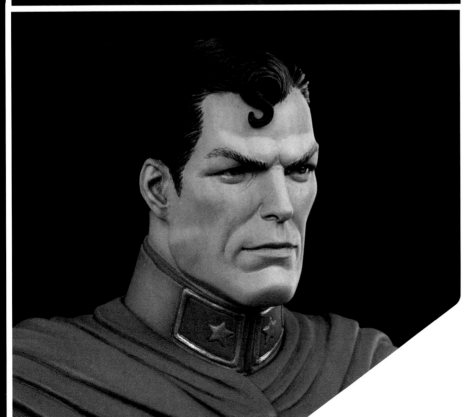

RED SON SUPERMAN VARIANT BASE

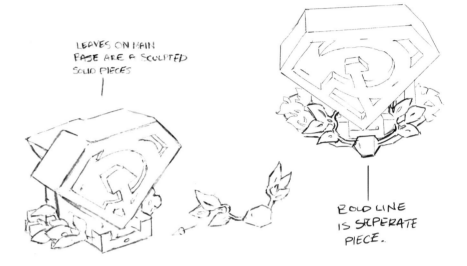

LEAVES ON MAIN
BASE ARE A SCULPTED
SOLID PIECES

BOLD LINE
IS SEPERATE
PIECE.

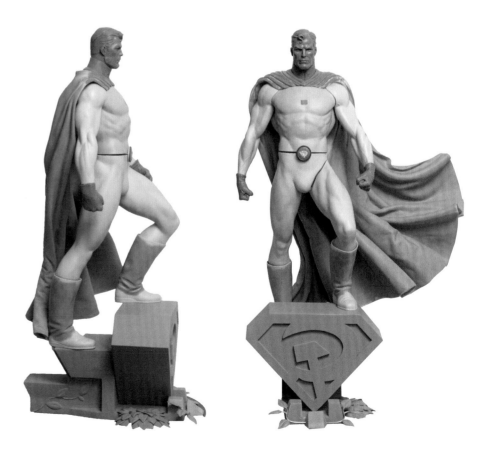

COLLECTOR EDITION BASE ART

PACKAGING

Just as the original *Superman: Red Son* comic book took its visual cues from bold Soviet iconography, the same source material was utilized by senior graphic designer Andrew McBride when developing the packaging for the Red Son Premium Format Figure line. "The Communist propaganda of the era is so striking, and the source material beautifully captures the boldness, rich colors, and designs that were often associated with the art that was used to excite and unite the people," notes McBride. "I wanted these packages for the Red Son series to evoke that feeling. The dichotomy of seeing Superman, the all-American Super Hero, with a large hammer and sickle emblazoned across his chest and seeing the iconic uniform and cape in such a contrast was a powerful image."

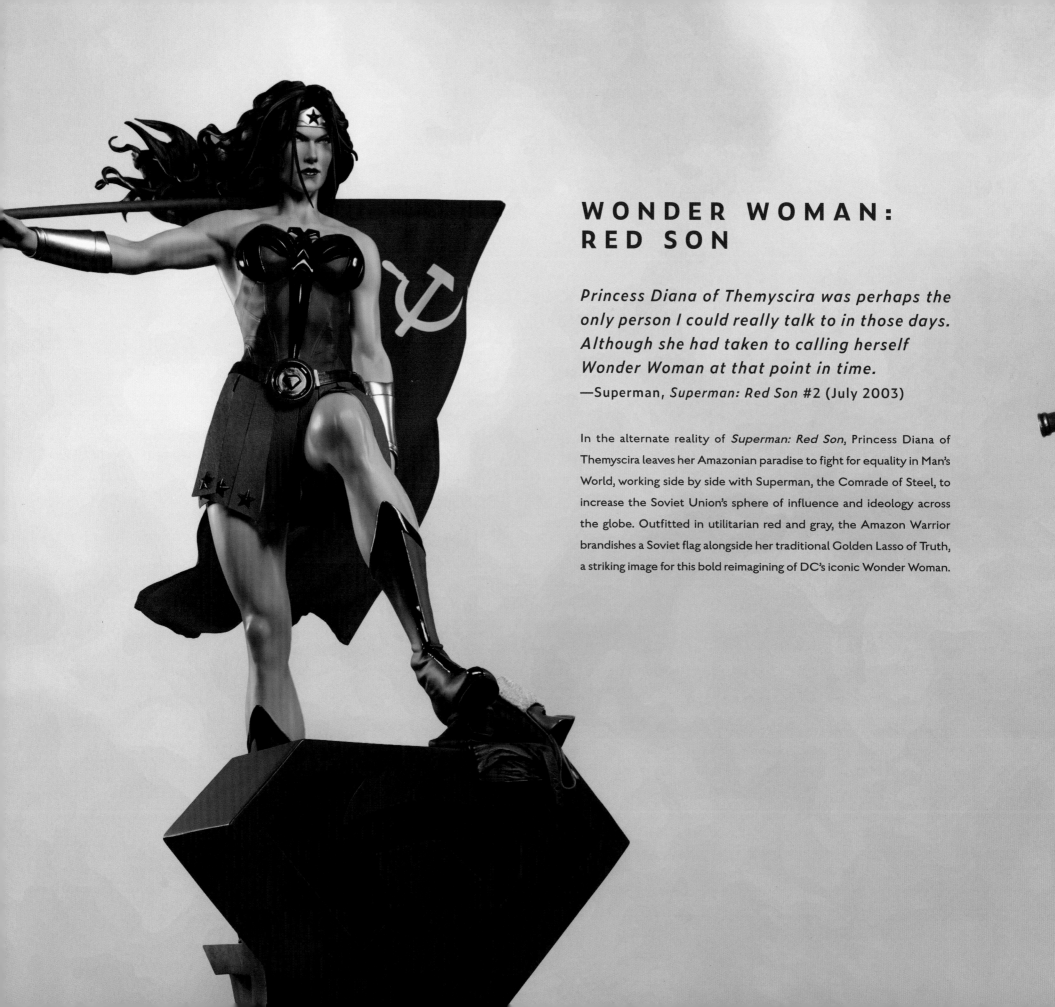

WONDER WOMAN: RED SON

Princess Diana of Themyscira was perhaps the only person I could really talk to in those days. Although she had taken to calling herself Wonder Woman at that point in time.
—Superman, *Superman: Red Son* #2 (July 2003)

In the alternate reality of *Superman: Red Son*, Princess Diana of Themyscira leaves her Amazonian paradise to fight for equality in Man's World, working side by side with Superman, the Comrade of Steel, to increase the Soviet Union's sphere of influence and ideology across the globe. Outfitted in utilitarian red and gray, the Amazon Warrior brandishes a Soviet flag alongside her traditional Golden Lasso of Truth, a striking image for this bold reimagining of DC's iconic Wonder Woman.

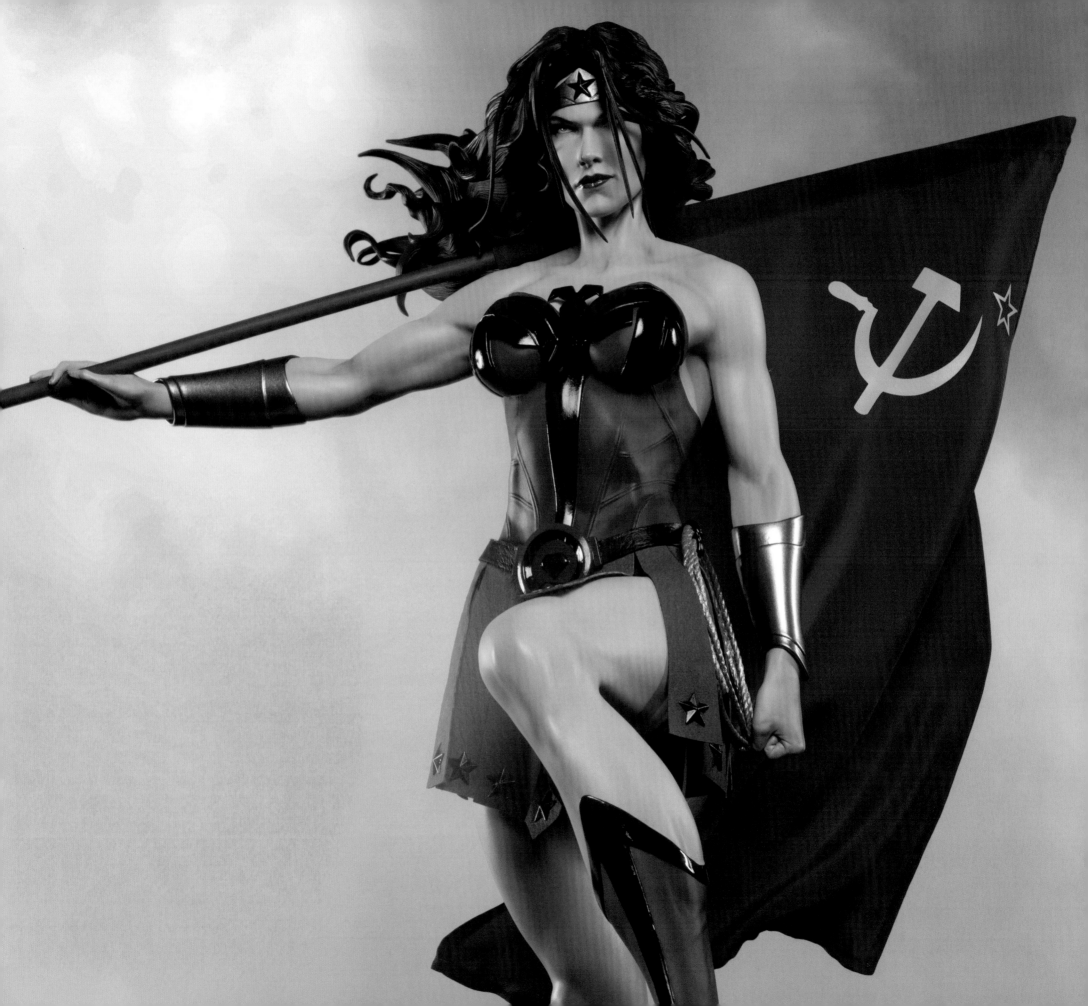

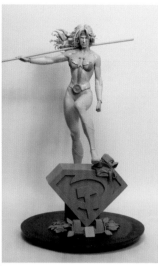

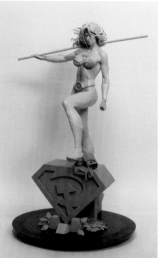

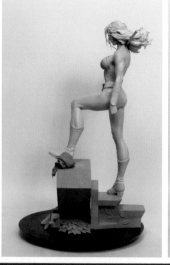

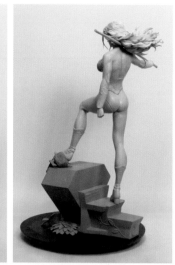

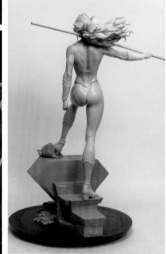

"This was a great revisit of an earlier project. I painted the original Wonder Woman Premium Format Figure that this piece was based on, so it was a treat to go back a few years later and do it again differently. This time we went with a paler, more porcelain-skinned Wonder Woman. I love how, with a few tweaks, you can end up with an entirely different figure."

—Kat Sapene, Painter

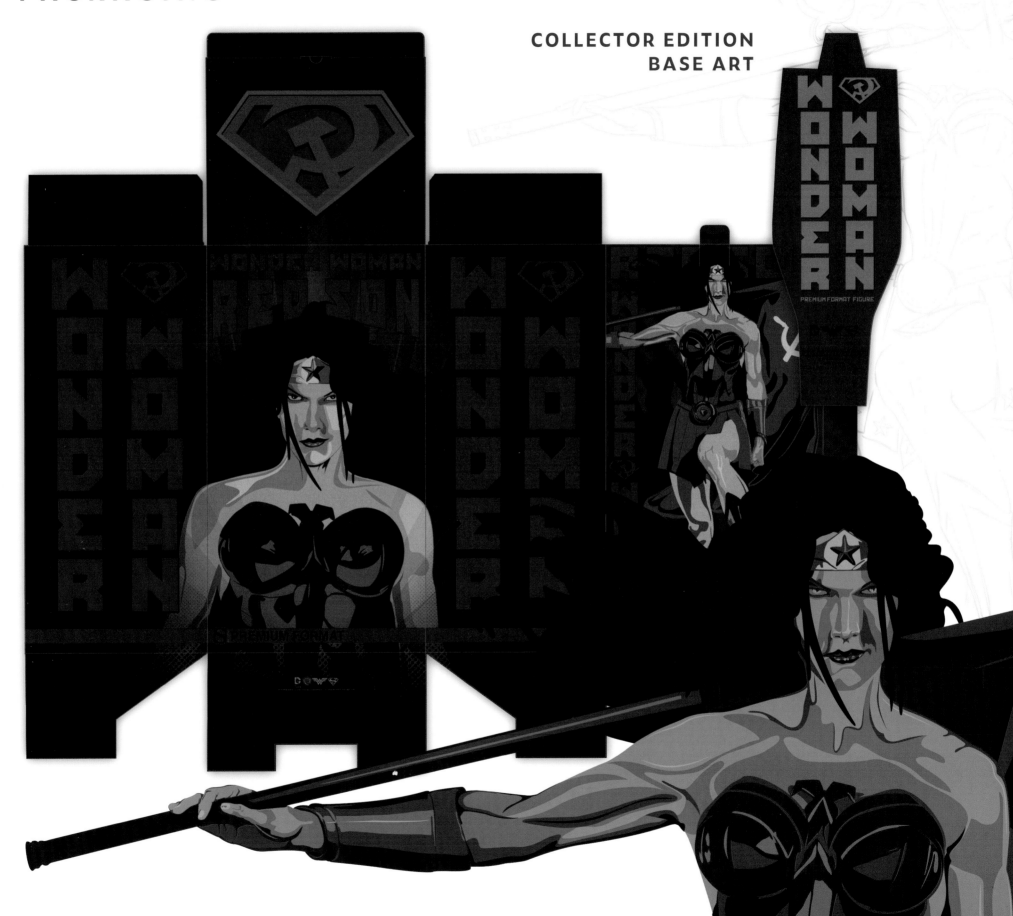

COLLECTOR EDITION
BASE ART

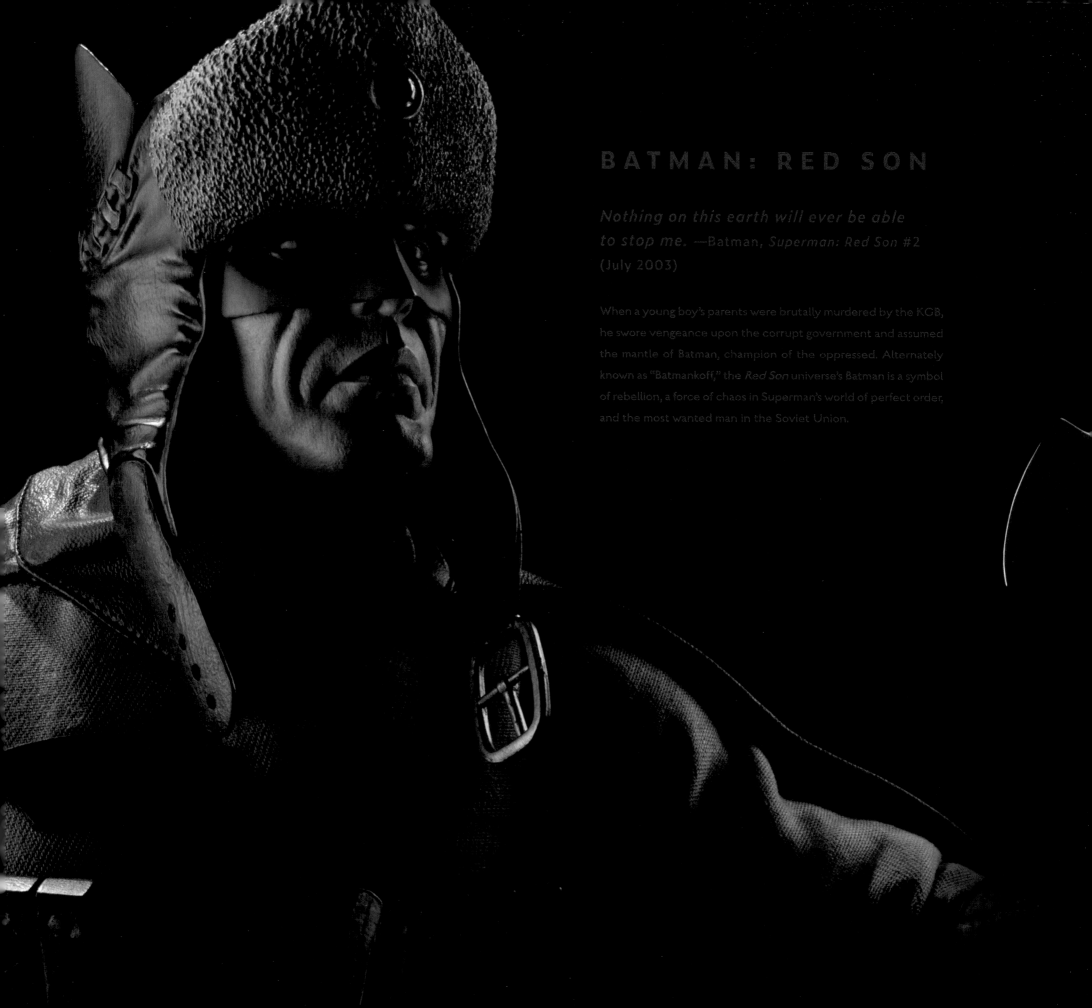

BATMAN: RED SON

Nothing on this earth will ever be able to stop me. —Batman, *Superman: Red Son* #2 (July 2003)

When a young boy's parents were brutally murdered by the KGB, he swore vengeance upon the corrupt government and assumed the mantle of Batman, champion of the oppressed. Alternately known as "Batmankoff," the *Red Son* universe's Batman is a symbol of rebellion, a force of chaos in Superman's world of perfect order, and the most wanted man in the Soviet Union.

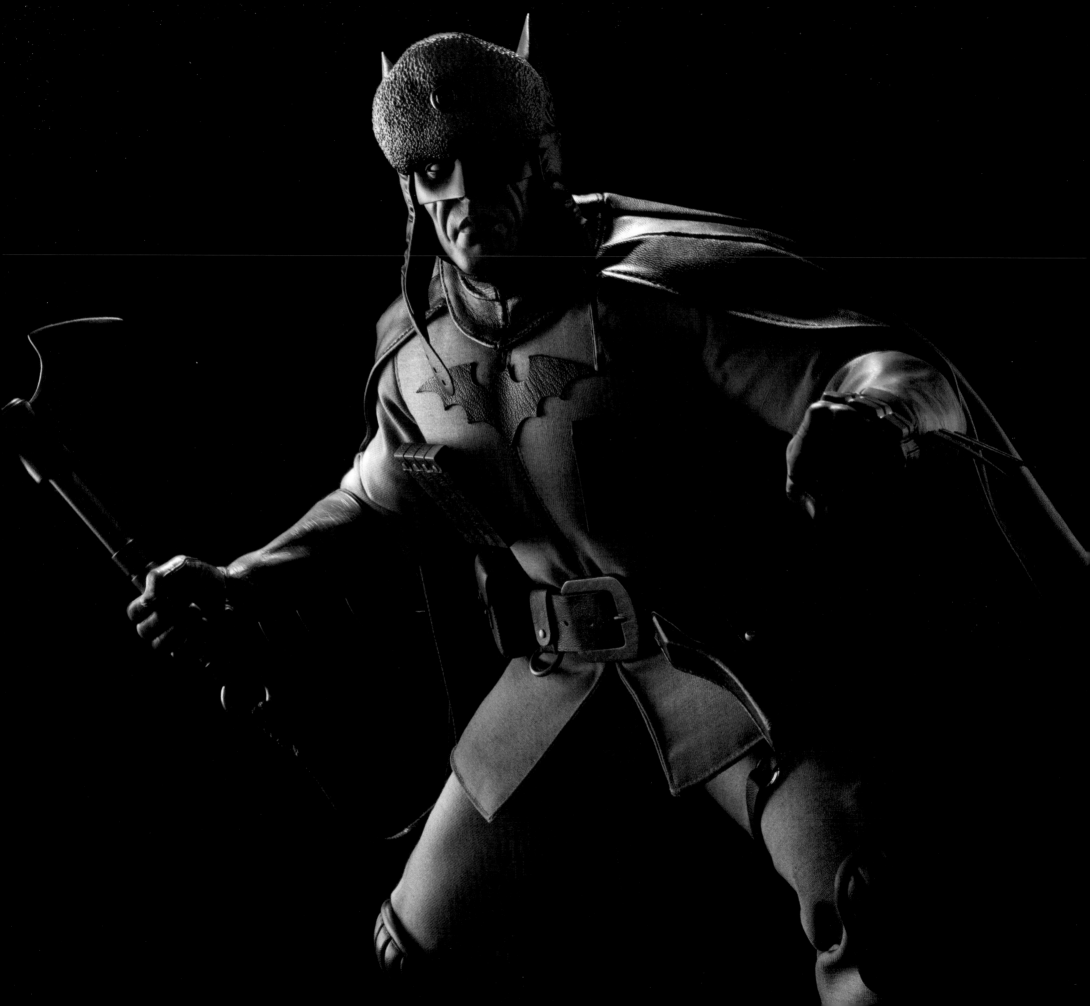

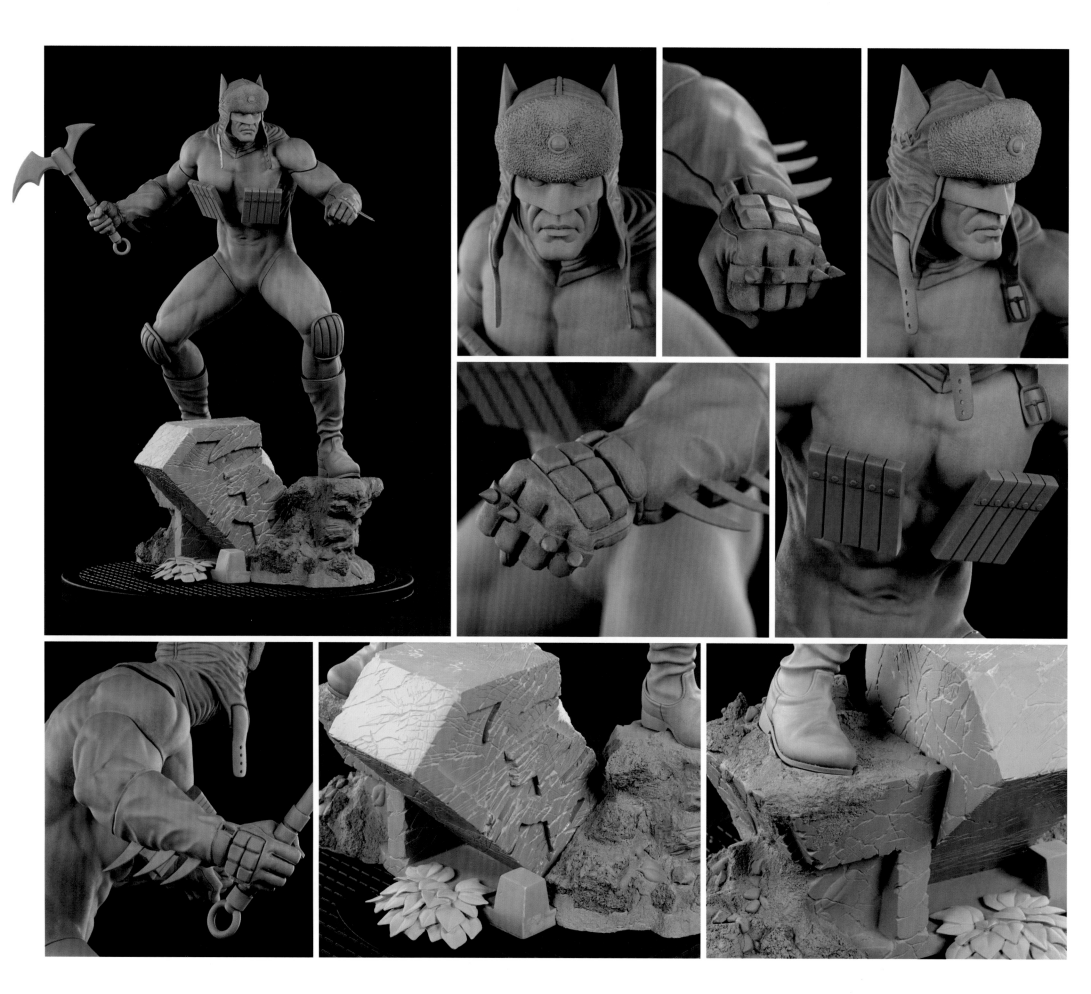

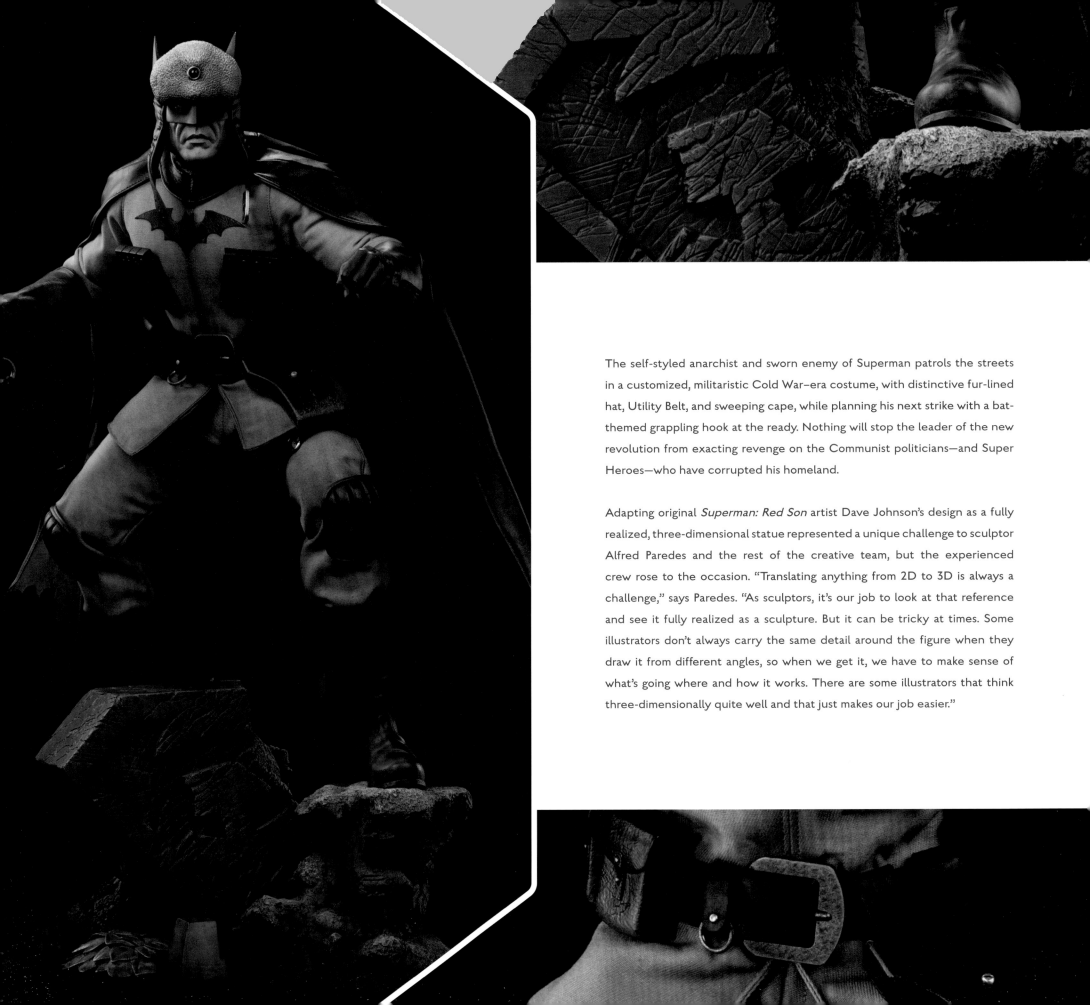

The self-styled anarchist and sworn enemy of Superman patrols the streets in a customized, militaristic Cold War–era costume, with distinctive fur-lined hat, Utility Belt, and sweeping cape, while planning his next strike with a bat-themed grappling hook at the ready. Nothing will stop the leader of the new revolution from exacting revenge on the Communist politicians—and Super Heroes—who have corrupted his homeland.

Adapting original *Superman: Red Son* artist Dave Johnson's design as a fully realized, three-dimensional statue represented a unique challenge to sculptor Alfred Paredes and the rest of the creative team, but the experienced crew rose to the occasion. "Translating anything from 2D to 3D is always a challenge," says Paredes. "As sculptors, it's our job to look at that reference and see it fully realized as a sculpture. But it can be tricky at times. Some illustrators don't always carry the same detail around the figure when they draw it from different angles, so when we get it, we have to make sense of what's going where and how it works. There are some illustrators that think three-dimensionally quite well and that just makes our job easier."

PACKAGING

Crafting the packaging for the Batman: Red Son Premium Format Figure presented an interesting challenge for senior graphic designer Andrew McBride, as the characters share a common design sensibility but encompass radically different worldviews. "Batman in the *Red Son* series is a vigilante terrorist, a stark contrast to Superman's 'Champion of the common worker who fights a never-ending battle for Stalin, socialism, and the international expansion of the Warsaw Pact,'" says McBride. "Visually I wanted to separate the two while maintaining a sense of cohesion."

While the Batman packaging complements the Superman: Red Son's, McBride made sure that each design represented a complete piece unto itself. "Personally, I can never assume a collector will always buy a set," notes McBride. "But as a collector myself, I always appreciate continuity in sets and collections. And given the opportunity to be able to create a set for the Red Son series, I jumped at the chance. I wanted each package to stand on its own and tell its own story for that character, but I also wanted a unity with the design that could work in a series."

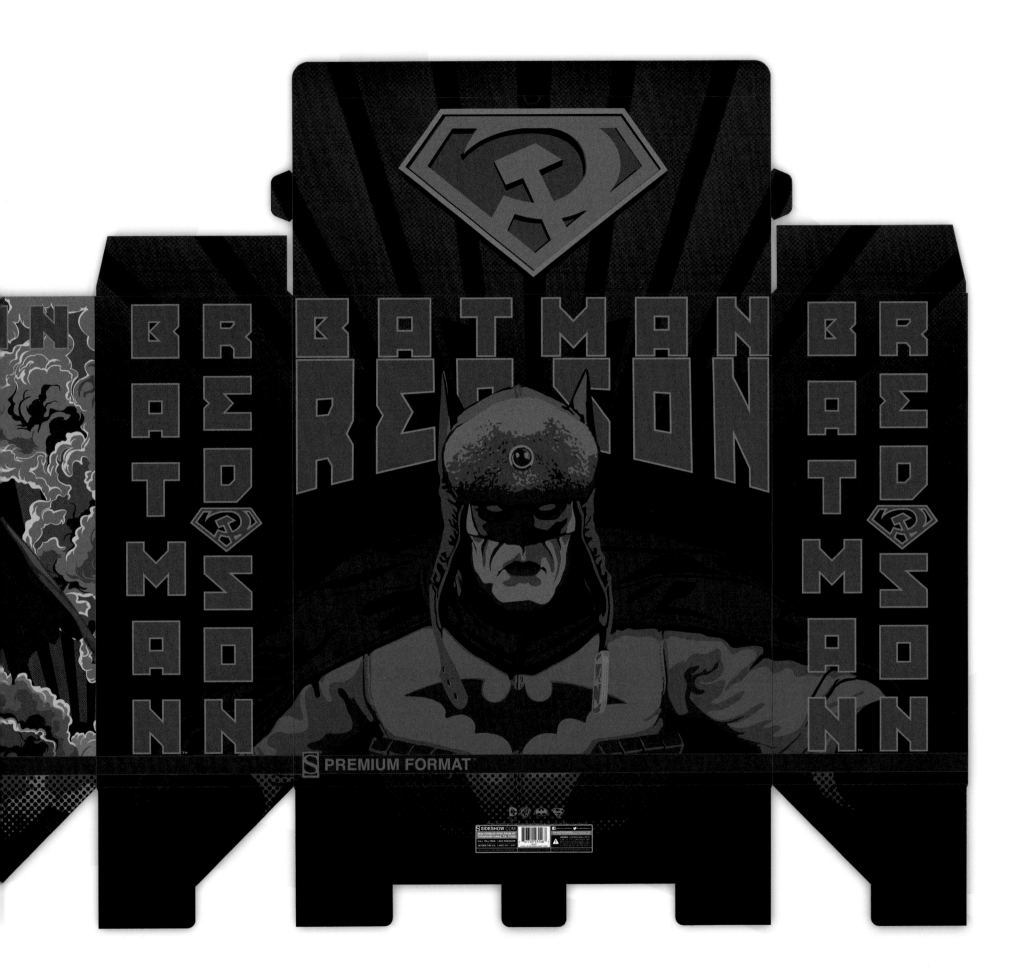

BATMAN RED SON

PREMIUM FORMAT

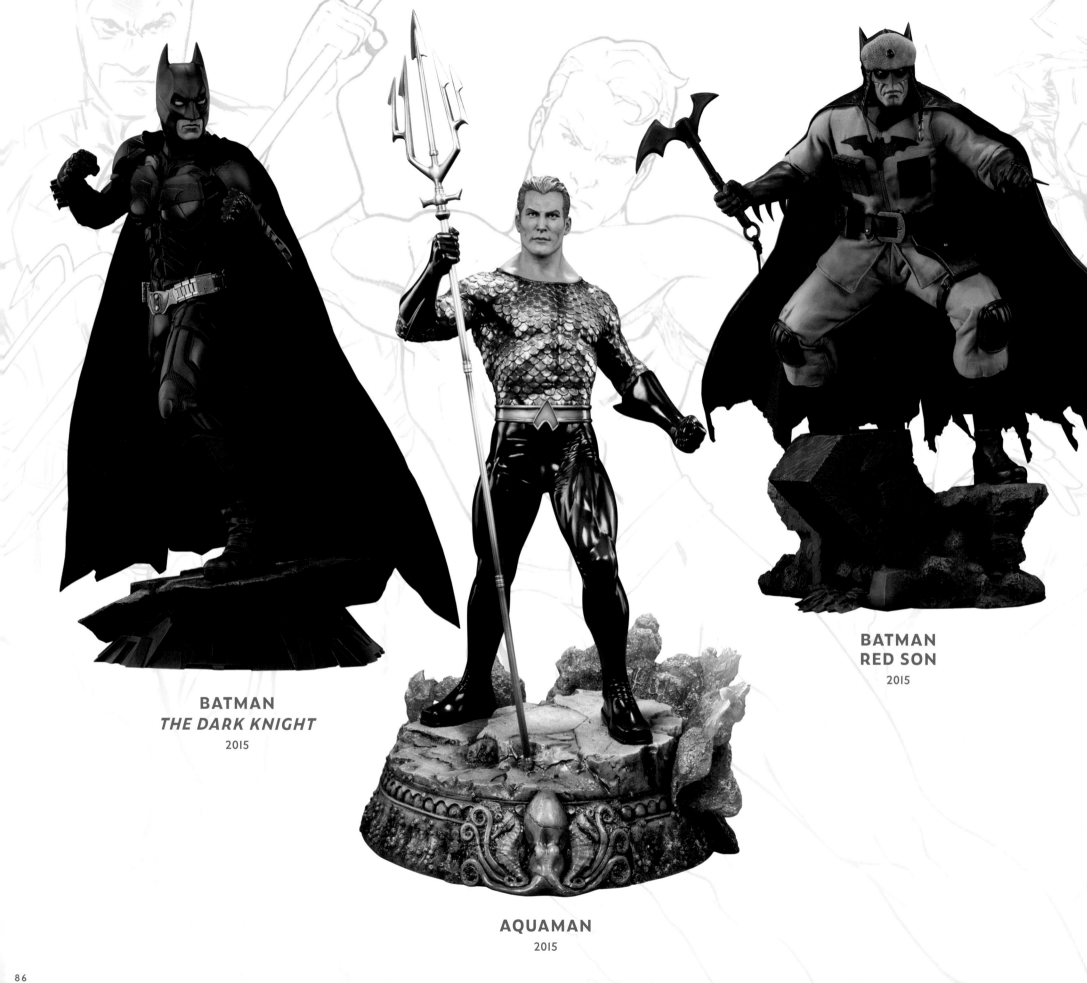

BATMAN
THE DARK KNIGHT
2015

AQUAMAN
2015

**BATMAN
RED SON**
2015

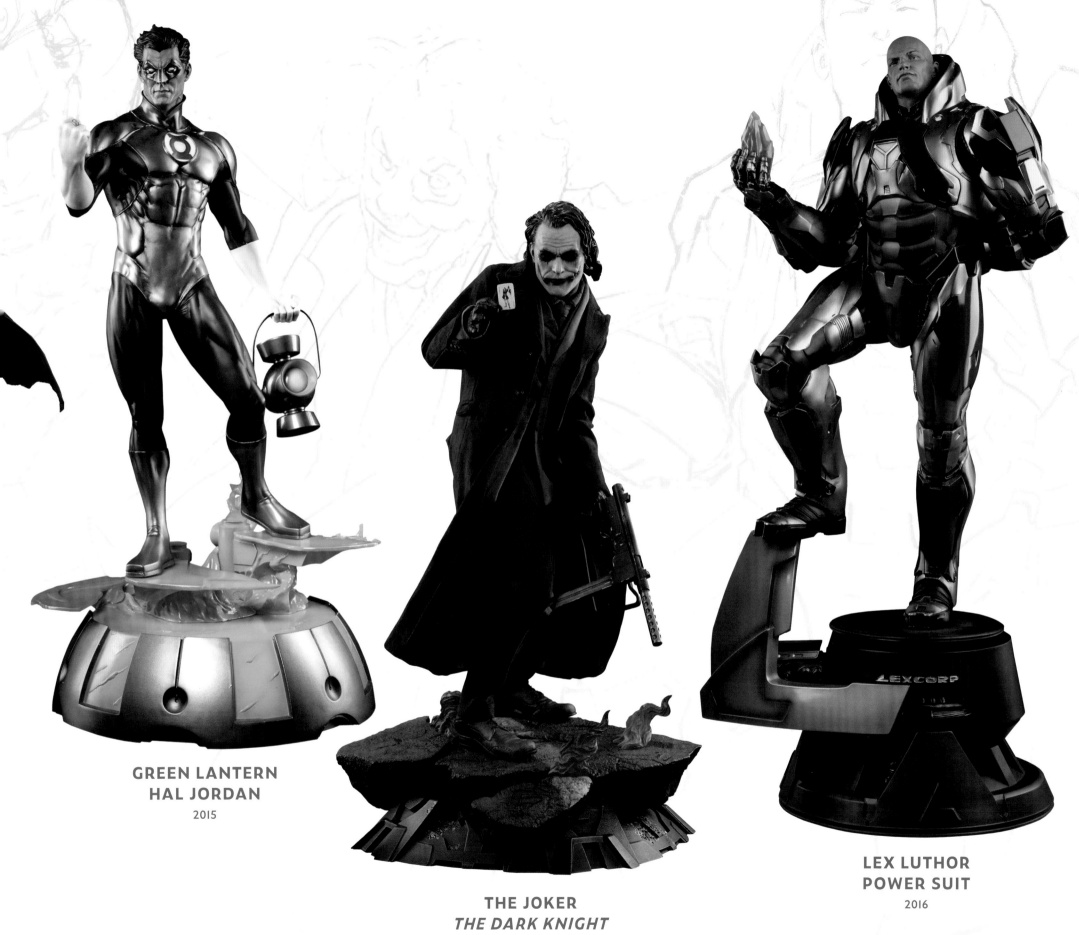

**GREEN LANTERN
HAL JORDAN**

2015

THE JOKER
THE DARK KNIGHT

2016

**LEX LUTHOR
POWER SUIT**

2016

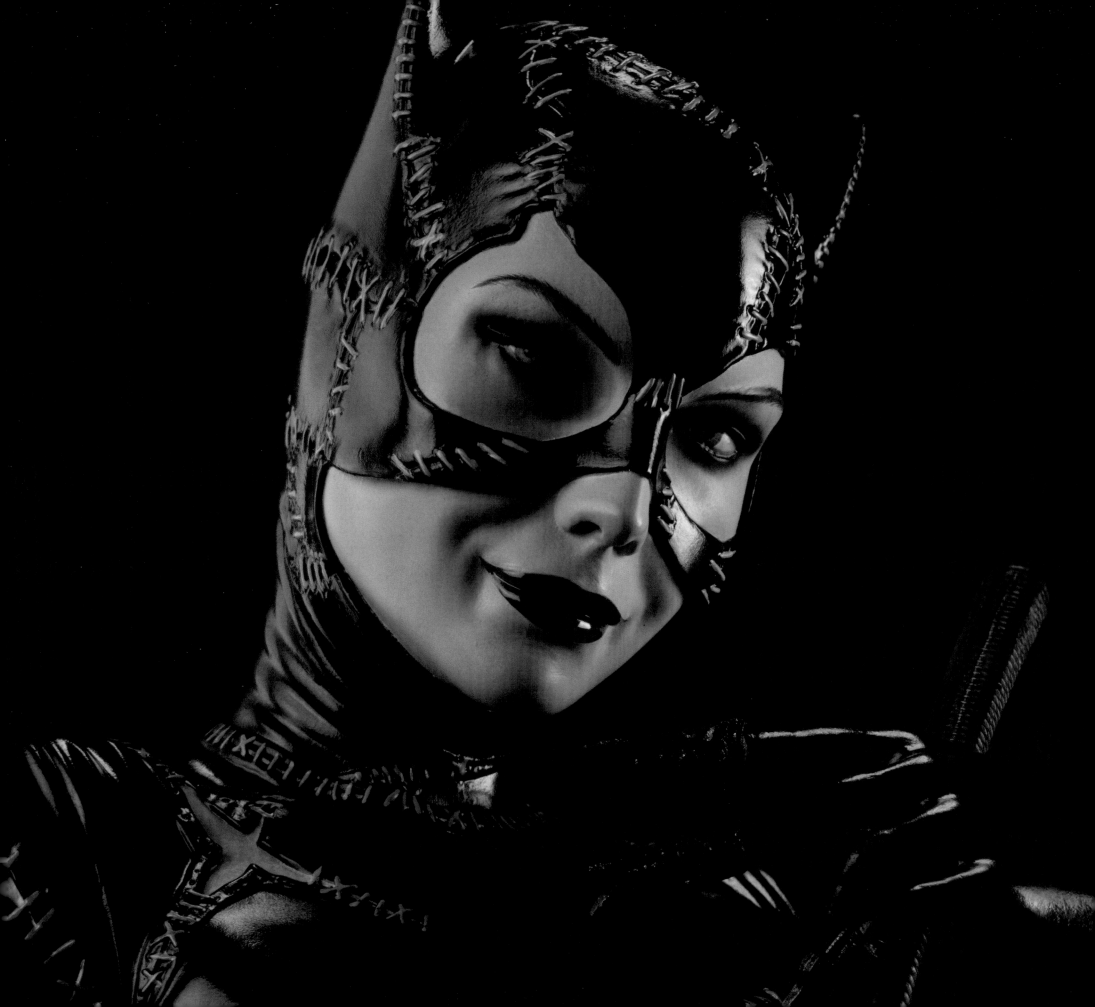

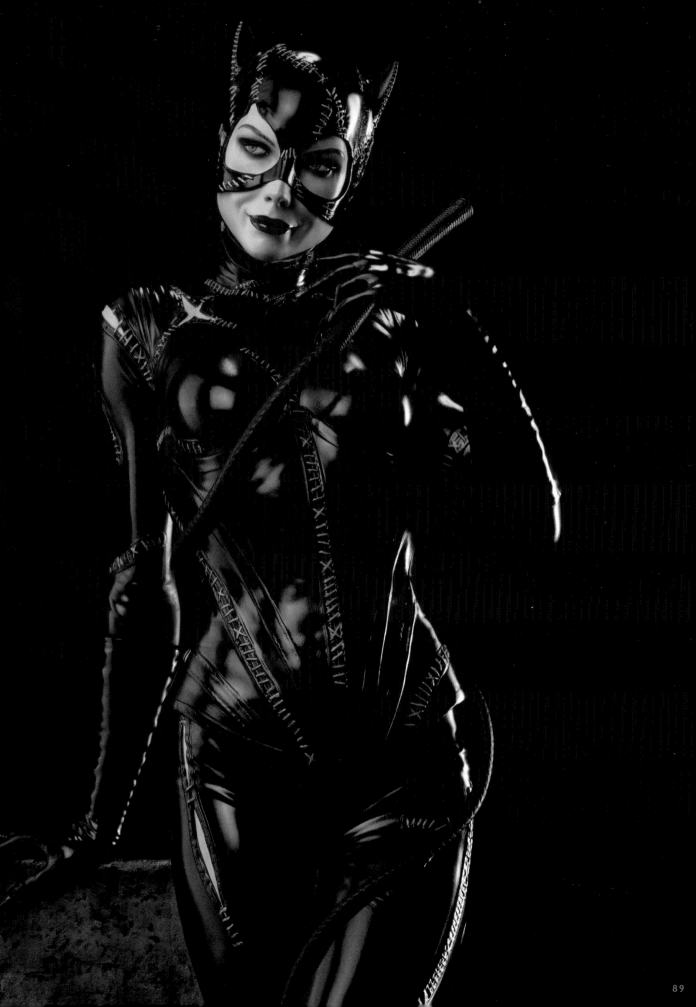

CATWOMAN
BATMAN RETURNS

You're catnip to a girl like me. Handsome, dazed, and to die for.
—Catwoman, *Batman Returns* (1992)

Although the Dark Knight earned top billing in the 1992 summer blockbuster *Batman Returns*, it was a cat burglar, appropriately enough, who stole his spotlight. Michelle Pfeiffer made an indelible impression upon audiences who witnessed her stunning transformation from overworked, underappreciated secretary Selina Kyle to Gotham City's own Catwoman.

Sideshow's Catwoman is a film-accurate re-creation of Pfeiffer's stunning *Batman Returns* character, with its scene-stealing, shiny black outfit, complete with her signature whip and her handcrafted, razor-sharp claws.

DETAILS

The importance of accuracy in translating these iconic characters from screen to Premium Format Figure isn't lost on sculptor Joe Menna. "Fans know these characters intimately, so accurately representing their costumes is essential," he observes. "Catwoman's costume looks so fantastic because of the amazing work of Kat Sapene. Without her expert skill, the piece would not have that final magical touch."

"This piece looks so simple, a glossy black outfit, a dark base, what could be so difficult?" asks Sapene. "Well, as we did the research, it turned out the stitching that's all over the costume was silver. Of course, we came across this info *after* I had already painted most of the stitches in white," she laughs.

Sapene continues, "Then there were the different fingertips on every finger. Those little guys kept popping off her hands and breaking. Many sets were printed and painted to have a finished prototype with all the right nails that weren't broken. And then, of course, there's the likeness of Michelle Pfeiffer. She's so beautiful and very unique. Her lips, in particular, have a very distinctive shape that was difficult to get just right at this scale. I think in the end they turned out great, but it took some time."

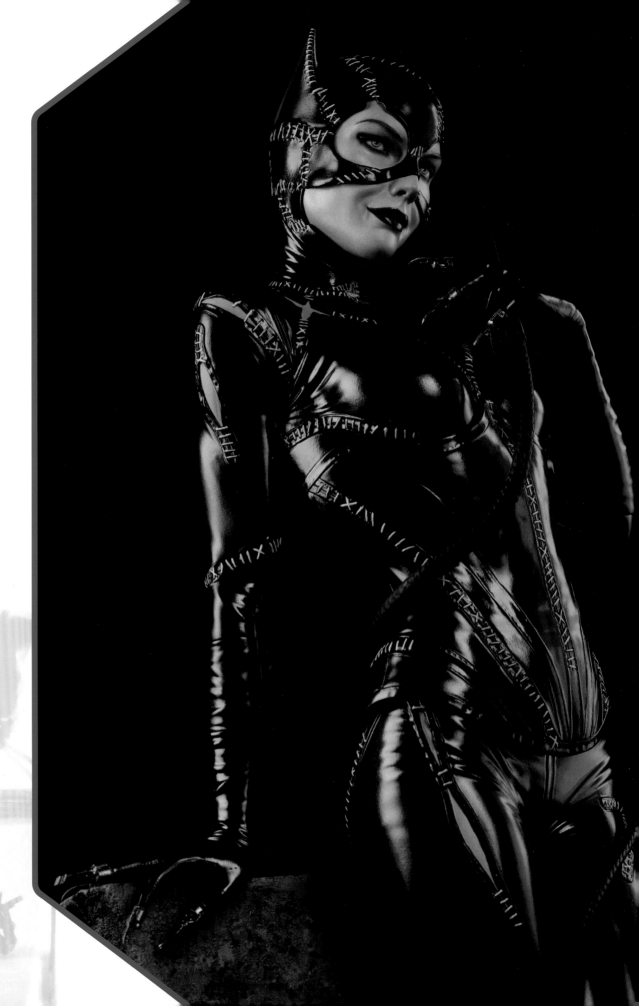

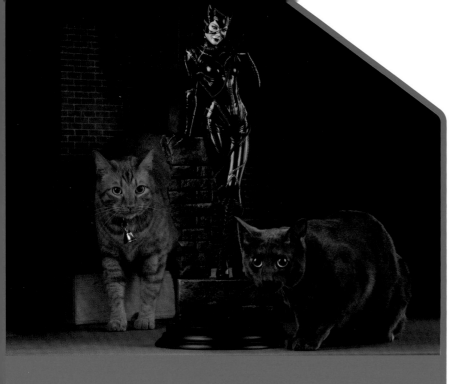

"One of my favorite parts of *Batman Returns* are the cats that seem to revive Selina into becoming the dangerously seductive Catwoman. When prepping for this shoot, I jokingly said to our art director, 'Hey, I might just need to bring my cats into this shoot.' He knew me well enough to realize I was actually half-serious, so he said, 'I dare you.' Pfeiffer's take on Selina Kyle is my absolute favorite—this is by far one of my favorite shoots as well as Sideshow pieces!"

—Jeannette Villarreal Hamilton, Photography Manager and Photographer

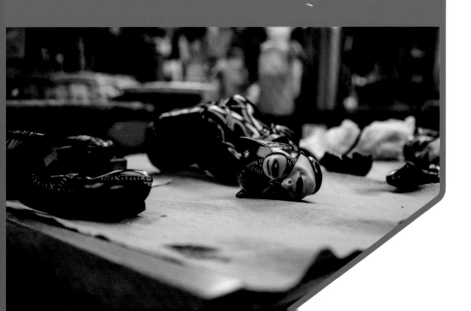

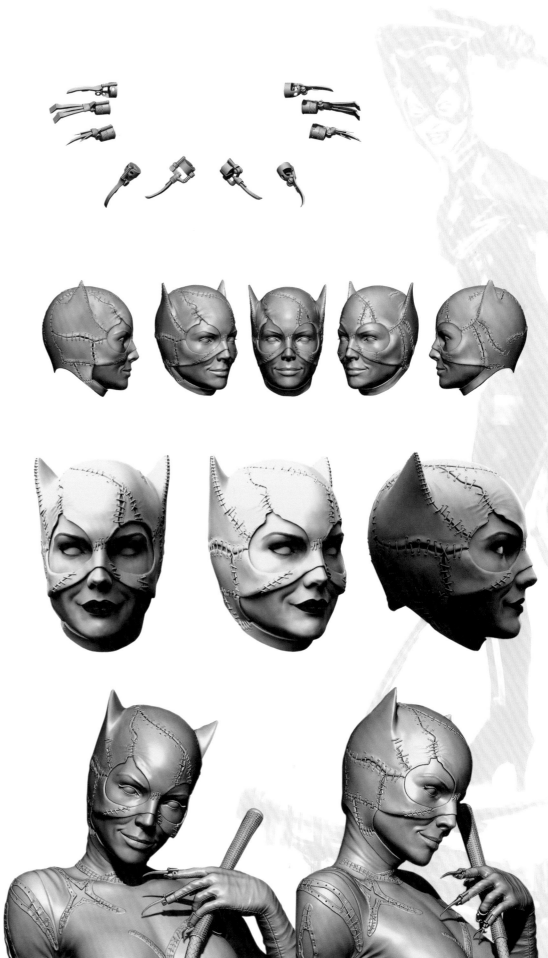

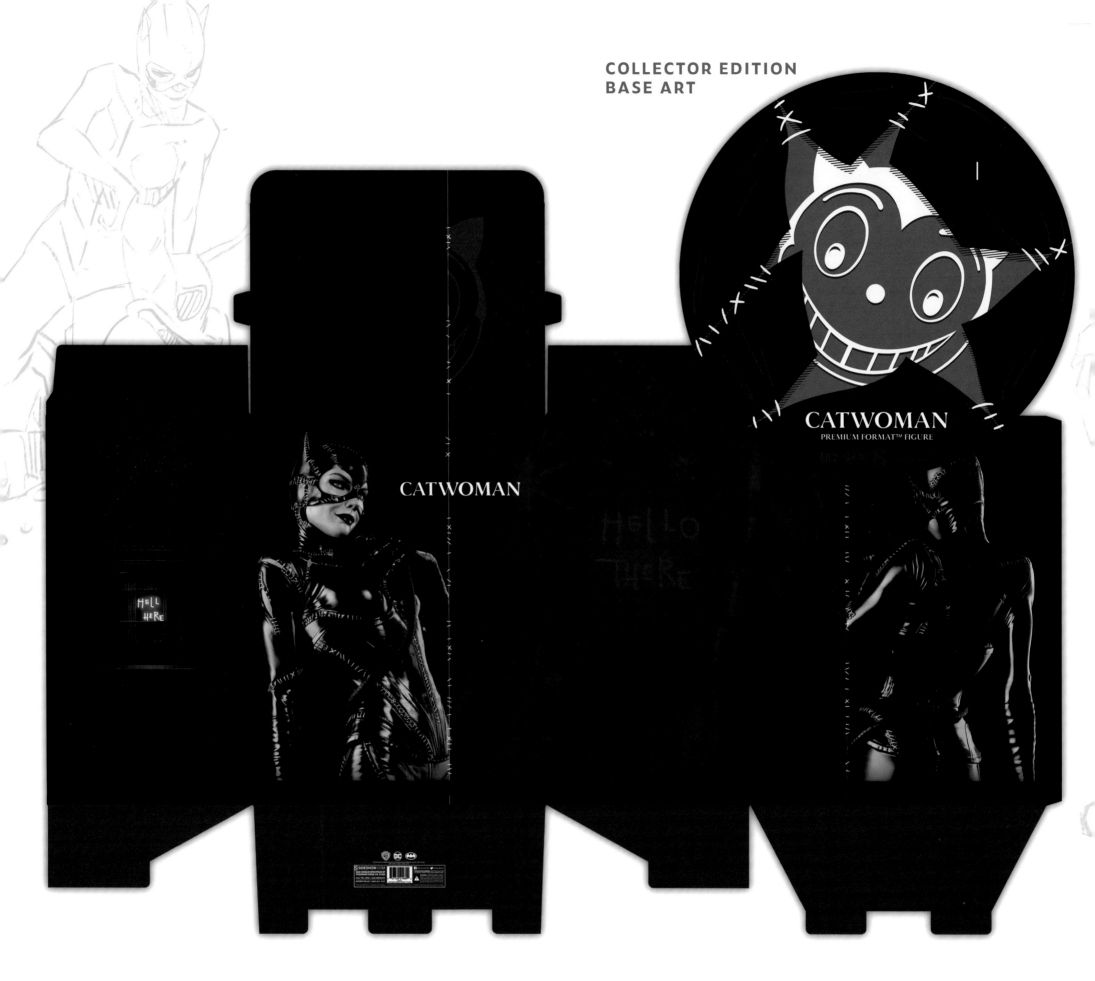

CATWOMAN

CATWOMAN
PREMIUM FORMAT™ FIGURE

HELL
HERE

HeLLo
THeRe

PACKAGING

Batman Returns director Tim Burton created the initial concept drawings for Michelle Pfeiffer's Catwoman and envisioned a stuffed calico cat coming apart at the seams as his core concept for the feline fatale's costume. It fell to costume designers Bob Ringwood and Mary Vogt to bring Burton's vision to life, and the end result was one of the most memorable villain designs in cinematic history.

Drawing inspiration from the eerie, nightmarish vision of Gotham City presented by Burton and production designer Bo Welch, graphic designer Katie Simpson combined the eerie purple neon of Selina Kyle's run-down apartment with the sleek, black leather outfit of Catwoman to create an irresistible package.

"While the old adage is true that we don't want to judge any book by its cover, we see value in how we package what we sell," says Sideshow CEO Greg Anzalone. "The packaging and the base art are both reflections of our intentionality that the consumer experience with our items includes those aspects that are seemingly inconsequential. For Sideshow, it's all-important."

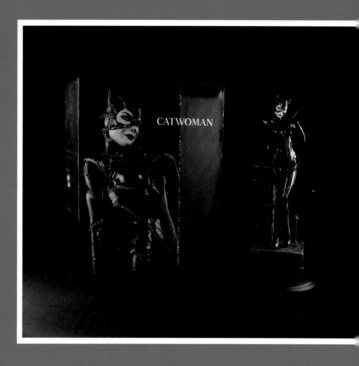

"Sideshow's packaging design is unique in the fact that the majority of the purchases of Sideshow products are made online," adds designer Katie Simpson. "So a lot of times, the first time the customer sees the packaging is when their collectible is delivered. With this in mind, we always try and design a package that enhances the overall experience of receiving a Sideshow figure."

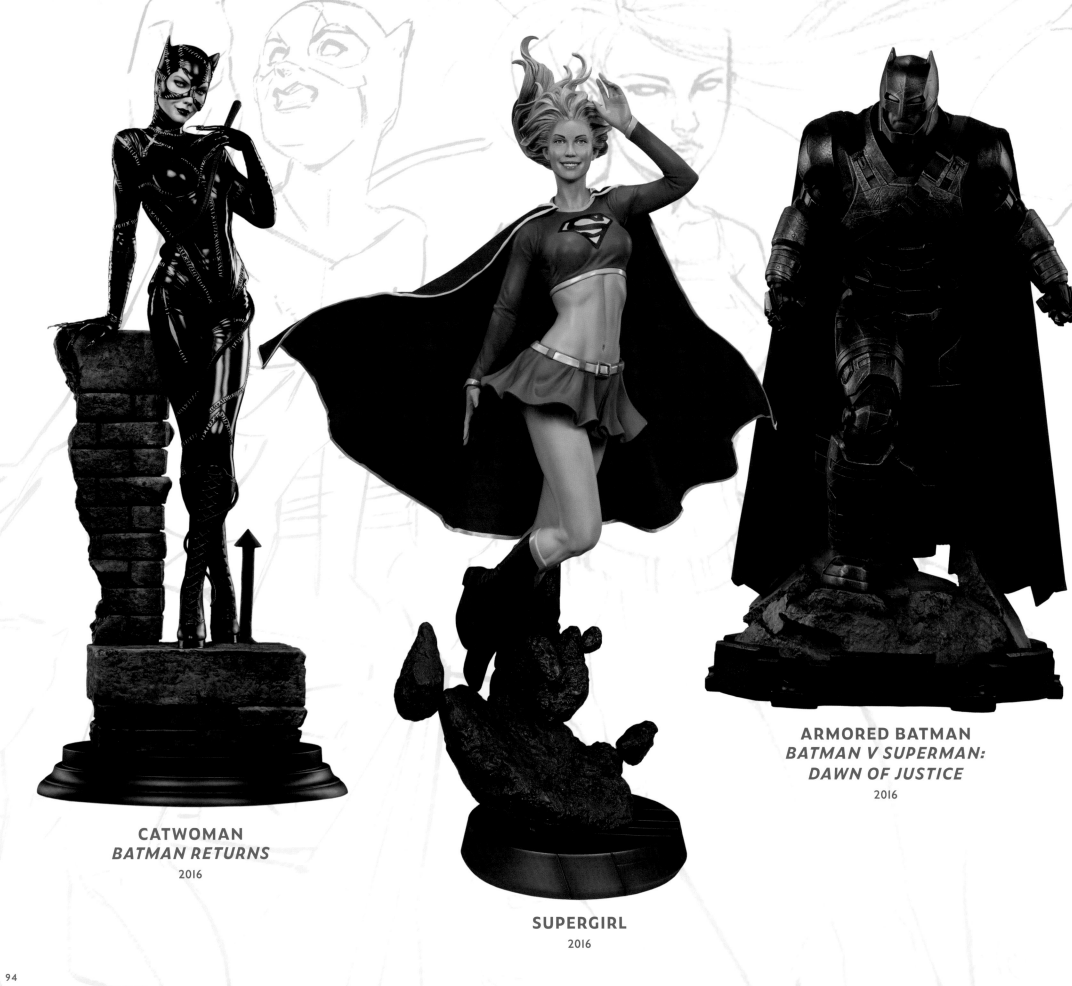

CATWOMAN
BATMAN RETURNS
2016

SUPERGIRL
2016

ARMORED BATMAN
BATMAN V SUPERMAN:
DAWN OF JUSTICE
2016

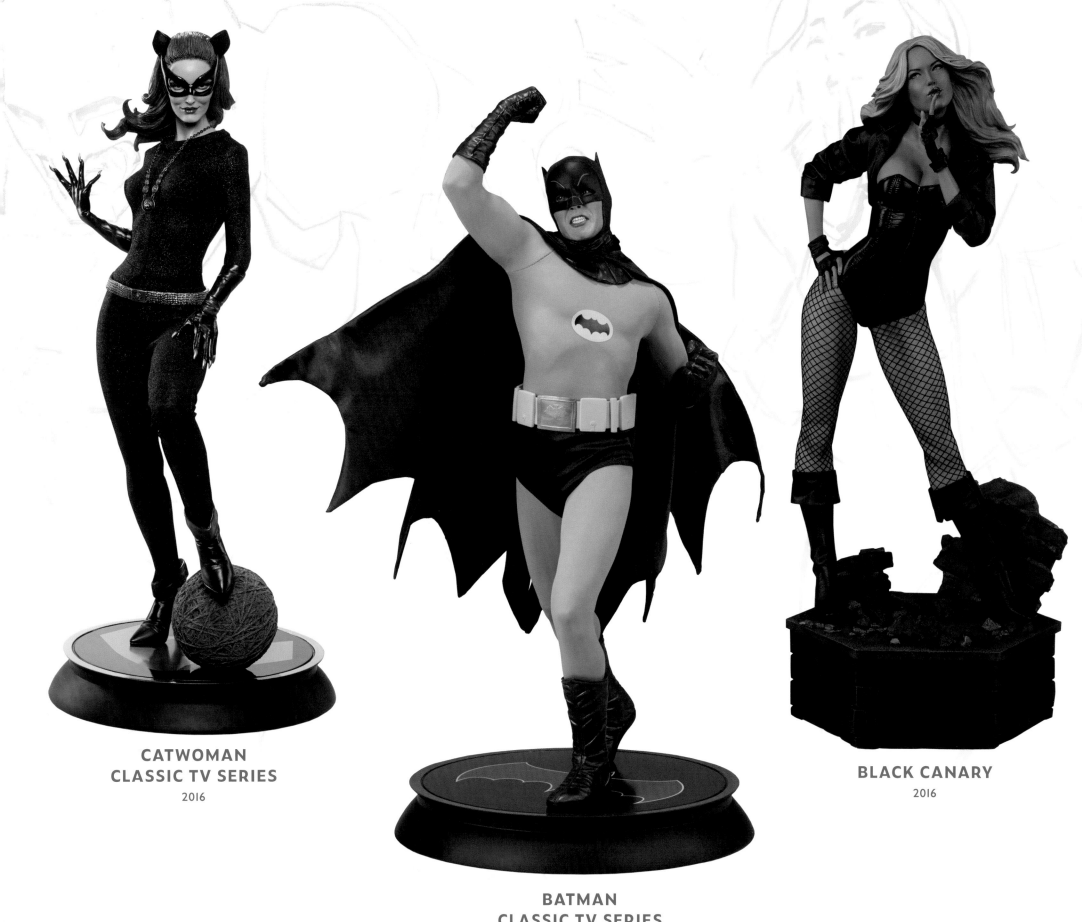

CATWOMAN
CLASSIC TV SERIES
2016

BATMAN
CLASSIC TV SERIES
2016

BLACK CANARY
2016

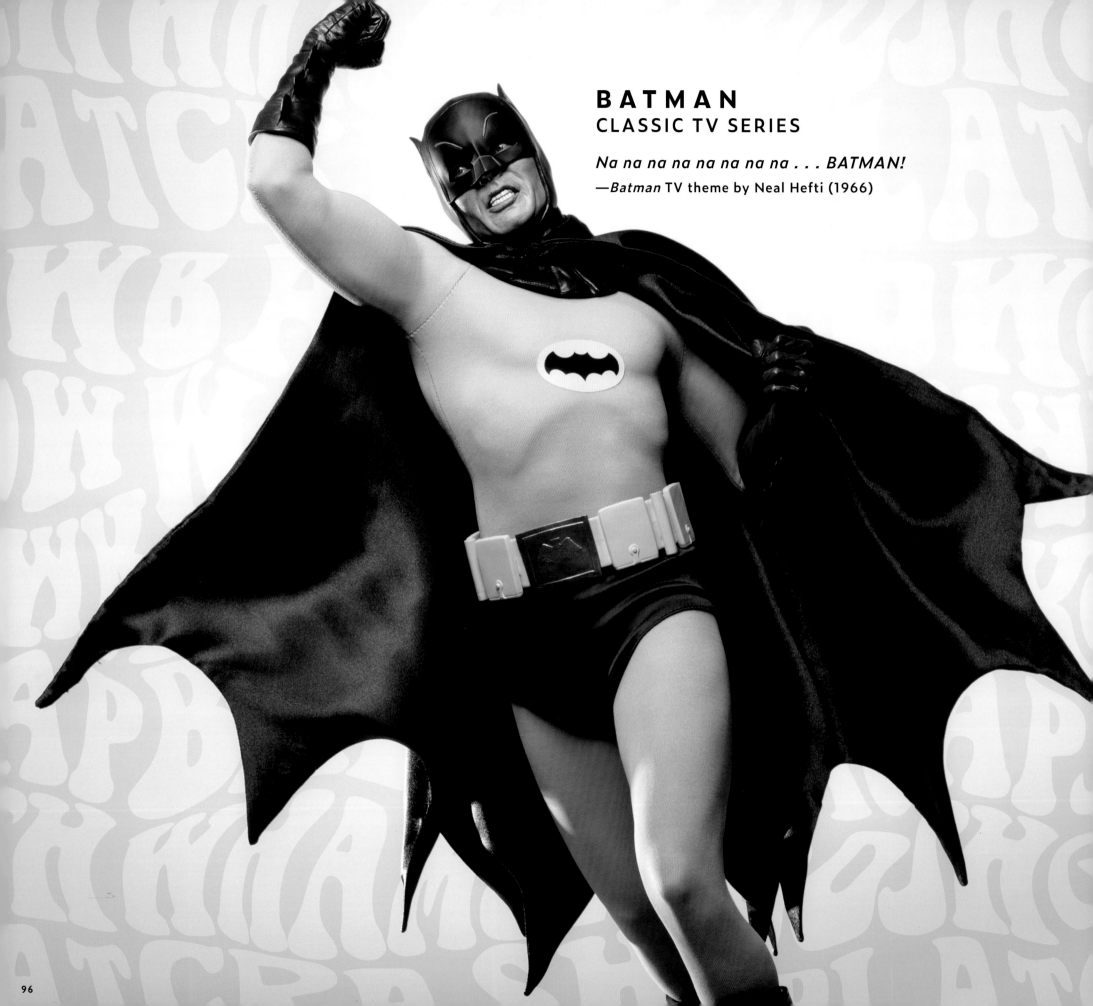

BATMAN
CLASSIC TV SERIES

Na na na na na na na na . . . BATMAN!
—*Batman* TV theme by Neal Hefti (1966)

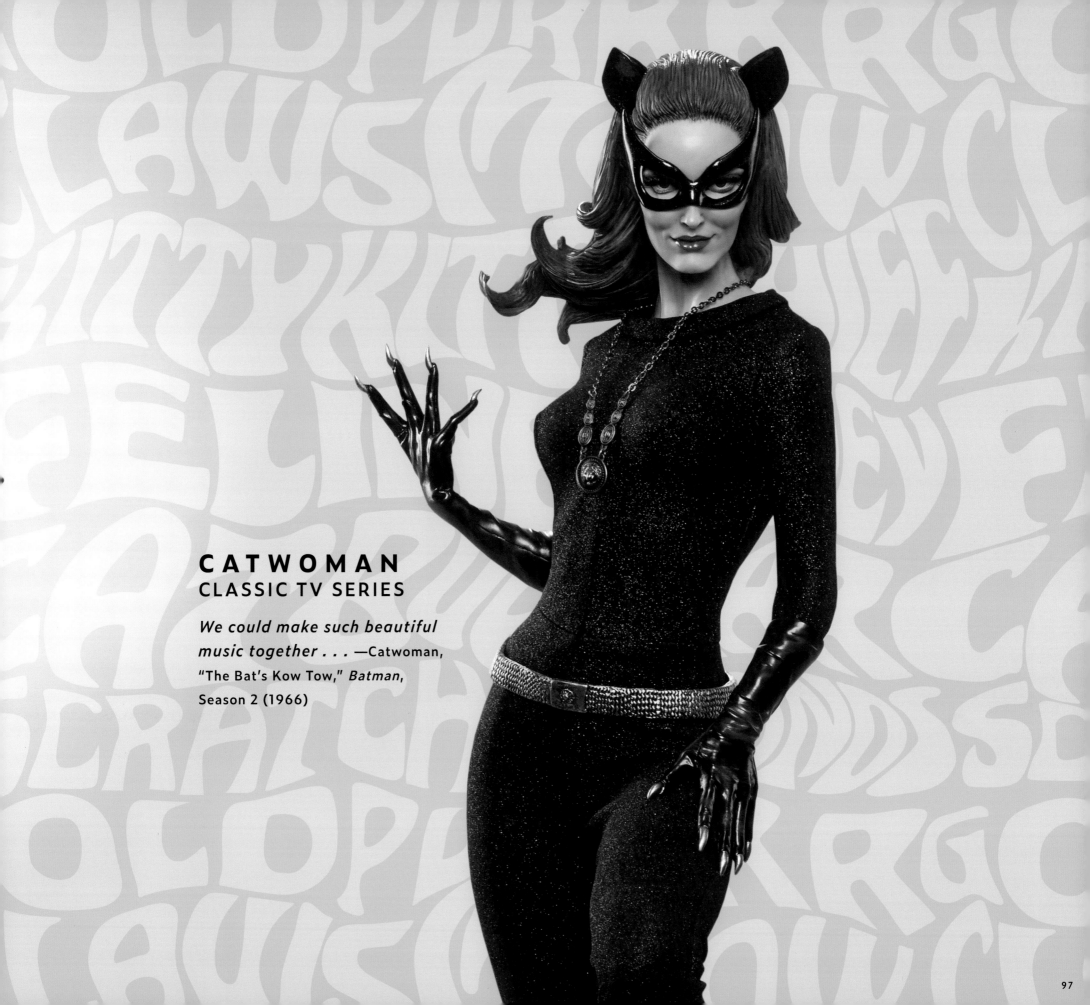

CATWOMAN
CLASSIC TV SERIES

We could make such beautiful music together . . . —Catwoman, "The Bat's Kow Tow," *Batman*, Season 2 (1966)

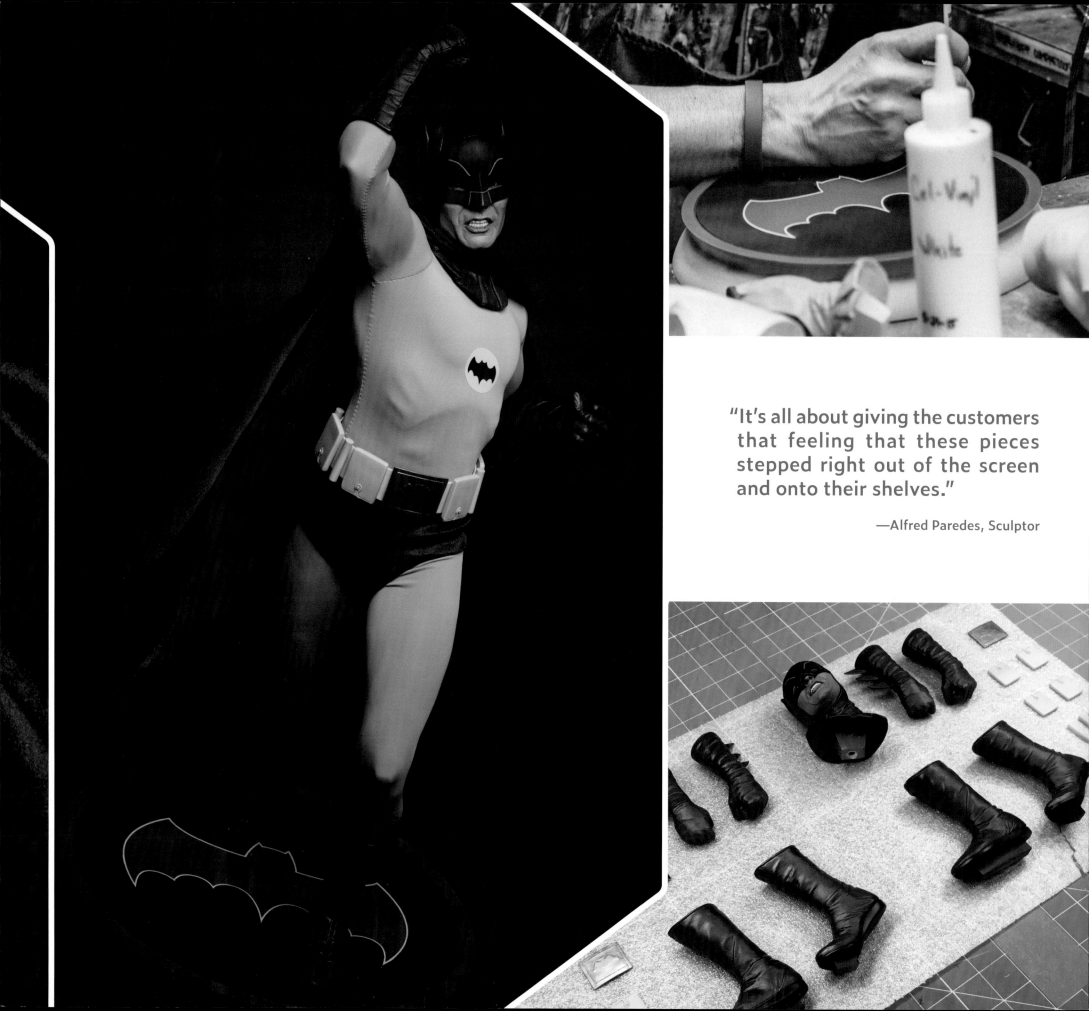

"It's all about giving the customers that feeling that these pieces stepped right out of the screen and onto their shelves."

—Alfred Paredes, Sculptor

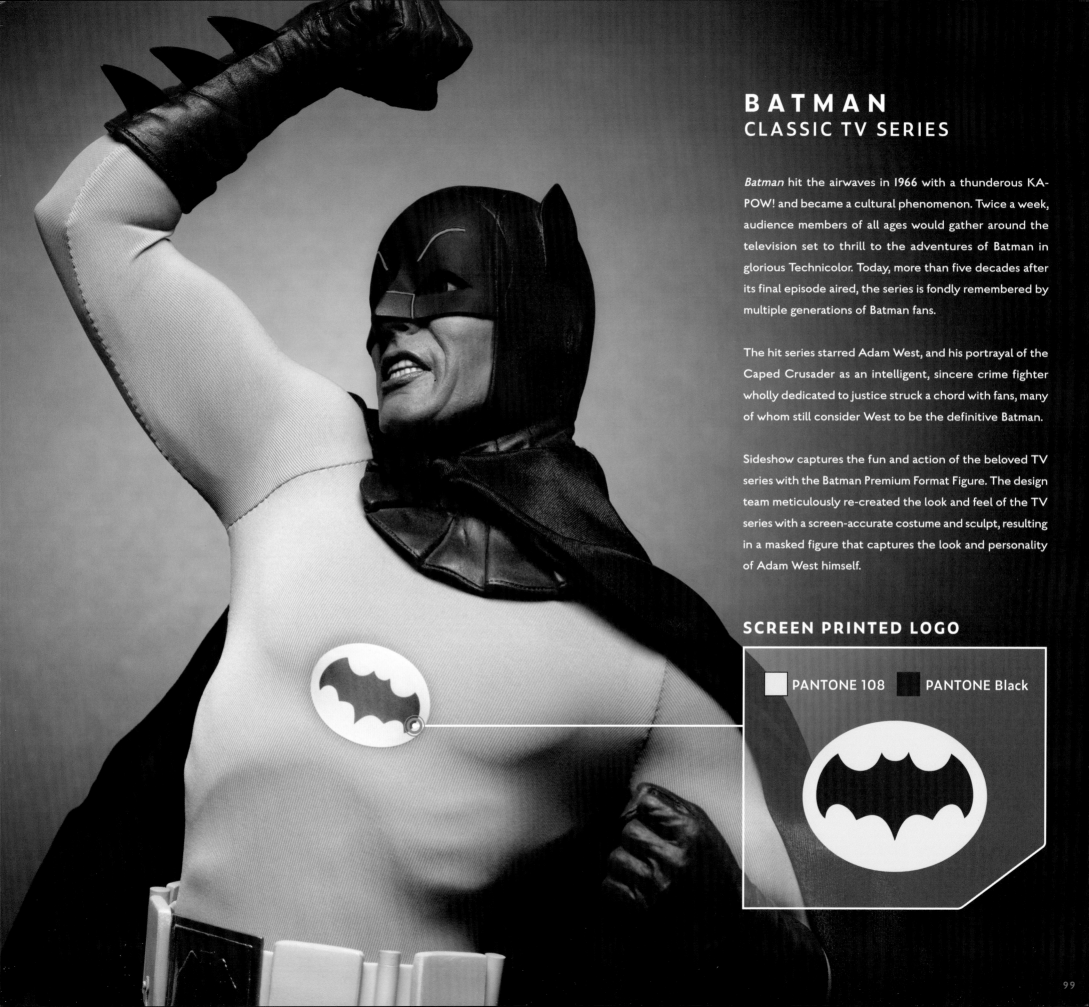

BATMAN
CLASSIC TV SERIES

Batman hit the airwaves in 1966 with a thunderous KA-POW! and became a cultural phenomenon. Twice a week, audience members of all ages would gather around the television set to thrill to the adventures of Batman in glorious Technicolor. Today, more than five decades after its final episode aired, the series is fondly remembered by multiple generations of Batman fans.

The hit series starred Adam West, and his portrayal of the Caped Crusader as an intelligent, sincere crime fighter wholly dedicated to justice struck a chord with fans, many of whom still consider West to be the definitive Batman.

Sideshow captures the fun and action of the beloved TV series with the Batman Premium Format Figure. The design team meticulously re-created the look and feel of the TV series with a screen-accurate costume and sculpt, resulting in a masked figure that captures the look and personality of Adam West himself.

SCREEN PRINTED LOGO

☐ PANTONE 108 ■ PANTONE Black

"When it comes to capturing something that's been on the big screen, it's all about reference," notes sculptor Alfred Paredes, "as much reference as we can get our hands on to try and match every detail we can. Whether the sculpture is being created as a fully sculpted figure or as a mixed-media piece with real fabric, we do our best to really get it as accurate as possible. When we're using real fabric, our talented team has to create those fabrics and prints, because the scale of the sculptures doesn't match the scale of the screen-used costumes. It's all about giving the customers that feeling that these pieces stepped right out of the screen and onto their shelves."

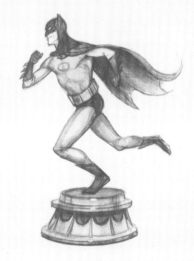

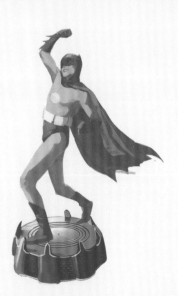
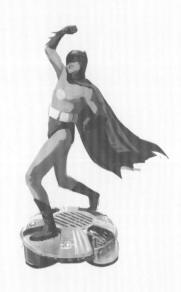
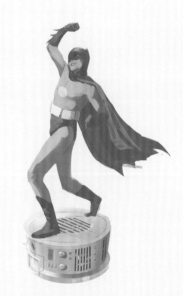
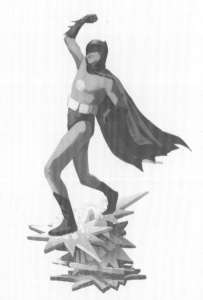

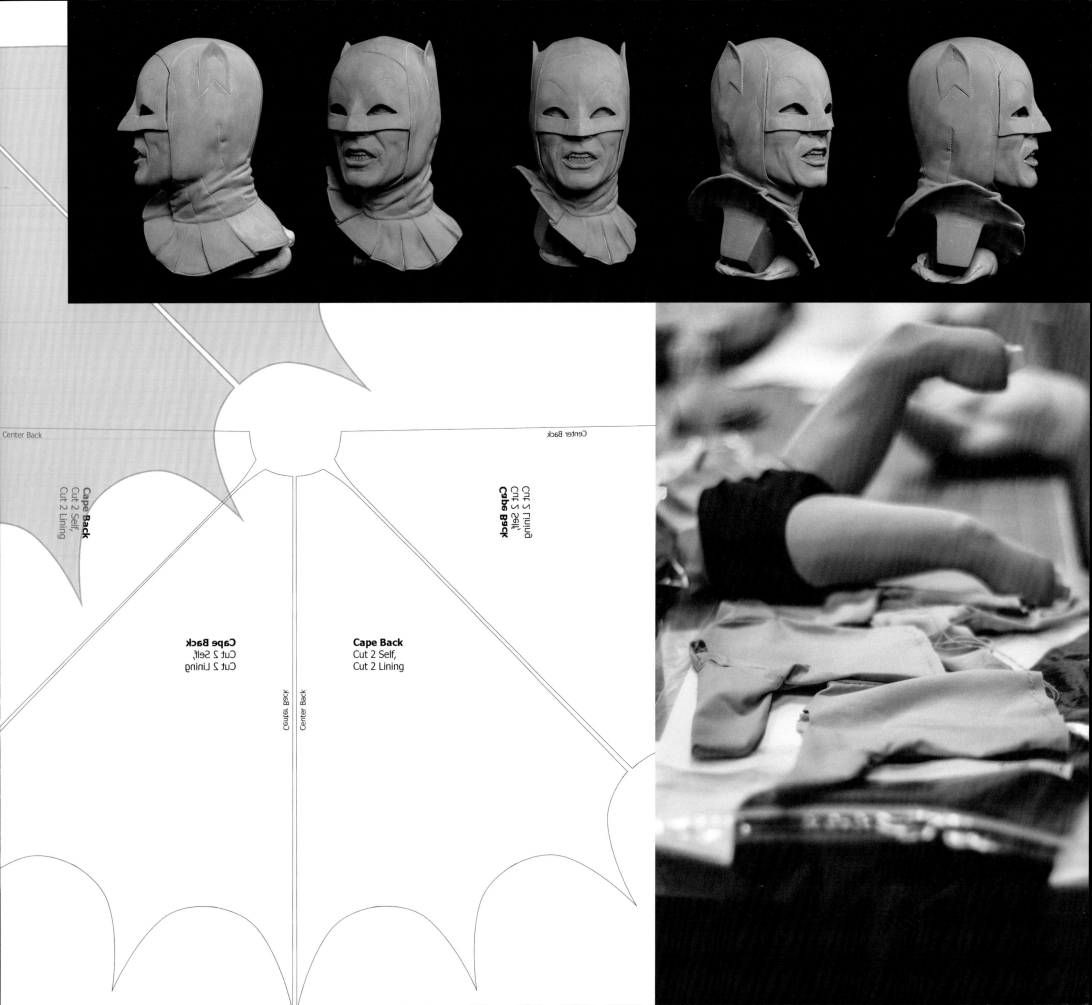

Cape Back
Cut 2 Self,
Cut 2 Lining

Center Back

Center Back

"I am in love with the fashion and aesthetic of this era. Julie Newmar in that sparkly suit and sexy kitten heels combined with that classic mod hairstyle is just eye candy. I kept the lighting simple and vintage-inspired, so no attention is taken away from the perfectly detailed statue."

—Jeannette Villarreal Hamilton, Photography Manager and Photographer

CATWOMAN
CLASSIC TV SERIES

From the moment she first slinked on-screen, Julie Newmar captivated audiences with her portrayal of Gotham City's favorite feline fatale, Catwoman. Although Batman tried in vain to guide her down the straight and narrow path, the thrill-seeking cat burglar could never fully give up her wicked ways.

This polystone piece crafted by Sideshow features details such as a show-accurate mask, gold cat medallion, fabric costume, and the stunning likeness of the legendary Julie Newmar.

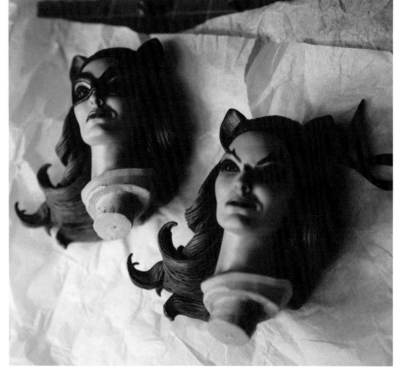

"It's always challenging to capture a real person's likeness," observes sculptor Mark Newman. "For me, capturing a female likeness is more difficult than a male likeness. Male faces are generally more angular and hard-edged, and easier to capture. There are subtleties in a female face that are sometimes hard to see that help define their unique look."

Newman continues, "I often search out online any caricature images of a famous person that have been done by other artists to help see what makes that person unique in their appearance. To see those exaggerated interpretations of someone's face really helps me narrow down their realistic look. It also helps me to see video of a person talking, acting, expressing emotions—to see what shapes the face makes when in action helps a lot to define their look and breathe a bit of life into a still sculpture."

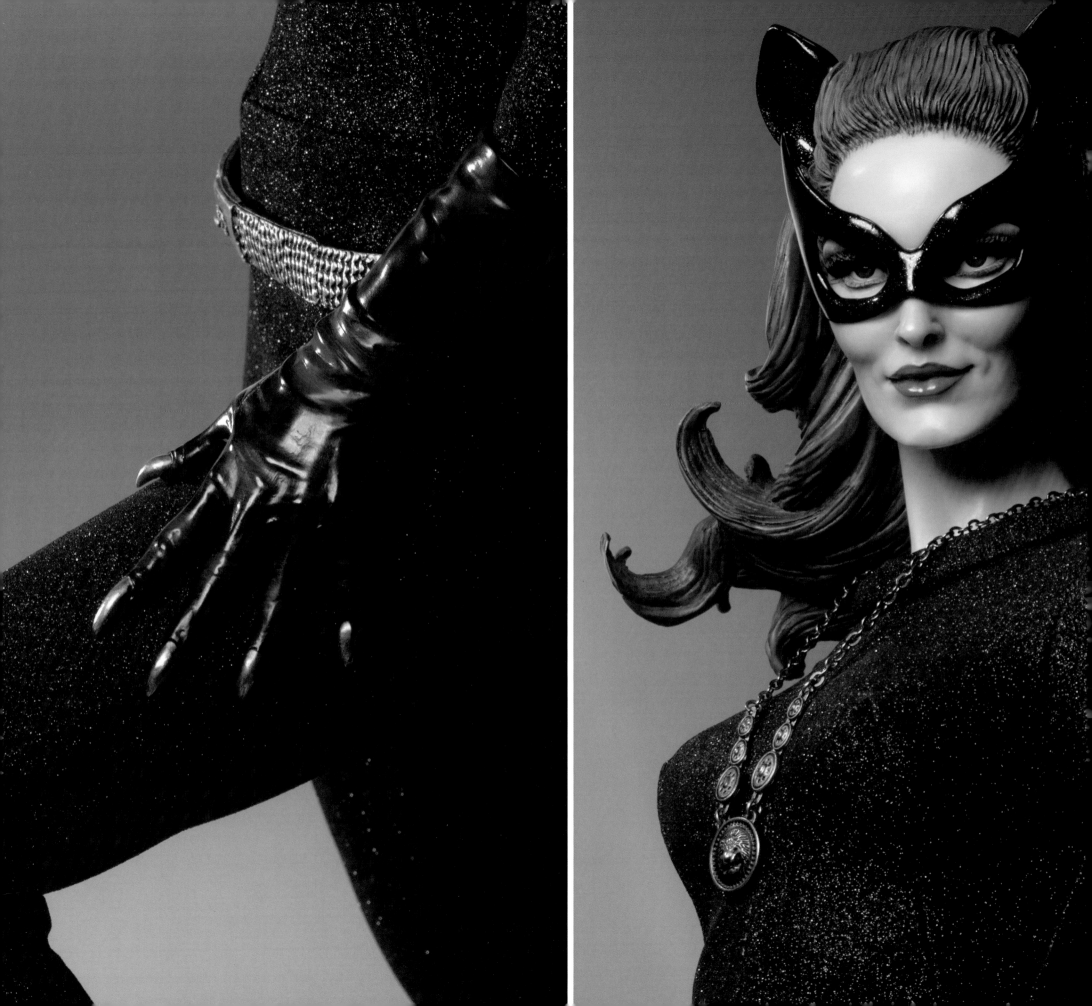

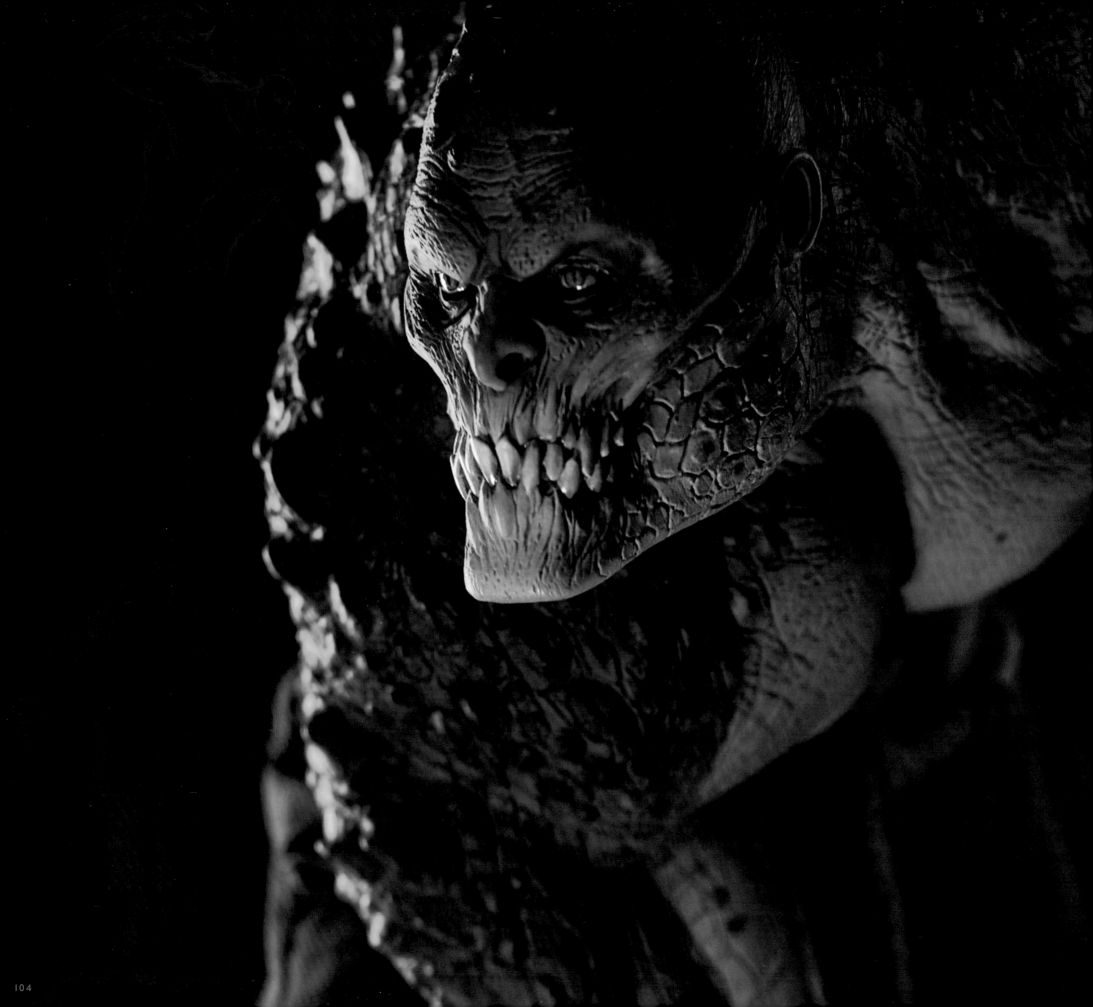

KILLER CROC

Killer Croc is what they called me! But someday, someday I knew they'd call me king! —Killer Croc, *Batman* #358 (April 1983)

Killer Croc might not be the brightest villain to ever grace the pages of DC Comics, but he is one of the toughest and most brutal. Born in bayou country with a genetic disorder that gave him a reptilian appearance and the strength and tenacity to match, Waylon Jones eventually made his way to Gotham City, where his condition continued to deteriorate. Killer Croc's body evolves to the point that it is no longer possible to tell where the man ends and the crocodile begins. His strength grows exponentially, as does his ferocity, making Killer Croc one of the deadliest Super Villains in Gotham City.

Just like Killer Croc himself, his Premium Format Figure is tough and durable—by design. Croc's leathery, textured skin evokes his reptilian namesake, and his tailored fabric pants are built to withstand a hard day's criminal activity. "We're always trying to consider these costumes for the long haul," says costume fabrication manager Tim Hanson. "It's absolutely possible, but not always necessary, to use the same or similar materials. Whether it's a fully poseable figure or statue, it all comes down to what serves each piece the best. With statues, the textiles essentially become part of the sculpture but still retain the wonderful aspect of having to be an art piece on their own, which had to be designed, tested, and created."

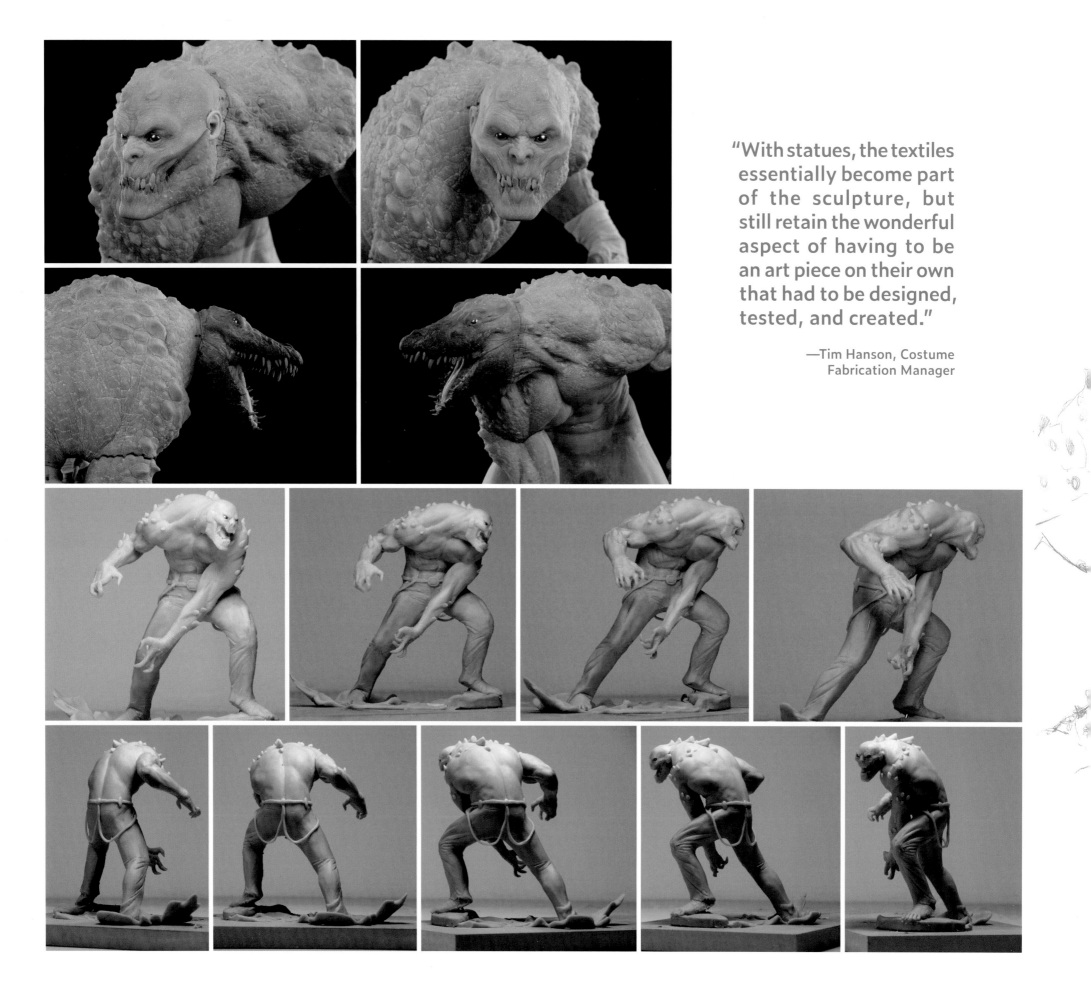

"With statues, the textiles essentially become part of the sculpture, but still retain the wonderful aspect of having to be an art piece on their own that had to be designed, tested, and created."

—Tim Hanson, Costume Fabrication Manager

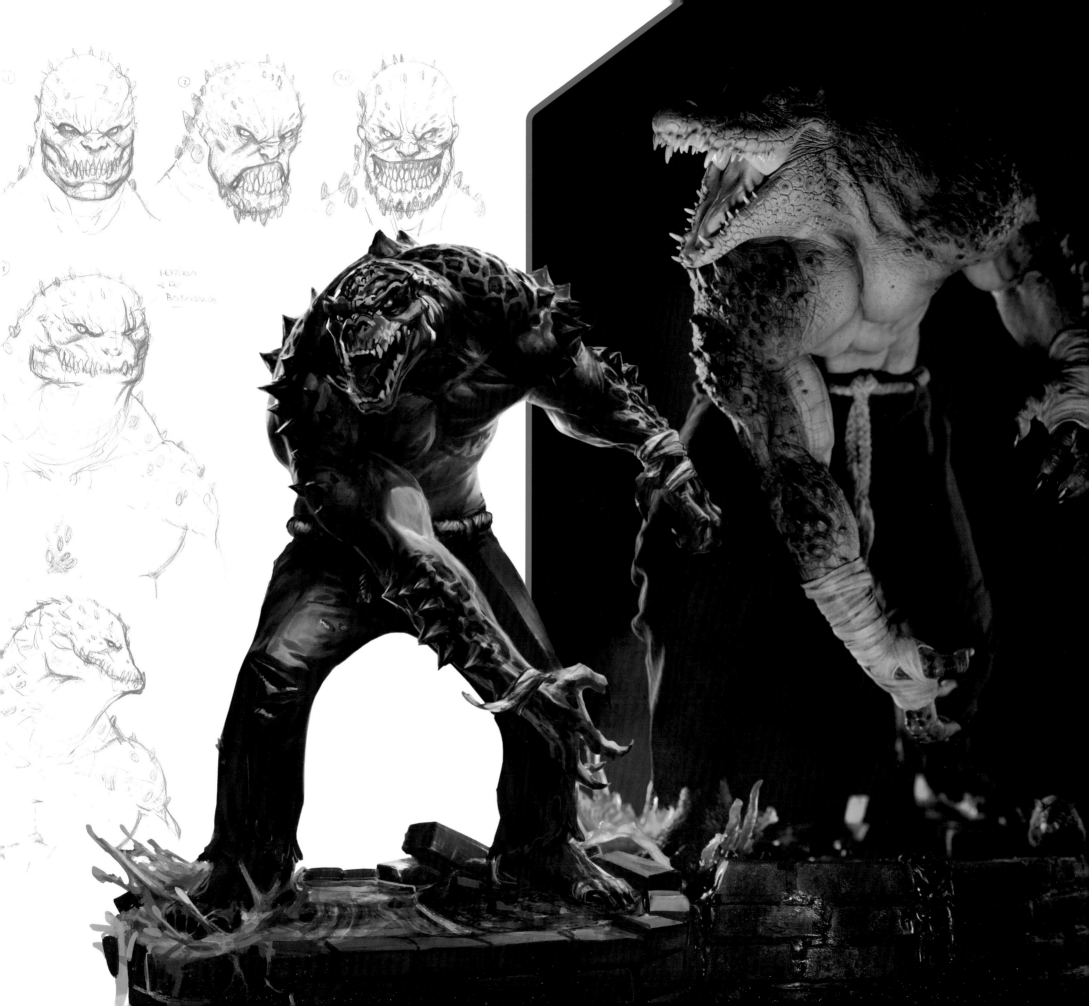

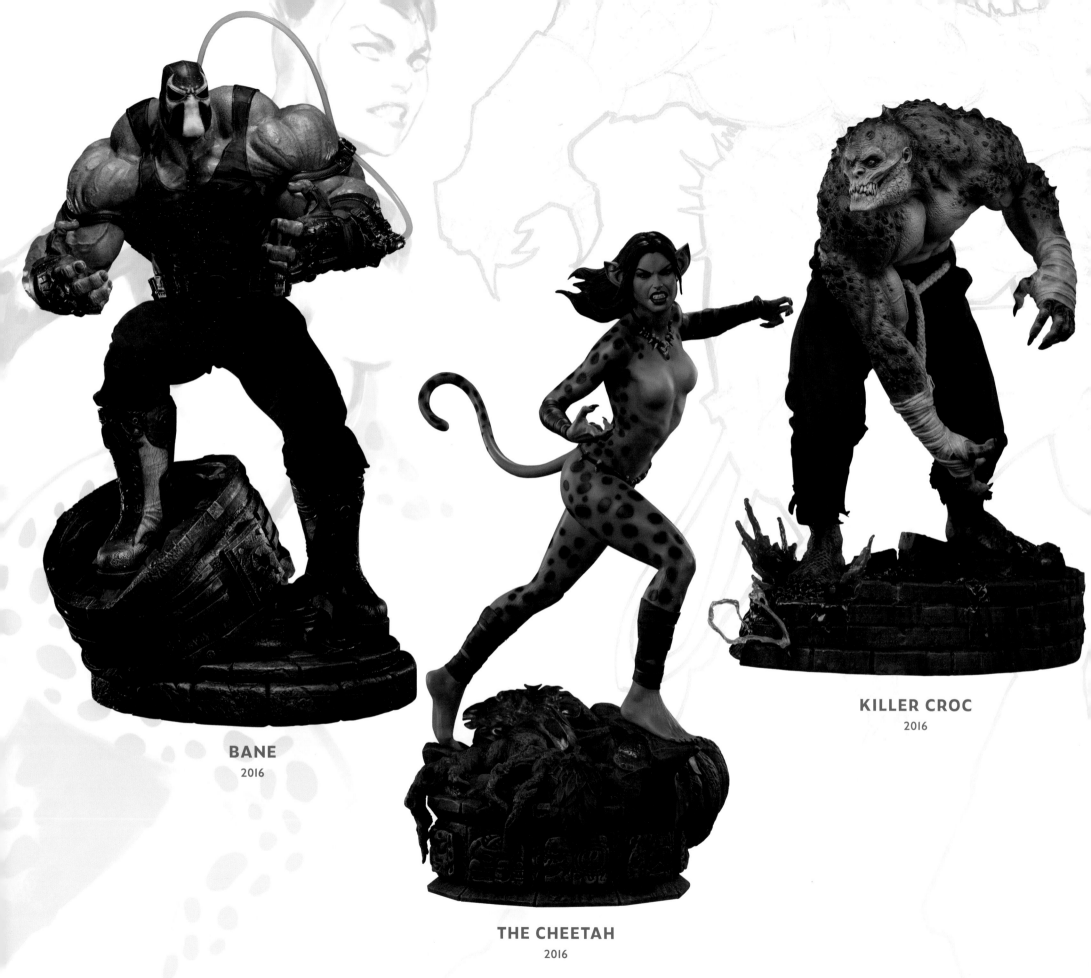

BANE

2016

THE CHEETAH

2016

KILLER CROC

2016

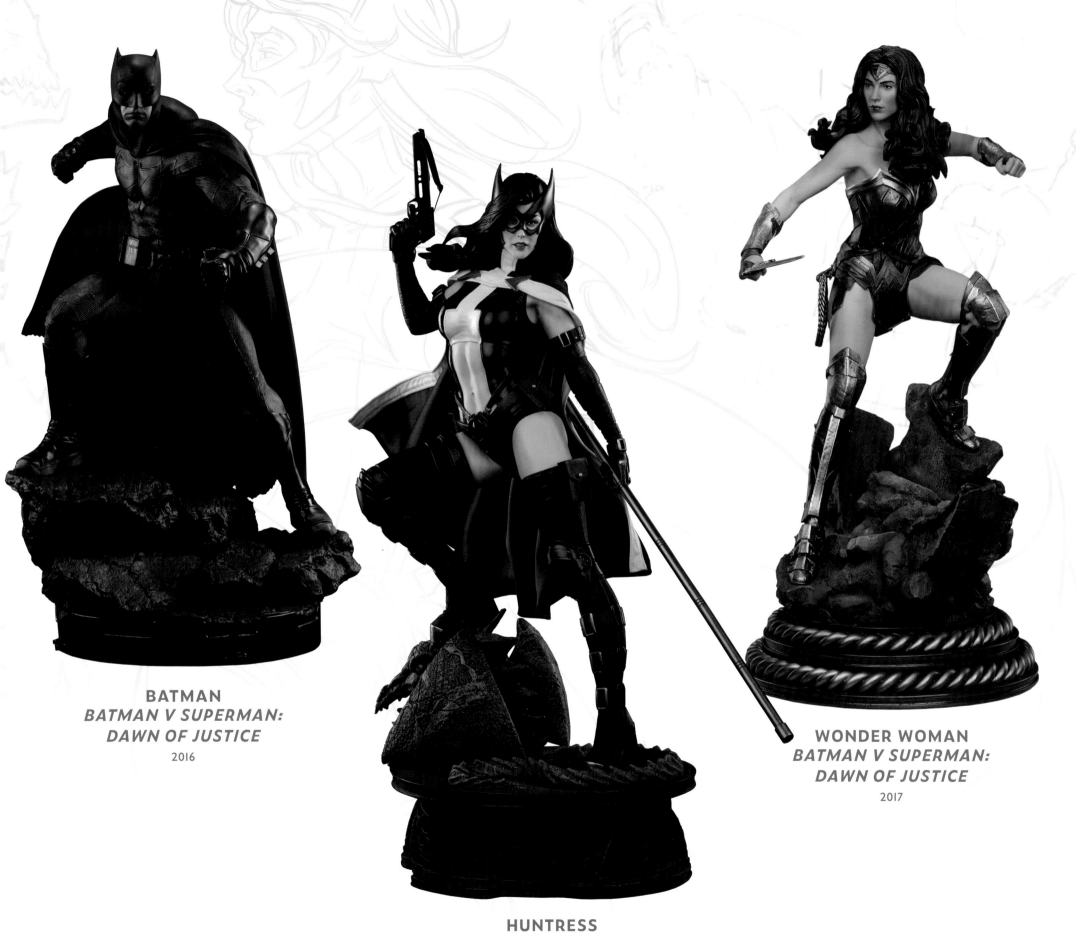

BATMAN
BATMAN V SUPERMAN:
DAWN OF JUSTICE
2016

HUNTRESS
2016

WONDER WOMAN
BATMAN V SUPERMAN:
DAWN OF JUSTICE
2017

ZATANNA

I'm not saying you can't be anything you want to be. But the whole Super Hero thing is much more than just wearing a cape and getting famous. —Zatanna, Seven Soldiers: Zatanna #2 (August 2005)

Zatanna is one of the world's most celebrated stage magicians—but unbeknownst to the general public, the Mistress of Magic is one of the most powerful sorcerers in the DC multiverse. Utilizing the skills and backward-spoken spells she learned from her father, the Golden Age magician Zatara, the talented Zatanna uses her magical abilities to protect the innocent and safeguard the world from mystical menaces alongside the World's Greatest Super Heroes.

The intelligent, confident Zatanna battles the forces of evil decked out in her iconic stage outfit, with her modified tuxedo jacket, high heels, and trademark fishnet stockings. Her knowing look and sleek black top hat draw the eye as the mistress of misdirection reveals that she has more than a few tricks up her sleeve—literally!

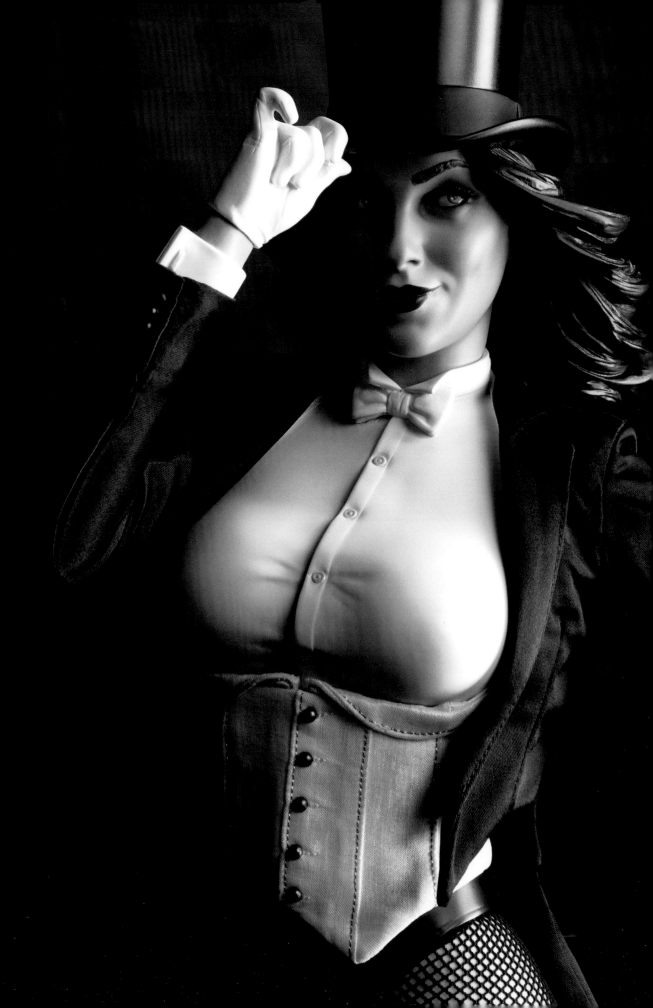

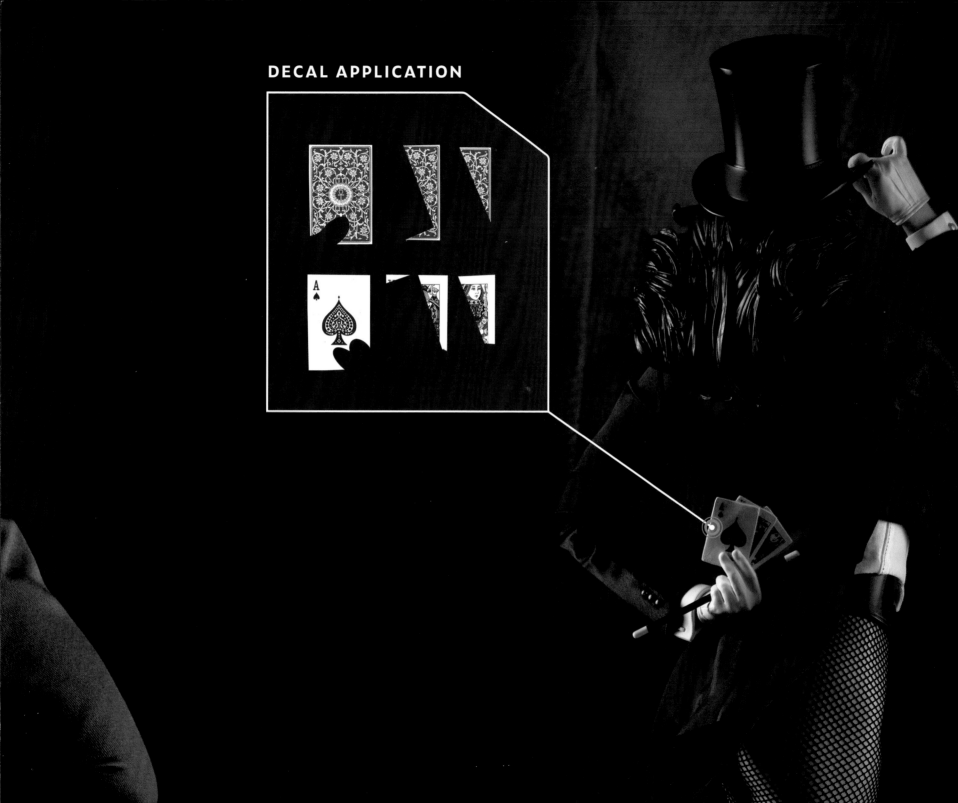

DECAL APPLICATION

RIGHT SLEEVE CAP PLACEMENT

SHOULDER

JACKET BACK RIGHT

JACKET FRONT RIGHT

LAPEL ROLL LINE

SIDE SEAM

SEAM

WAIST

SHOULDER PAD LEFT (TOP LAYER)

BACK

FRONT

JACKET SLEEVE LEFT

FRONT SEAM

BACK SEAM

HEM (FOLD)

(SELF-FAC

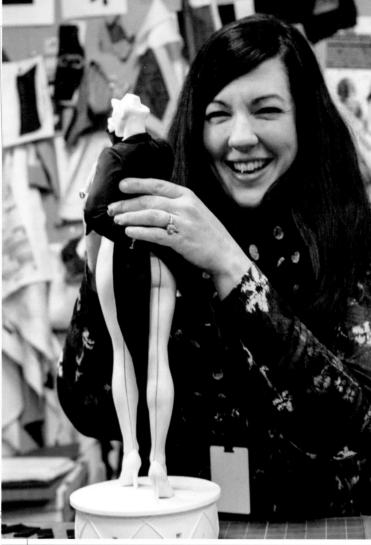

Capturing Zatanna's classic stage outfit was no easy task, but costume fabricator Esther Skandunas worked her own magic on this Premium Format Figure. "I create costumes for our figures completely from scratch," says Skandunas. "Most of our characters are posed as if their image was captured in a moment in time, like a snapshot, so there is a sense of movement to their pose. This means that when I create the patterns for the garments, I need to accommodate for the action that they are in, and it's quite a fun challenge. Zatanna is posed with her arms bent, so I had to approach each arm in the pattern process completely differently from the other in order to fit the pose correctly."

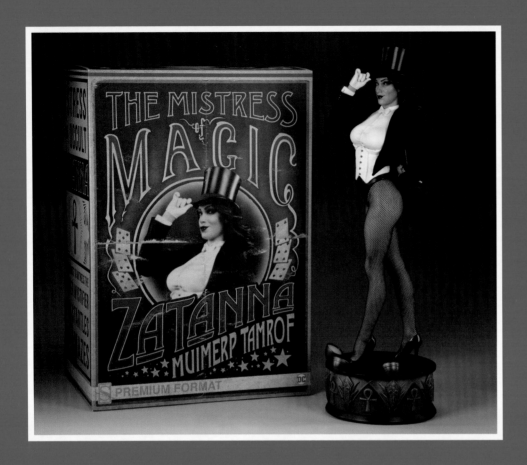

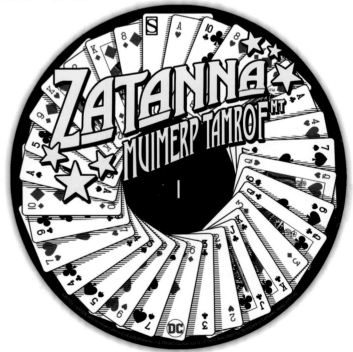

PACKAGING

Designer Margaux Piñero is proud of the care and effort that Sideshow puts into each and every one of its packages. "The philosophy behind our packaging is to enhance the product inside it," says Piñero. "We want to give our fans a memorable experience as soon as they open the shipping carton. The best compliment I have heard from collectors is that they are running out of space trying to find places to display both the piece and its box. It's really nice to know that tour fans see the packaging just as collectible as the figure it holds."

Katie Simpson, who designed Zatanna's packaging, drew inspiration from DC comic books when determining her approach to the Mistress of Magic. "When I was first researching Zatanna, I came across a comic book cover that was in the style of a classic magic poster, and I loved the aged look it had. Once I saw the cover, I knew that was the direction I wanted to go in for this package. I then referenced a lot of classic Harry Houdini magic posters, along with other classic posters, for this packaging. One of my favorite aspects of this package is the hidden message on the top flap that says, 'esaeleR em morf siht xob,' which is 'Release me from this box' spelled backward."

BOX THIS FROM ME ELSEWHERE

THE AMAZING
ZATANNA

MISTRESS
OF THE OCCULT
ZATANNA

YOUR CHANCE TO WITNESS THE
MASTER MYSTIFIER
WHO STARTLES
AND **AMAZES**

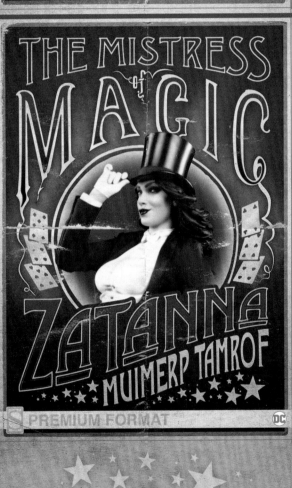

THE MISTRESS
of
MAGIC
ZATANNA
MUIMERP TAMROF

PREMIUM FORMAT

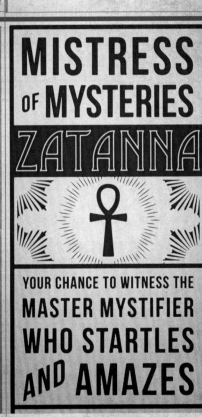

MISTRESS
OF MYSTERIES
ZATANNA

YOUR CHANCE TO WITNESS THE
MASTER MYSTIFIER
WHO STARTLES
AND **AMAZES**

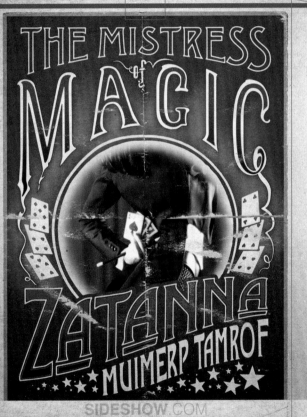

THE MISTRESS
of
MAGIC
ZATANNA
MUIMERP TAMROF

SIDESHOW.COM

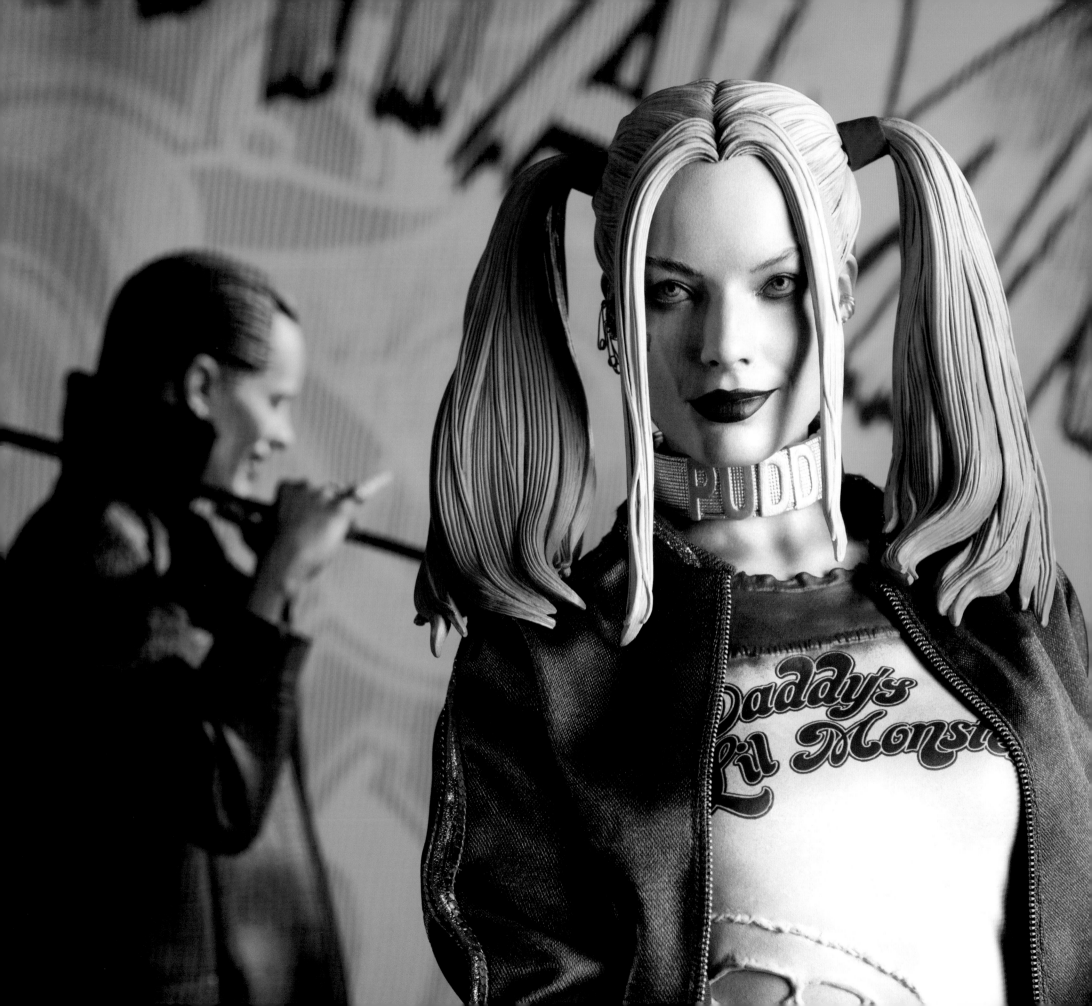

HARLEY QUINN
SUICIDE SQUAD

Normal's a setting on the dryer. People like us, we don't get normal! —Harley Quinn, *Suicide Squad* (2016)

Decked out in her *Suicide Squad* fighting gear, this bold reinvention of the Maid of Mischief has Harley Quinn ready for fun and more than her share of gratuitous violence.

Painstakingly crafted by Sideshow, this Premium Format Figure captures actress Margot Robbie's now-iconic performance as Daddy's Little Monster, the mischievous misfit who braves even the deadliest mission with a smile on her face, a song in her heart, and a weapon in her hand.

Costume fabricator Esther Skandunas was tasked with bringing Robbie's signature *Suicide Squad* costume from the screen to Premium Format, and was more than up to the challenge. "When adapting a costume that has been on film or TV, my goal is to create a garment that looks as close to the full-size garment as possible," says Skandunas. "To accomplish this, I have to make sure that the color, texture, and weight of the fabrics look correct. I cannot use the actual fabrics that were used on set. I have to use fabrics that translate well to a smaller scale. The fabrics I use are very fine and thin. If the fabrics get too heavy or have too much texture or weight, the illusion of being a shrunken down version of the costume is broken. The garments can end up looking like doll clothes rather than actual replicas."

Attention to detail is crucial to this kind of figure, according to Skandunas. "Another important aspect to getting the correct look of scale is the clothing embellishments and accessories, such as the chain on Harley's jacket sleeves."

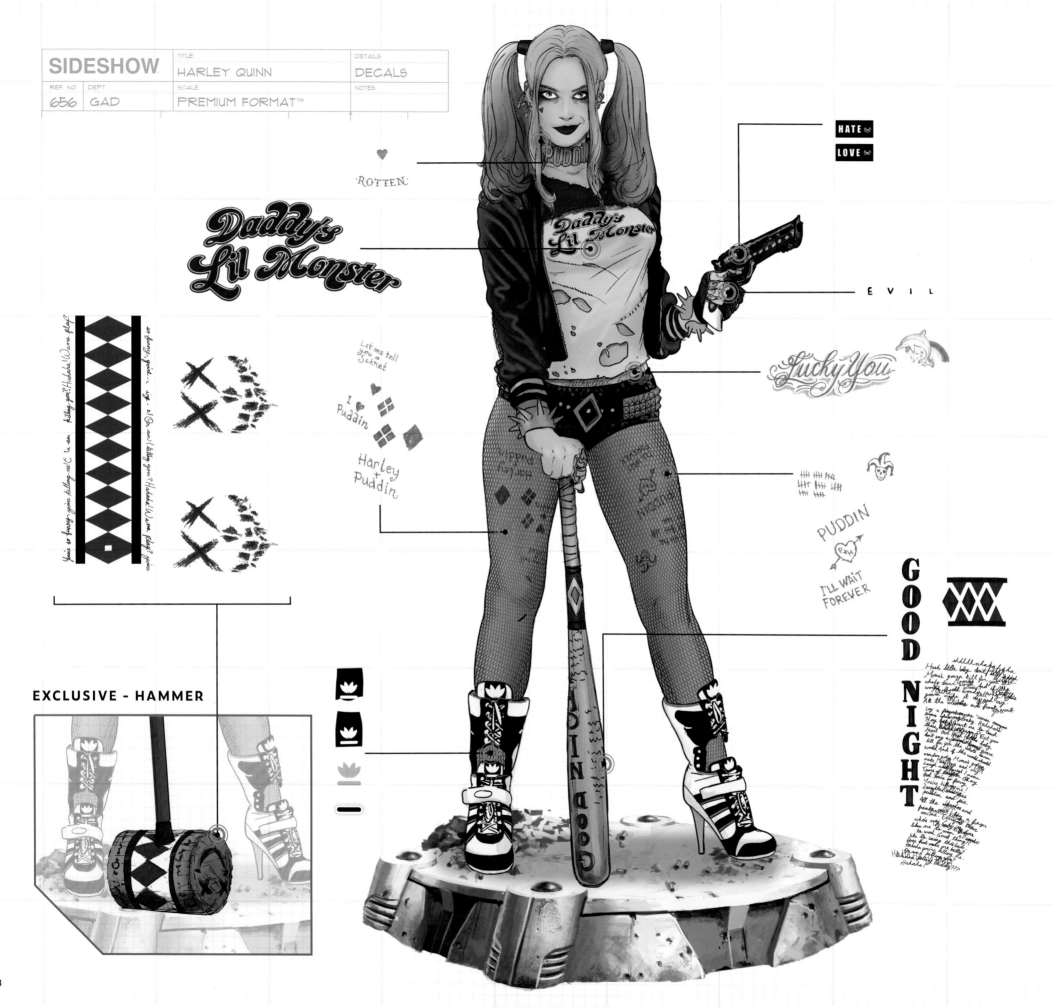

LEFT
JACKET BACK
(BLUE)

ARMSEYE

CENTER BACK

SIDE SEAM

GATHER

RIGHT
JACKET BACK
(RED)

CENTER BACK

ARMSEYE

SIDE SEAM

GATHER

LEFT SLEEVE
FRONT
(BLUE)

SLEEVE SIDE FRONT SEAM

UNDER ARM / SIDE SEAM

ARMSEYE

GATHER

WAIST BAND
FRONT
(SATIN)
(FOLD)

SIDE FRONT

< 1 RED,
1 BLUE

*Property
of
Joker*
— established —

since ◆ 4ever

PUDDIN
FREAKY
stylie

WRISTBAND
(FOLD)

COLLAR

NECK

CENTER BACK

(FOLD)

(LEFT)

(RIGHT)

SLEEVE SIDE BACK SEAM

RIGHT
JACKET FRONT
(RED)

SHOULDER
NECK

ARMSEYE

CENTER FRONT

SIDE SEAM

POCKET PLACEMENT

GATHER

LEFT
JACKET FRONT
(BLUE)

NECK
SHOULDER

CENTER FRONT

ARMSEYE

SIDE SEAM

POCKET PLACEMENT

GATHER

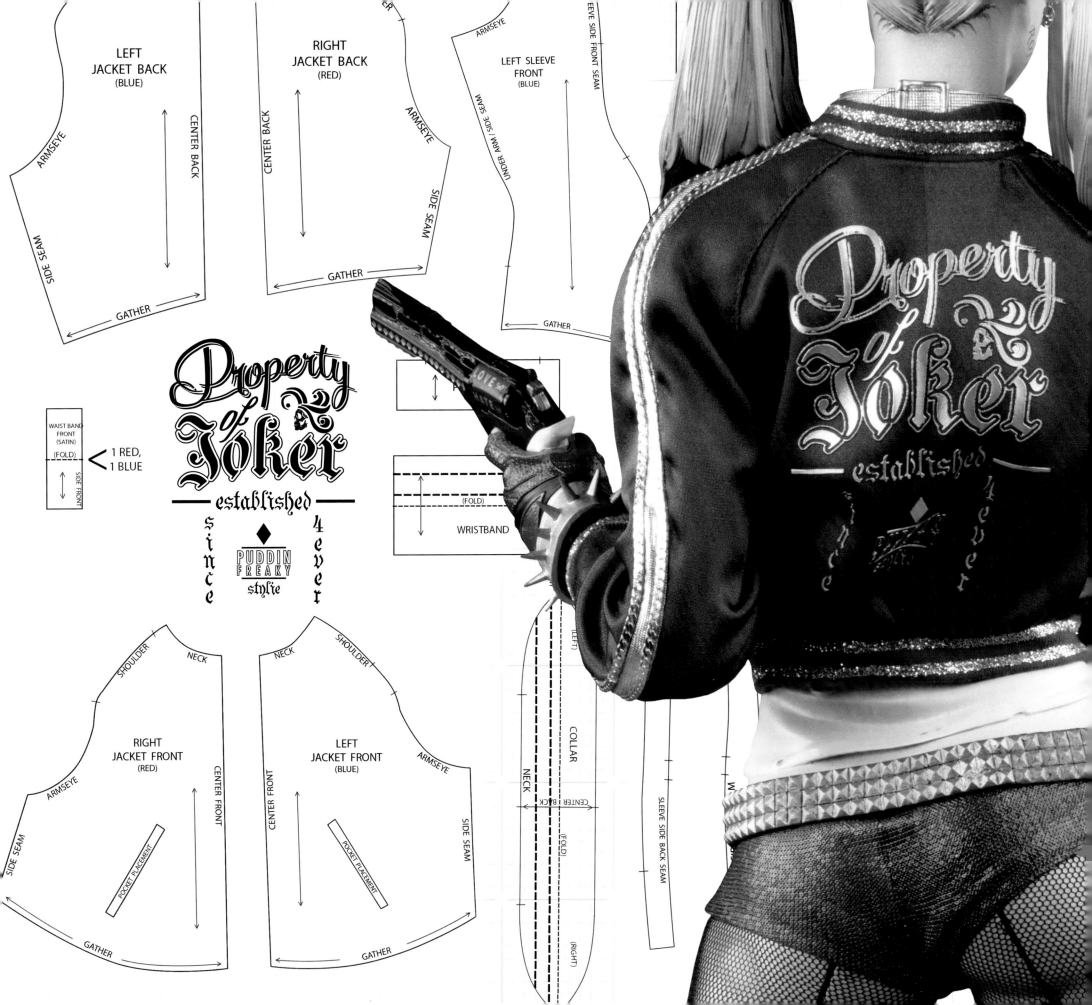

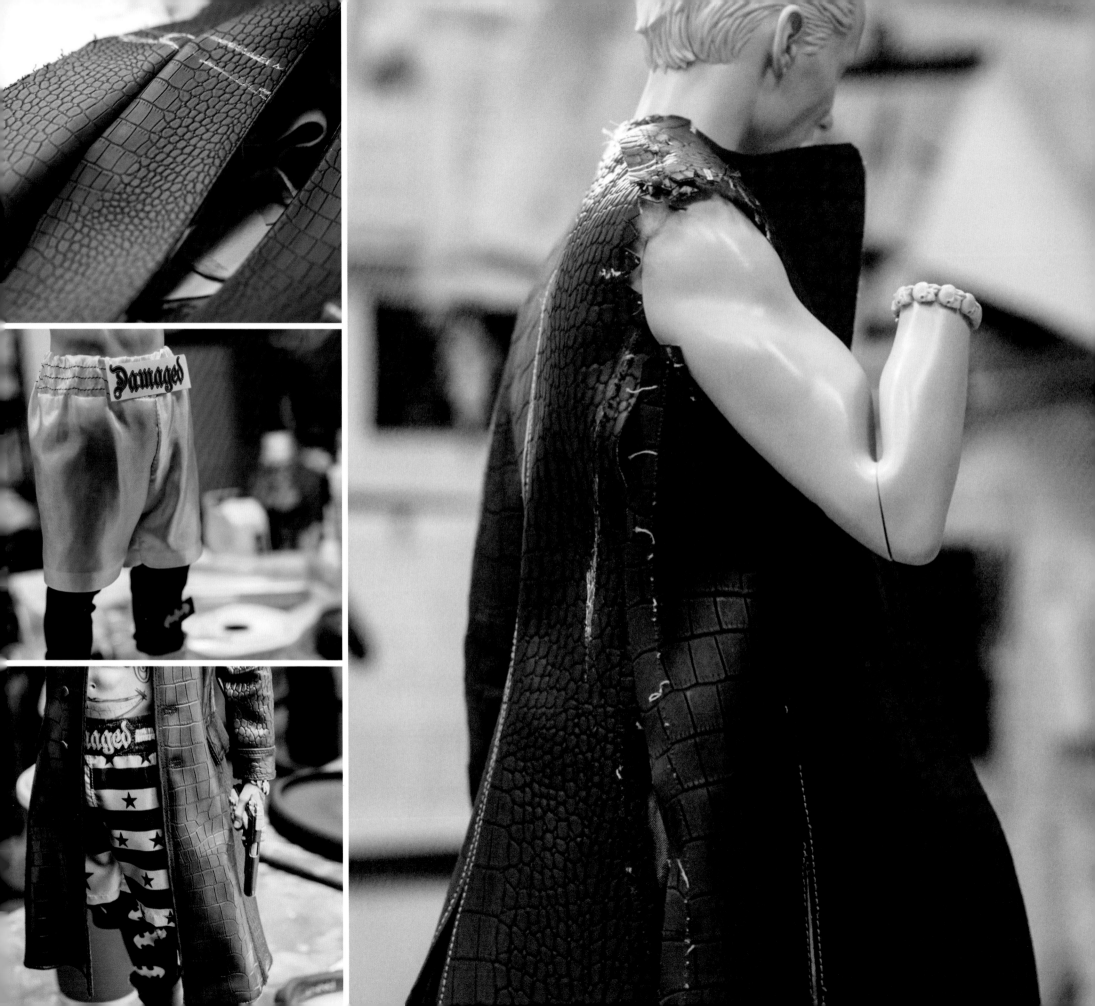

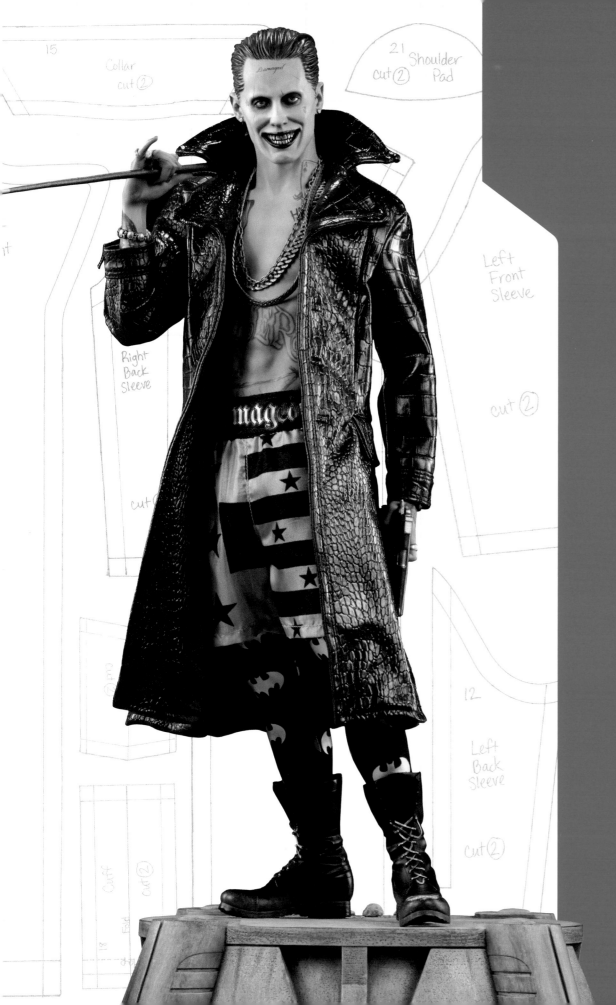

THE JOKER
SUICIDE SQUAD

If you weren't so crazy, I'd think you were insane.
—The Joker, *Suicide Squad* (2016)

Suicide Squad brought us a version of The Joker unlike any we'd ever seen before, thanks to Jared Leto's memorable, maniacal performance and a radical reimagining of the Clown Prince of Crime as Gotham City's undisputed criminal kingpin.

Decked out with flair from head to toe, Sideshow's Premium Format Figure is a master class in detail, with every ring, chain, grill, and tattoo meticulously crafted straight from The Joker's on-screen appearance. The mixed-media elements include a stunning purple faux-alligator coat, purple-and-gold fabric boxers, and just for kicks, a pair of Batman-themed leggings.

Adapting a life-size movie costume to the Premium Format Figure scale represents some special challenges, according to costume fabrication manager Tim Hanson. "Our *Suicide Squad* Joker was particularly interesting as far as that's concerned," he observes. "After an unsuccessful search for the jacket material, we decided to just make it ourselves. I mean, what the hell could be so difficult about finding a pearlescent purple crocodile-skin fabric light enough to work as a miniature jacket? So our Graphic Arts Department, affectionately called the GAD, generated the pattern digitally, then we did several screen print tests on multiple fabrics."

"The crazy thing was, one of our production facilities actually found some very similar fabric overseas, but it was much heavier than we'd normally use in production," Hanson continues. "As a result, there were constant tweaks, pattern alterations, fittings. At this level of costuming, small changes make noticeable differences. It was quite a feat to work out everything on the figure, from the chains around his neck, his jacket, the shorts, and tights. Every layer was customized."

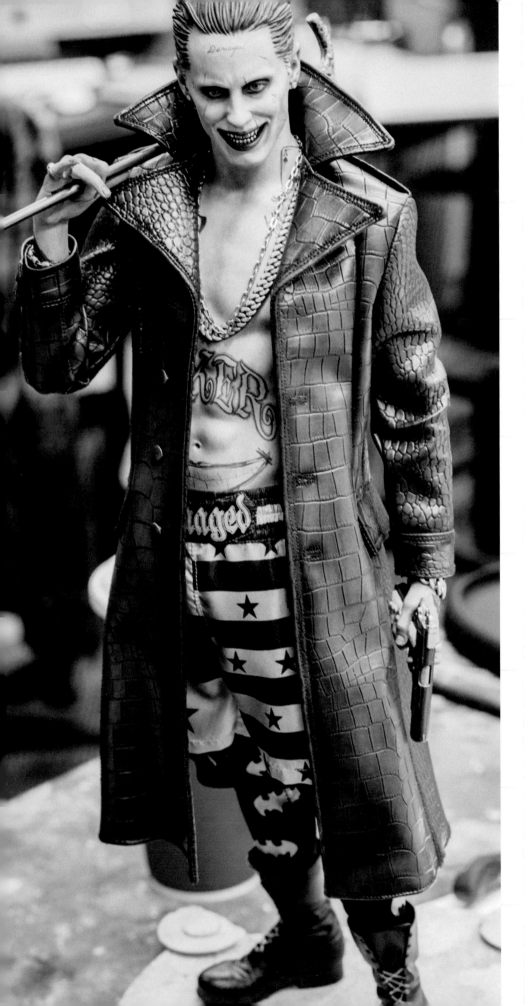

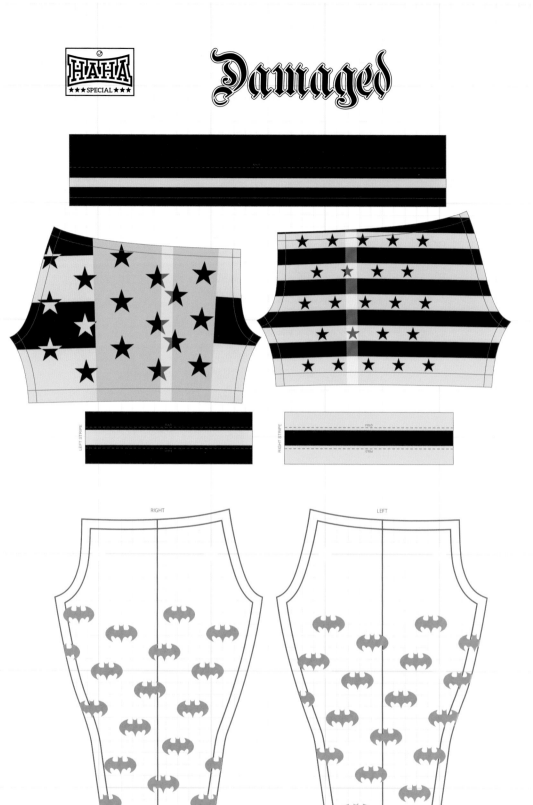

Damaged

HAHA ★★★ SPECIAL ★★★

SIDESHOW.	TITLE		DETAILS	
	THE JOKER		CUT &SEW	
REF. NO.	DEPT.	SCALE	NOTES	
657	CUT &SEW / GAD	PREMIUM FORMAT™		

LEFT STRIPE

RIGHT STRIPE

FOLD

RIGHT LEFT

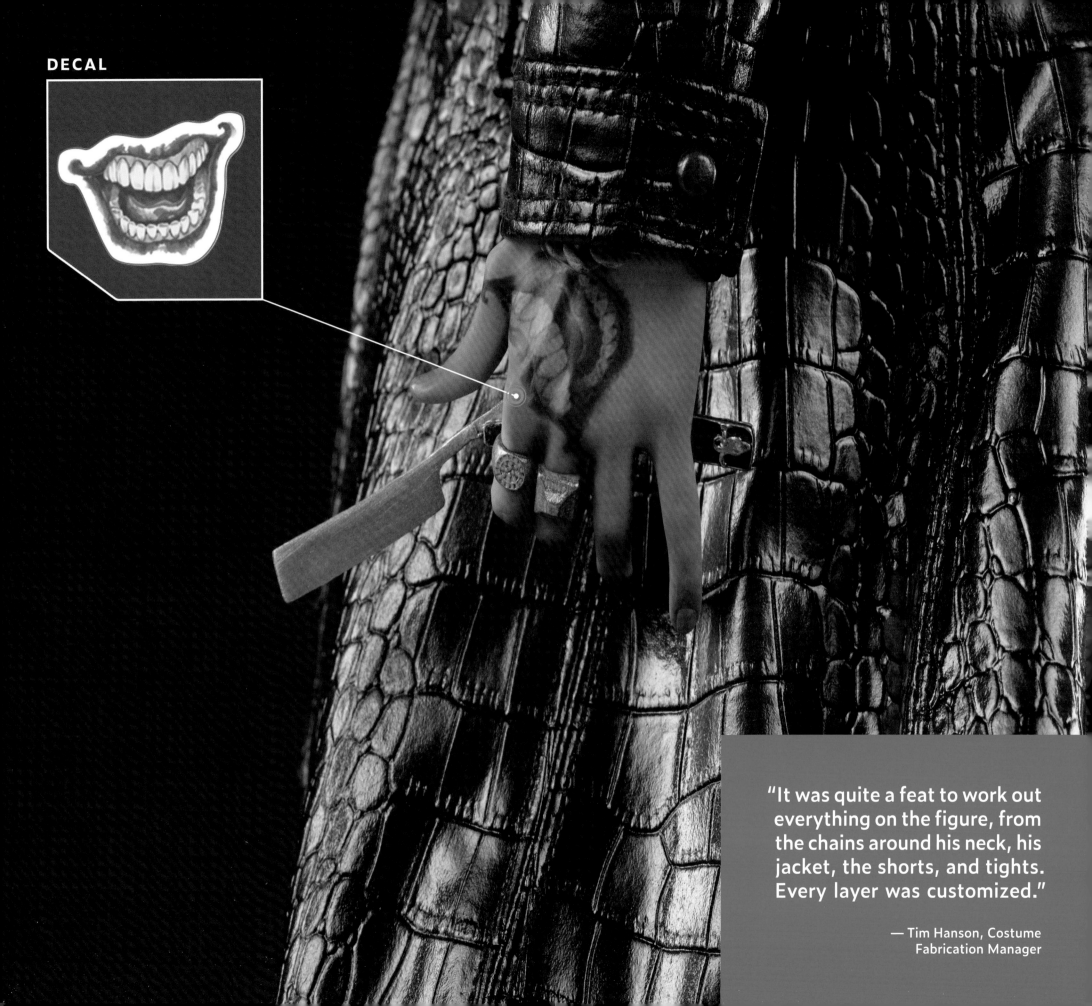

DECAL

"It was quite a feat to work out everything on the figure, from the chains around his neck, his jacket, the shorts, and tights. Every layer was customized."

— Tim Hanson, Costume Fabrication Manager

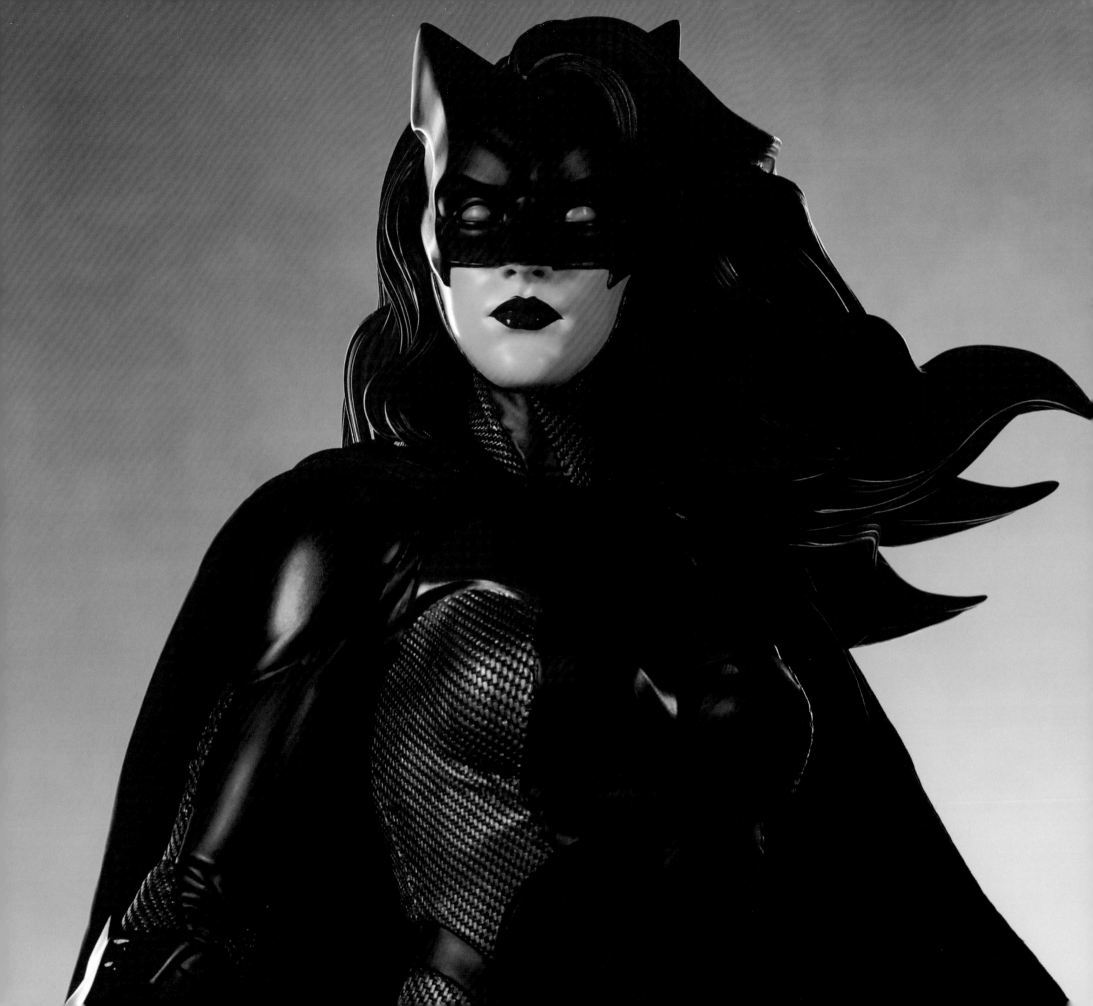

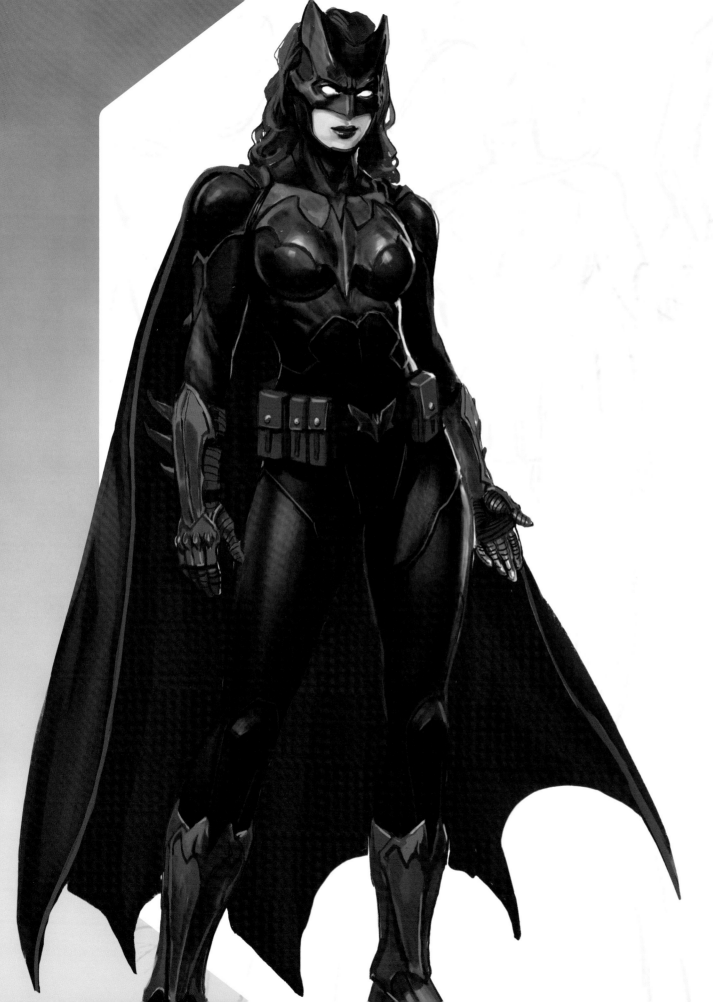

BATWOMAN

New age of crime, meet new age of crime fighter. —Batwoman, *Batman and Robin*, #9 (April 2010)

After a chance encounter with the Dark Knight, heiress Kate Kane decided to use her military training, athletic ability, keen tactical mind, and vast fortune to bring her own brand of justice to the streets of Gotham City. Inspired by, but not beholden to, her famous cousin, Bruce Wayne, Kane reinvents herself as Batwoman, a new crime fighter for a new age of crime. Cloaked in darkness while striving to bring light to Gotham City, Batwoman is truly a force to be reckoned with.

The Batwoman Premium Format Figure brings the bold visuals of the DC icon to life, with a striking red-and-black costume that mixes military grade armor and weaponry into its sleek design. Kane's pale skin enhances the stark contrast and bold graphic design of this highly detailed piece, equipped with a Utility Belt, boots, gloves, gauntlets, and a grappling hook, all in her signature style. Batwoman also sports a tailored fabric cape with a black exterior and red inner lining, and wiring to allow custom cape poses when displaying the piece.

Batwoman's sculpted suit has unique textures and detailing to reflect the reinforcement of her armor, which is emblazoned with a vibrant red bat-symbol on the chest. Her strange, almost supernatural, appearance strikes fear into the hearts of evildoers.

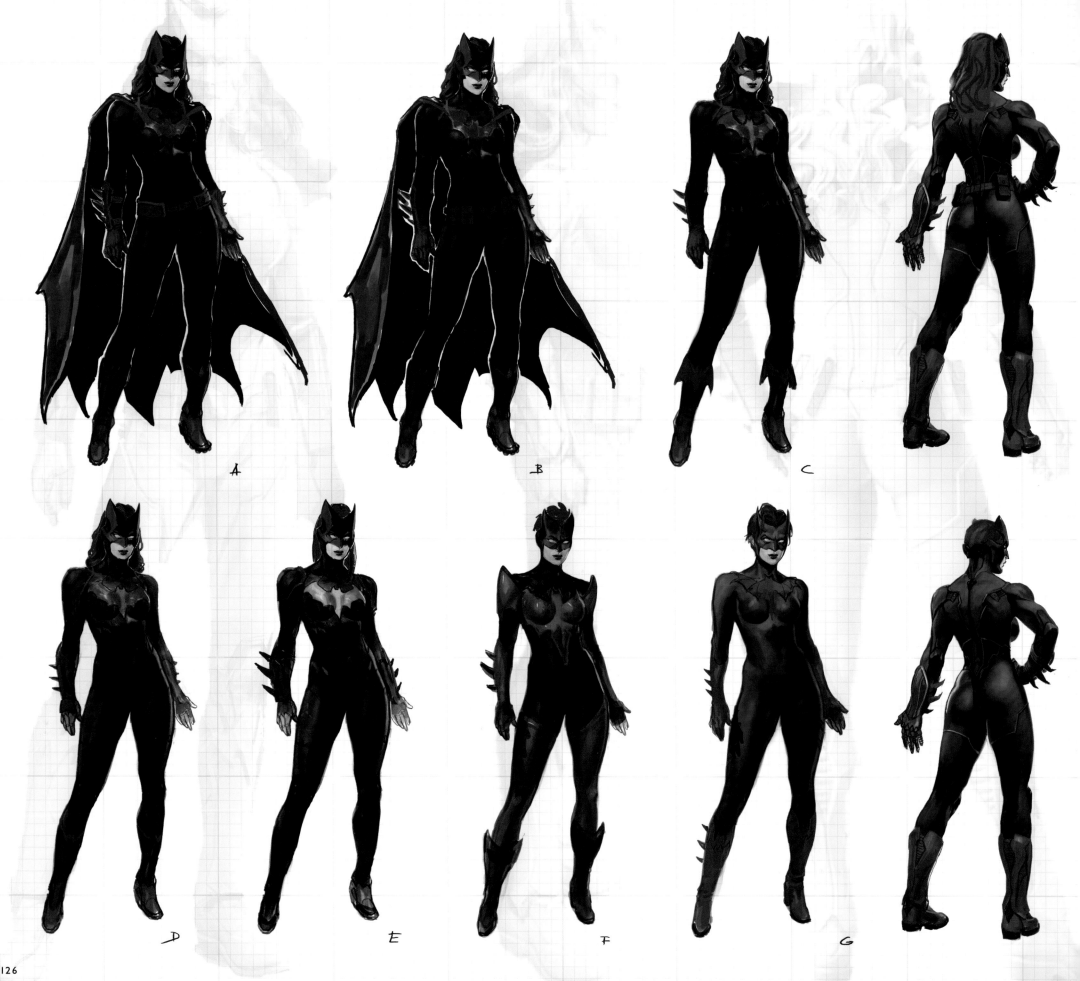

A

B

C

D

E

F

G

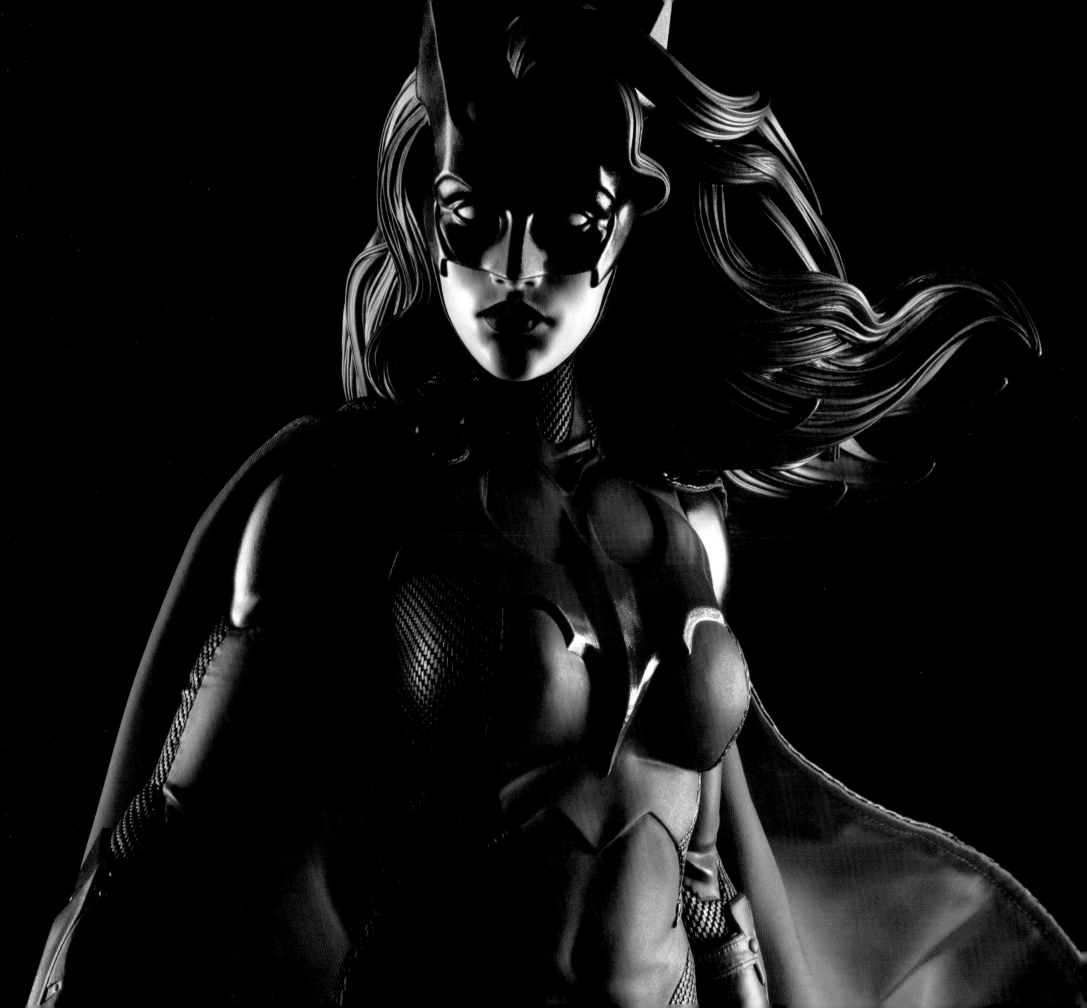

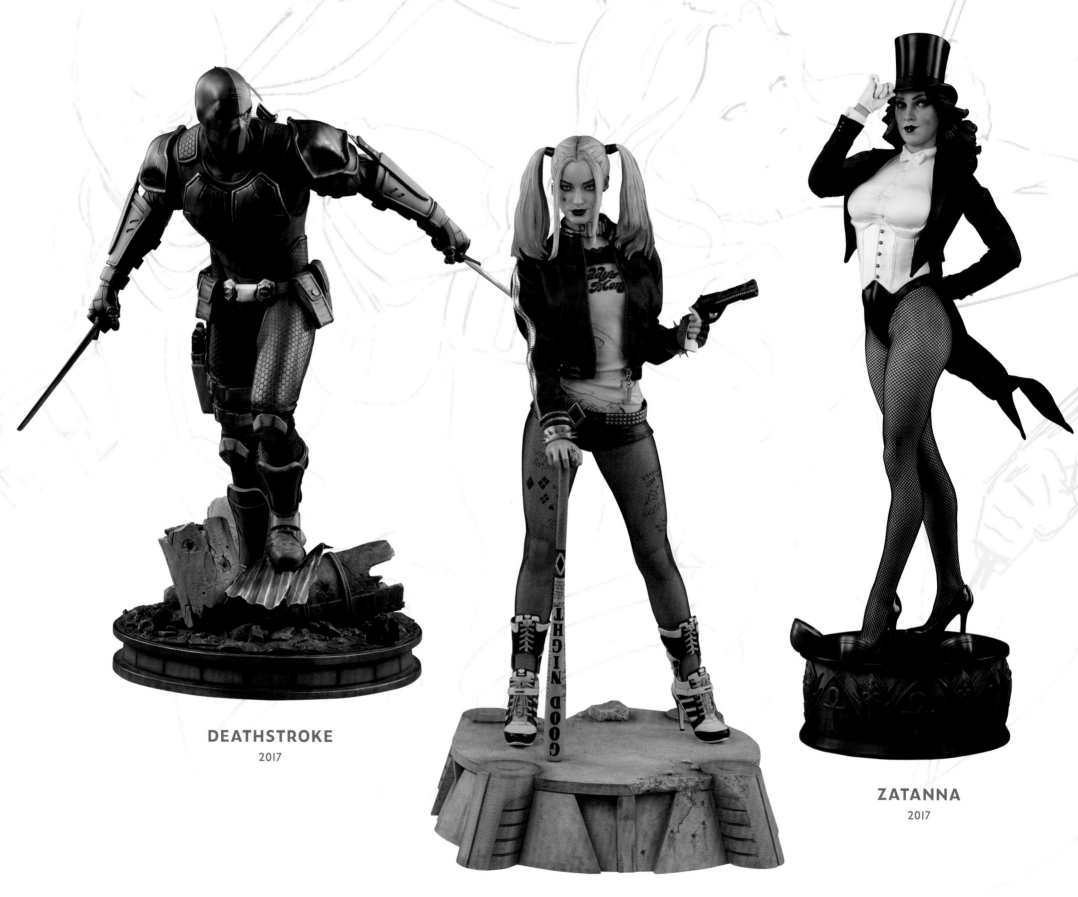

DEATHSTROKE
2017

HARLEY QUINN
SUICIDE SQUAD
2017

ZATANNA
2017

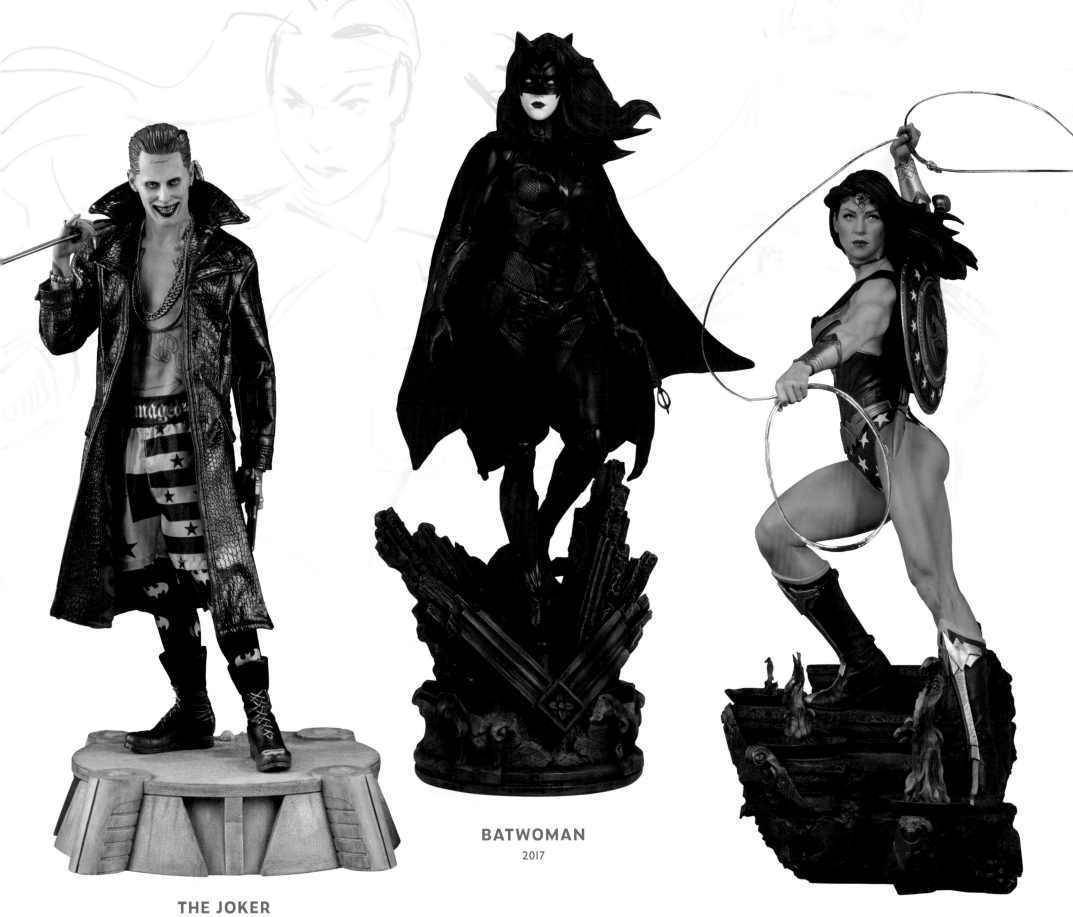

THE JOKER
SUICIDE SQUAD
2017

BATWOMAN
2017

WONDER WOMAN
2018

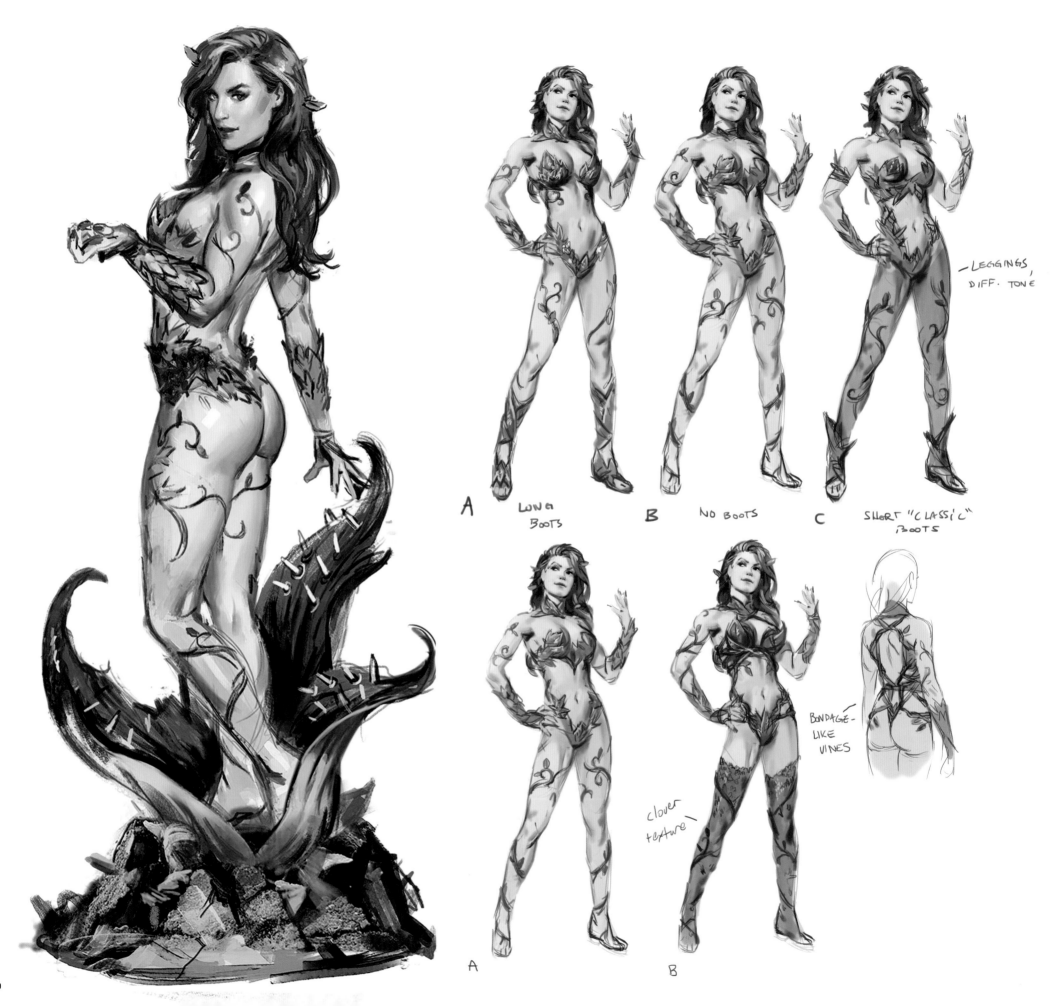

LEGGINGS,
DIFF. TONE

A LONG
 BOOTS

B NO BOOTS

C SHORT "CLASSIC"
 BOOTS

clover
texture!

A

B

BONDAGE-
LIKE
VINES

130

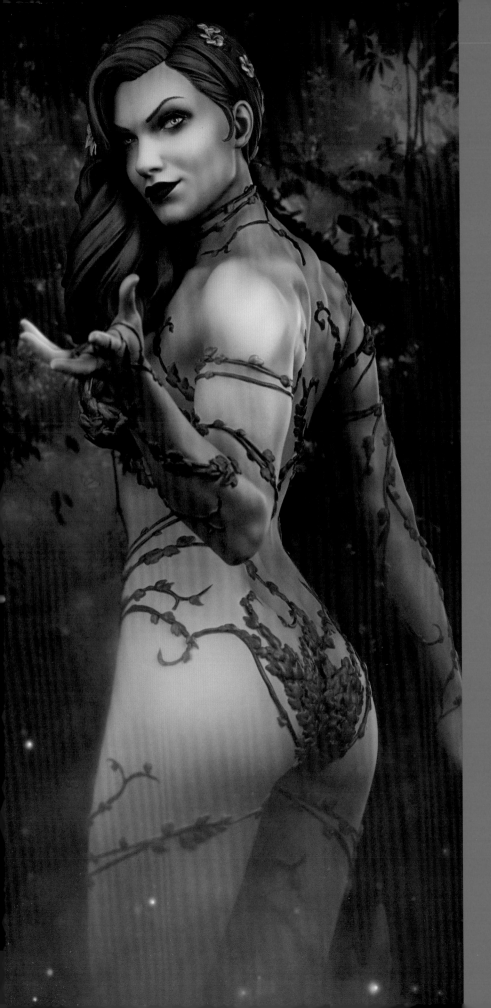

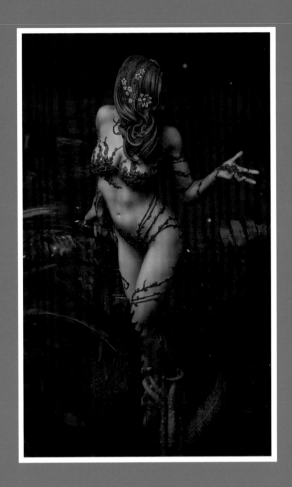

POISON IVY

If you are strong enough, you will survive. That is the law of the jungle.
—Poison Ivy, *Batgirl* #52 (July 2004)

Innovative, radical botanical biochemist Pamela Isley took her environmental activism to the extreme as she reinvented herself as Poison Ivy, a beautiful but deadly ecoterrorist, and one of the most dangerous foes in the DC multiverse. Through radical experimentation, Ivy has granted herself the ability to control both plant life and humans through her feminine wiles and mesmerizing pheromones. Her natural immunity to poisons and toxins has gifted Poison Ivy with a lethal touch—and kiss, as many an unsuspecting victim has discovered. A self-appointed defender of the environment, Poison Ivy sees herself not as a villain, but as an ecological warrior fighting to save the world from itself.

The Poison Ivy Premium Format Figure emerges from a carnivorous plant with monstrous roots bursting from the earth below; its purple petals open to reveal the toxic temptress. The stunning polystone sculpture is exquisitely detailed, as intricate vines and leaves spread across Ivy's figure to form her signature costume. Kat Sapene's spectacular painting strikes a bold contrast between Ivy's cool green skin and her fiery red hair dotted with purple blossoms—reminding her victims that the prettiest flowers can be the most poisonous.

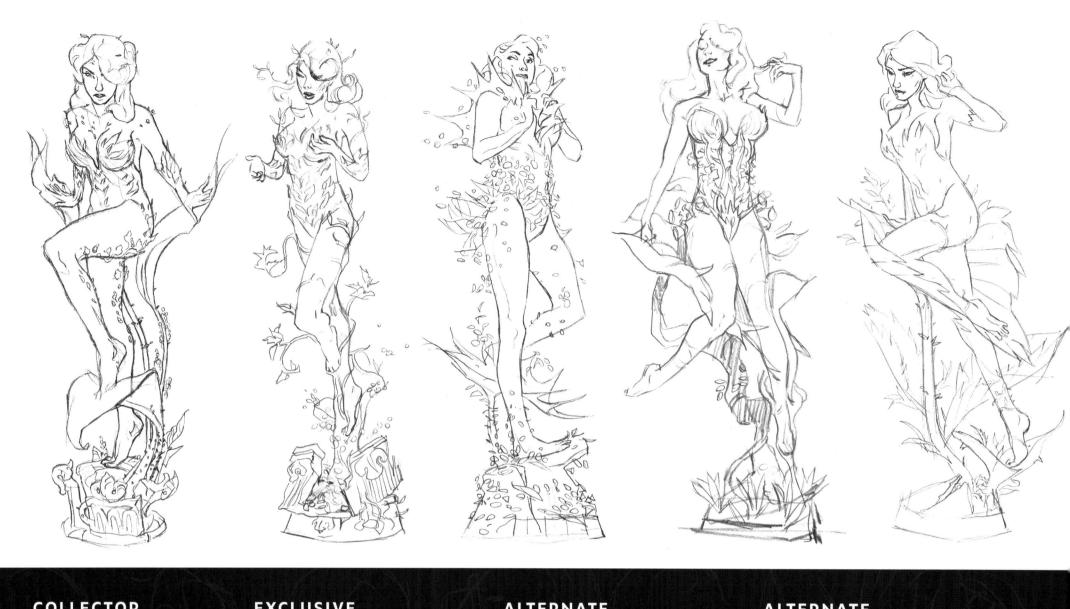

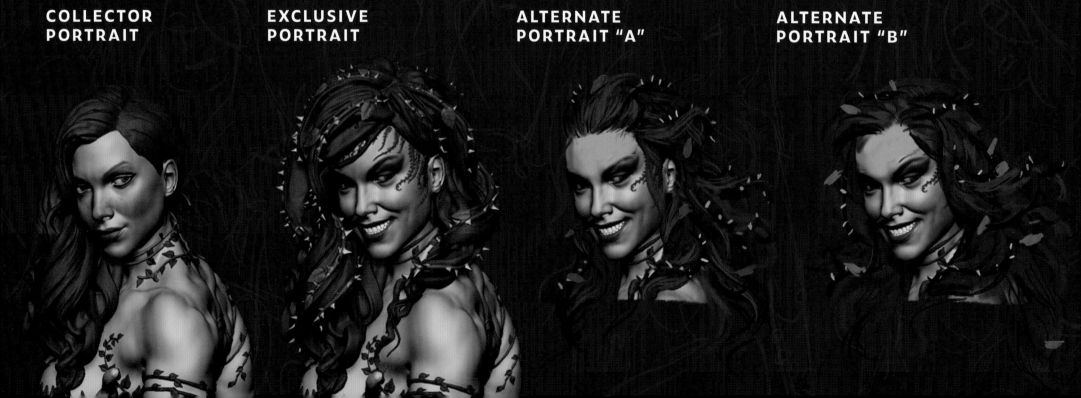

COLLECTOR
PORTRAIT

EXCLUSIVE
PORTRAIT

ALTERNATE
PORTRAIT "A"

ALTERNATE
PORTRAIT "B"

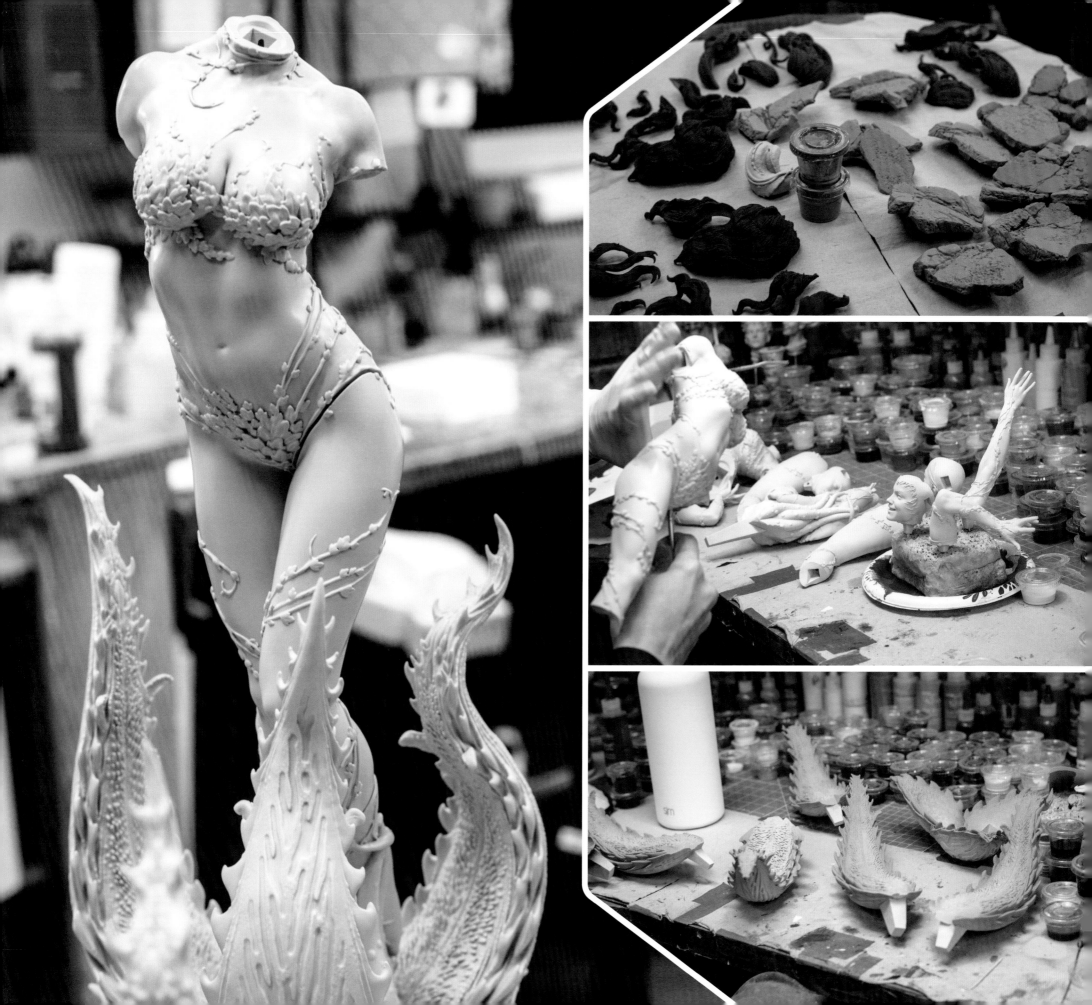

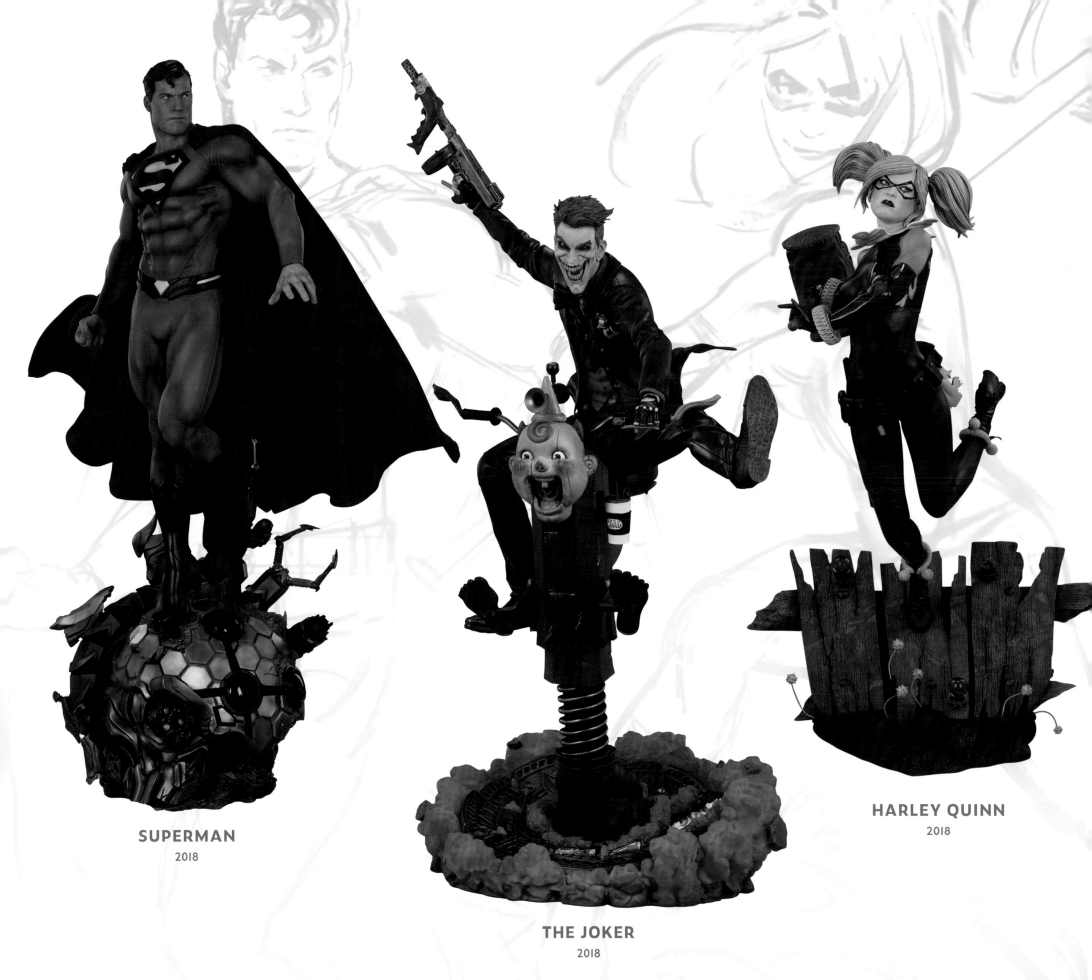

SUPERMAN

2018

THE JOKER

2018

HARLEY QUINN

2018

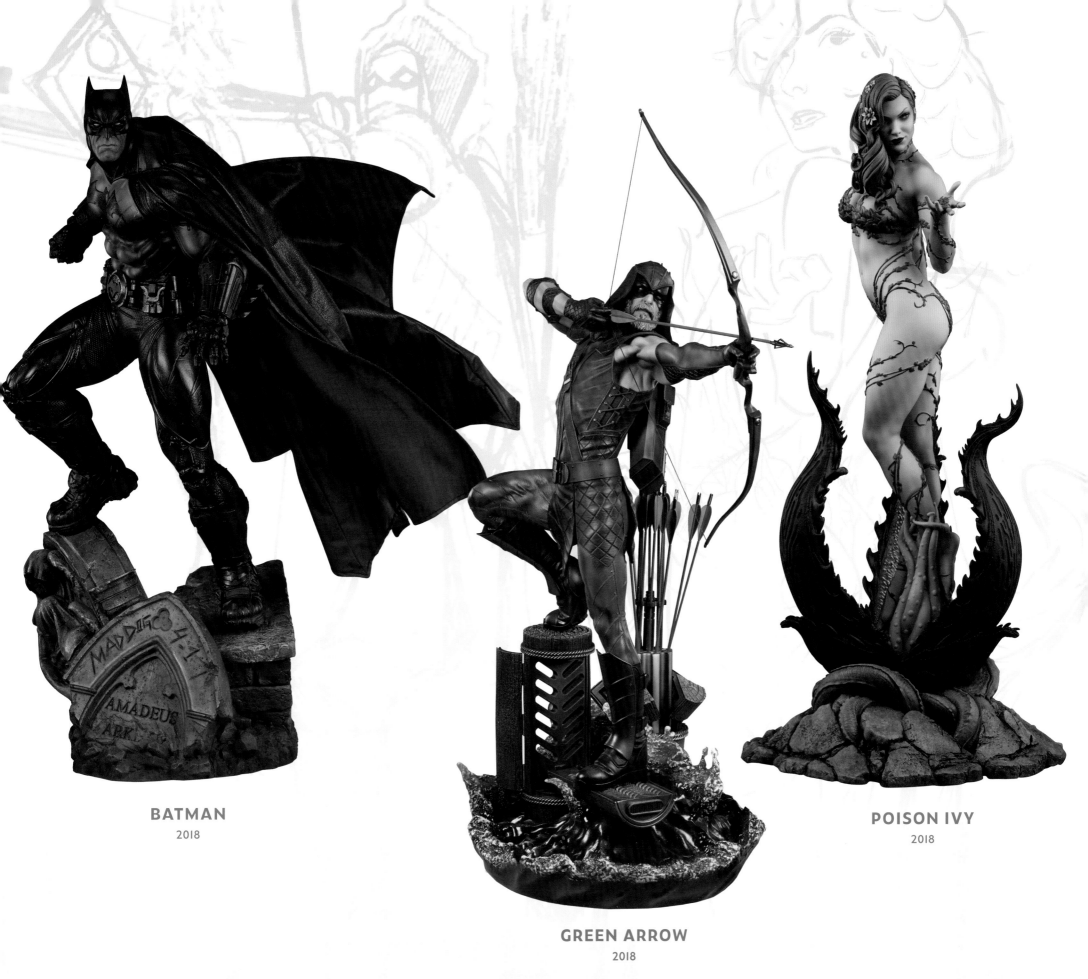

BATMAN

2018

GREEN ARROW

2018

POISON IVY

2018

135

AQUAMAN
AQUAMAN

A son of land, and a son of the seas. —Aquaman, *Aquaman* (2018)

Born of a land-dwelling father and an Atlantean mother, Arthur Curry boasts superhuman strength and an aquatic telepathy that make him one of the most powerful heroes in the DC multiverse. As king of Atlantis, he has dominion over a kingdom that spans three-quarters of the Earth's surface.

Following his scene-stealing appearance in *Justice League*, Aquaman starred in his own feature film, directed by James Wan, whose epic cinematic vision captured the majesty and grandeur of Aquaman's Atlantis.

Sideshow's Aquaman Premium Format Figure brings that cinematic sensibility to life in stunning detail, in a painstakingly crafted sculpture that replicates Aquaman's orange metallic scale armor, golden trident, and the likeness of charismatic star Jason Momoa. The figure also wears textured green fabric pants and boot elements carefully tailored to complete the costume inspired by Aquaman's most iconic, colorful look.

"Aquaman was an interesting challenge, because we had to match the movie as accurately as possible before we'd seen the film, since it hadn't been completed yet," notes painter Casey Love.

"We had proper suit reference and still photos, but that doesn't tell you how it will look on-screen. Kat Sapene, one of our in-house painters, had some great ideas on how to achieve the armor look the suit had, and provided some guidance that helped me achieve the right look, basically which paints to use and how to layer them.

"Chie Izuma handled paint duty on the portrait and hands, and she did a fantastic job nailing the proper skin tones and look of Jason as Aquaman. Katie Simpson from Graphic Design, Tim Hanson of our cut and sew department . . . it took a huge team effort to bring Jason Momoa's Aquaman to life, from sculpt to mold," says Love.

And that hard work paid off in a big way when the subject of their efforts got tv o see the final product. "Andy Smith, our PR manager, was able to track down Jason Momoa and present our hard work backstage during a show where we were able to capture his reactions on video," Love adds. "It was amazing to see that as well as the director's reaction during his visit to Sideshow. It takes a team to create something special, and that's what we all achieved!"

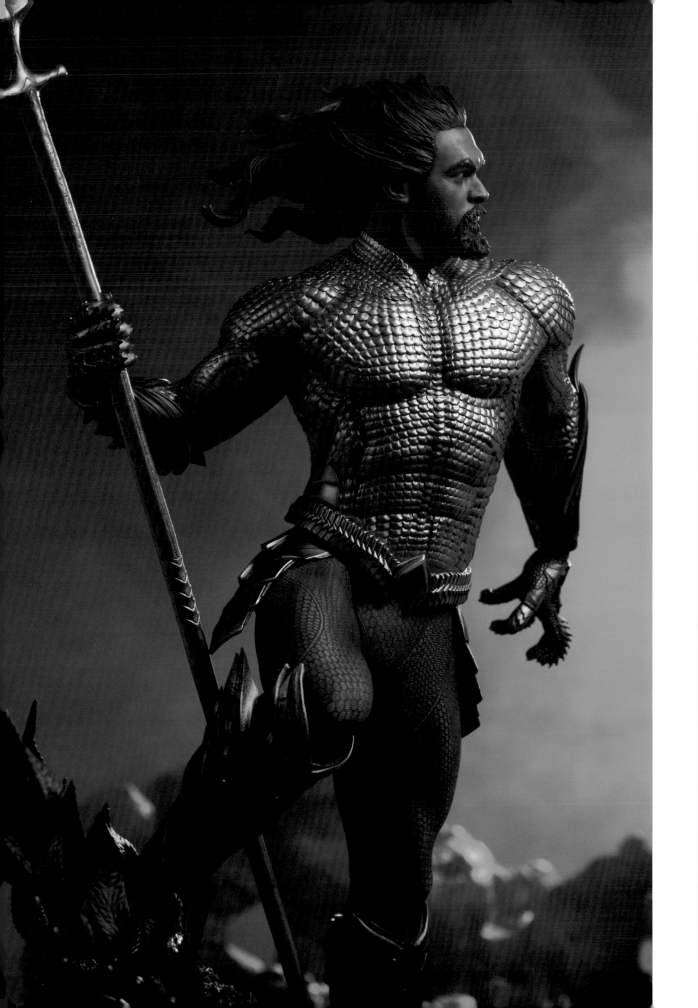

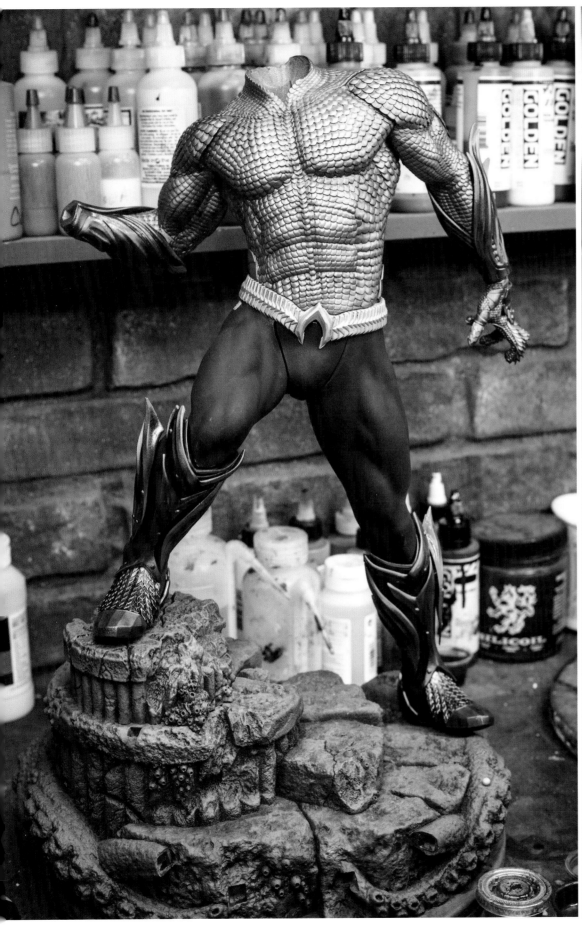

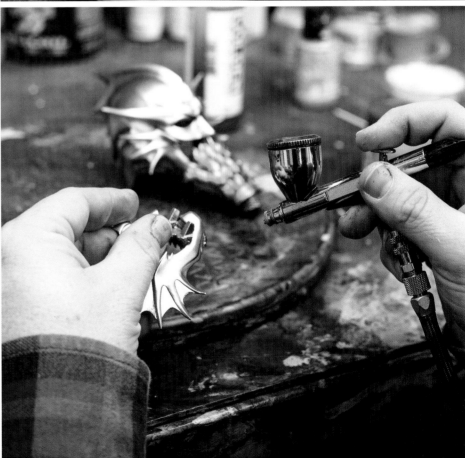

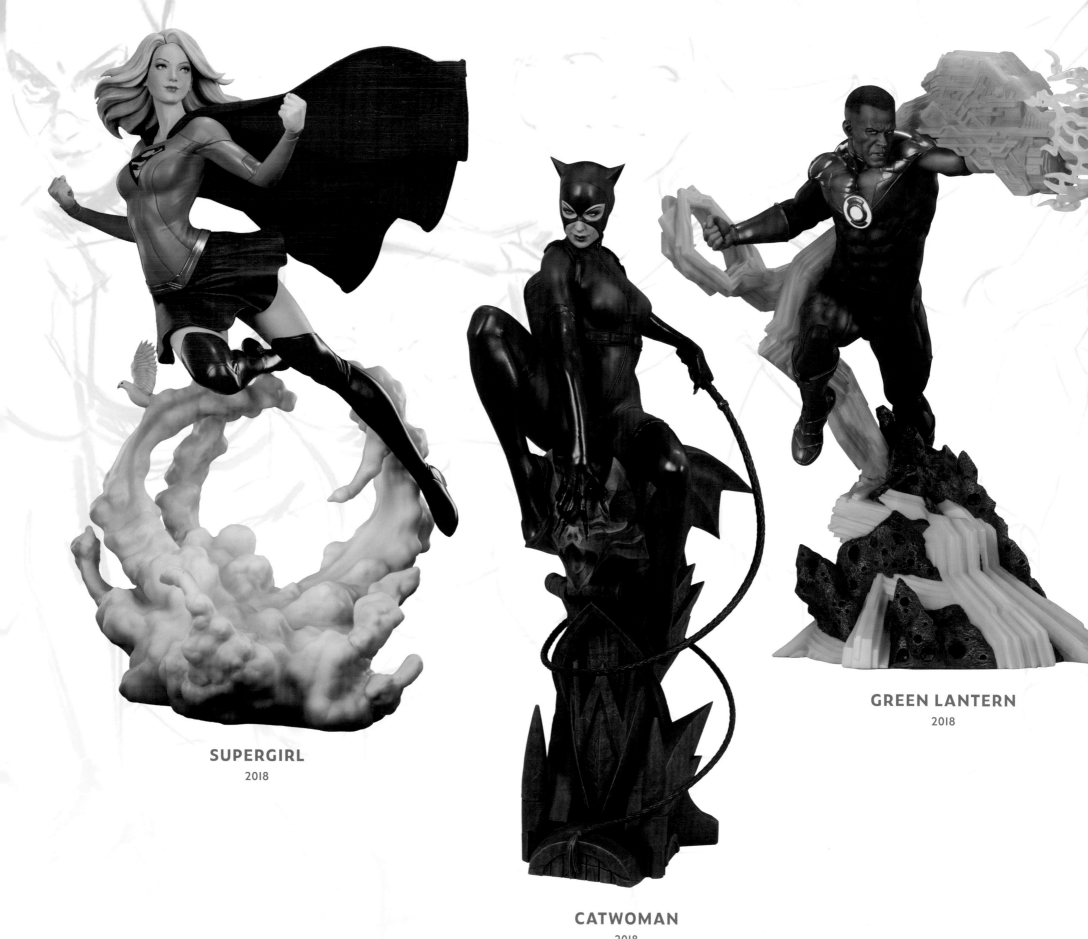

SUPERGIRL

2018

CATWOMAN

2018

GREEN LANTERN

2018

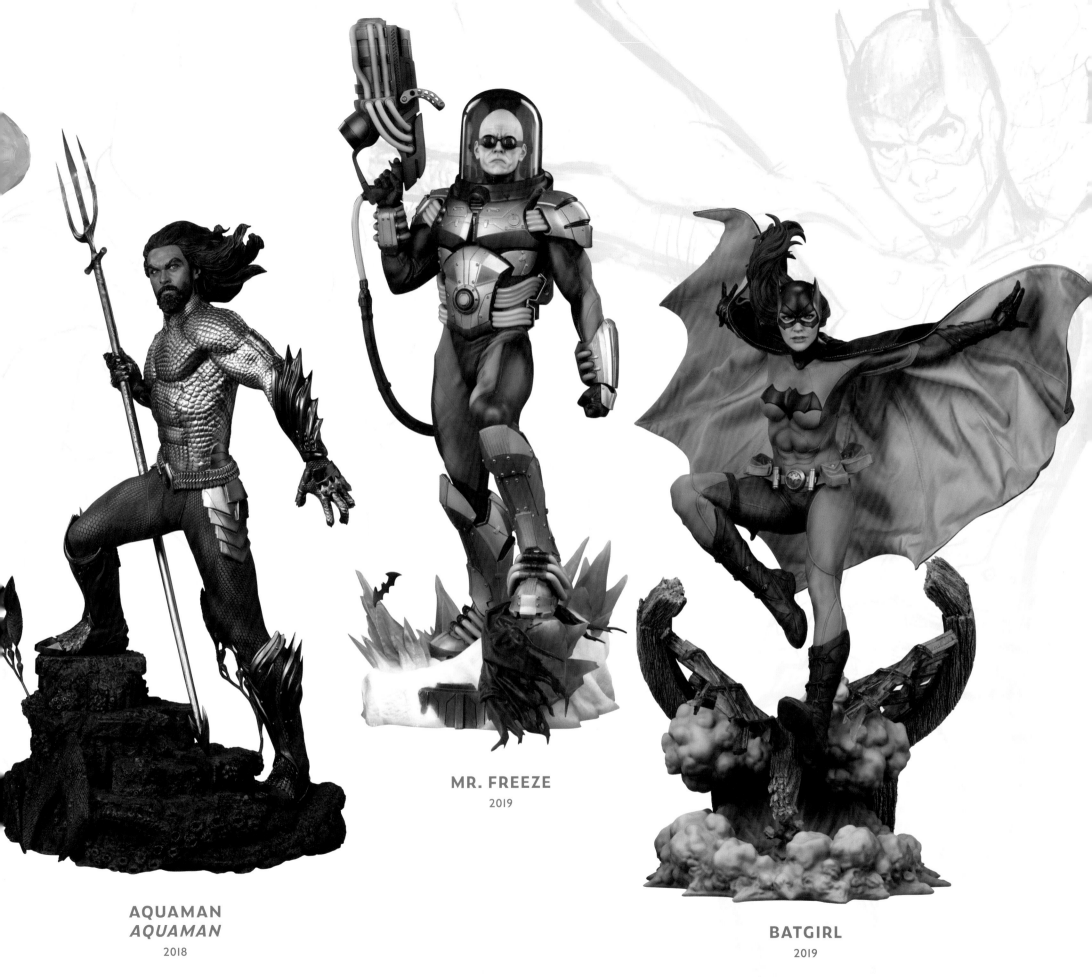

AQUAMAN
AQUAMAN
2018

MR. FREEZE
2019

BATGIRL
2019

MR. FREEZE

Threats are meaningless to a man who has lost everything. —Mr. Freeze, *Batman: Arkham Origins* video game

Gotham City's most chilling villain, Mr. Freeze, is also its most tragic.

When Nora, the wife of cryogenics expert Victor Fries, was diagnosed with a terminal illness, Fries placed her in suspended animation until a cure could be found. A resulting lab accident permanently altered Fries's body chemistry and personality, making it impossible for him to survive above freezing temperatures. The brilliant scientist survived and fabricated a suit designed to sustain his subzero body temperature, and the emotionally deadened Fries adopted the new persona of Mr. Freeze, a cold-blooded villain with a heart to match.

The Mr. Freeze Premium Format Figure stands atop a frostbitten laboratory base, armed with a cryogenic gun and a chilly disposition. The polyresin figure features a fully sculpted survival suit detailed with intricate armor paneling and blue tubing that is a part of the complex machinery keeping him alive as he prepares to unleash a new Ice Age upon Gotham City.

"This was a great piece to paint on," says Bernardo Esquivel. "It was a real team effort, actually. I came in and did some minor tweaks and adjustments to enhance the piece a little bit and give it more atmosphere. What I did for that was mist some transparent blue over white to bring some coolness to the ice and snow portions. I also misted some white with a stippling effect to show frost on some areas as well. My favorite part, though, was painting the red lenses on the goggles. Going in with different reds and being loose with the brush strokes gave it a real comic book element."

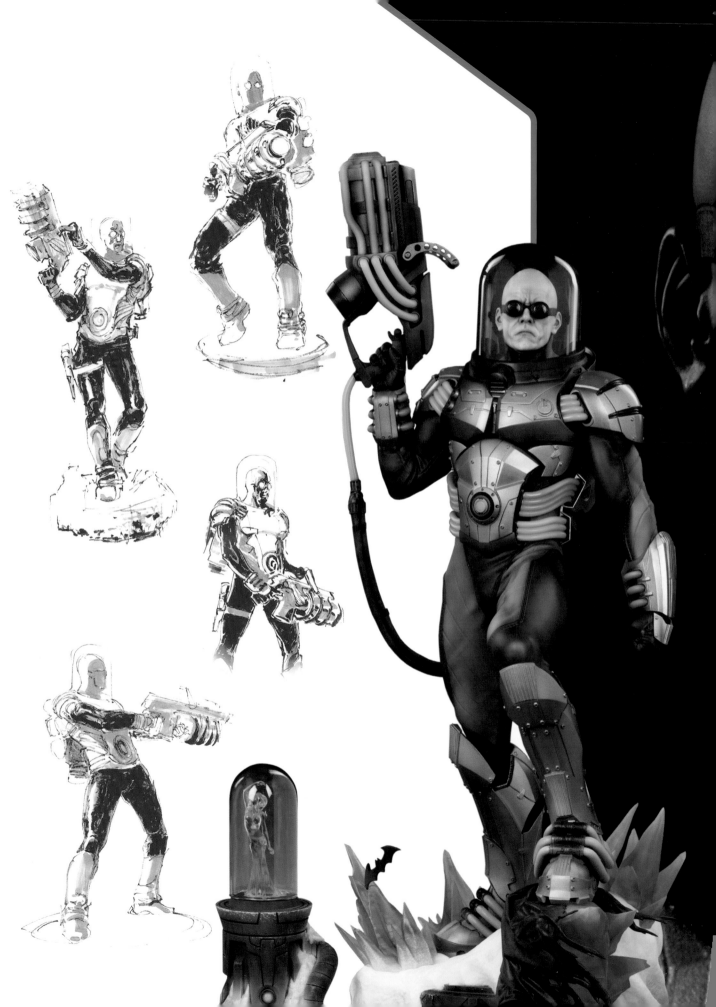

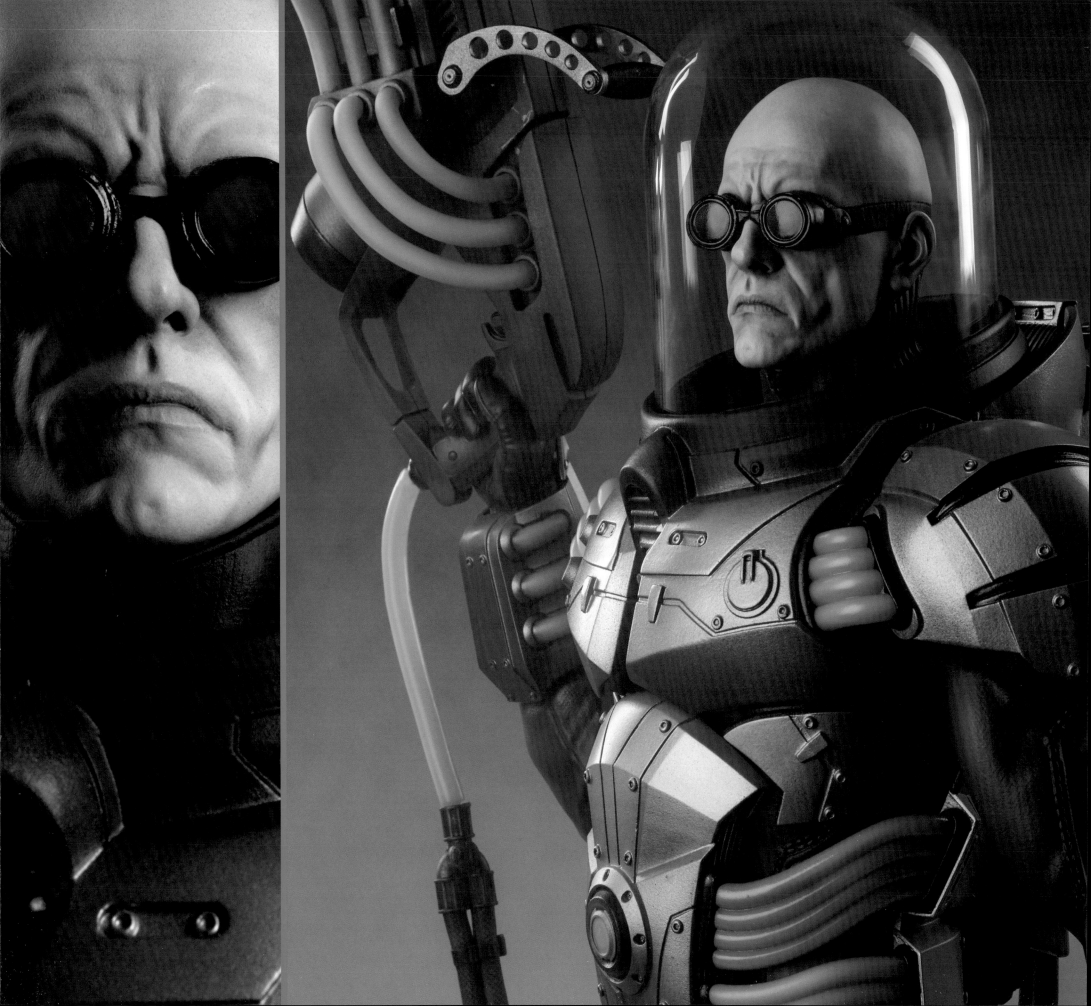

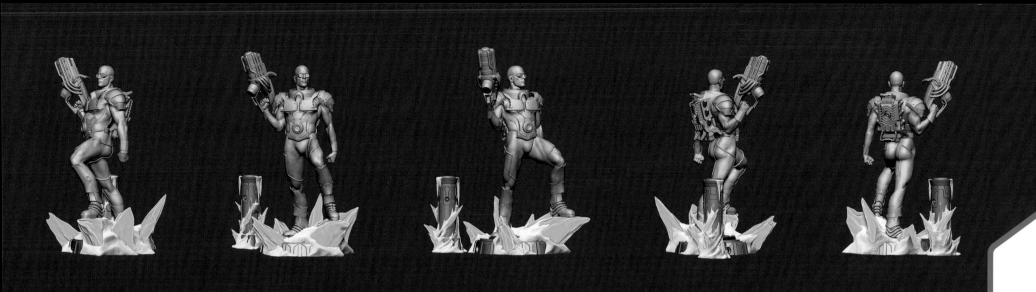

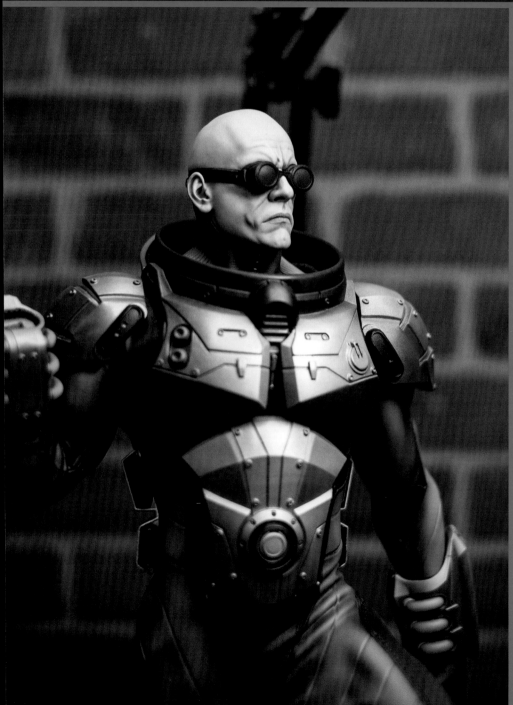

"Mr. Freeze has a very unique, almost retro-futurist look about him that no other character in the DC pantheon has . . ."

—Nathan Lewis, Graphic Designer

**EXCLUSIVE EDITION
BASE ART**

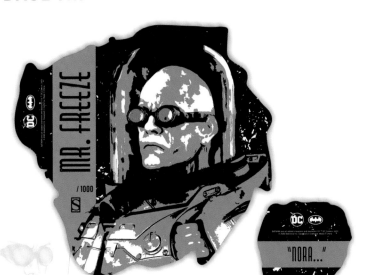

**COLLECTOR EDITION
BASE ART**

The diabolical Mr. Freeze has long been one of the most unusual members of Batman's Rogues Gallery, from his distinctive containment suit to his chilling powers and abilities. "Mr. Freeze has a very unique, almost retro-futurist look about him that no other character in the DC pantheon has," says graphic designer Nathan Lewis. "His design has a great 'shape language' that has a timeless quality that would fit in equally well in early 1950s sci-fi as it does today. He instantly visually embodies a tortured soul that blurs the line between machine and man."

Mr. Freeze's rich visual history encompasses comic books, live-action films, television, animation, and video games, which gave Lewis plenty of inspiration when he designed the packaging for the Mr. Freeze Premium Format Figure. "I wanted to bring a bit of that sleek feeling and instant readability into the design for the package as well, so I chose to go with a very limited color palette and bold accent lines, which I hoped would mimic features like the tubing along his suit," adds Lewis. "I wanted the box to read as dark and brooding, as Mr. Freeze is a very tragic character with a tragic story. I felt that more solemn tone was appropriate, so I kept a lot of black in the composition while choosing to highlight his wife, Nora, on the back panel as kind of his shining light in the darkness."

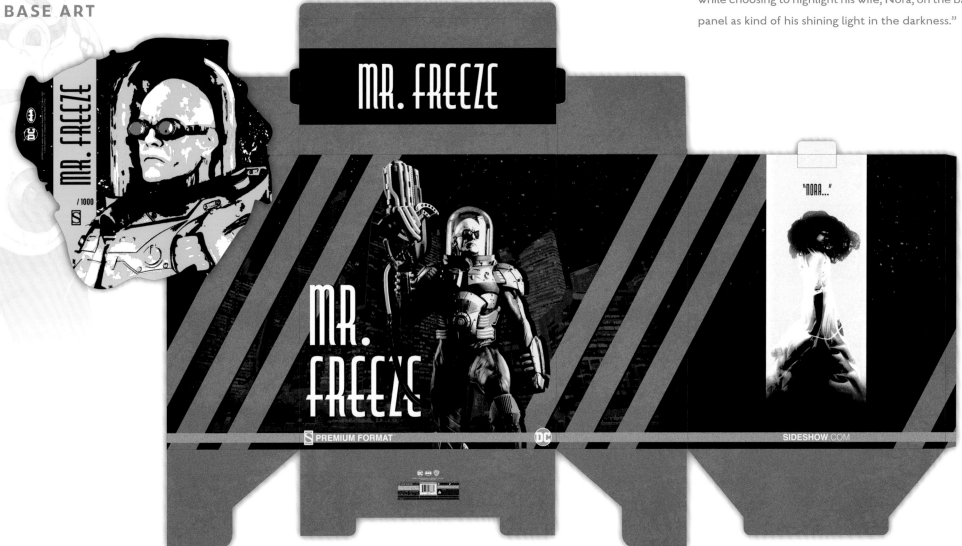

SCARECROW

By the time I get done with you . . . you'll understand what fear is all about. —Scarecrow, *Batman: The Dark Knight* #11 (2012)

Professor Jonathan Crane was obsessed with the study of fear, and that obsession turned to madness as he transformed himself into Scarecrow, the Master of Fear. Through his use of hallucinogenic fear toxins, Scarecrow continues his academic studies as he uses his sinister talents to learn everything there is to know about the fundamental nature of fear itself. This field of study, not surprisingly, often puts him at odds with Batman, perhaps the only man alive whose mastery of fear rivals Scarecrow's.

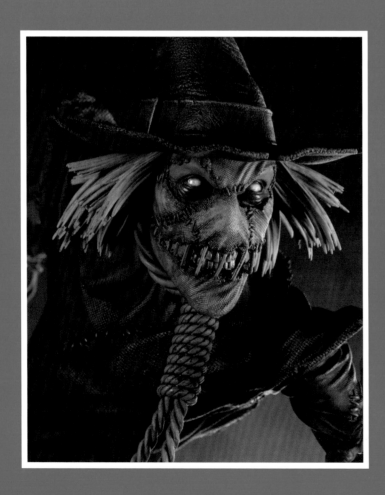

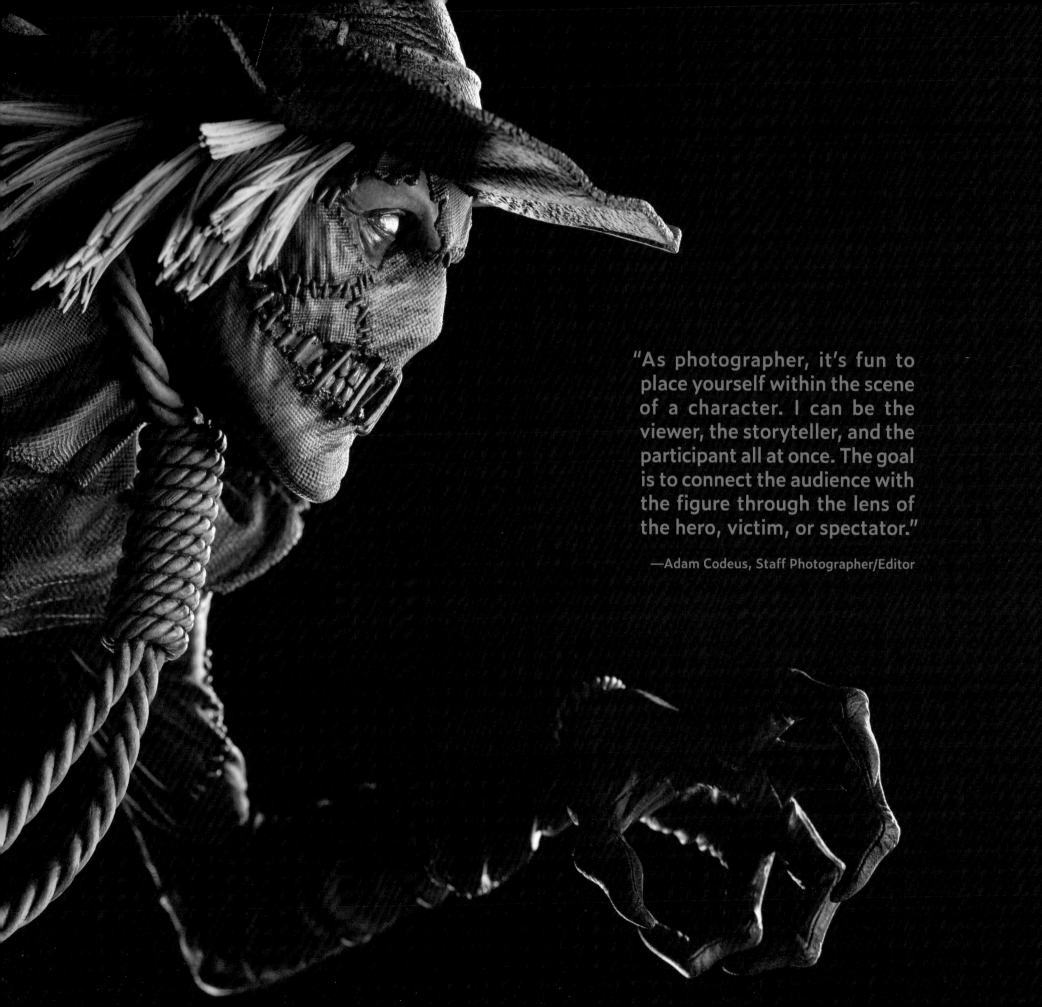

"As photographer, it's fun to place yourself within the scene of a character. I can be the viewer, the storyteller, and the participant all at once. The goal is to connect the audience with the figure through the lens of the hero, victim, or spectator."

—Adam Codeus, Staff Photographer/Editor

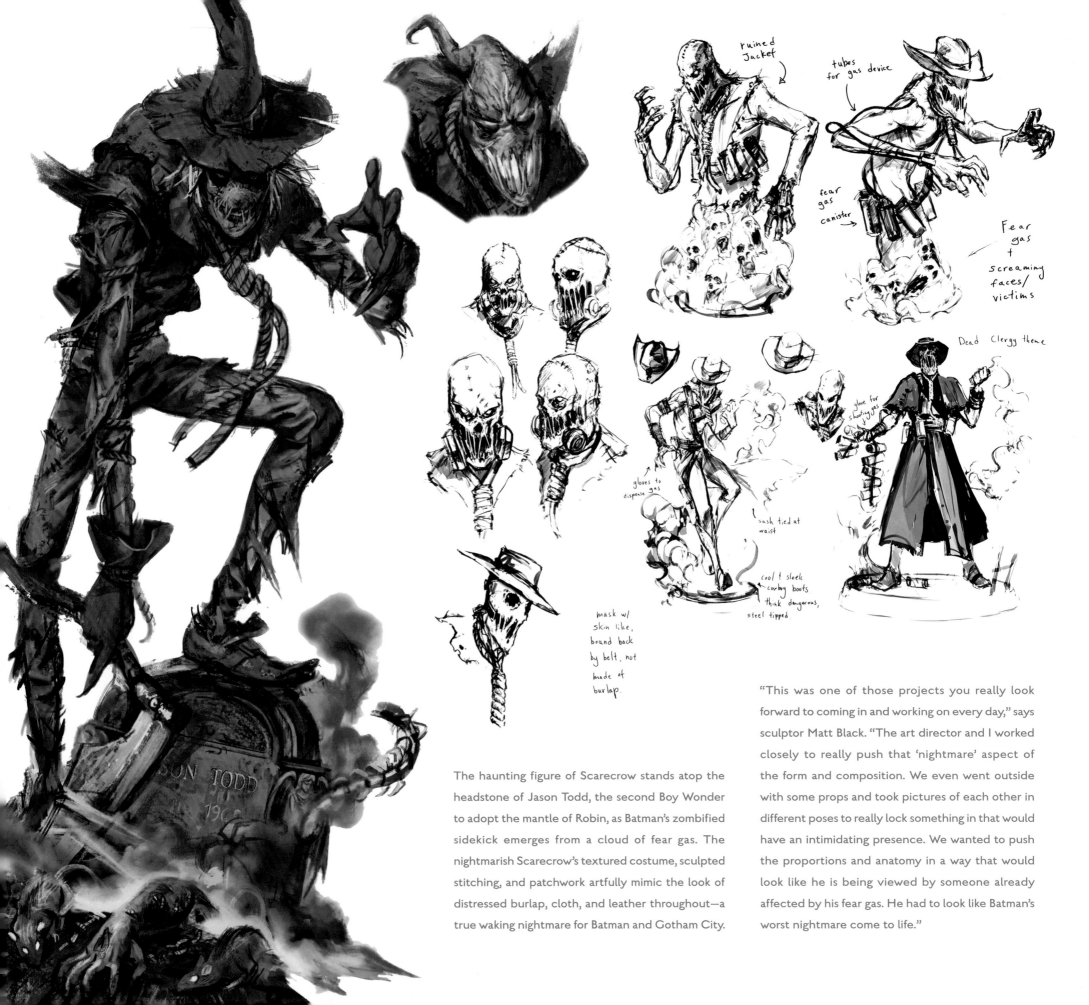

ruined Jacket

tubes for gas device

fear gas canister

Fear gas + screaming faces/ victims

Dead Clergy theme

gloves to dispense gas

sash tied at waist

cool & sleek cowboy boots think dangerous, steel tipped

glove for shooting gas

mask w/ skin like, bound back by belt. not made of burlap.

ON TODD 190

The haunting figure of Scarecrow stands atop the headstone of Jason Todd, the second Boy Wonder to adopt the mantle of Robin, as Batman's zombified sidekick emerges from a cloud of fear gas. The nightmarish Scarecrow's textured costume, sculpted stitching, and patchwork artfully mimic the look of distressed burlap, cloth, and leather throughout—a true waking nightmare for Batman and Gotham City.

"This was one of those projects you really look forward to coming in and working on every day," says sculptor Matt Black. "The art director and I worked closely to really push that 'nightmare' aspect of the form and composition. We even went outside with some props and took pictures of each other in different poses to really lock something in that would have an intimidating presence. We wanted to push the proportions and anatomy in a way that would look like he is being viewed by someone already affected by his fear gas. He had to look like Batman's worst nightmare come to life."

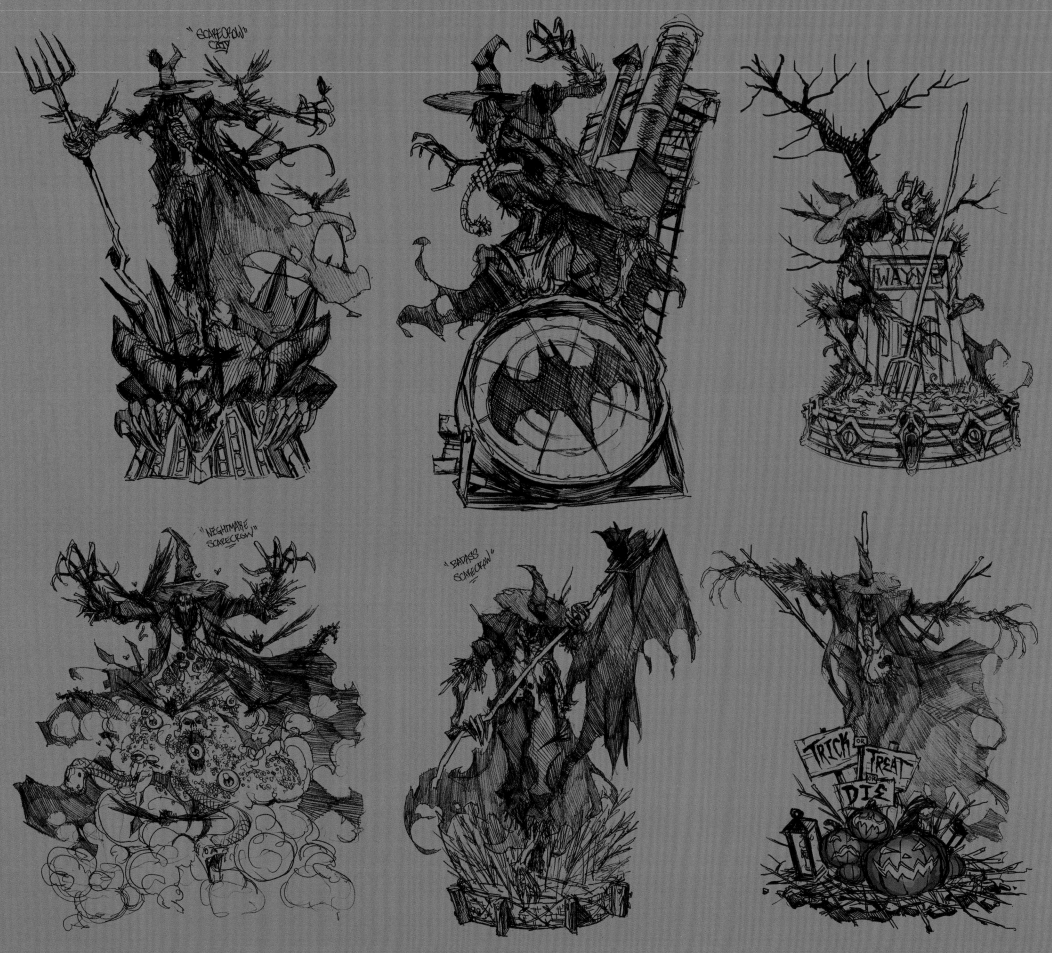

"SCARECROW" CITY

"NIGHTMARE SCARECROW"

"BADASS SCARECROW"

WAYNE

TRICK OR TREAT OR DIE

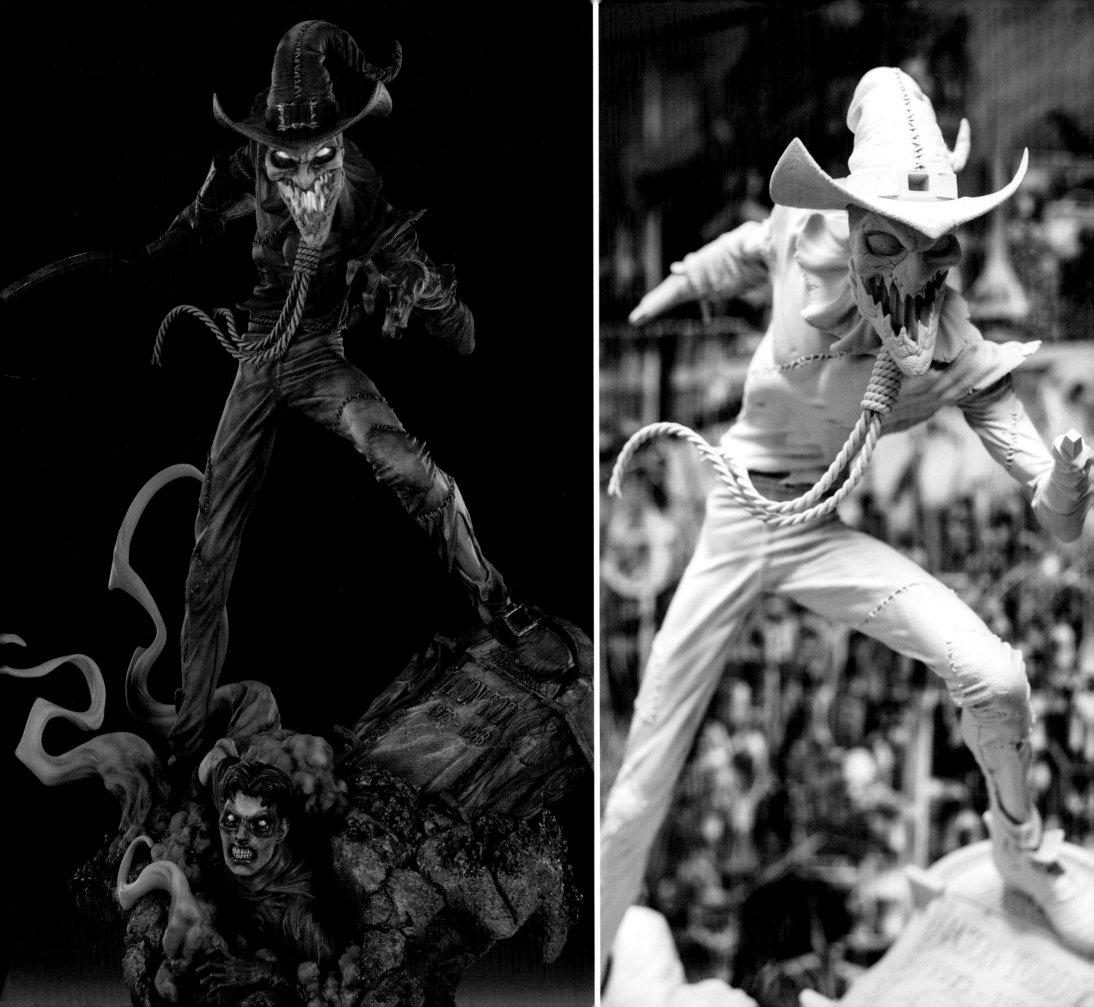

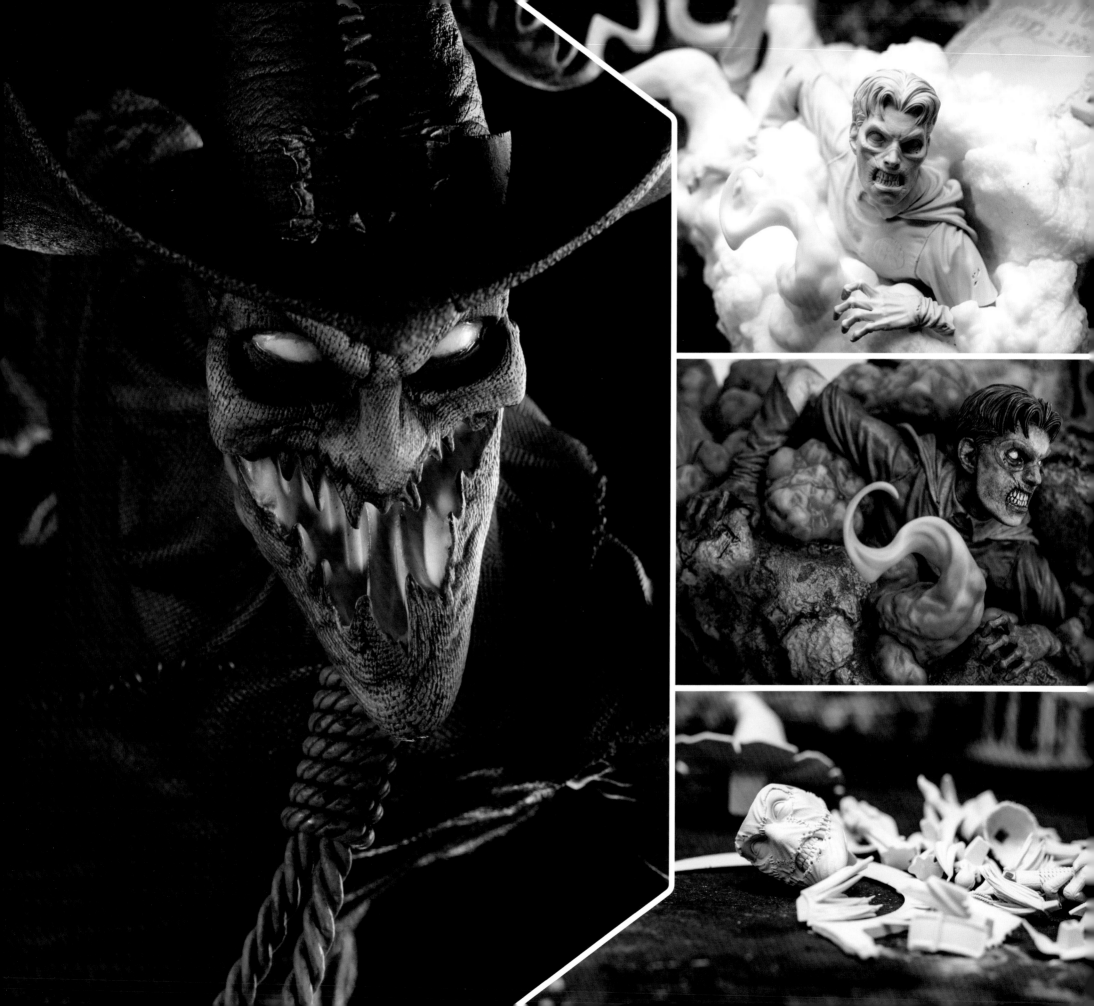

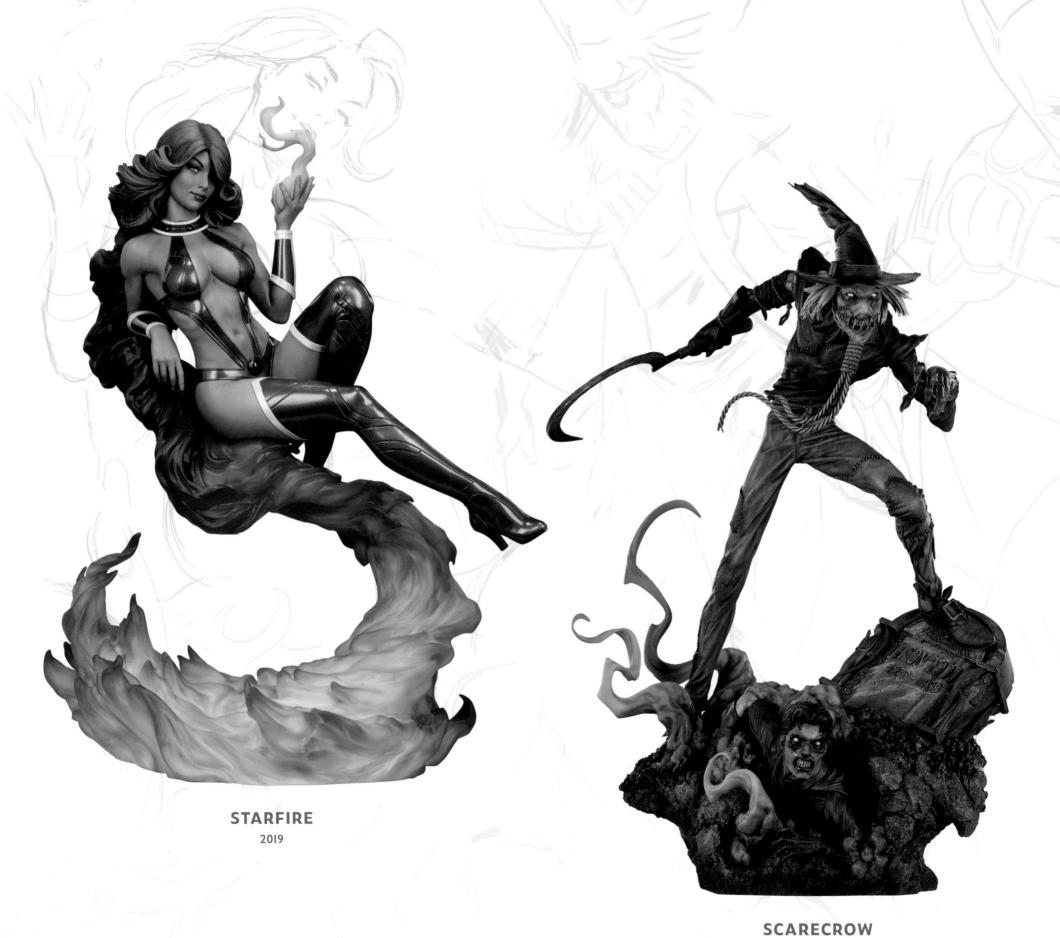

STARFIRE

2019

SCARECROW

2019

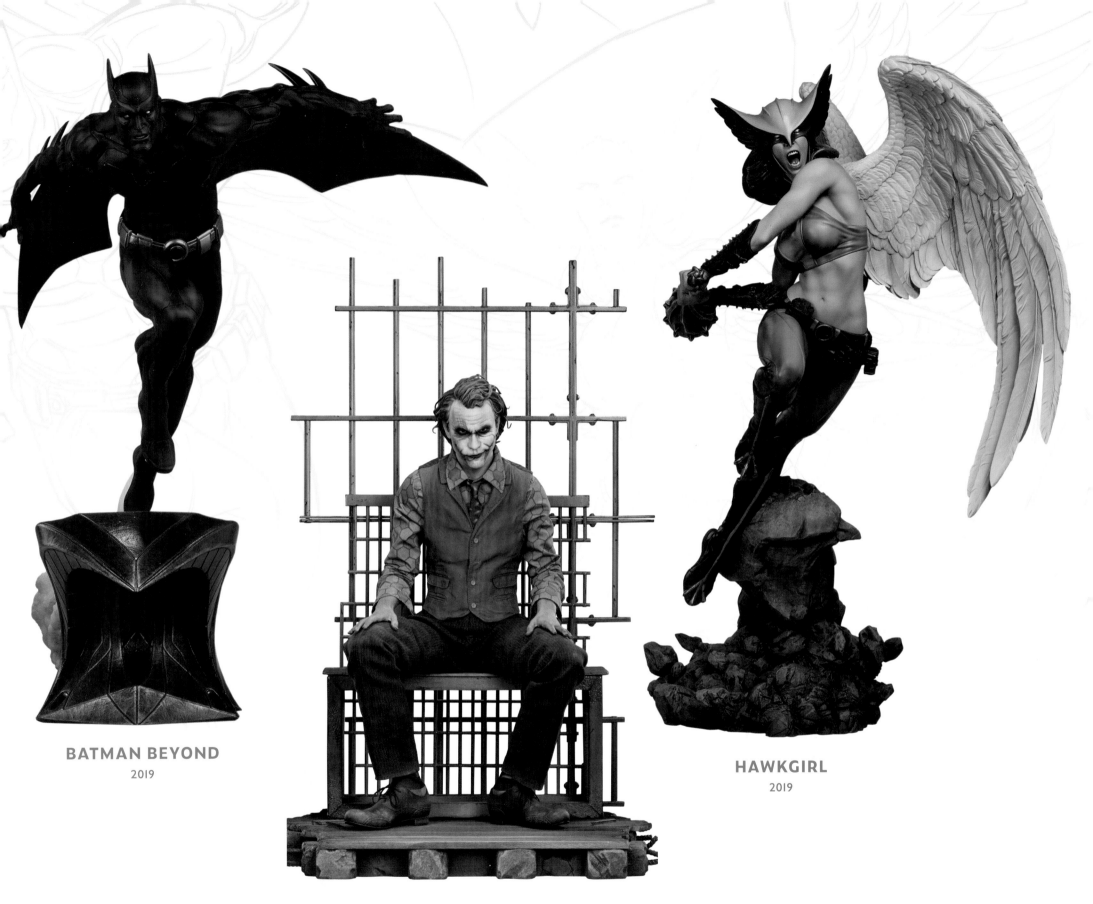

BATMAN BEYOND
2019

THE JOKER
THE DARK KNIGHT
2019

HAWKGIRL
2019

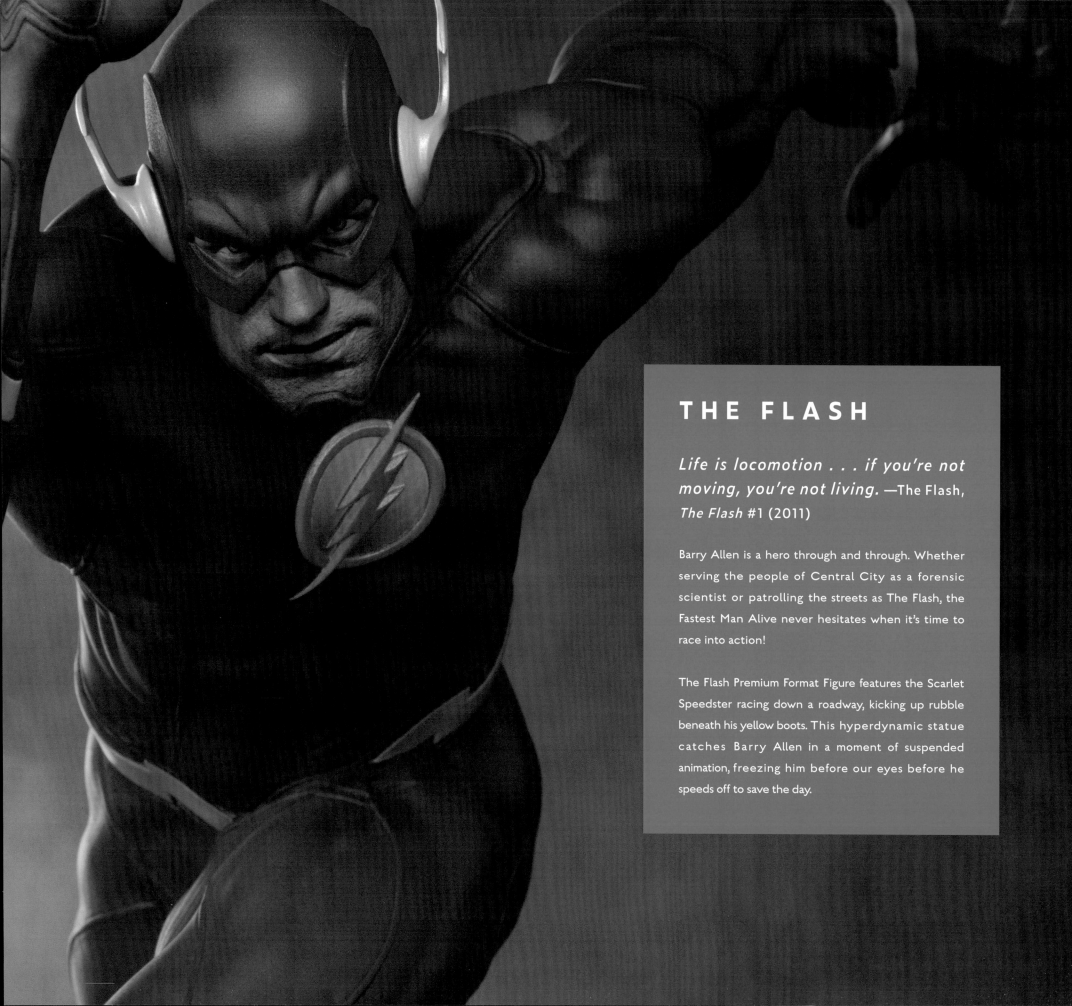

THE FLASH

Life is locomotion . . . if you're not moving, you're not living. —The Flash, *The Flash* #1 (2011)

Barry Allen is a hero through and through. Whether serving the people of Central City as a forensic scientist or patrolling the streets as The Flash, the Fastest Man Alive never hesitates when it's time to race into action!

The Flash Premium Format Figure features the Scarlet Speedster racing down a roadway, kicking up rubble beneath his yellow boots. This hyperdynamic statue catches Barry Allen in a moment of suspended animation, freezing him before our eyes before he speeds off to save the day.

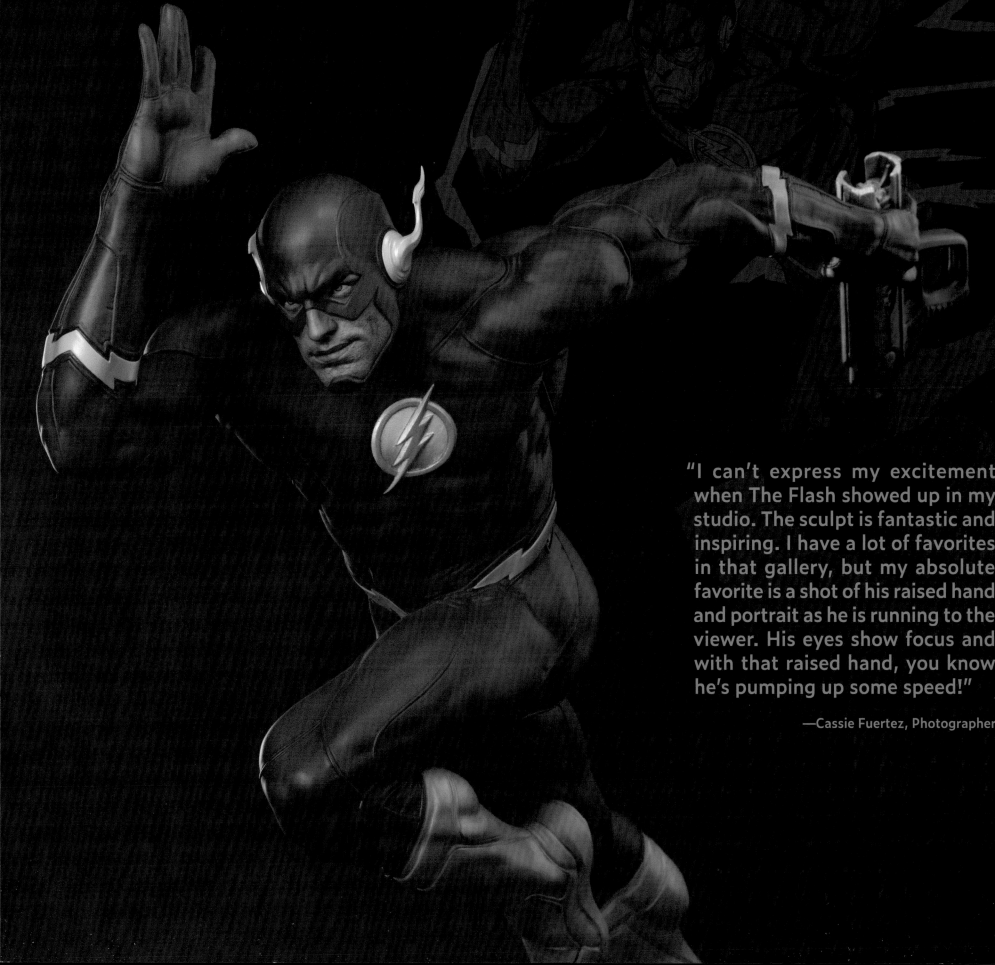

"I can't express my excitement
when The Flash showed up in my
studio. The sculpt is fantastic and
inspiring. I have a lot of favorites
in that gallery, but my absolute
favorite is a shot of his raised hand
and portrait as he is running to the
viewer. His eyes show focus and
with that raised hand, you know
he's pumping up some speed!"

—Cassie Fuertez, Photographer

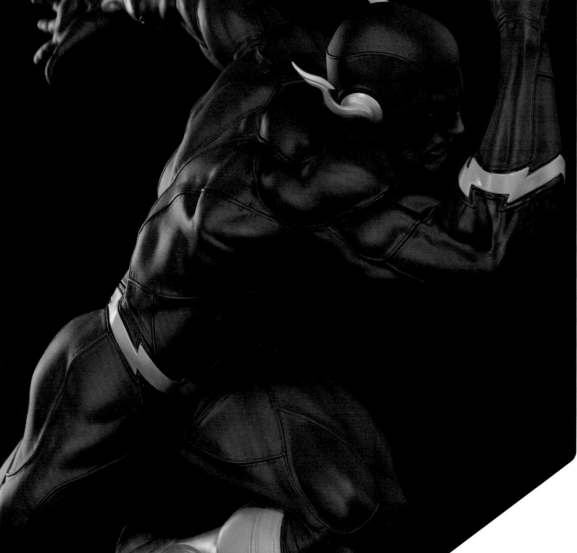

"It's all about the gesture, meaning the flow and positioning of a character's body," says designer Richard Luong, when it comes to capturing this moment in time. "In order to really showcase his speed, we wanted his limbs at full tension and extension. All of his motion is going in one direction, so when you look at him, your eye is following this flow. We also pushed this effect with the base exploding from the impact.

"We read things as relative to other objects, so when we see him going in one direction and exploding debris behind him, then the collector can really feel the energy," continues Luong. "On top of it, I give so much of the credit to sculptor Daniel Bel, just absolutely knocking it out of the park. The small details in musculature and pose are so important to nail it, and he is a master."

Designer and sculptor Daniel Bel adds, "There's a whole locomotion study behind a statue like this, in which you have to transmit movement with a static piece. This pose depicts what we call an 'in-between moment,' which refers to an instance that is neither the beginning nor the end of an action; it's something in between. It's hard to get, but if you study the curves and lines that the body produces in certain poses you will be able to do it. It takes time, but with the help of good references and a sharp eye, this is something you will perfectly achieve."

PACKAGING

When designing the package for The Flash Premium Format Figure, graphic designer Erick Torres knew he had to go straight to the original source material if he wanted to catch the Fastest Man Alive. "My inspiration for the package design and elements came from the comic books themselves," says

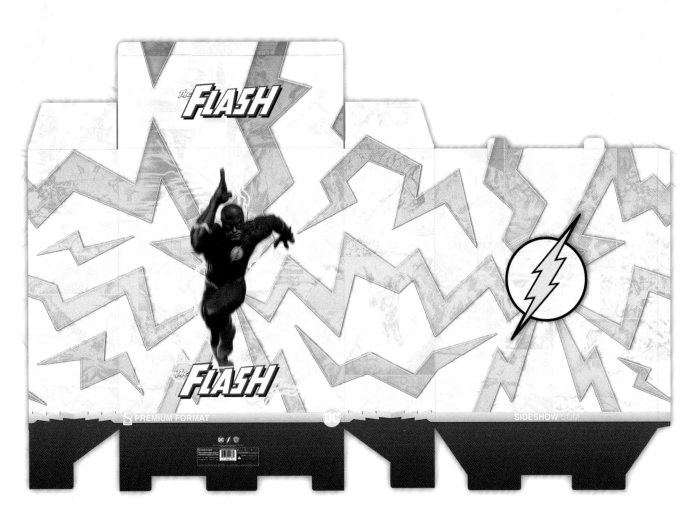

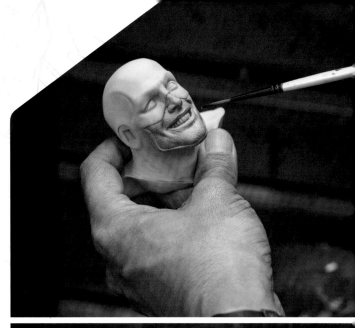

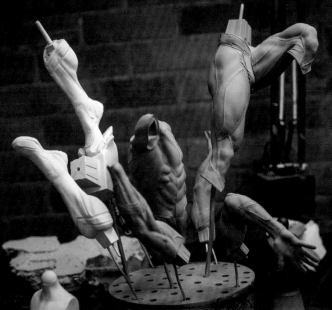

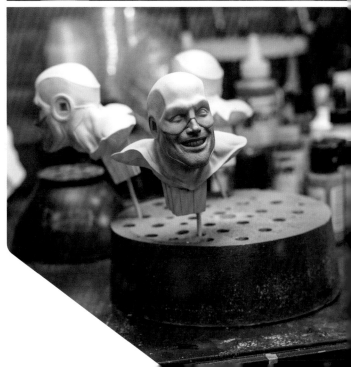

Torres. "I decided to make the whole box a collage of comic strips from *The Flash*. I believe that using elements from the comics makes packaging more interesting to look at. My favorite design element from this package is the band at the bottom of the box that wraps around. I designed the sides of the band to mimic The Flash's belt. I've always been a Flash fan; he has a dope story and upbringing."

Translating The Flash's faster-than-light motion to a static package is difficult, notes Torres, but not impossible. "Capturing The Flash's speed from a still photograph can be a bit tricky. There are a few fun tricks and filters that can be used to manipulate the photograph to capture motion. I used these techniques on the front image to capture his speed."

COLLECTOR EDITION BASE ART

EXCLUSIVE EDITION BASE ART

HARLEY QUINN
HELL ON WHEELS

I have white skin, two colors of hair, and I dress like a Roller Derby reject. What part of 'covert' do you think I do?—Harley Quinn, *Suicide Squad: War Crimes Special* #1 (October 2016)

When Harley Quinn's second solo comic book series launched in 2013, she picked up a new home in Coney Island and a new pastime as she joined her local Roller Derby team, the Brooklyn Bruisers. Harley also gained a new look, courtesy of artist Amanda Conner, as she modified her *Suicide Squad* costume for superpowered skating action.

Harley is truly Hell on Wheels as she rocks a pair of handcrafted roller skates, thigh-high stockings, a bustier, and a custom jacket, all in her signature red-and-black color scheme. This Premium Format Figure also rocks an oversize mallet, in case Harley runs into any unexpected trouble on the track. Fans have the option of displaying Harley with her dip-dyed red-and-blue pigtails or with an alternate masked portrait featuring Harley's original black domino mask and two-toned jester's hood. The neon-themed rink base completes the package, as the Maid of Mischief gets ready to roll.

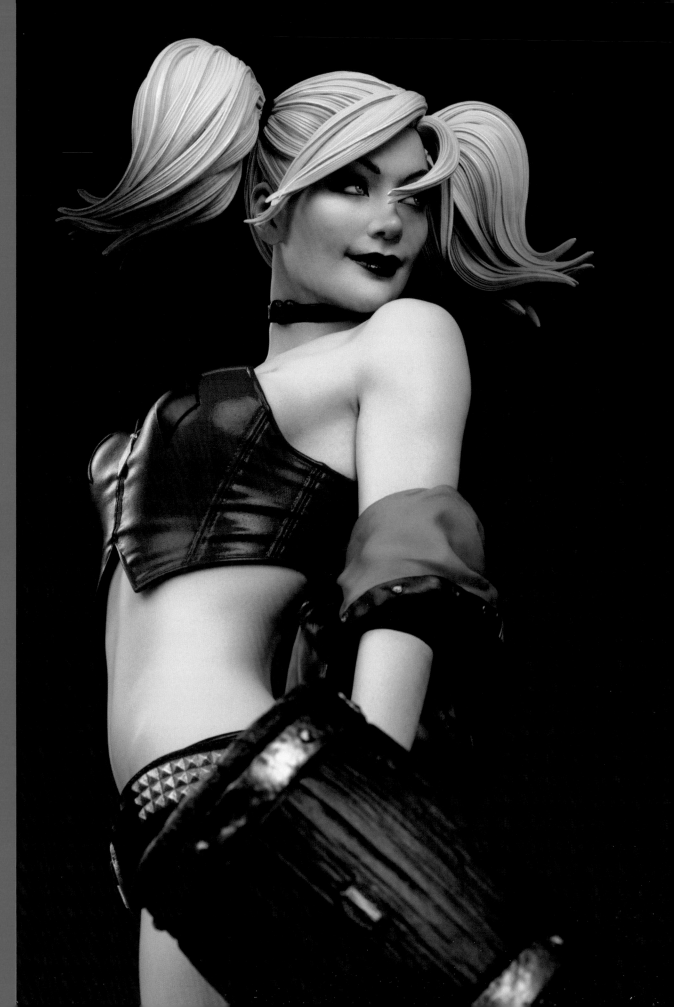

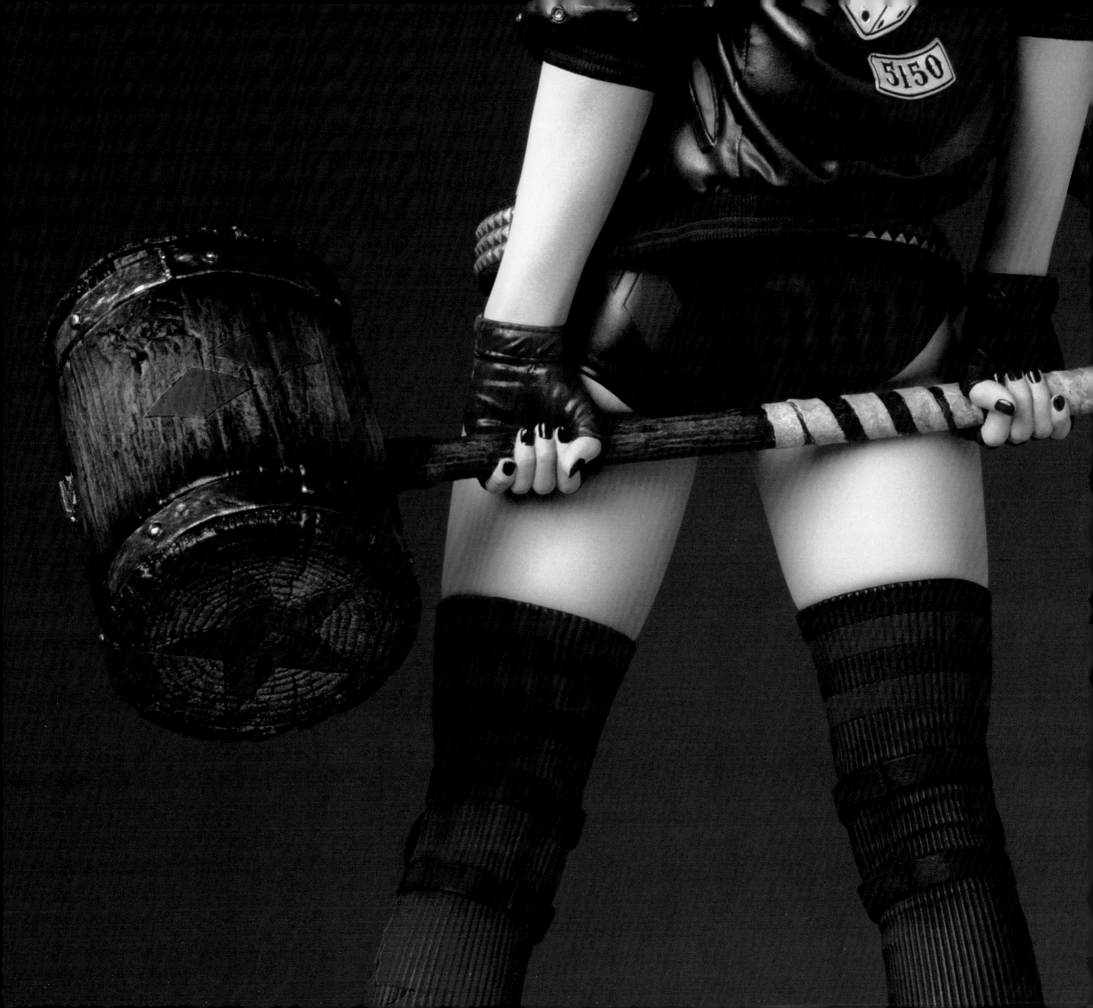

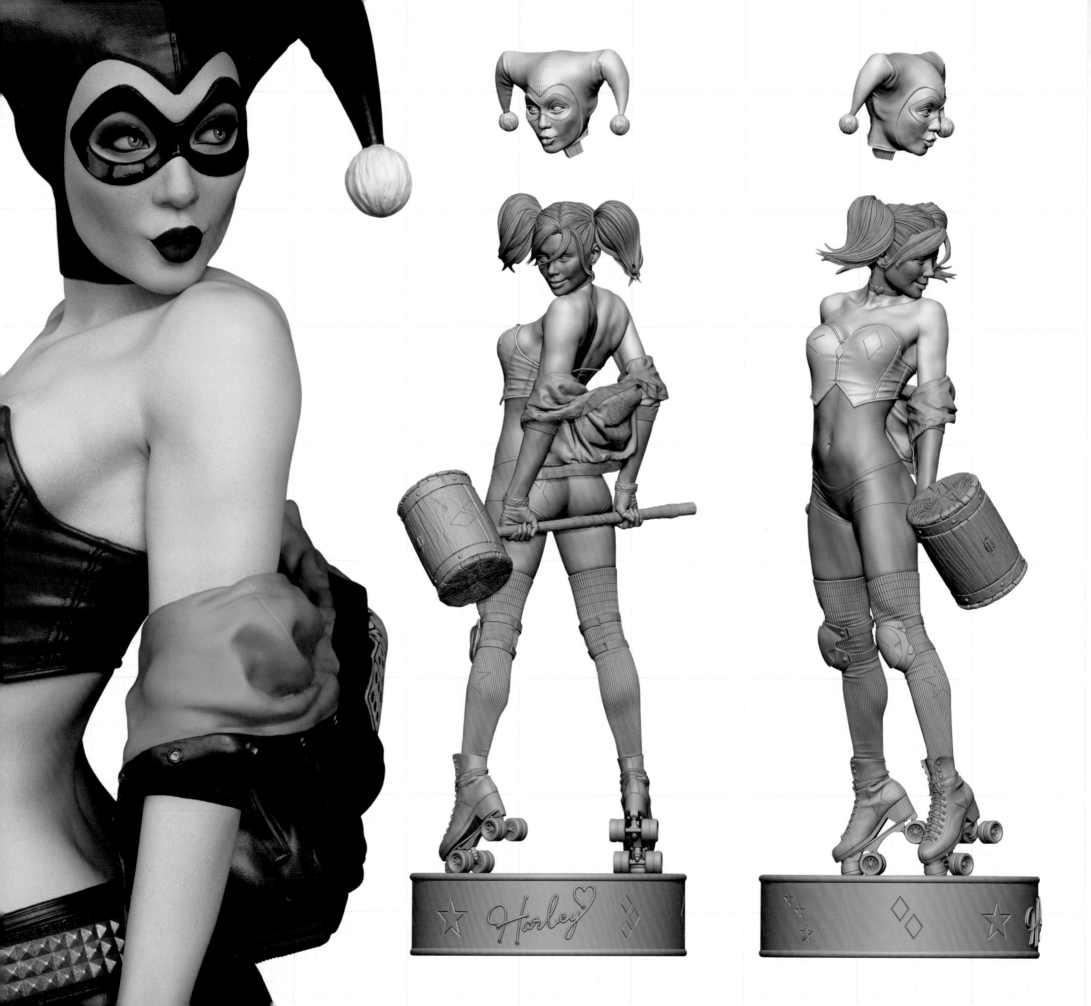

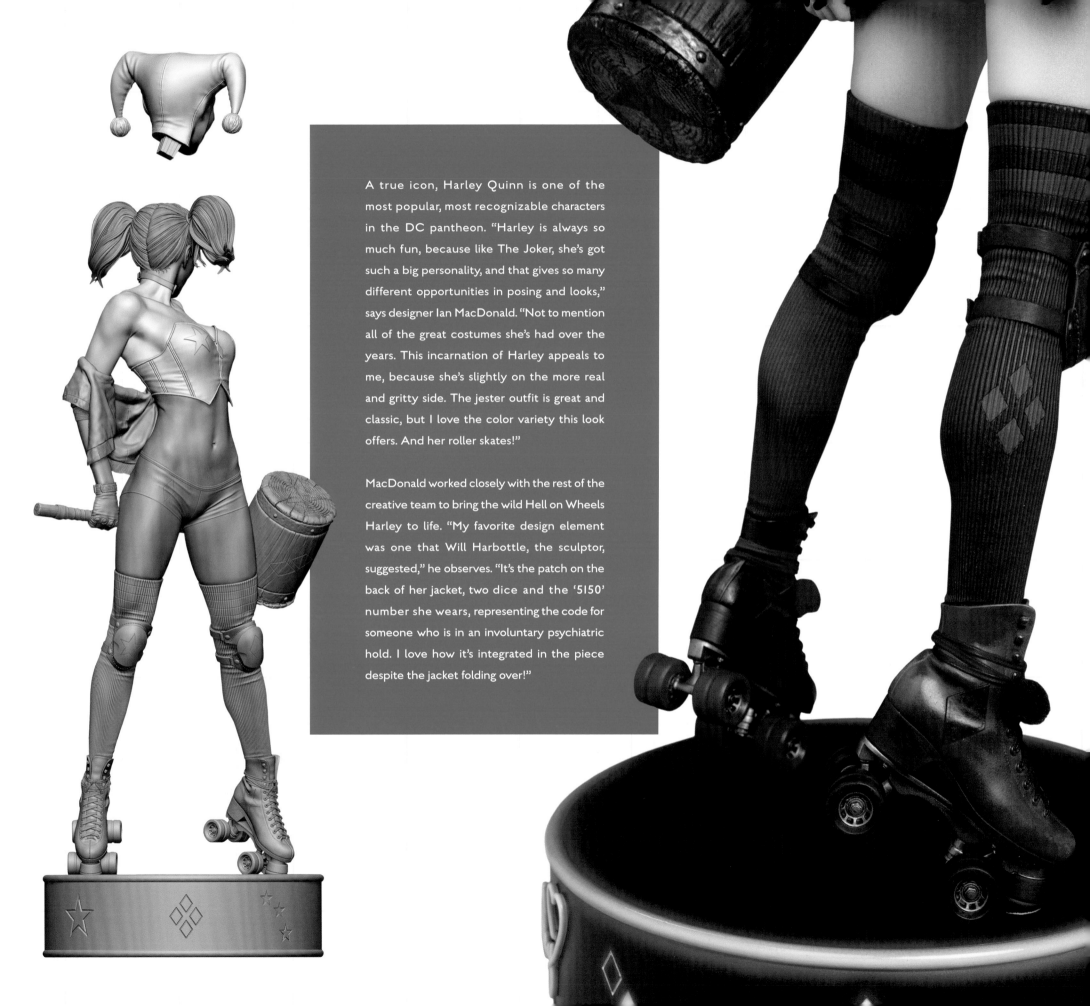

A true icon, Harley Quinn is one of the most popular, most recognizable characters in the DC pantheon. "Harley is always so much fun, because like The Joker, she's got such a big personality, and that gives so many different opportunities in posing and looks," says designer Ian MacDonald. "Not to mention all of the great costumes she's had over the years. This incarnation of Harley appeals to me, because she's slightly on the more real and gritty side. The jester outfit is great and classic, but I love the color variety this look offers. And her roller skates!"

MacDonald worked closely with the rest of the creative team to bring the wild Hell on Wheels Harley to life. "My favorite design element was one that Will Harbottle, the sculptor, suggested," he observes. "It's the patch on the back of her jacket, two dice and the '5150' number she wears, representing the code for someone who is in an involuntary psychiatric hold. I love how it's integrated in the piece despite the jacket folding over!"

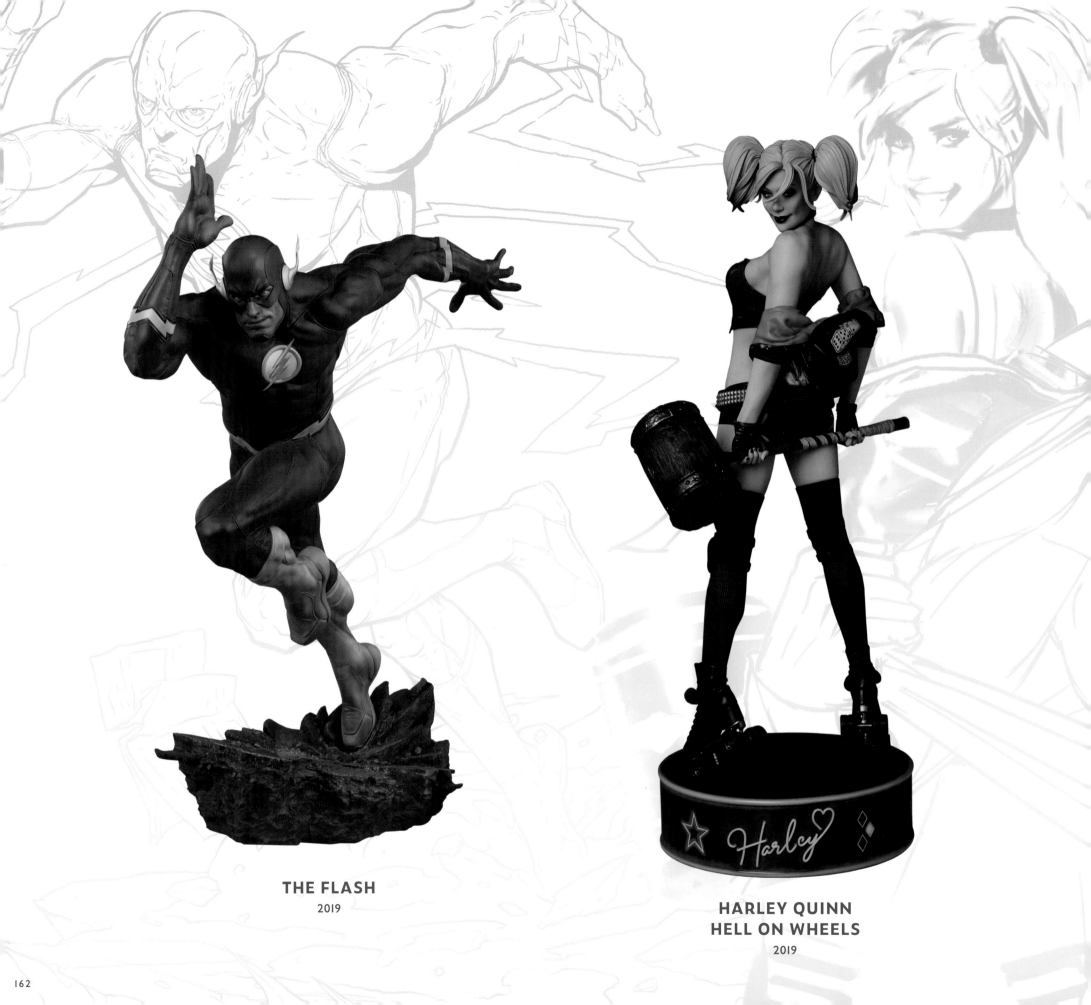

THE FLASH

2019

**HARLEY QUINN
HELL ON WHEELS**

2019

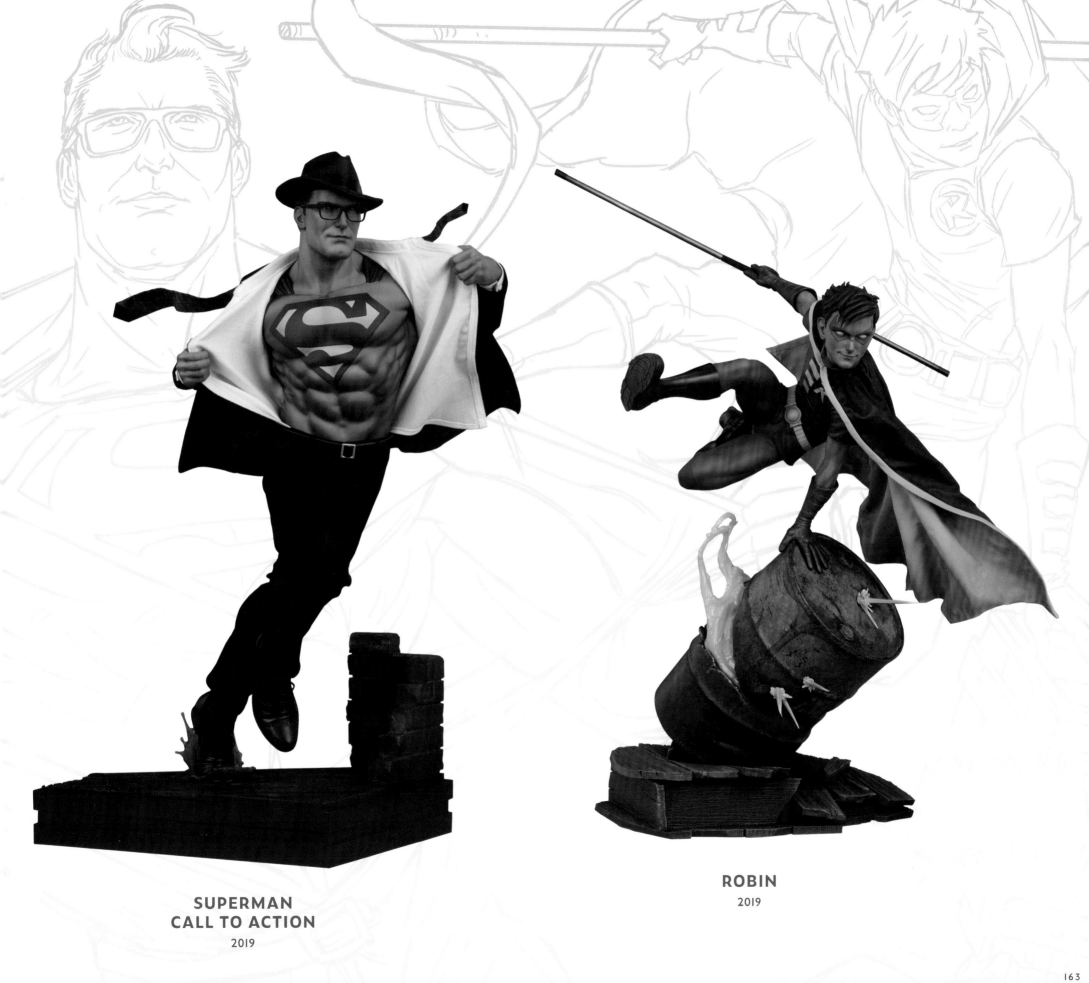

**SUPERMAN
CALL TO ACTION**
2019

ROBIN
2019

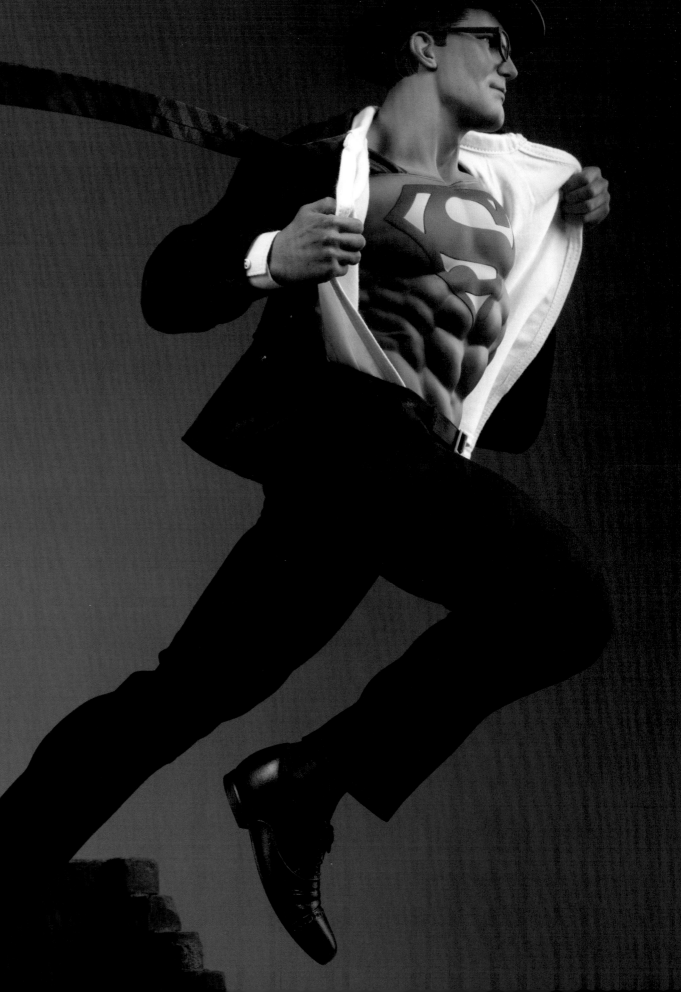

SUPERMAN
CALL TO ACTION

Nobody tears my city apart and gets away with it. —Superman, *Superman* #75 (1992)

This dynamic DC statue captures one of the most celebrated transformations in popular fiction, as Clark Kent rips open his shirt to reveal the iconic chest emblem known as a beacon of hope throughout the universe.

One of the most inspiring collectibles ever crafted by Sideshow, the Superman: Call to Action Premium Format Figure is an ambitious combination of sculptural elements, fabric costuming, and hand-painted elements unlike any attempted by the studio before, and the results are astonishing. It's impossible to behold the Superman: Call to Action Premium Format Figure without feeling inspired to join Superman's never-ending battle for truth and justice.

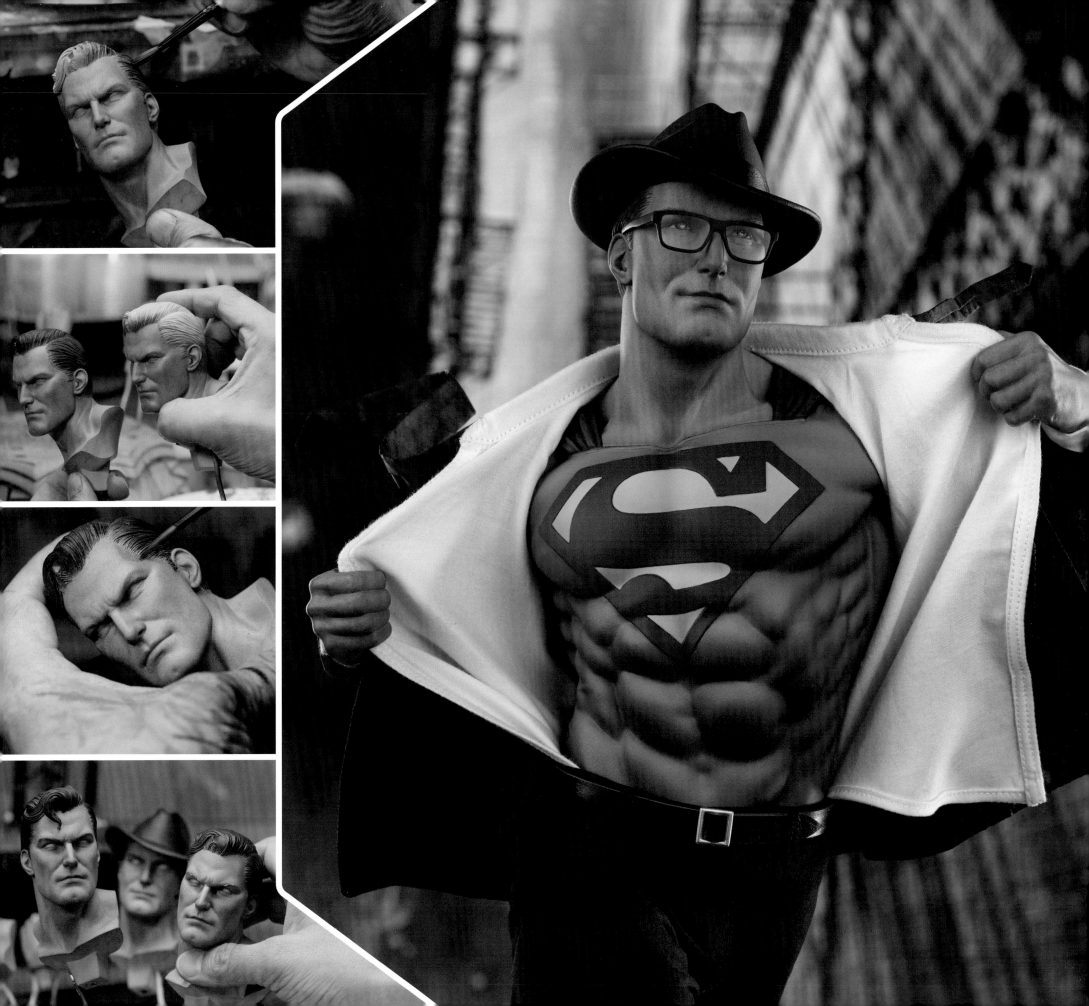

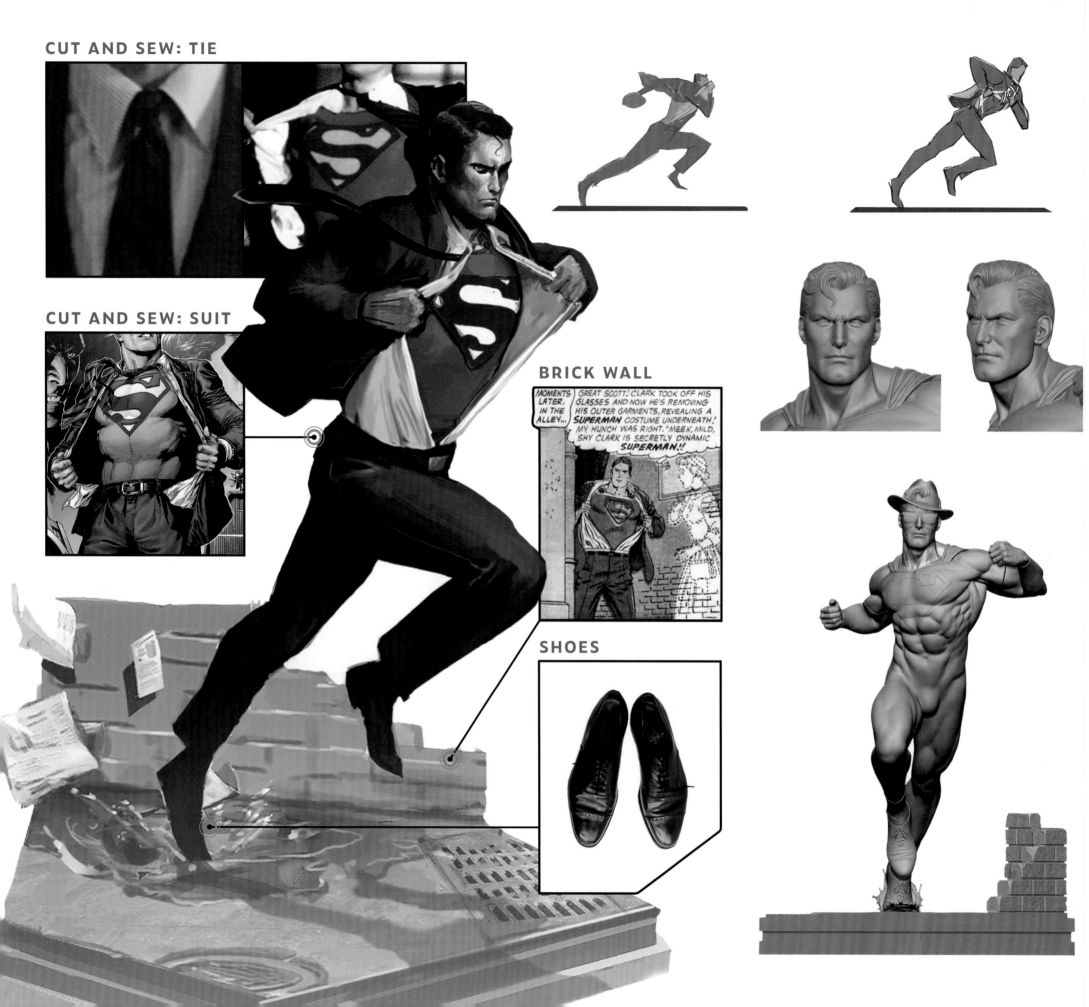

CUT AND SEW: TIE

CUT AND SEW: SUIT

BRICK WALL

MOMENTS LATER, IN THE ALLEY...

GREAT SCOTT! CLARK TOOK OFF HIS GLASSES AND NOW HE'S REMOVING HIS OUTER GARMENTS, REVEALING A *SUPERMAN* COSTUME UNDERNEATH.' MY HUNCH WAS RIGHT. "MEEK, MILD, SHY CLARK IS SECRETLY DYNAMIC *SUPERMAN*.!!

SHOES

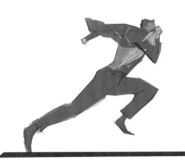
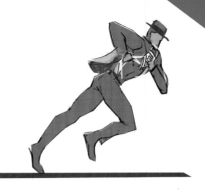
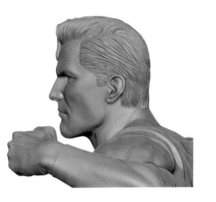
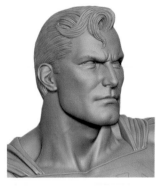
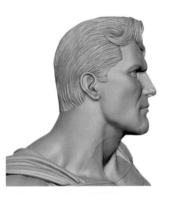
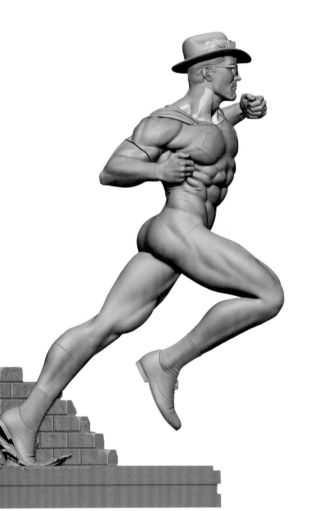
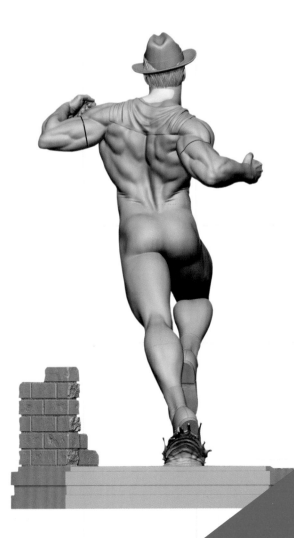
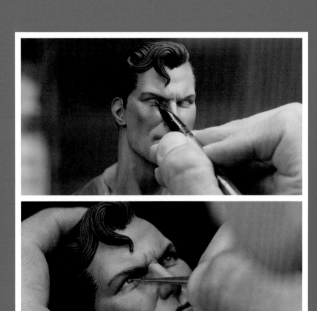

"Call to Action will always be a project that's very near and dear to me, as it was my first art directed piece," says Tim Hanson. "Being able to go through all the phases, from 2D design all the way to prototyping, was a very special process, and one that I greatly enjoyed. We looked at several iterations of the idea in the design phase, from standing heroically all the way to leaping off the ground. Superman has an enormous wealth of history in so many forms of media, it was fun to dive into them and explore."

CUT AND SEW

Superman has made an indelible impression on fans through comic books, television, and film. Costume fabrication manager Tim Hanson and his team drew from a wealth of reference material when developing their ideal Man of Steel. "We had the important decision of representing both Superman *and* Clark Kent in this format, and I'm very proud of achieving that. The fedora and glasses, with the smirk, really sells that good-natured, old-fashioned charm of the character," says Hanson.

"Most of the time, our characters hands don't have to specifically interact with the fabric costume. But this time, it was absolutely pivotal," Hanson adds. After experimenting with different 3D elements and fabrics, Hanson found the perfect combination of materials for the Call to Action figure's street clothes, which complemented Superman's heroic costume. "I had specific ideas of where the shirt would tuck, with the tension from one hand, up across the back of the neck, to the other hand. The wired tie is an essential element to the whole figure also, both functionally and aesthetically. It really carries the action of the scene."

Making sure every element of Call to Action was just right required a lot of hard work and difficult decisions, but for Hanson, ultimately, it was a labor of love. "It was challenging to work around this pose, and to really find the right shape of the garments that best complemented the Super Heroic anatomy underneath," says Hanson. "Because of this action pose and the costume layers, there's quite a bit of fitting that needs to happen before everything lands just where it should. It really is one of my favorite pieces ever."

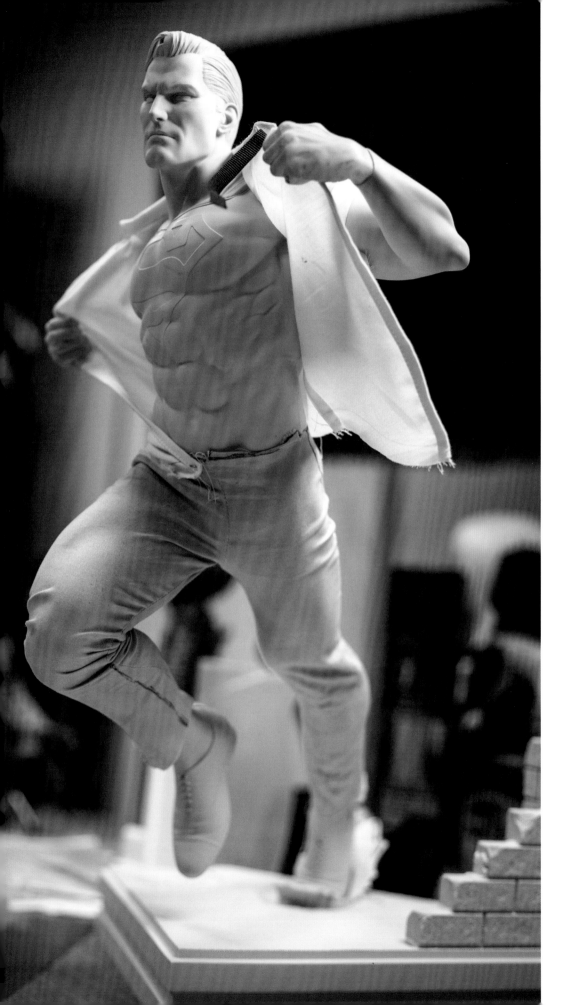

SUPERMAN: CALL TO ACTION PF #300715
SUIT PATTERN

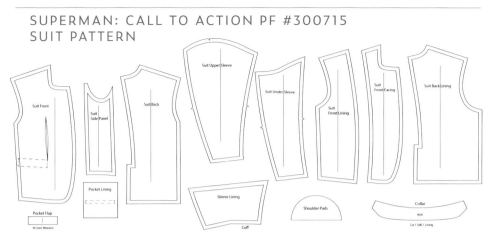

SUPERMAN: CALL TO ACTION PF #300715
PANTS PATTERN

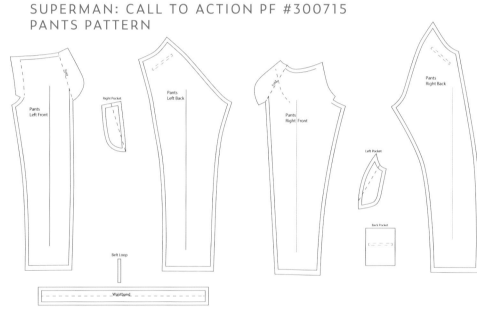

SUPERMAN: CALL TO ACTION PF #300715
SHIRT PATTERN

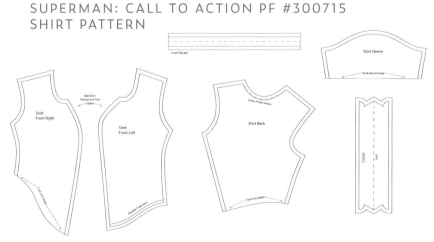

ROBIN

Of course we're going to do this. I said it looked tough, not unbeatable.
—Robin, *Young Justice: Secret Files and Origins* #1 (January 1999)

Robin, the Boy Wonder, leaps into action in a dynamic collectible that proves that Batman's young sidekick is truly a force to be reckoned with. The Teen Titan dodges gunfire at Gotham City's Ace Chemical warehouse, armed with a battle staff and a devil-may-care attitude.

The polyresin Robin Premium Format Figure features a sculpted red-and-green costume complete with a black-and-yellow fabric cape with a removable hood. This action-packed DC statue also includes two distinct portraits featuring differing hairstyles, expressions, and green domino masks, so that collectors can choose which version of this iconic hero they want to display.

This particular version of Robin is Damian Wayne, son of Bruce Wayne and his longtime love interest and rival Talia al Ghul. Damian's training at the hands of the legendary League of Assassins—and his proficiency with all forms of armed and unarmed combat—make him one of the most dangerous crime fighters in the DC multiverse.

"This project was a really fun creative challenge," says sculptor Matt Black. "Great character, great costume, and wonderful pose. That aerial leap was one of the most exciting aspects of the concept." Comic books were just the tip of the iceberg when Black compiled research materials for this particular figure. "I ended up watching a *ton* of parkour videos as well as Olympic gymnasts," Black notes. "I really wanted to understand the mechanics of this type of action, to get some idea as to how to make it balanced and planted."

Capturing that graceful, athletic motion was very important to costume fabricator Esther Skandunas, who was tasked with outfitting the Boy Wonder. "I really enjoyed creating the cape for Robin," says Skandunas. "I created it so that it has wires between the layers of the fabric. By doing this, the wired cape allows the collector to pose the fabric any way they like. It almost has a life of its own."

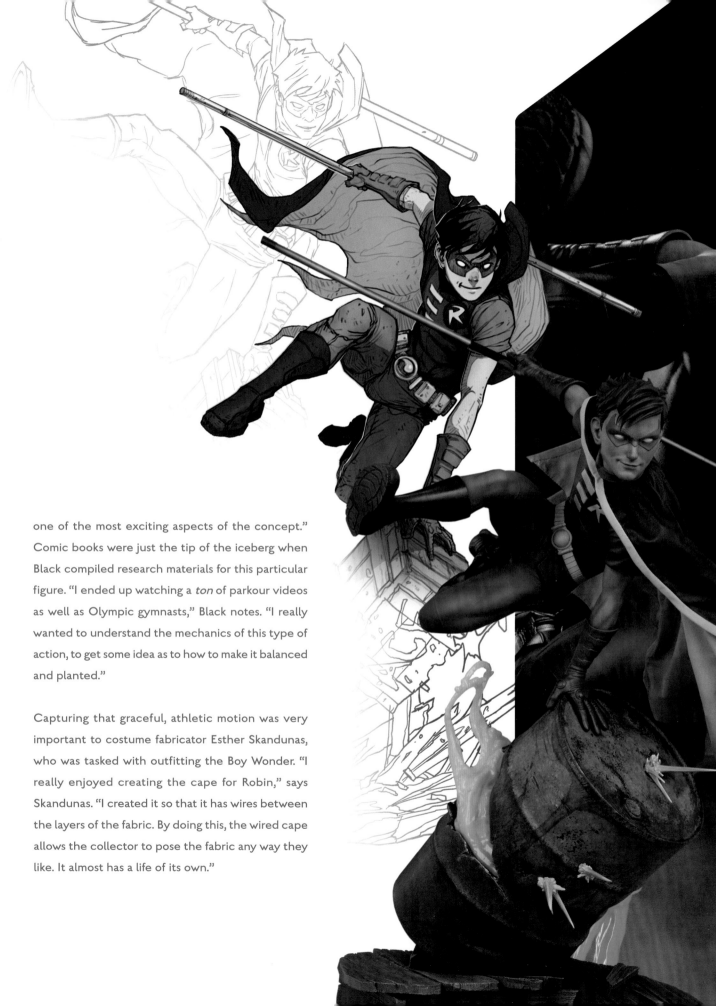

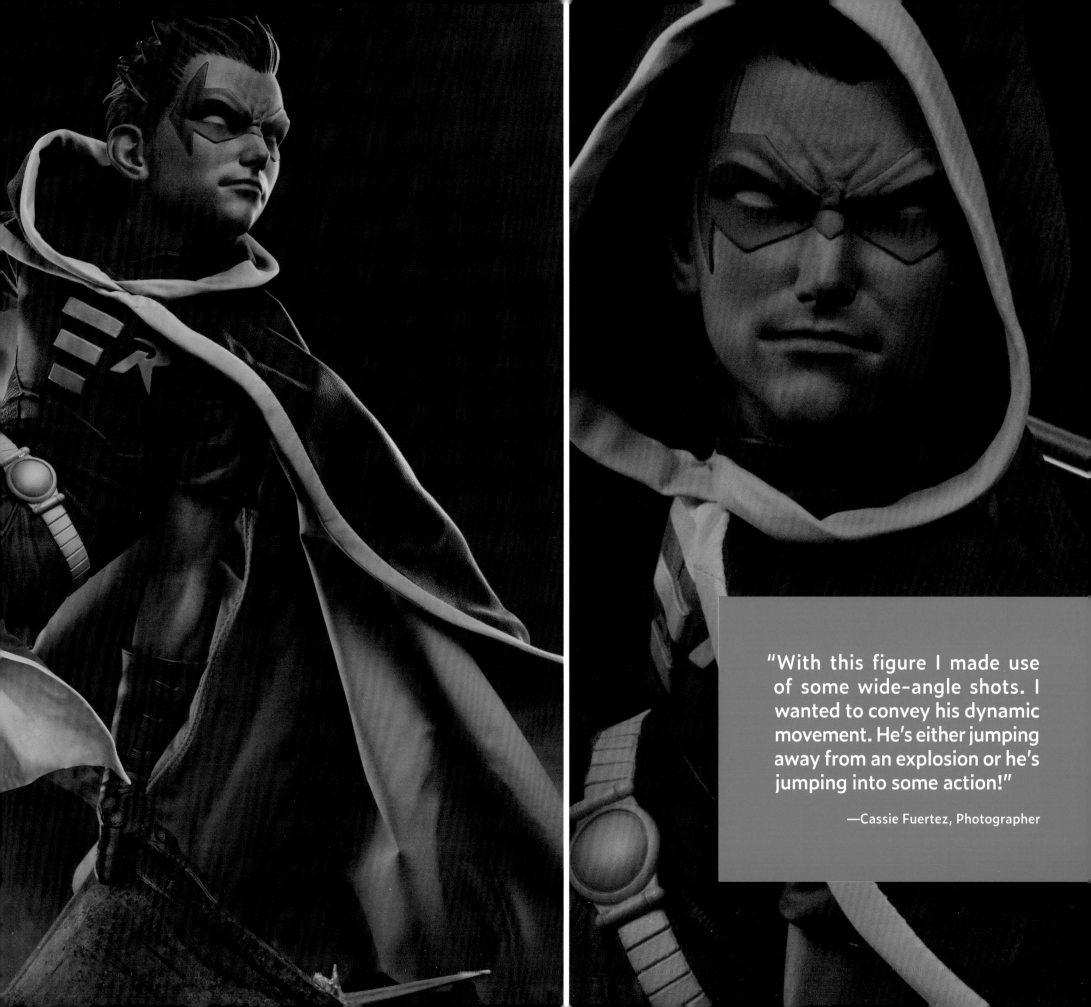

"With this figure I made use of some wide-angle shots. I wanted to convey his dynamic movement. He's either jumping away from an explosion or he's jumping into some action!"

—Cassie Fuertez, Photographer

BUSTS

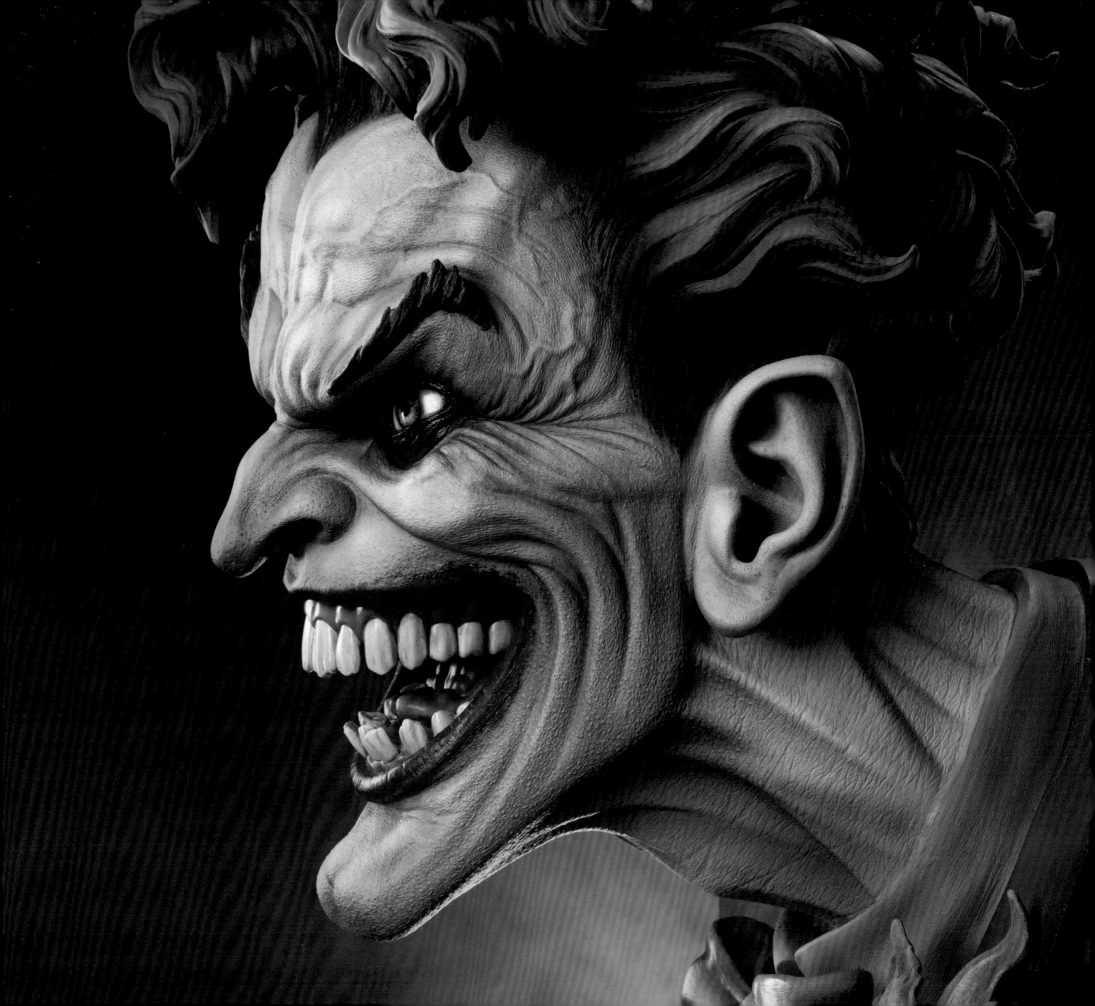

> ## "I'M WILLING TO FIGHT FOR THOSE WHO CANNOT FIGHT FOR THEMSELVES."
> —WONDER WOMAN, *WONDER WOMAN* (2017)

BUSTS

Unlike the Premium Format Figures, which capture a specific moment in time, the Sideshow Polystone Busts are classic, museum-quality portraits of DC's most celebrated and iconic characters. These sculptures feature a staggering level of craft and detail, from the life-size 1:1-scale portrait busts to the 1:3-scale busts depicting dynamic renditions of DC's most legendary characters, including the Trinity—Superman, Batman, and Wonder Woman.

The enhanced scale of the busts presents a daunting challenge to Sideshow's creative team, as every element of these deluxe format sculptures will be studied and scrutinized to an extent that smaller collectibles won't. That extra-large canvas, however, gives the designers, sculptors, and painters the opportunity to bust out all their skills with more nuanced portraits of these classic characters.

Designer and sculptor Ryan Peterson loves the 1:1 format, and the opportunities for self-expression that each piece presents. "With all the 1:1 busts, I scour the Internet, graphic novels, books, etc., for references to extrapolate from," says Peterson. "In addition, I will often get some loose expression and pose references from the Sideshow design team. All of it acts as the springboard for the characteristics that we would like to see in the finished piece. The challenge is to not borrow too heavily from one source or artist interpretation of the character and try to achieve something fresh and new."

"Once the direction is established, I will finalize the ZBrush [sculpting program] design and print out a small maquette from my Form2 3D printer," Peterson adds. "From there I will create the armature and sculpt the bust with feedback from Sideshow along the way. Since I currently live in Utah, the final step involves me loading up the sculpture in a car and driving eleven hours to the Sideshow building in Thousand Oaks, California. If Interstate 15 is not too bumpy and my armature is sound, my delivery will be a success!"

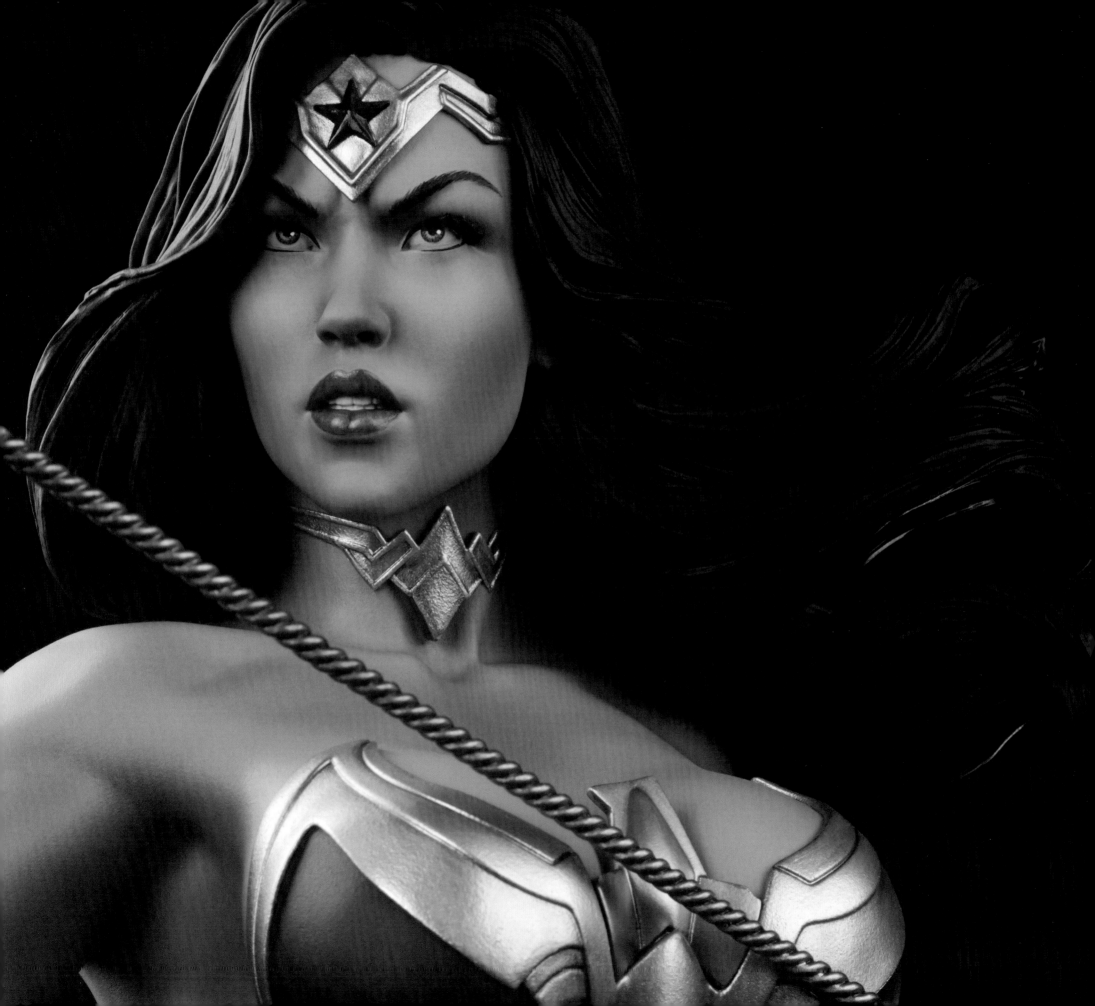

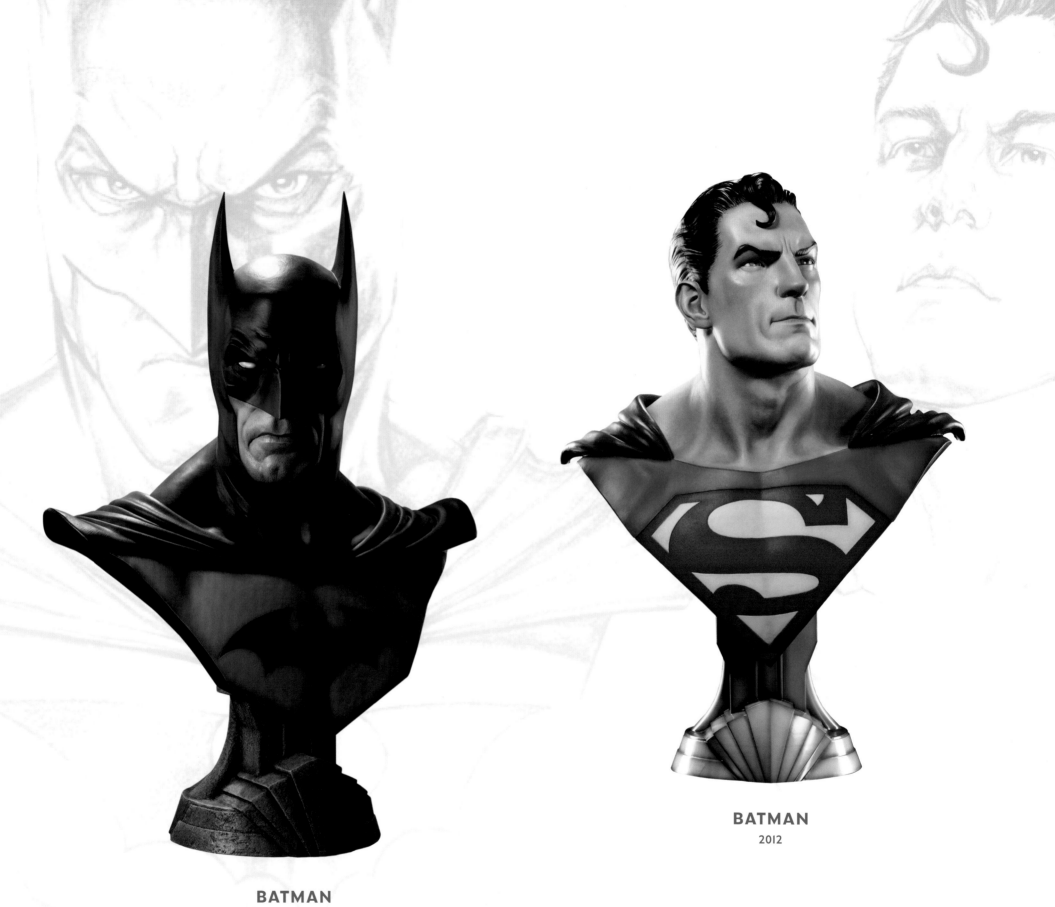

BATMAN

2011

BATMAN

2012

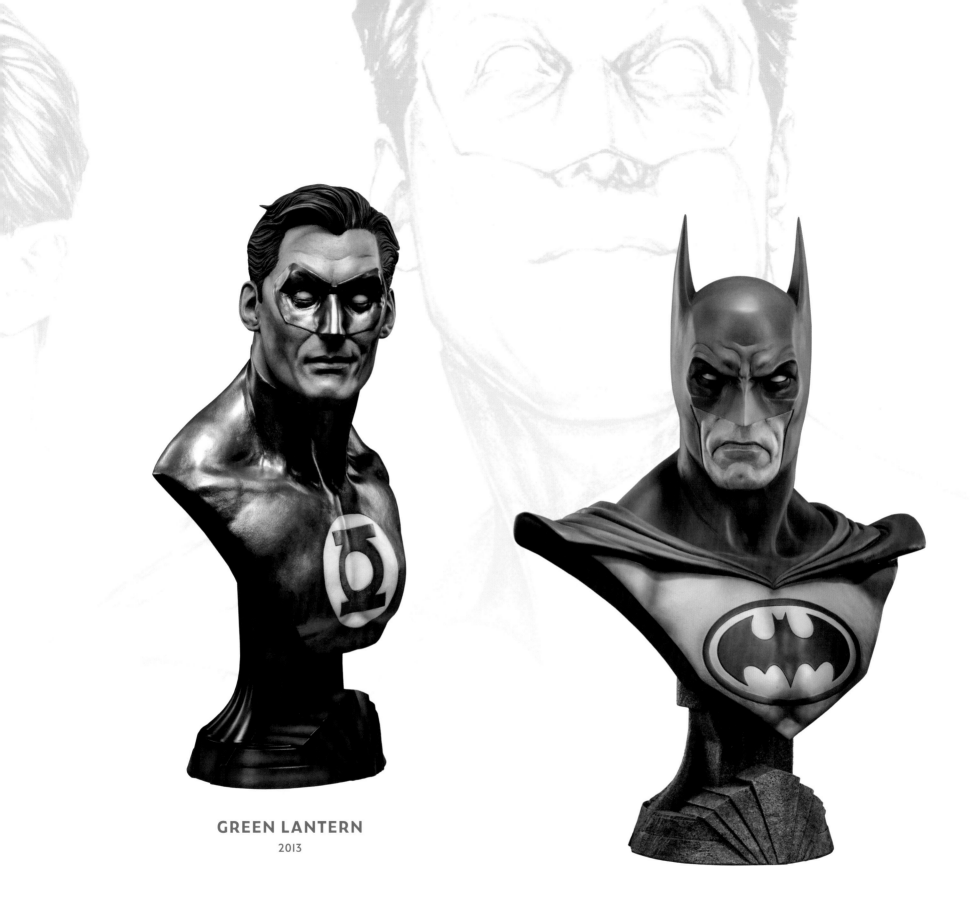

GREEN LANTERN

2013

BATMAN MODERN AGE

2013

BATMAN

Sideshow launched its line of DC Comics Life-Size Busts with the Dark Knight himself, Batman. The exquisitely detailed sculpture has been faithfully rendered at 1:1 scale, standing a massive 29 inches tall and 22 inches shoulder to shoulder.

"The sculpture was based on artwork created by one of our very talented designers," says sculptor Andy Bergholtz. "The character has such a powerfully rich visual history that there is certainly no shortage of inspiration to draw from. This piece represented an opportunity for us to bring our own style and attitude to the character. Rather than basing it on any specific comic book art or film depiction, it represents an amalgam of our favorite elements from the Batman mythos. I think we were able to create something unique that still has a classic, iconic feel."

Bergholtz continues, "I've always sort of had a vision for Batman in my head that I've wanted to bring to life in sculpture. In regards to the cowl, we wanted to capture a perfect mix of organic and hard-edged. I love the idea that it's more than just a mask, but rather something that's almost a physical part of Batman that he can emote through. This allowed us to create a more intense expression, which is essential for such a powerful character."

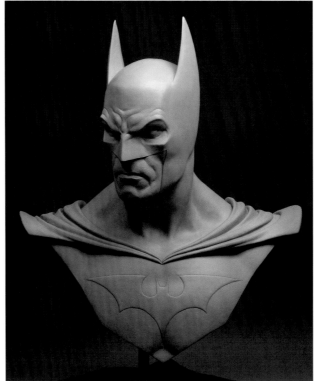
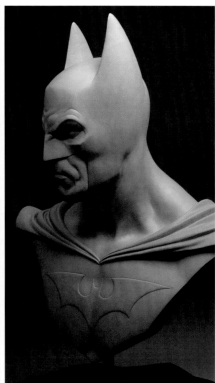
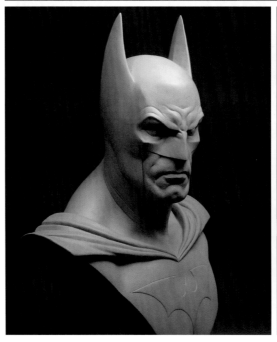
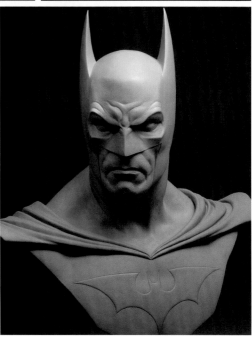

Tell everyone. All the punks, junkies, gunsels, enforcers . . . all the wise guys, leg-breakers, muscle boys . . . tell them they're finished. Tell them the streets belong to the Batman. —Batman, *Batman: Legends of the Dark Knight* #1 (November 1989)

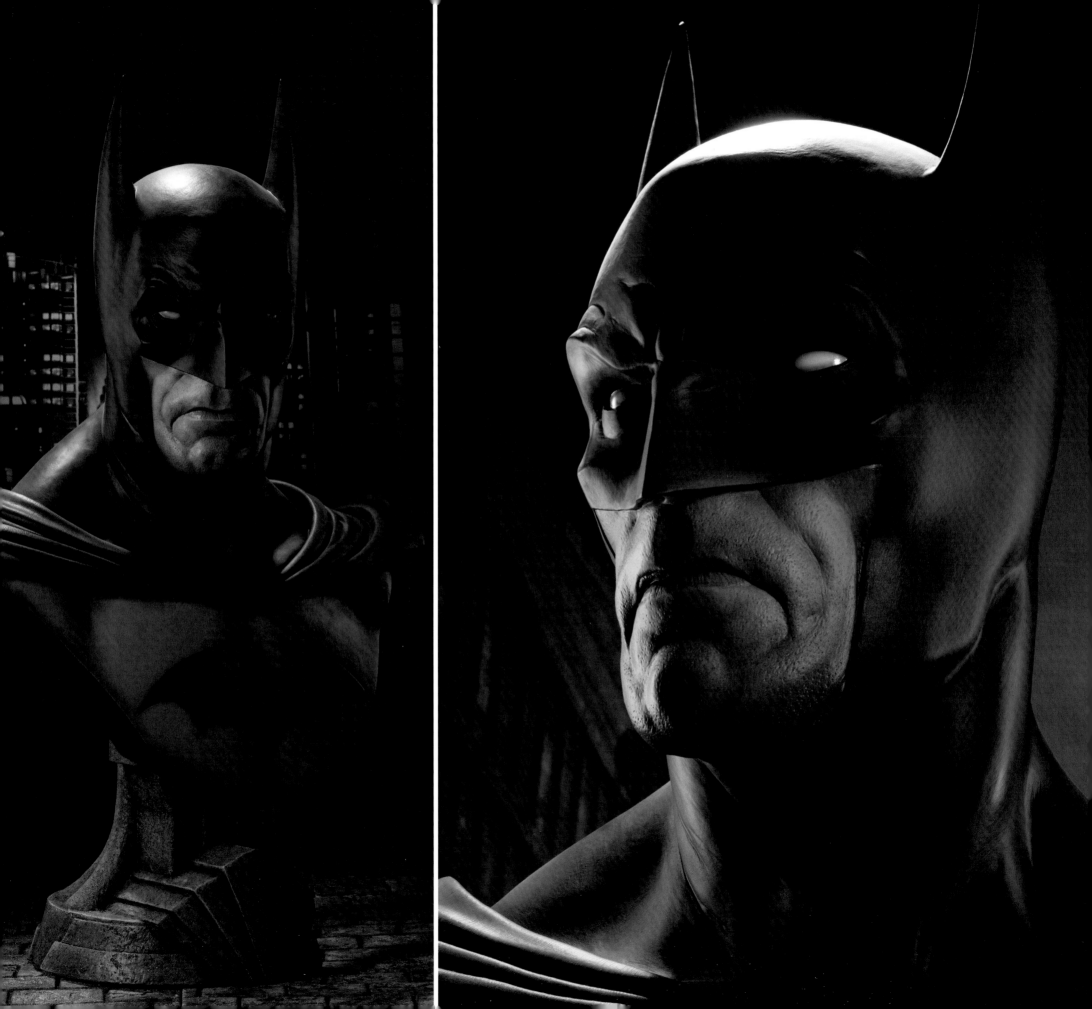

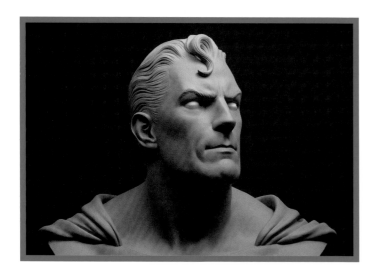

SUPERMAN

I'll always be there. Always. It's not the powers. Not the cape. It's about standing up for justice. For truth. As long as people like you are out there, I'll be there. Always. —Superman, *Action Comics* #840 (August 2006)

The Last Son of Krypton gets his due in this striking Life-Size Bust. Superman is crafted in impressive 1:1 scale, capturing every detail of this icon of the DC multiverse, designed by artist Kris Anka to capture the nobility, humanity, and heroism of the Man of Steel.

"When creating a bust, you don't have the benefit of using body language and anatomy to portray emotion the way you do with a full-sculpted figure," says Sideshow's Andy Bergholtz, explaining some of the unique challenges of this particular format. "Finding just the right facial expression is particularly important."

Getting into the right frame of mind to bring life to the Man of Steel is easier than you'd think, according to painter Bernardo Esquivel. "First, I listen to the John Williams *Superman: The Movie* soundtrack for inspiration," he laughs. "That helps me to set the overall mood of the piece. I look at and start to plot out the lighting with highlights and shadows to set a mood and tone to the overall look of the piece. Superman requires a much different approach than a character like Lobo."

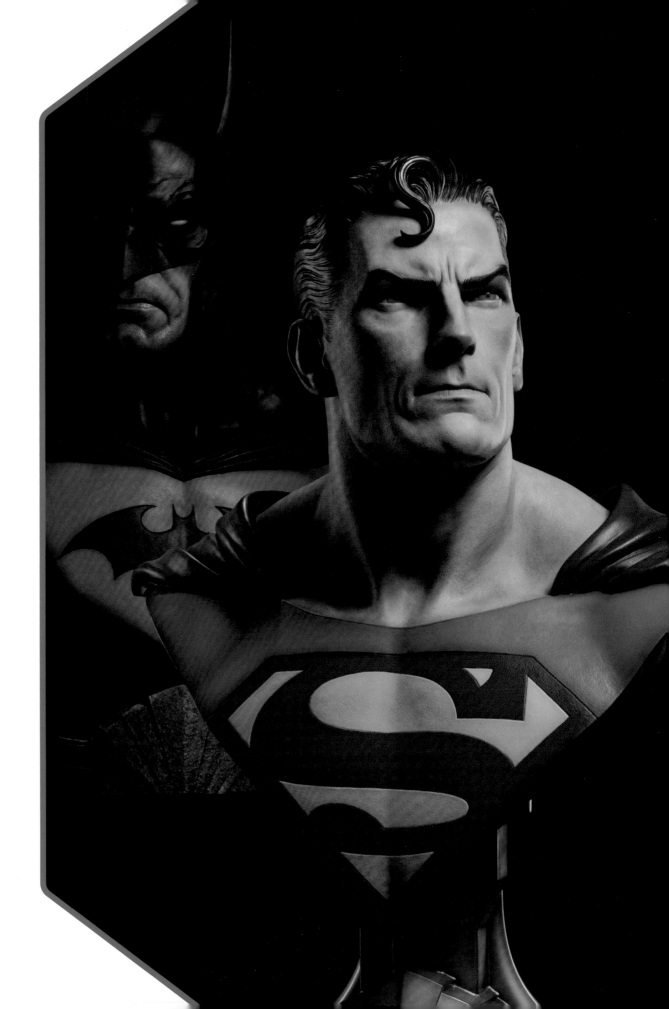

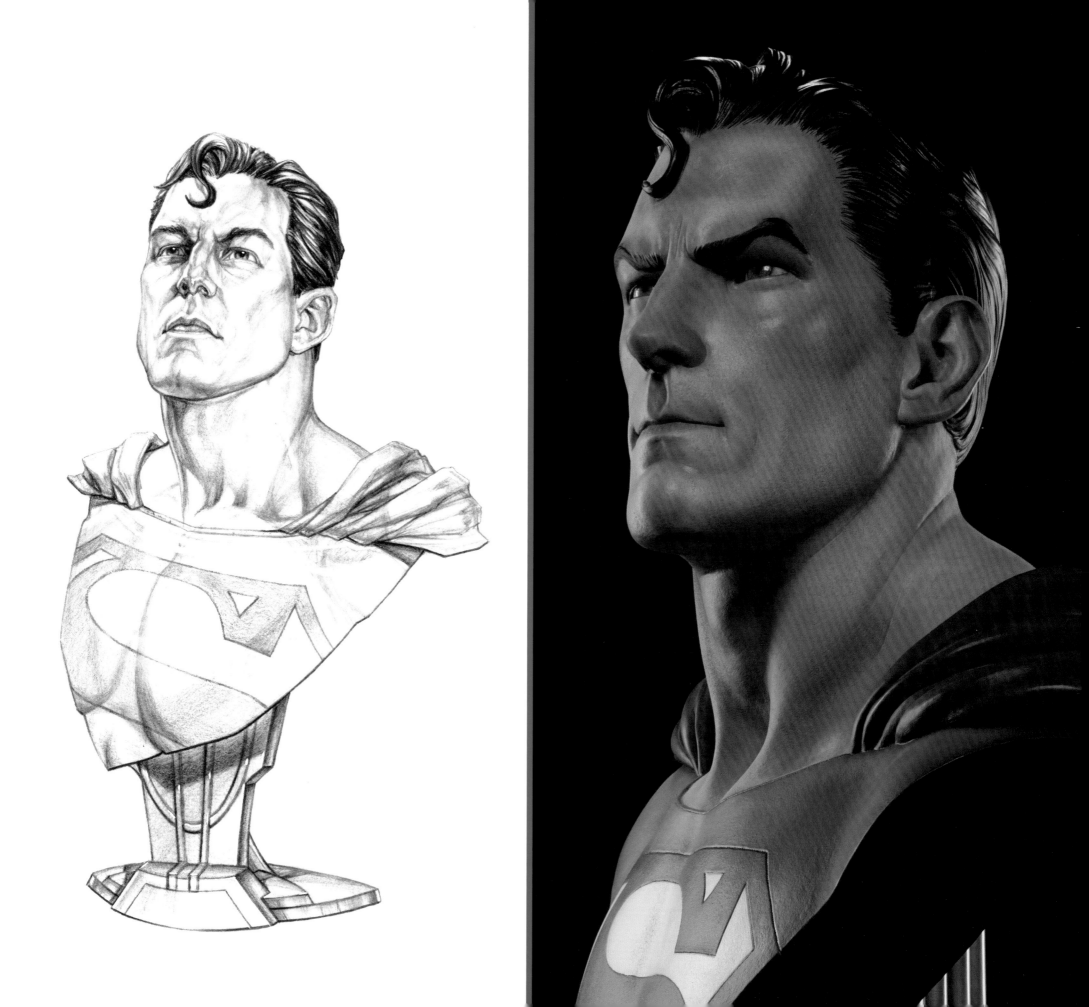

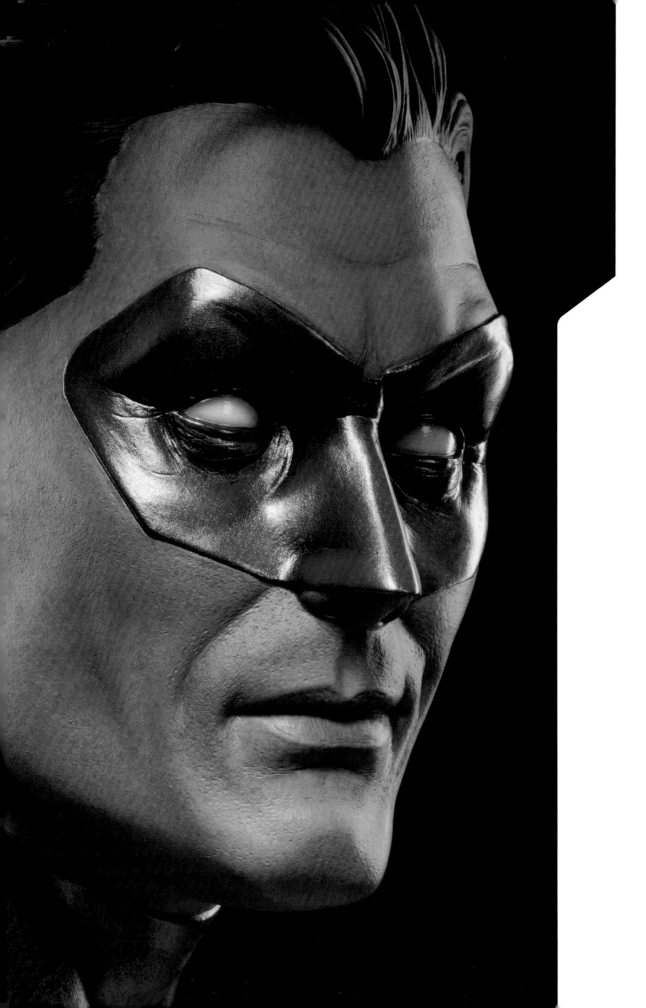
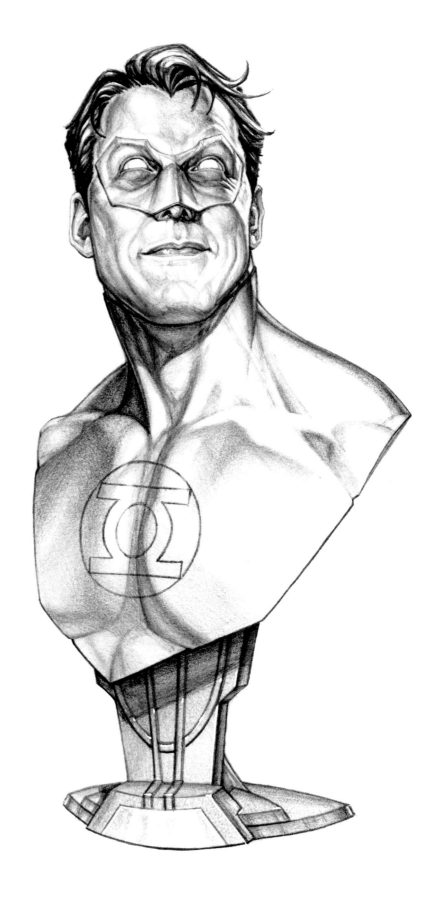

Painter Bernardo Esquivel enjoys painting 1:1-scale busts like Green Lantern, but acknowledges that these sculptures present challenges not found in smaller-scale pieces. "Painting a bust is tricky because it depends on the subject matter or character and sculpt," says Esquivel. "You don't have much liberty adding drama to a bust, as it's so big, but at the same time you gotta add something to it so it's not so plain as well. Finding the right balance of color to be realistic or to be more 'comic-booky' is a bit of a challenge. The bust will most likely have a facial expression, but then we have to make sure the eyes—or in this case, GL's mask—are painted to match that expression as well."

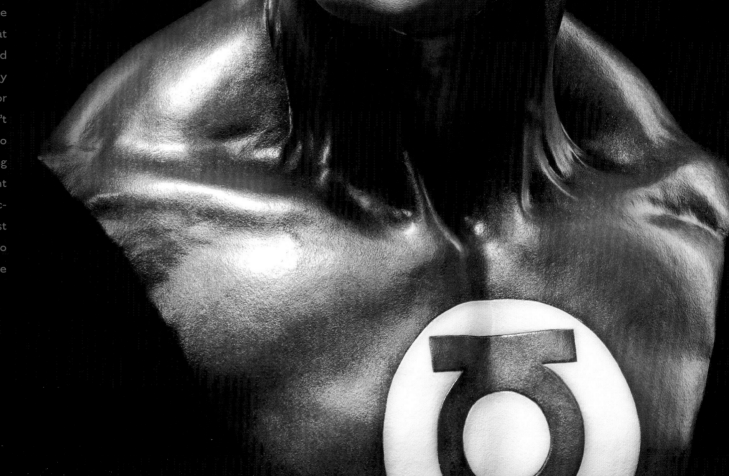

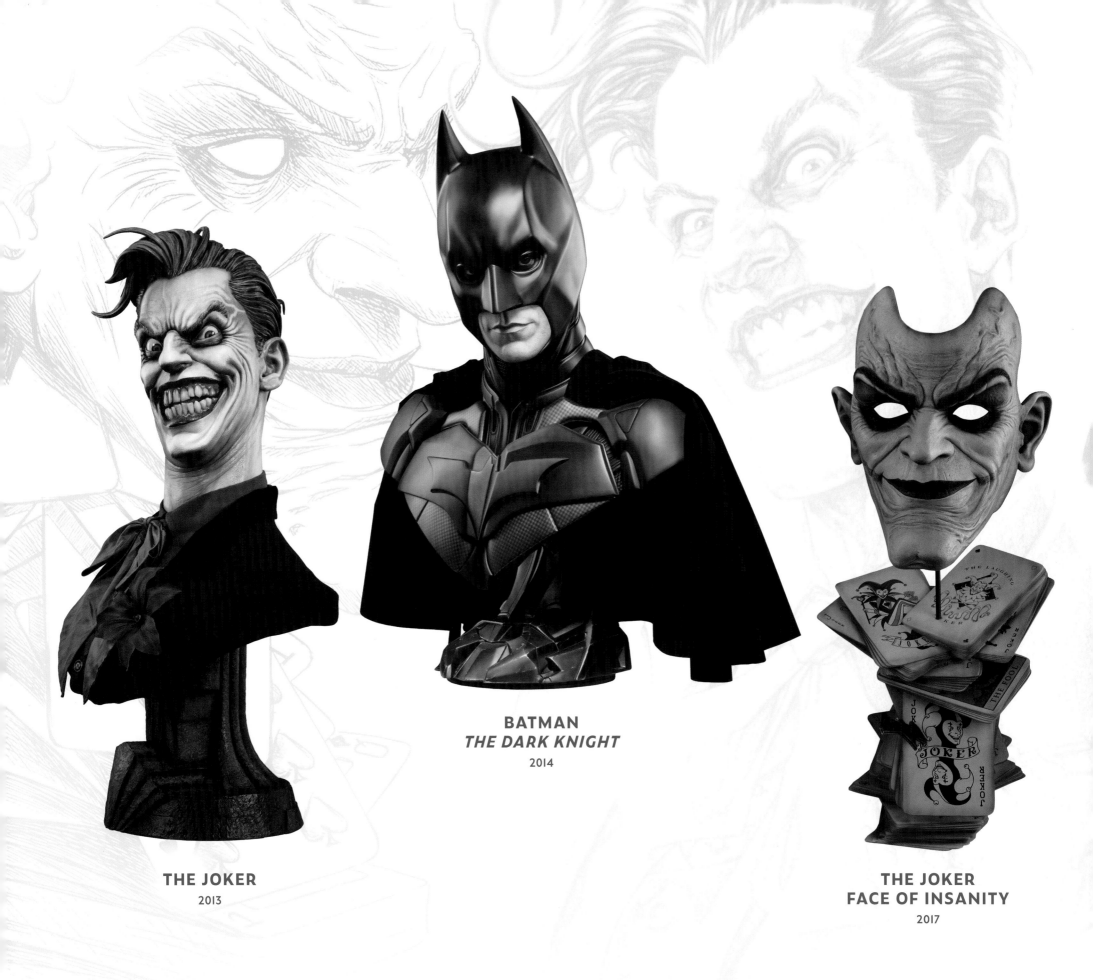

THE JOKER

2013

BATMAN
THE DARK KNIGHT

2014

THE JOKER
FACE OF INSANITY

2017

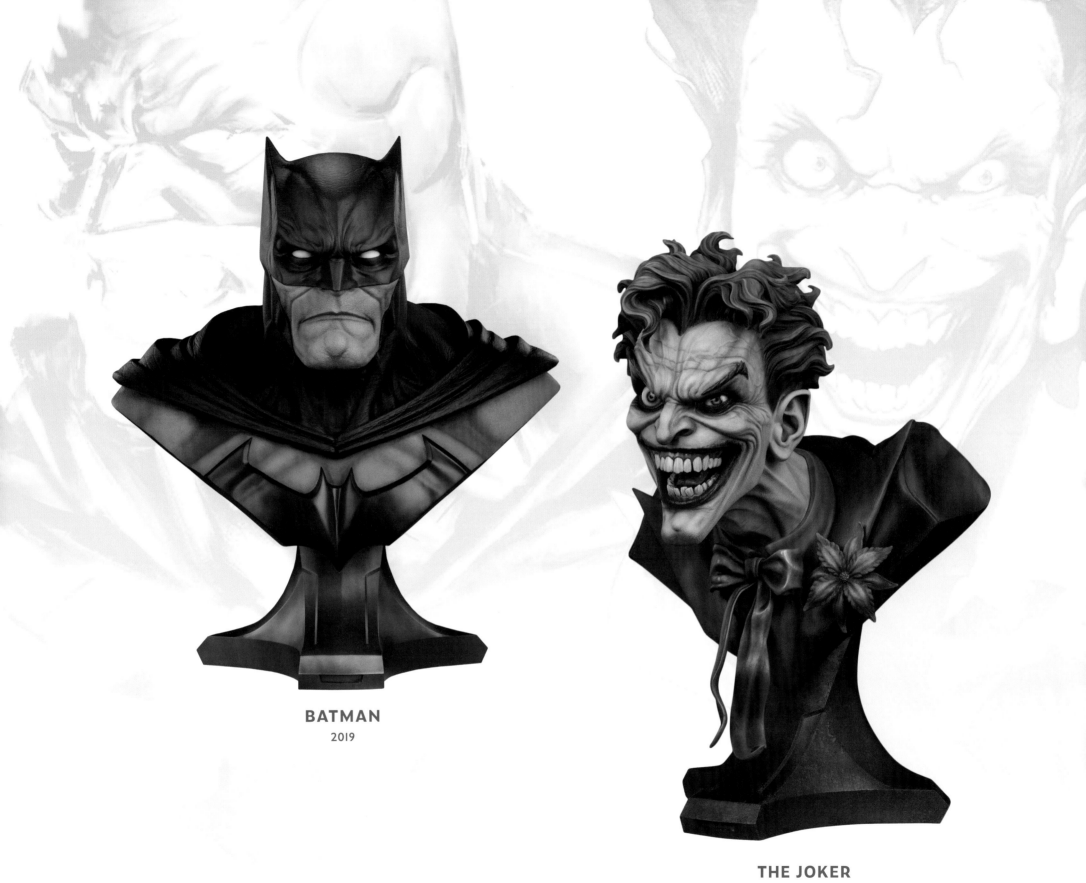

BATMAN

2019

THE JOKER

2019

DARK KNIGHT

Batman has no limits. —Batman, *The Dark Knight* (2008)

Director Christopher Nolan's epic film trilogy redefined the Dark Knight, and Christian Bale's indelible performance as Batman thrilled audiences whose enthusiasm and support made the movies an international phenomenon.

Sideshow's Dark Knight Life-Size Bust meticulously captures every detail from the costume that Bale wore on-screen in the trilogy's second film, *The Dark Knight*. Based on designs provided by Warner Bros. Studios, this full-size sculpture captures every subtle detail of the costume's intricate armored plating and utilities, including Batman's newly redesigned cowl and velvety black cape. From the top of his cowl to the Wayne Enterprises art deco base, this sculpture presents an intimate portrait of the hero Gotham deserves.

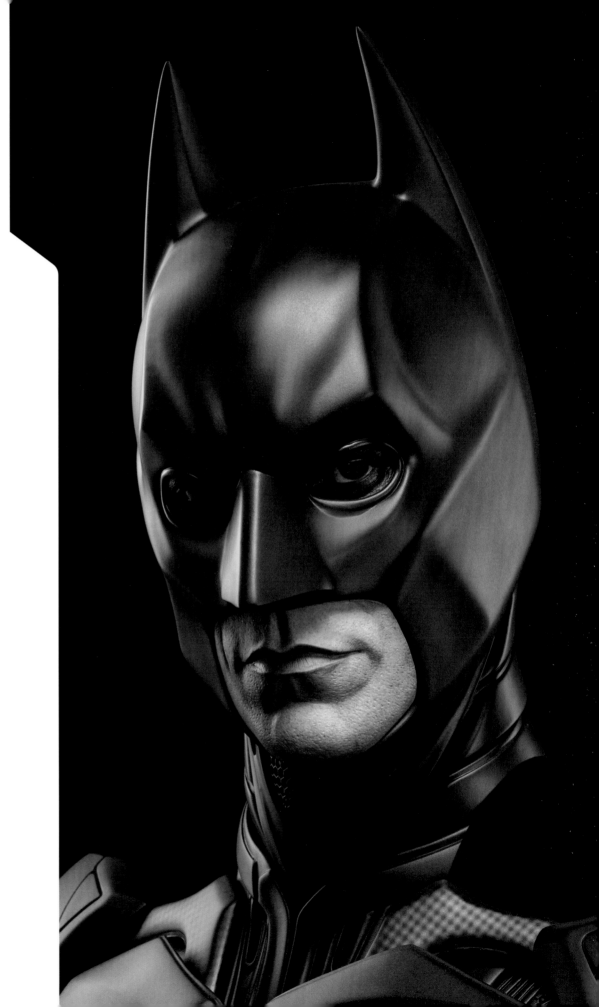

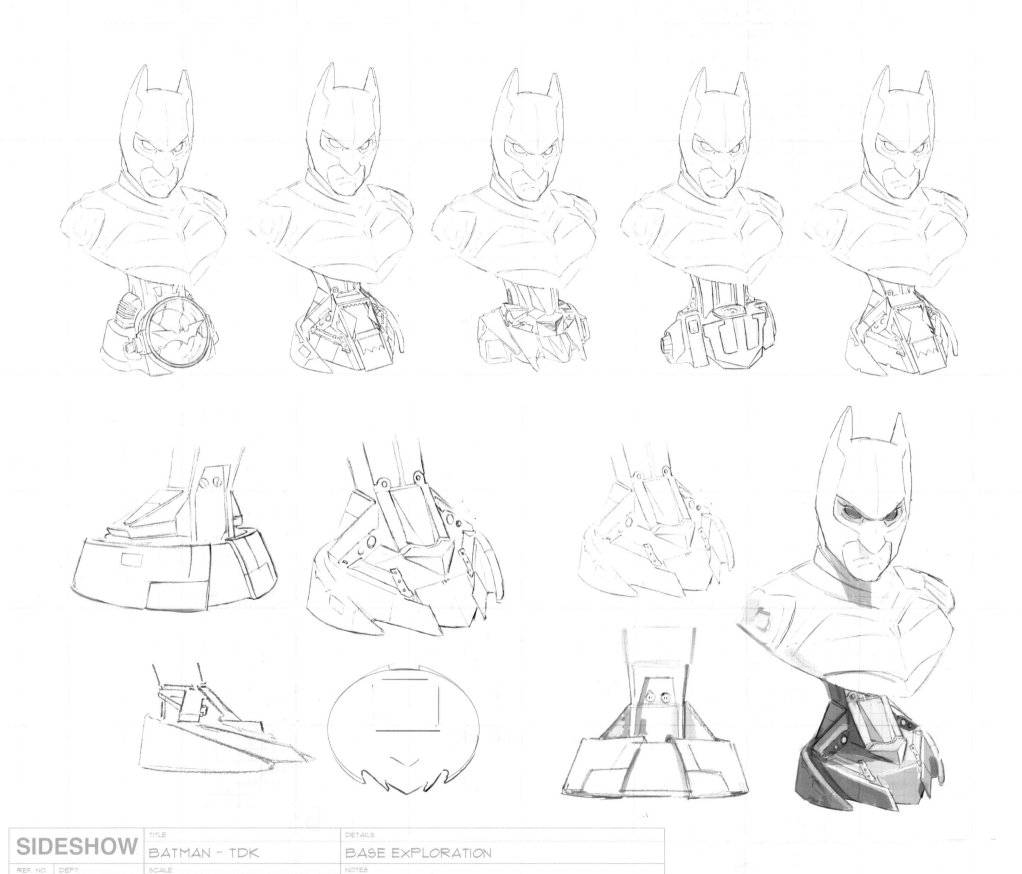

SIDESHOW	TITLE		DETAILS	
	BATMAN - TDK		BASE EXPLORATION	
REF. NO.	DEPT.	SCALE	NOTES	
225	CONCEPT	LIFE-SIZE		

PLAYING CARD ARTWORK

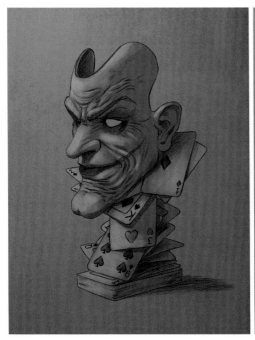 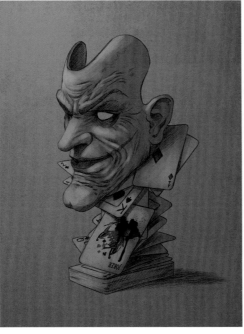

THE JOKER
FACE OF INSANITY

I'm not mad at all. I'm just differently sane. —The Joker, *Batman and Robin* #14 (October 2010)

Sideshow and PureArts bring collectors face-to-face with Batman's greatest foe in a chilling portrait of evil, The Joker: Face of Insanity Life-Size Bust. Equal parts comedy and tragedy, this bust is meticulously sculpted to capture every detail of The Joker's madness, from the furrow in his focused brow to creases formed by his signature smile. The piece is made of resin with a metal mask stand, which holds the frightening face aloft.

The sculpture's base is composed of a cascade of playing cards, all featuring classic depictions of jokers and jesters past. The iconic gaming imagery and the twisted visage of the Clown Prince of Crime make for an unforgettable combination.

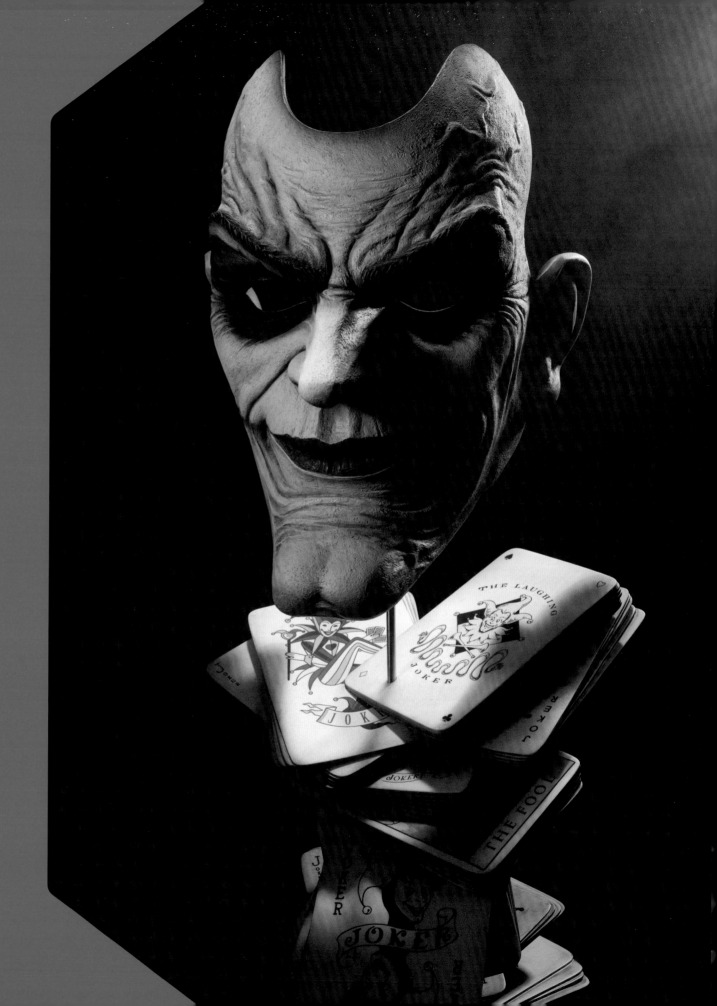

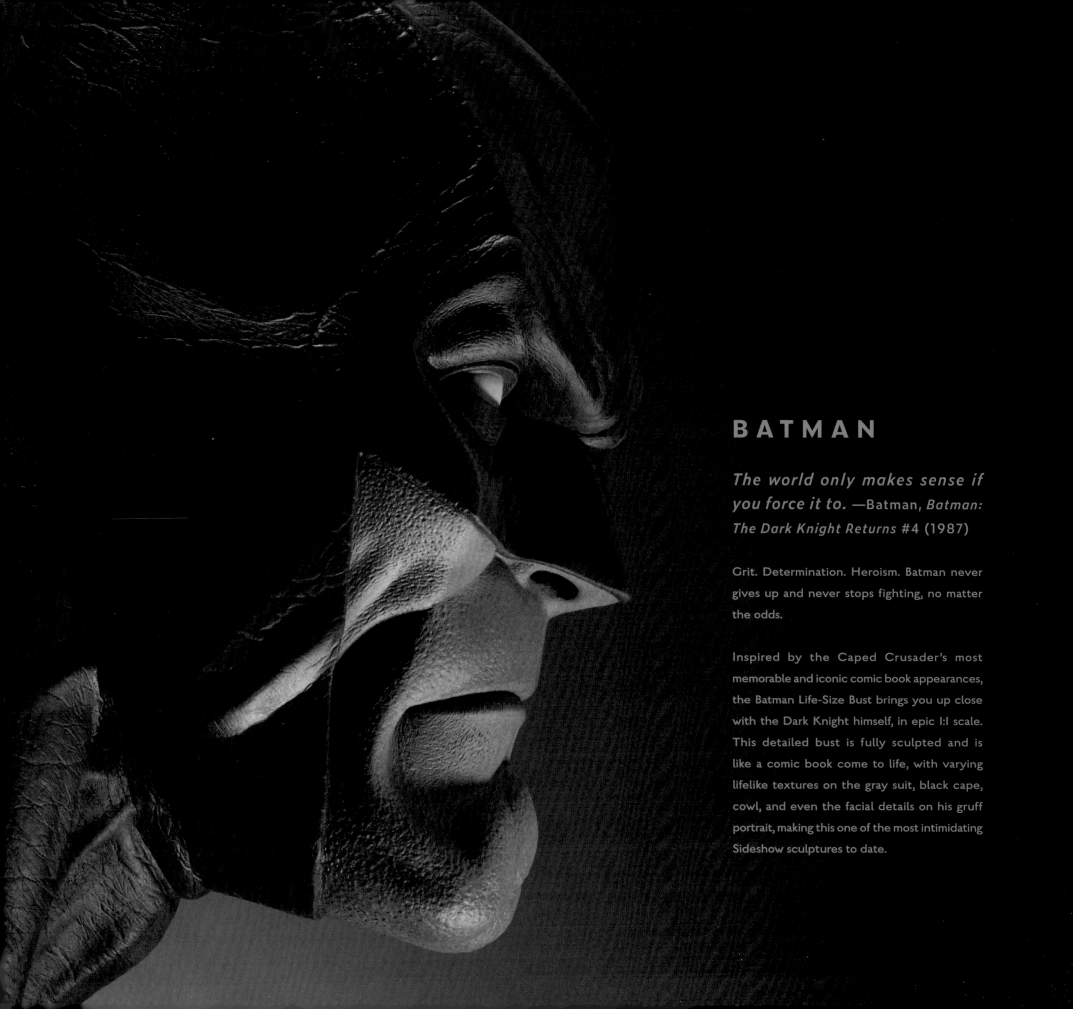

BATMAN

The world only makes sense if you force it to. —Batman, *Batman: The Dark Knight Returns* #4 (1987)

Grit. Determination. Heroism. Batman never gives up and never stops fighting, no matter the odds.

Inspired by the Caped Crusader's most memorable and iconic comic book appearances, the Batman Life-Size Bust brings you up close with the Dark Knight himself, in epic 1:1 scale. This detailed bust is fully sculpted and is like a comic book come to life, with varying lifelike textures on the gray suit, black cape, cowl, and even the facial details on his gruff portrait, making this one of the most intimidating Sideshow sculptures to date.

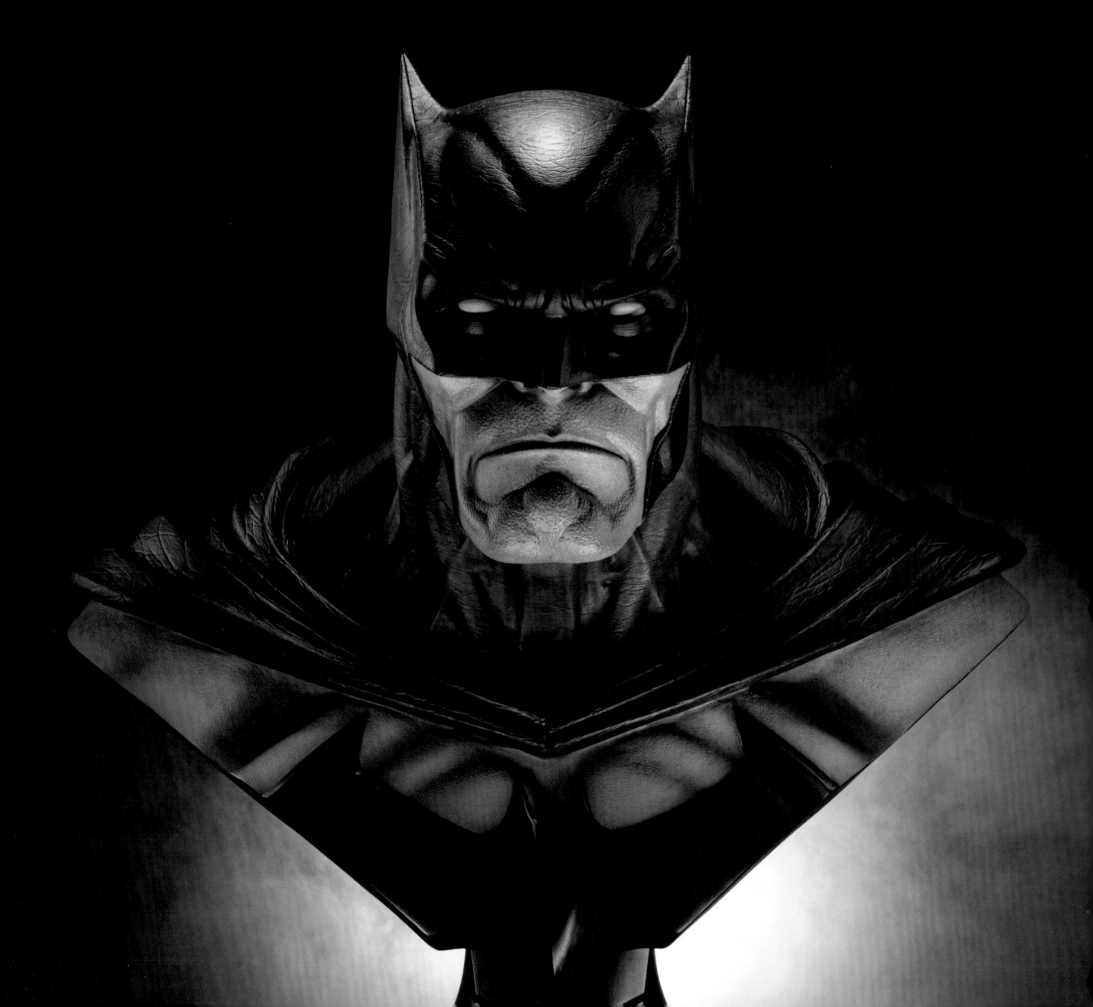

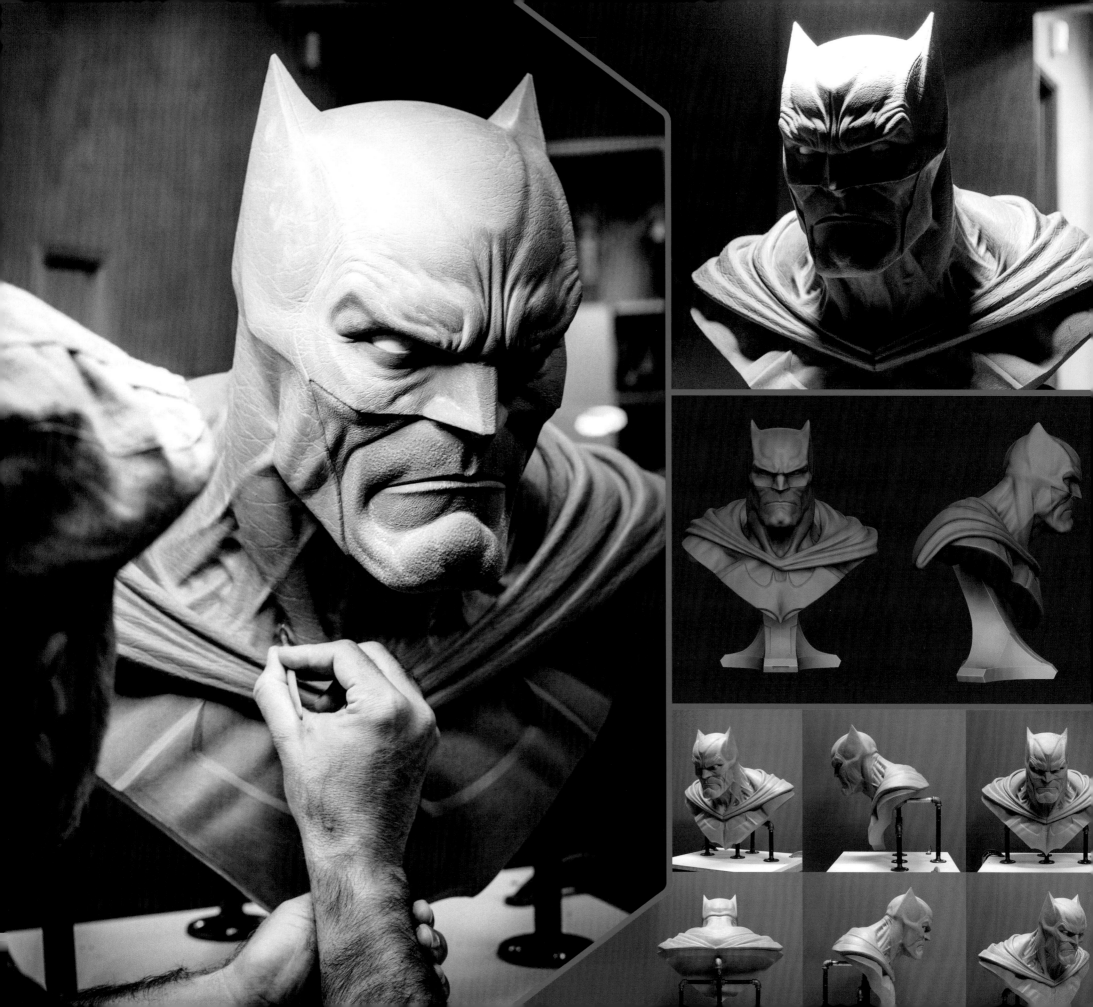

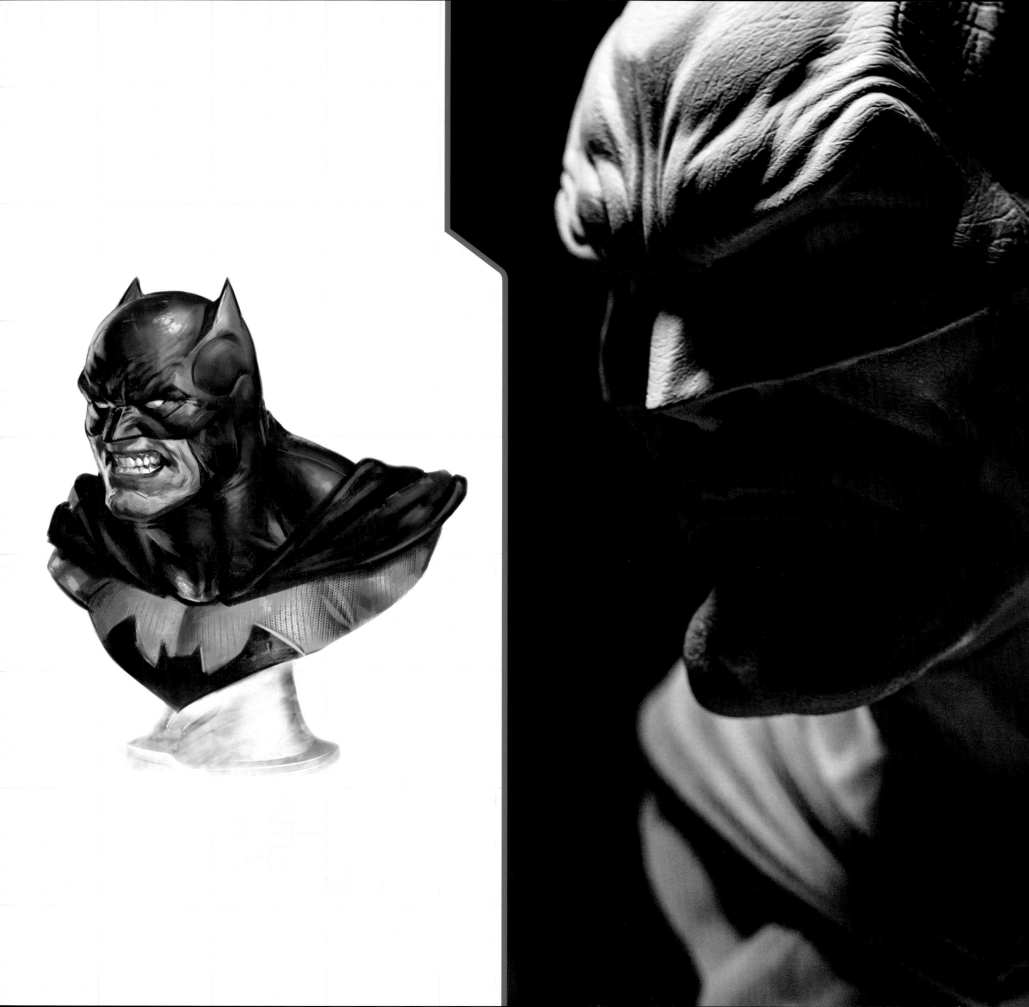

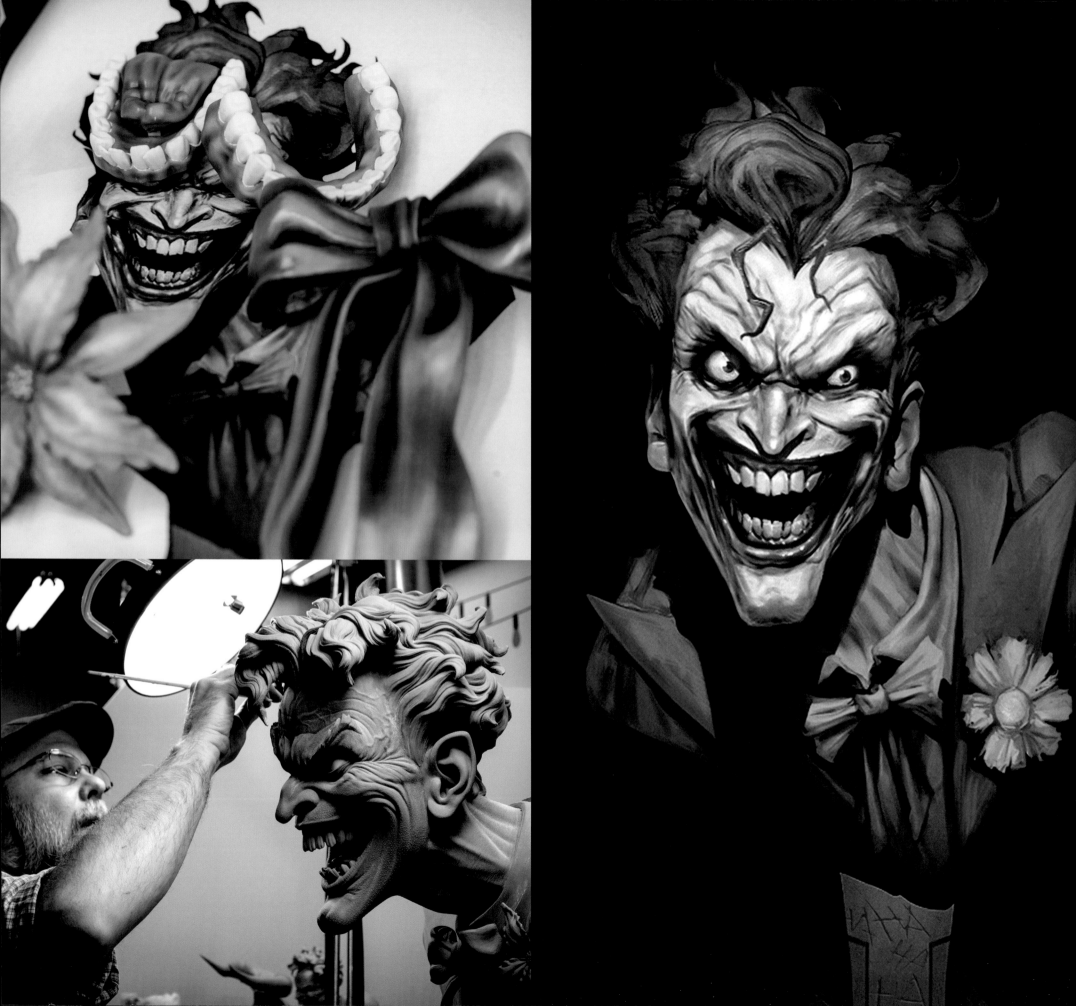

THE JOKER

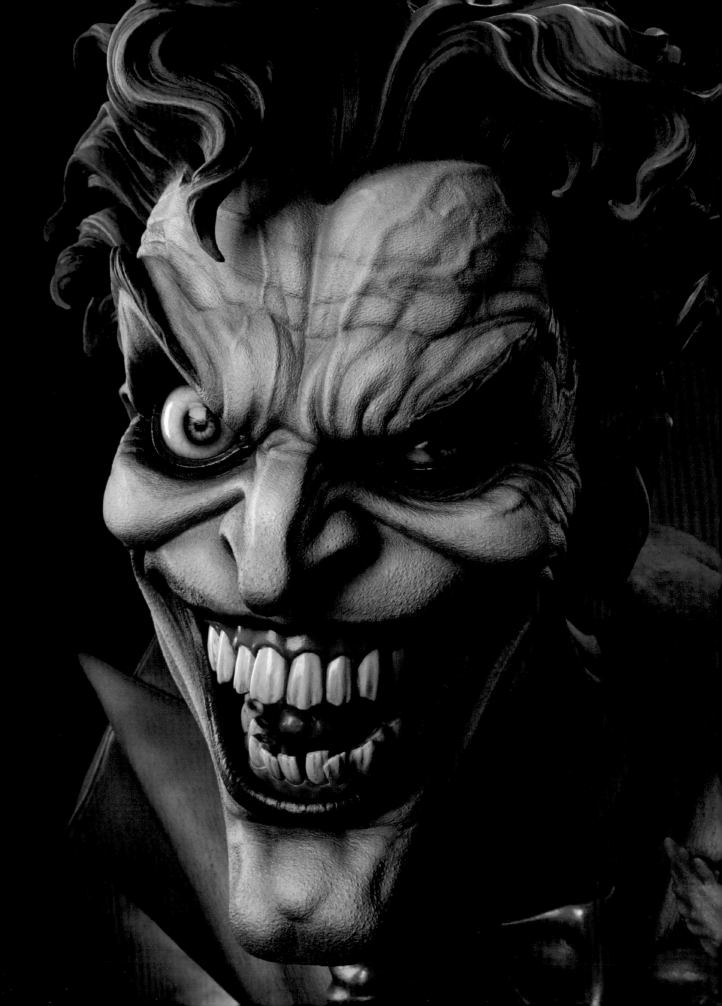

Why aren't you laughing? —The Joker,
Batman: The Killing Joke #1 (1988)

The Clown Prince of Crime is big as life and twice as
crazy in this addition to Sideshow's collection of DC
Comics Life-Size Busts. This fiberglass and resin statue
captures The Joker's madness as well as his distinctive
fashion sense, as the dapper master criminal sports a
tailored fabric dress shirt, tie, and jacket, topped off
with a silk flower on his lapel. This chilling portrait
of evil portrays The Joker's maniacal grin, gleefully
crazed eyes, and devilish attitude.

Bringing The Joker's insanity to life required a unique
set of skills and artistic sensibilities, says designer and
sculptor Ryan Peterson. "I consider myself to be a
low-tech guy, which is ironic considering that most
of my essential tools are digital," says Peterson. "My
education and experience have mainly been practical,
with clay, and that is what my brain has marinated in
for most of my life.

"With the Joker bust," Peterson notes, "I brought those
elements together, with both practical and digital
sculpting and design. I realize, due to technological
advancements, that it may not last, but for now, it has
been nice keeping both sides of my brain balanced
between these two worlds. For this piece, I sculpted
everything out of clay except for the teeth and
tongue, which I digitally sculpted and 3D printed
instead. It was a fun mixture of both."

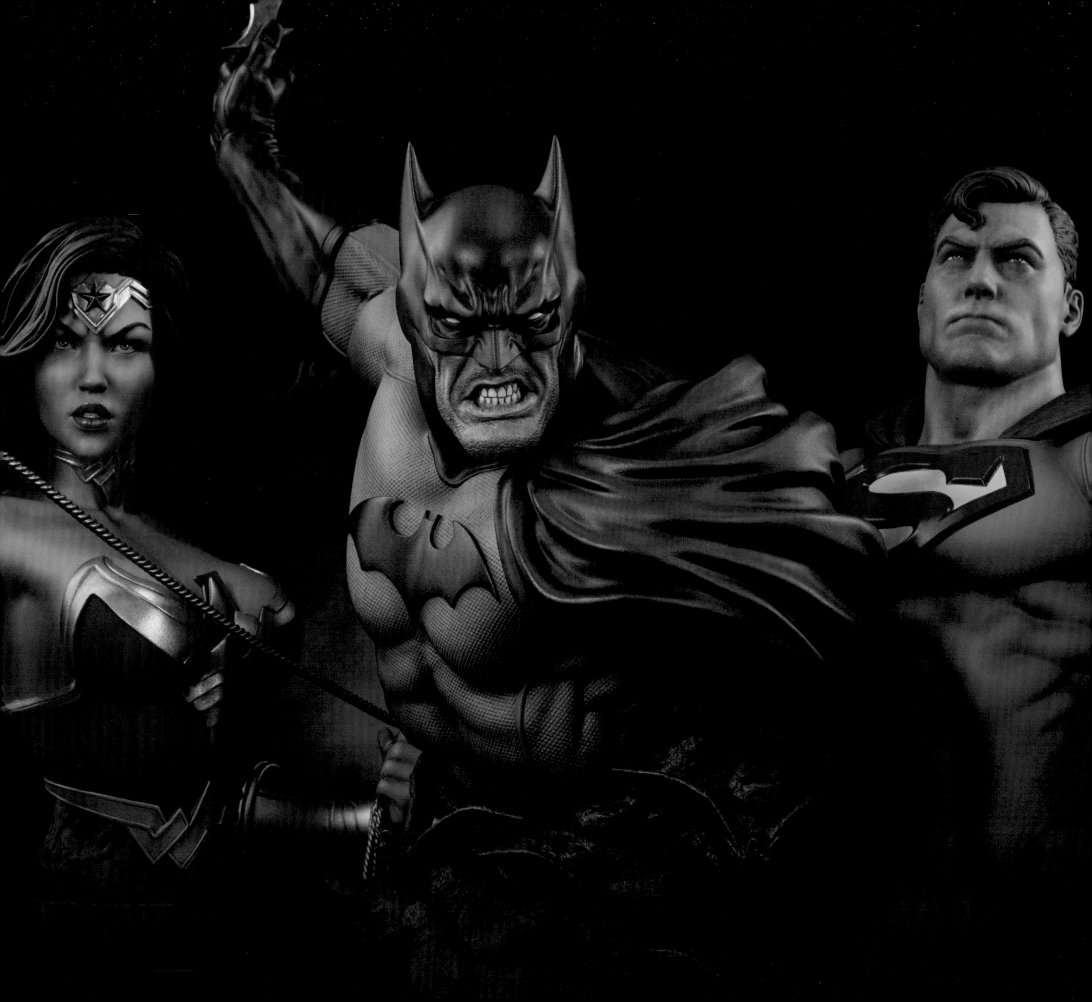

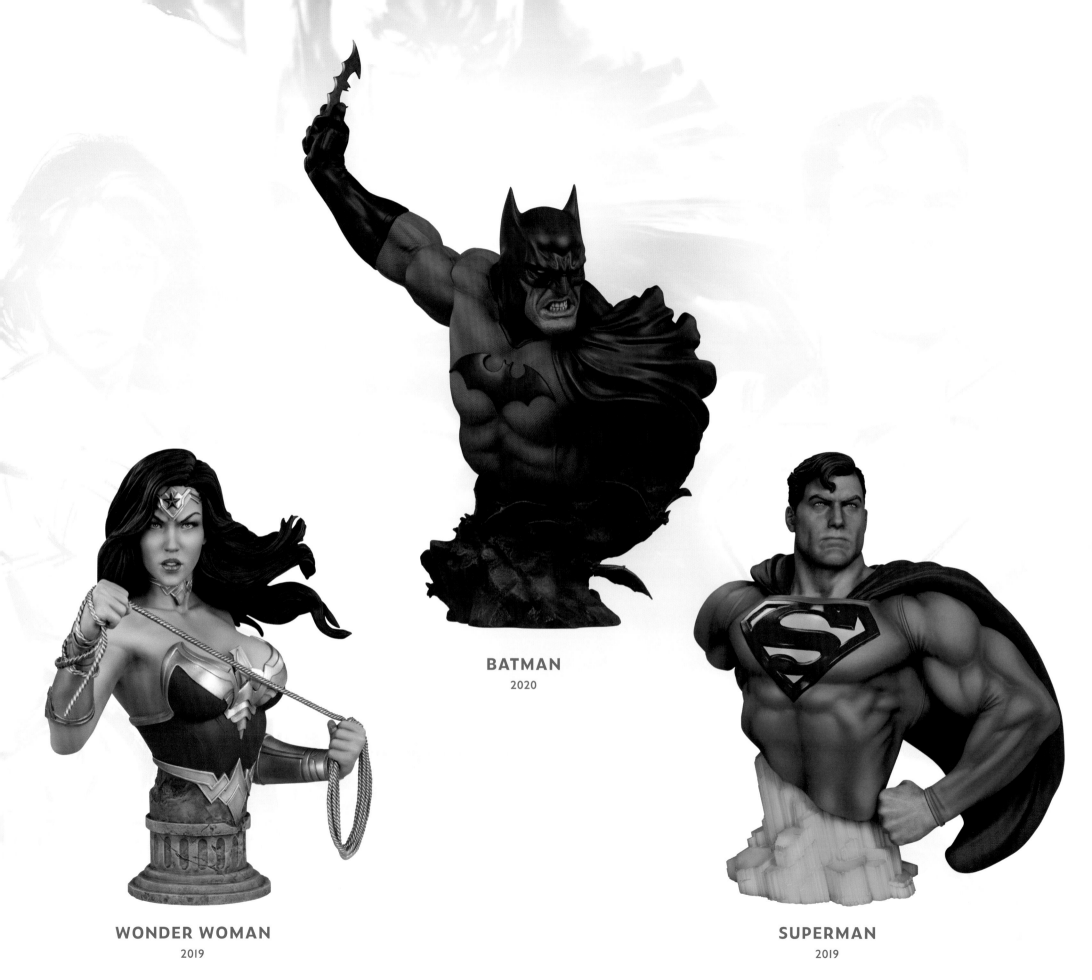

BATMAN
2020

WONDER WOMAN
2019

SUPERMAN
2019

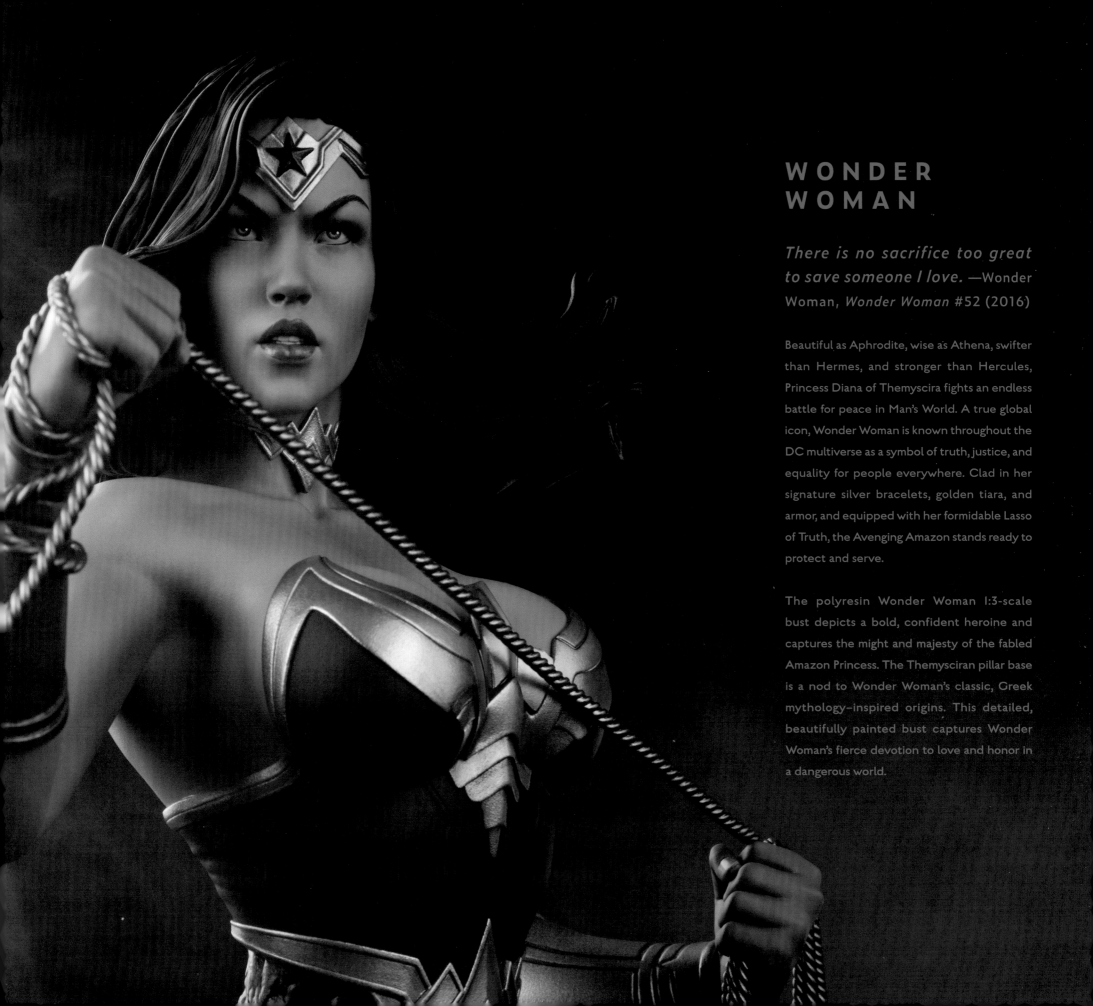

WONDER WOMAN

There is no sacrifice too great to save someone I love. —Wonder Woman, *Wonder Woman #52 (2016)*

Beautiful as Aphrodite, wise as Athena, swifter than Hermes, and stronger than Hercules, Princess Diana of Themyscira fights an endless battle for peace in Man's World. A true global icon, Wonder Woman is known throughout the DC multiverse as a symbol of truth, justice, and equality for people everywhere. Clad in her signature silver bracelets, golden tiara, and armor, and equipped with her formidable Lasso of Truth, the Avenging Amazon stands ready to protect and serve.

The polyresin Wonder Woman 1:3-scale bust depicts a bold, confident heroine and captures the might and majesty of the fabled Amazon Princess. The Themysciran pillar base is a nod to Wonder Woman's classic, Greek mythology–inspired origins. This detailed, beautifully painted bust captures Wonder Woman's fierce devotion to love and honor in a dangerous world.

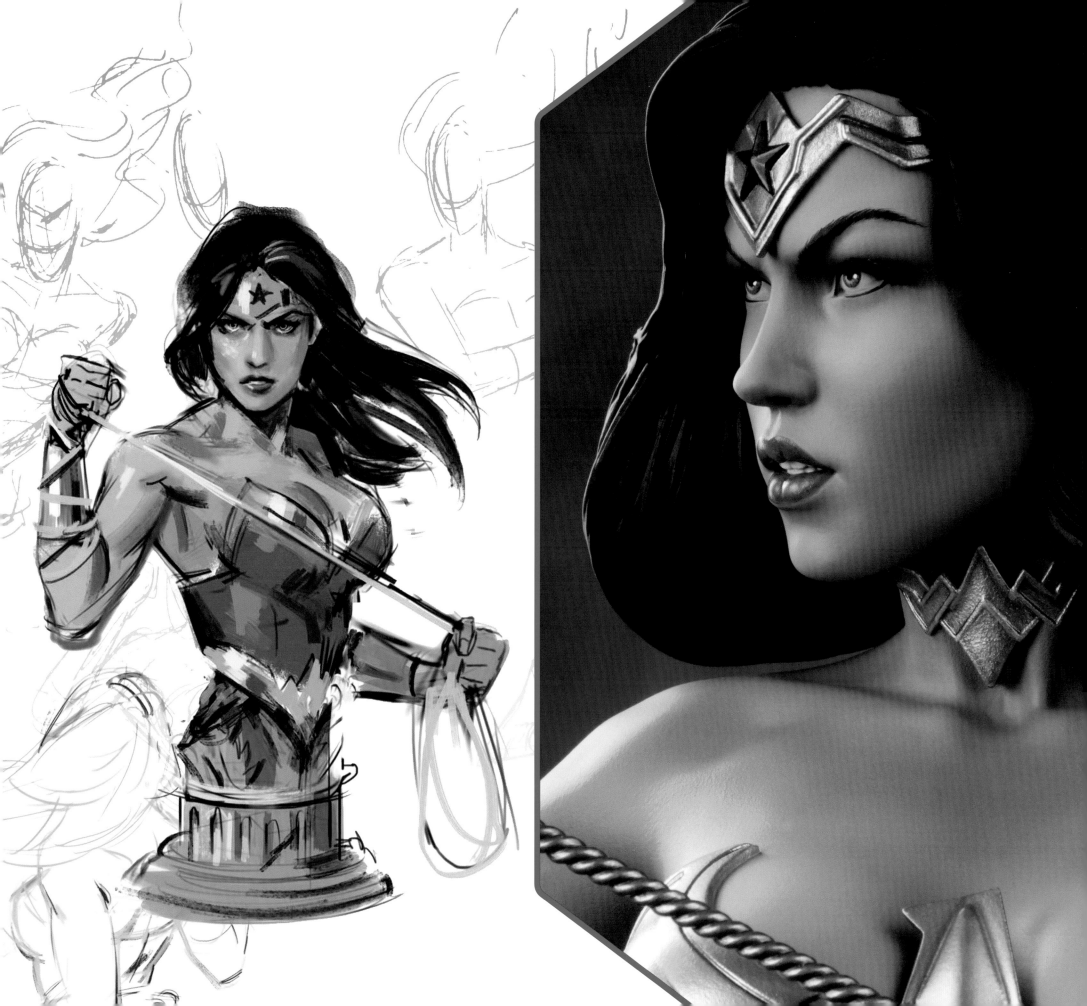

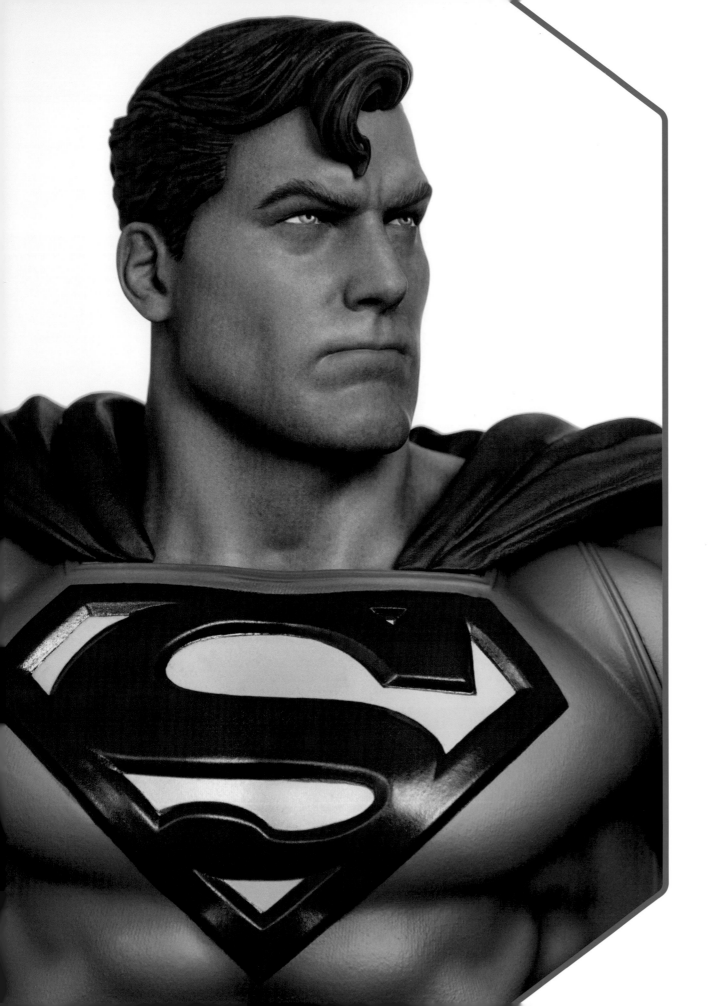

SUPERMAN

I'm here to stand up for people when they can't stand up for themselves, and I'm here to help out and make things better any way I can. I'm here to stay. —Superman, *Action Comics* #8 (2011)

Superman's greatest ability, beyond even his incredible strength, speed, and power of flight, is his ability to inspire hope. His sincere belief in the ideals of truth and justice have made the Man of Steel an enduring symbol of hope and optimism for generations of fans around the world.

The polyresin Superman 1:3-scale bust captures DC's original Super Hero in all his might as he strikes a majestic pose atop a blue crystalline base evocative of his Fortress of Solitude headquarters. The Man of Tomorrow's classic costume, with its bold primary colors, is rendered in loving detail with the sculpt of his iconic red cape dramatically flowing behind him.

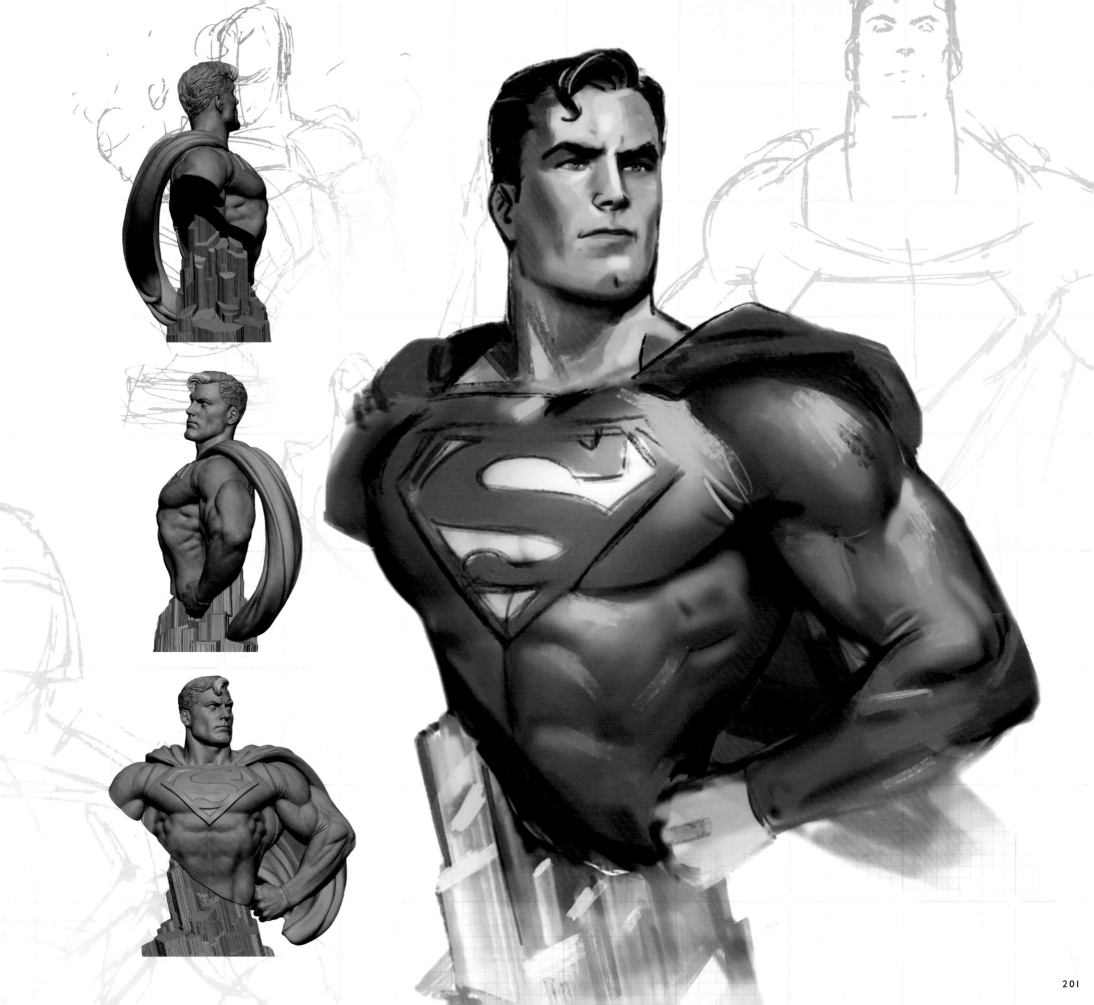

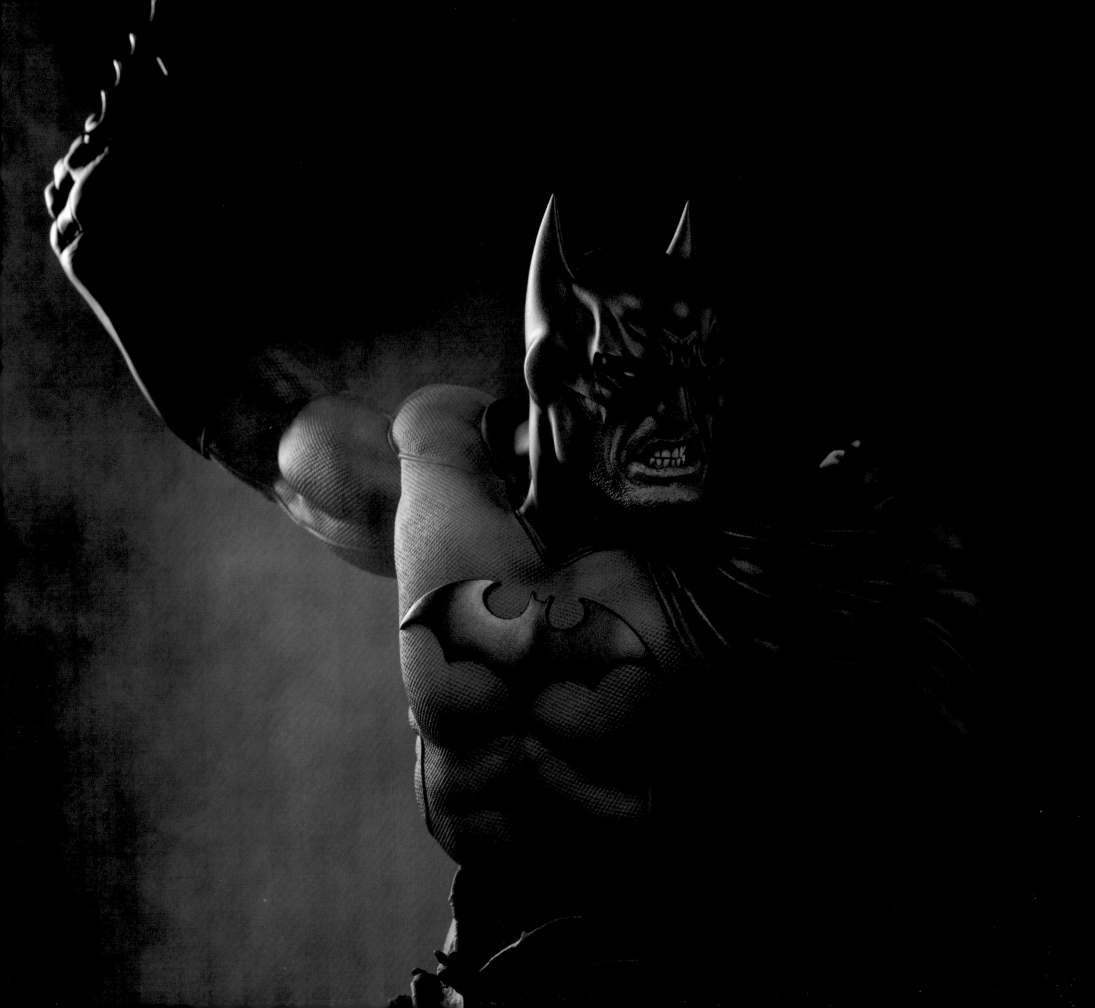

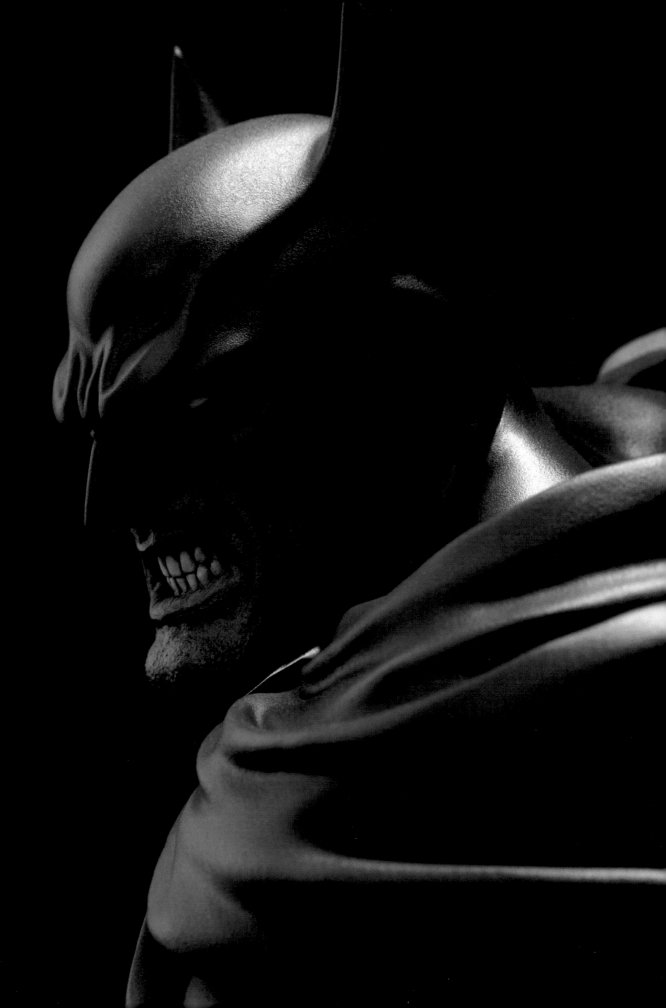

BATMAN

You and I . . . with what we do . . . what's at stake . . . we can't fail. Others don't understand, but even if it's impossible, we still have to succeed. —Batman, *Batgirl* #3 (June 2000)

The Dark Knight prepares to strike in Sideshow's fierce polyresin Batman Bust. This dynamic 1:3-scale sculpture captures Batman's intensity as he charges into battle armed with only a Batarang and his indomitable fighting spirit. Unlike his Justice League teammates Superman and Wonder Woman, Batman is cloaked in shadow, with a dark cowl and dark countenance to match.

No character in the DC multiverse is featured in as many of Sideshow's sculptures as Batman, but each rendition of the Dark Knight brings new creative challenges and opportunities according to sculptor Ryan Peterson. "The most challenging aspect of the Batman bust was striking the right balance between realism and stylization," says Peterson. "Duplicating reality is less exciting to me than embellishing it. It's what I see in comic book art. So, to bring that sensibility into the real world alters the viewer's perception, where they're seeing realistic pores and skin texture on top of dramatic, powerful muscles and bone structure; creating a potent, contrasting cocktail between subtlety and exaggeration. It's not an easy approach, but I know there is something exciting to be mined there."

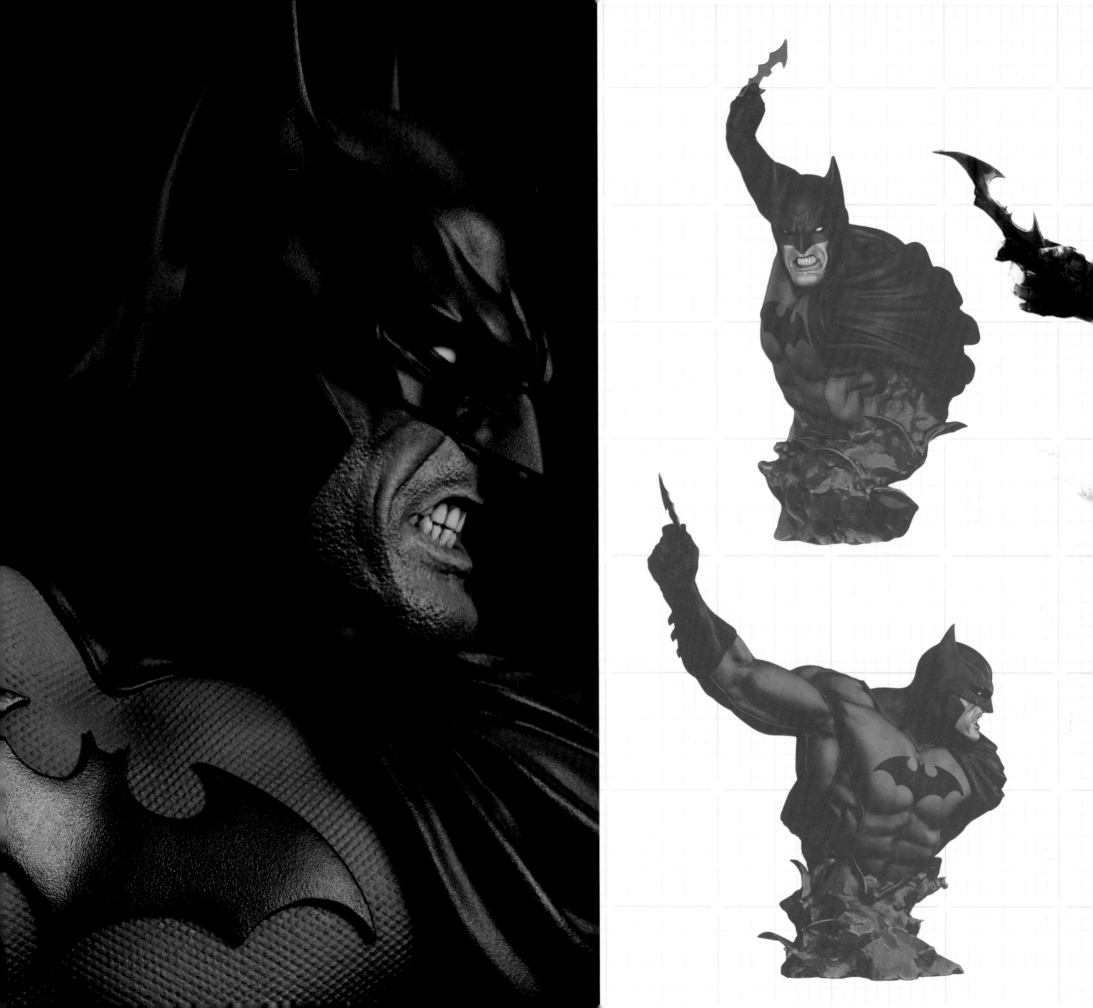

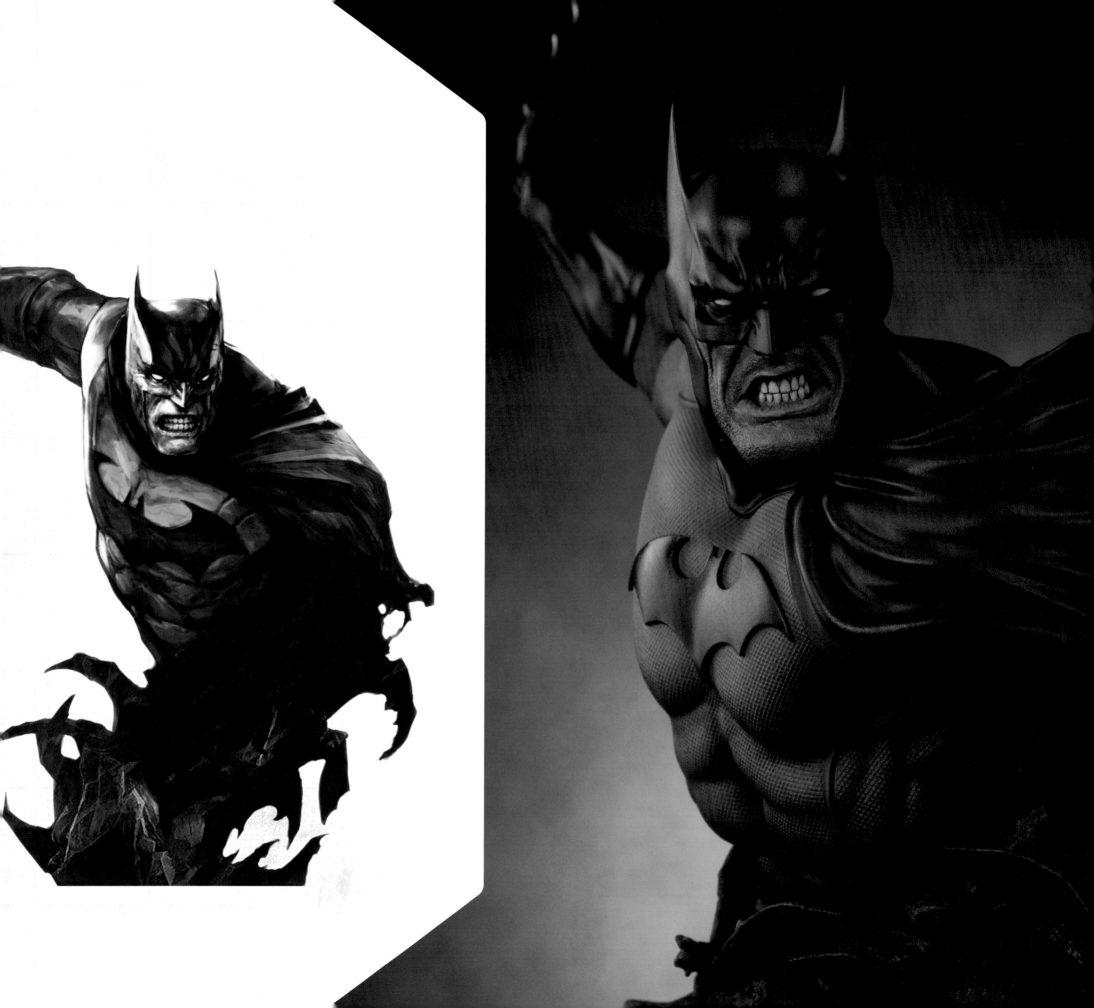

HIGH-END FORMATS

LEGENDARY SCALE™, MAQUETTES AND DIORAMAS

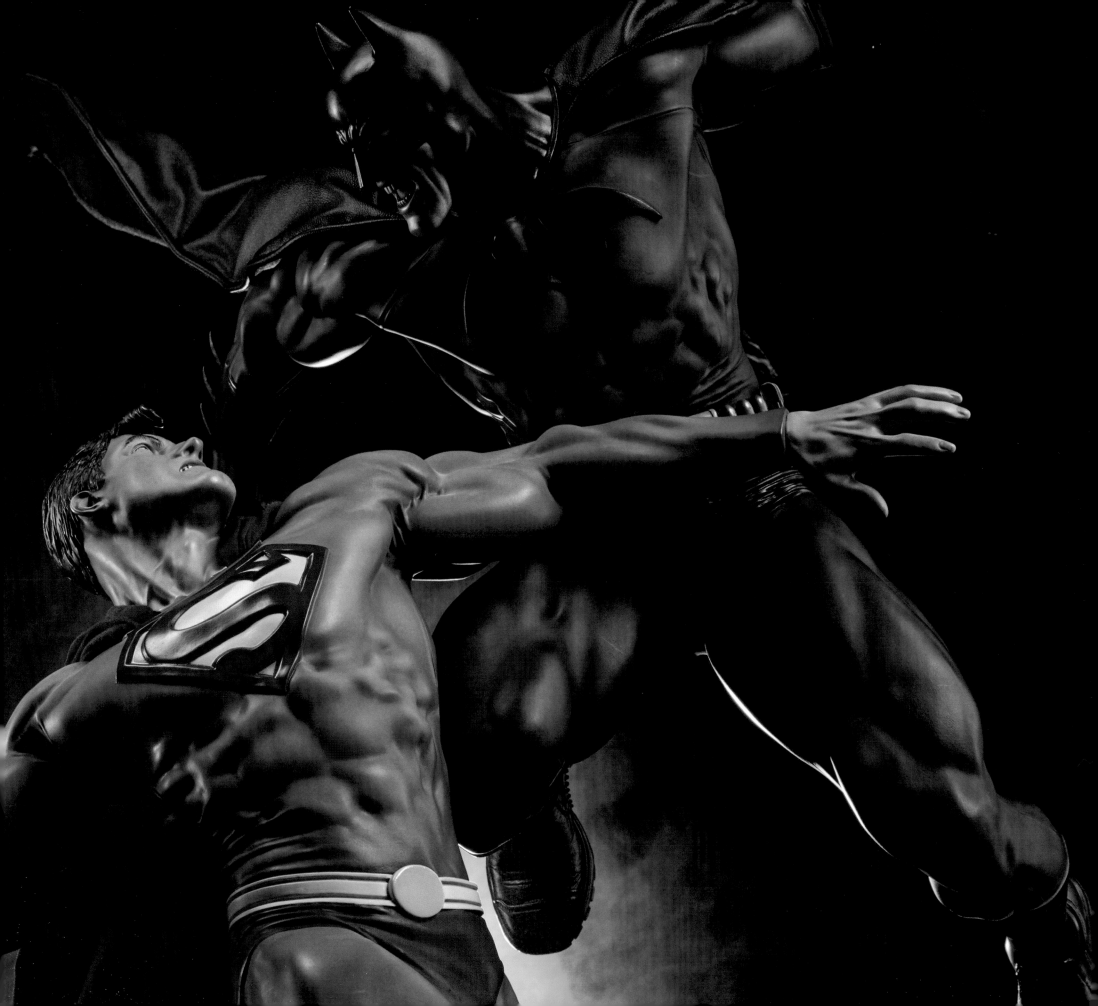

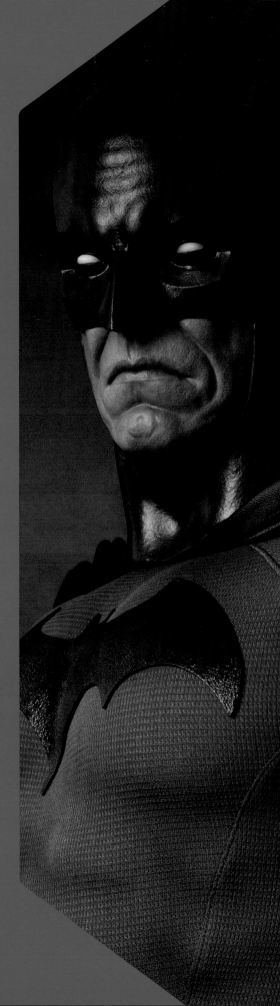

> "I WANT YOU TO DO ME A FAVOR. I WANT YOU TO TELL ALL YOUR FRIENDS ABOUT ME."
> –BATMAN, *BATMAN* (1989)

HIGH-END FORMATS

LEGENDARY SCALE™, MAQUETTES AND DIORAMAS

Sideshow's high-end statues build on the craft and innovation of the Premium Format Figures and take them to the next level—and a grander scale. Larger figures, bolder designs, radical settings—these are the hallmarks of Sideshow's high-end figures: the Legendary Scale™ series, maquettes, and dioramas.

The Legendary Scale format is truly incredible, with figures scaled at roughly one-half life-size, towering over even the largest Sideshow busts and statues. "Legendary Scale is so fun," says costume fabrication manager Tim Hanson. "They're big and badass and immediately grab someone's attention. We're always after the best version we can achieve."

Sideshow's maquettes are comparable in scale to Premium Format Figures but are more fully integrated with their settings, allowing the creative teams to realize a more complete vision for each character. DC's darker characters—the myths and monsters of the DC multiverse—particularly lend themselves to this format, as creators cut loose with their bold interpretations of characters like Swamp Thing, Doomsday, and Lobo.

Sculptor Paul Komoda has always had an affinity for dark, weird characters, and he gets to indulge himself

when creating new maquettes for Sideshow. "I got my start with drawing, often scribbling on things I shouldn't have. It took a while longer before I picked up clay, and that led to creating entire Plasticine bestiaries, which I'd sometimes use in stop-motion film experiments," says Komoda. "Between attending giant monster movies, collecting piles of rubber creature toys and Aurora model kits, and seeing prehistoric aquatic museum exhibits, my interest in sculpting was fueled. These weird and perverse subjects have been cavorting around in my head from the start, and it's taken a lifetime to develop the talent to express them more articulately."

While the maquettes focus on single characters and settings, Sideshow's polystone dioramas capture dynamic conflicts in a dynamic tabletop format. Although most of Sideshow's dioramas depict epic confrontations between good and evil, the creative team decided to "flip the script" with DC's own battle of the century—Batman vs. Superman! "I grew up lovWing these characters, and we want the fans and collectors to display these proudly and be able to feel these things come to life on their shelf," says designer Richard Luong, when asked about the diorama format. "These are an encapsulation of our childhoods and are a big part of who we are today."

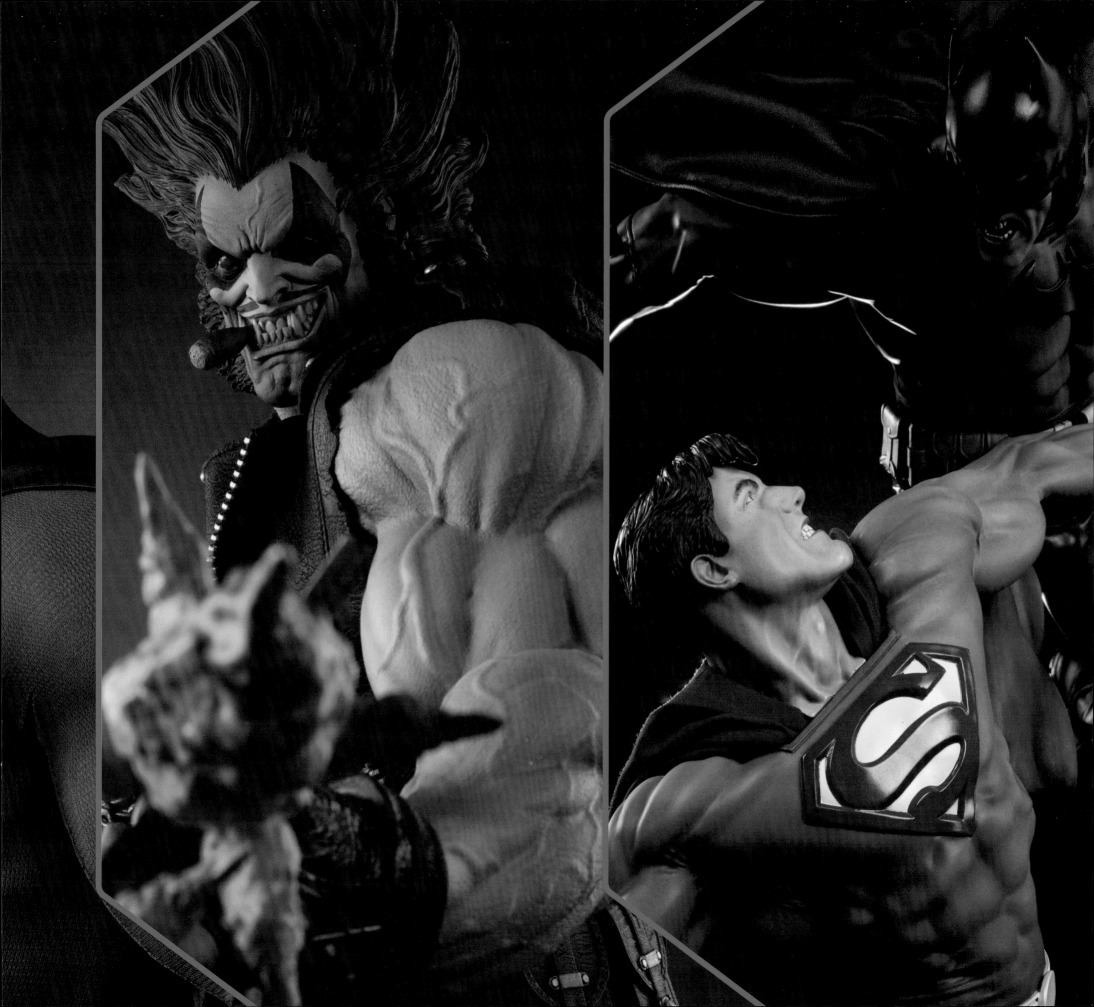

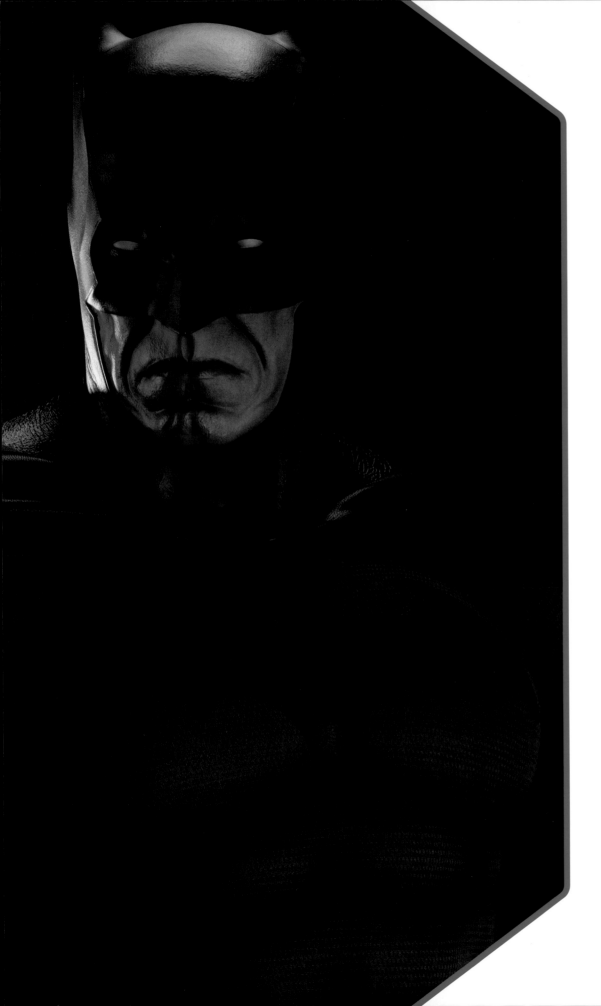

BATMAN
LEGENDARY SCALE FIGURE

I wear a mask. And that mask, it's not to hide who I am, but to create what I am. —Batman, *Batman* #624 (2004)

The first DC hero to join Sideshow's line of Legendary Scale Figures was Gotham City's own Dark Knight, Batman. Based on his classic comic book appearance, Batman is outfitted in his signature gray-and-black costume, with a fully articulated yellow Utility Belt and iconic black bat insignia on his chest. Batman's long, flowing fabric cape shrouds him in darkness as he prepares to emerge from the shadows to confront evil in his city.

This epic figure is crafted out of polyresin, fiberglass, and fabric and is presented at half-scale, measuring an astonishing 43 inches tall and 23 inches wide at the base. "Working at larger scales definitely requires a different approach," notes sculptor Alfred Paredes about the Legendary Scale format. "The details will be scrutinized much more, simply because they will be much more visible. The materials behave differently at that scale than at smaller scale, so there needs to be careful attention paid to how the figure will look under the costume elements. The accessories and smaller details need to be pumped up to show off as much realism as possible at that scale."

Creating a hero at that scale presents a series of challenges, but it also provides opportunities that aren't present in small figures. "With the Legendary Scale Batman, it was a fun challenge to create a body that felt powerful but also wasn't so large it would make Batman look even bigger than he already does," adds Paredes. "We had to be incredibly thorough with every aspect of this piece."

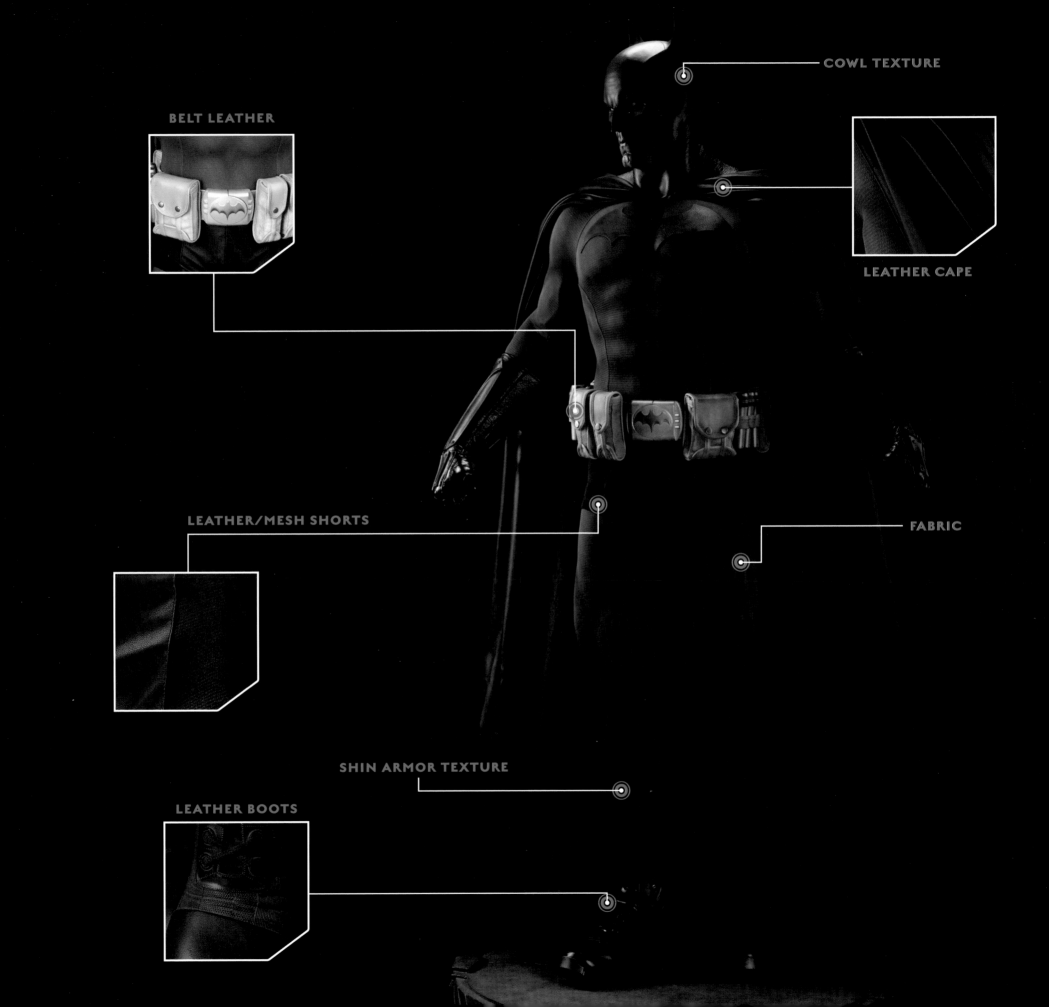

COWL TEXTURE

BELT LEATHER

LEATHER CAPE

LEATHER/MESH SHORTS

FABRIC

SHIN ARMOR TEXTURE

LEATHER BOOTS

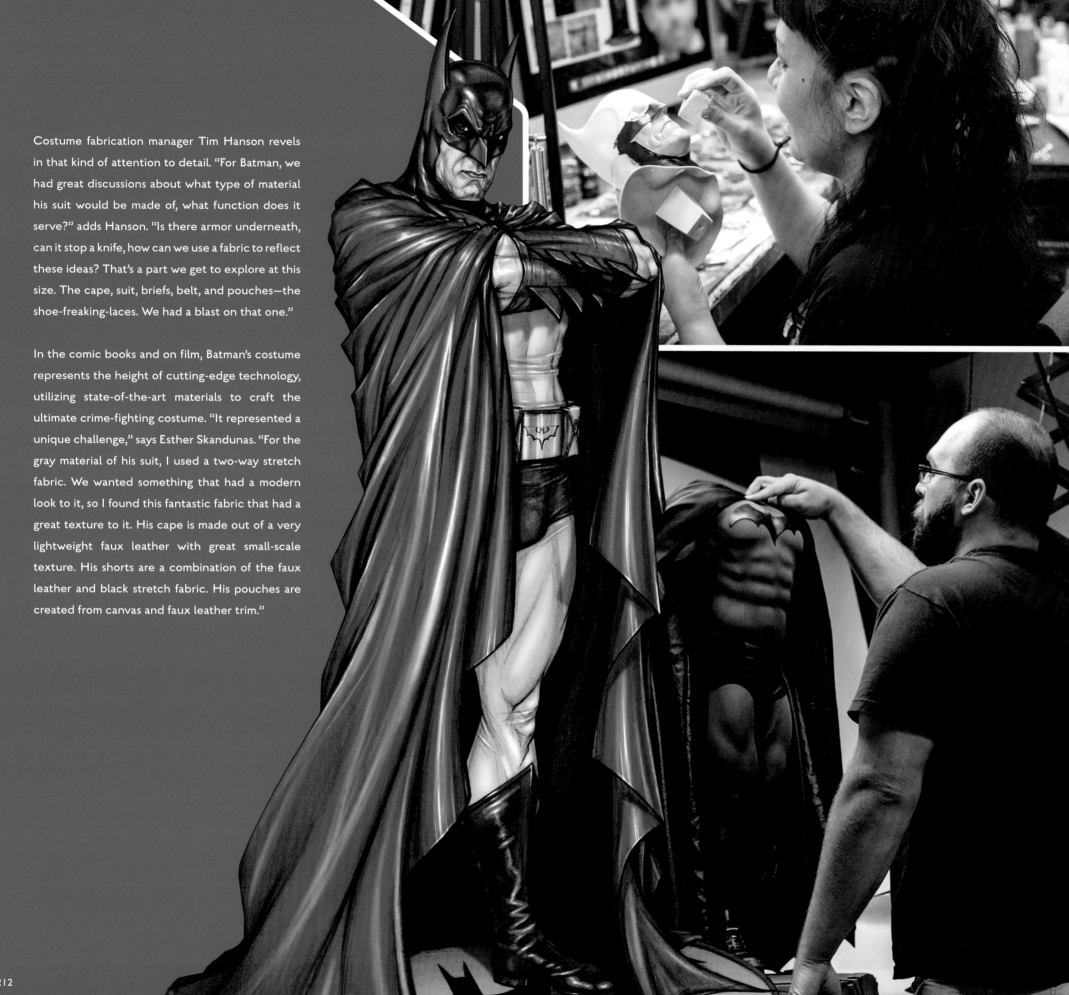

Costume fabrication manager Tim Hanson revels in that kind of attention to detail. "For Batman, we had great discussions about what type of material his suit would be made of, what function does it serve?" adds Hanson. "Is there armor underneath, can it stop a knife, how can we use a fabric to reflect these ideas? That's a part we get to explore at this size. The cape, suit, briefs, belt, and pouches—the shoe-freaking-laces. We had a blast on that one."

In the comic books and on film, Batman's costume represents the height of cutting-edge technology, utilizing state-of-the-art materials to craft the ultimate crime-fighting costume. "It represented a unique challenge," says Esther Skandunas. "For the gray material of his suit, I used a two-way stretch fabric. We wanted something that had a modern look to it, so I found this fantastic fabric that had a great texture to it. His cape is made out of a very lightweight faux leather with great small-scale texture. His shorts are a combination of the faux leather and black stretch fabric. His pouches are created from canvas and faux leather trim."

DETAILS

To achieve that same effect with the Batman Legendary Scale Figure, costume fabricator Esther Skandunas used all the tools and materials at her disposal. "When choosing fabric for a character like Batman, durability and making sure that the fabric poses well on the figure is key," Skandunas notes. "That is one of the first things I think about when choosing materials. We wanted his suit to be able to cling to his body to show off those amazing muscles, so I knew immediately that the fabric had to have some stretch qualities to it, but it also needed to look like it had a weight to it as well, without actually being thick and heavy fabric. That is where texture really plays a vital role. The texture of the gray material gives his suit the visual quality of being heavier than it actually is."

Each member of Sideshow's creative team brings a unique skill set to every project. Painter Chie Izuma moved to the United States from Japan to study painting and ceramics, then worked as a painter of toys and prototypes for ten years before joining Sideshow's Paint Department. The beautiful work that she produces, says Izuma, is due to the accomplishments of her talented collaborators.

"I'm amazed at the quality of 3D outputting and the incredible level of detail our sculptors are able to achieve," Izuma notes. "It allows us to take the paint to a new world entirely. And with our illustrators, I pay attention closely to their artwork, especially their choice of colors, and try to manipulate and bring their drawings to life in three dimensions."

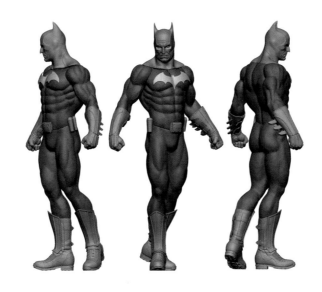

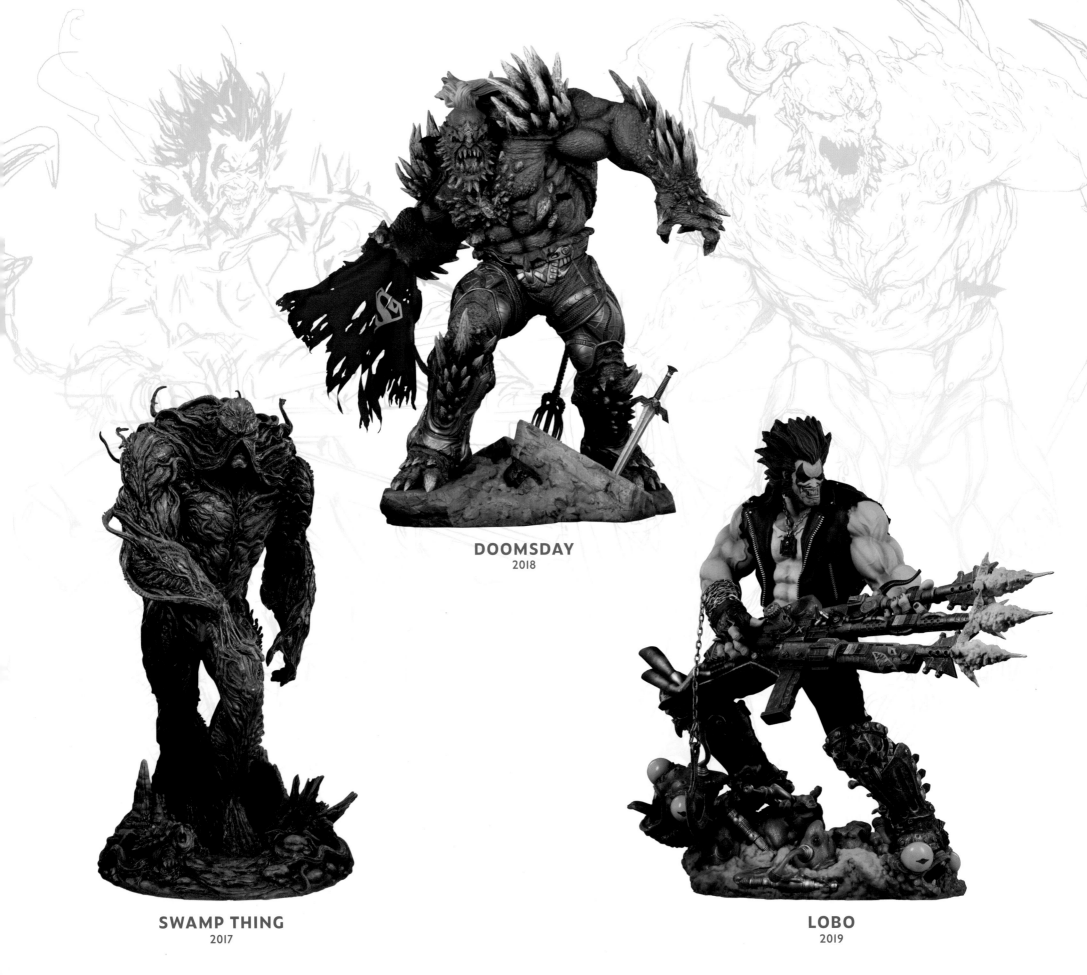

DOOMSDAY
2018

SWAMP THING
2017

LOBO
2019

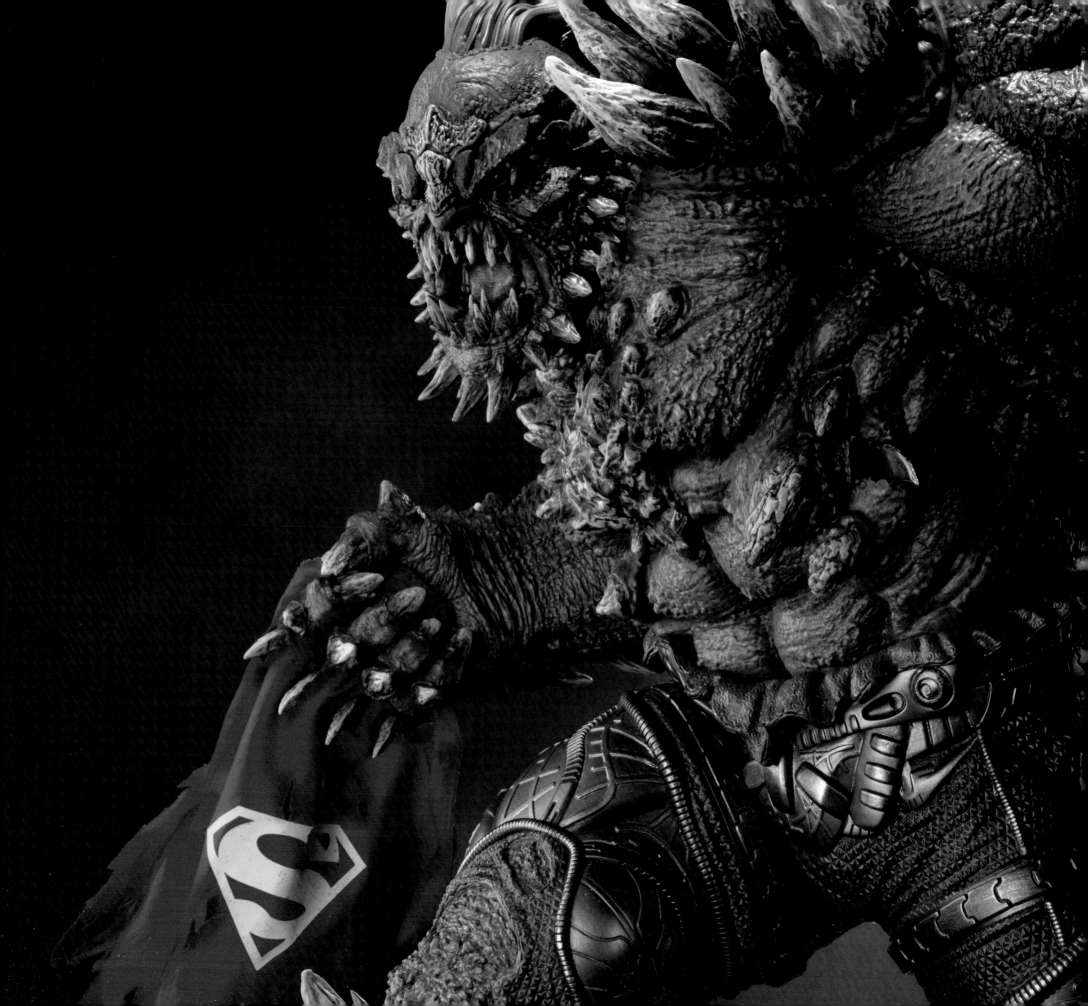

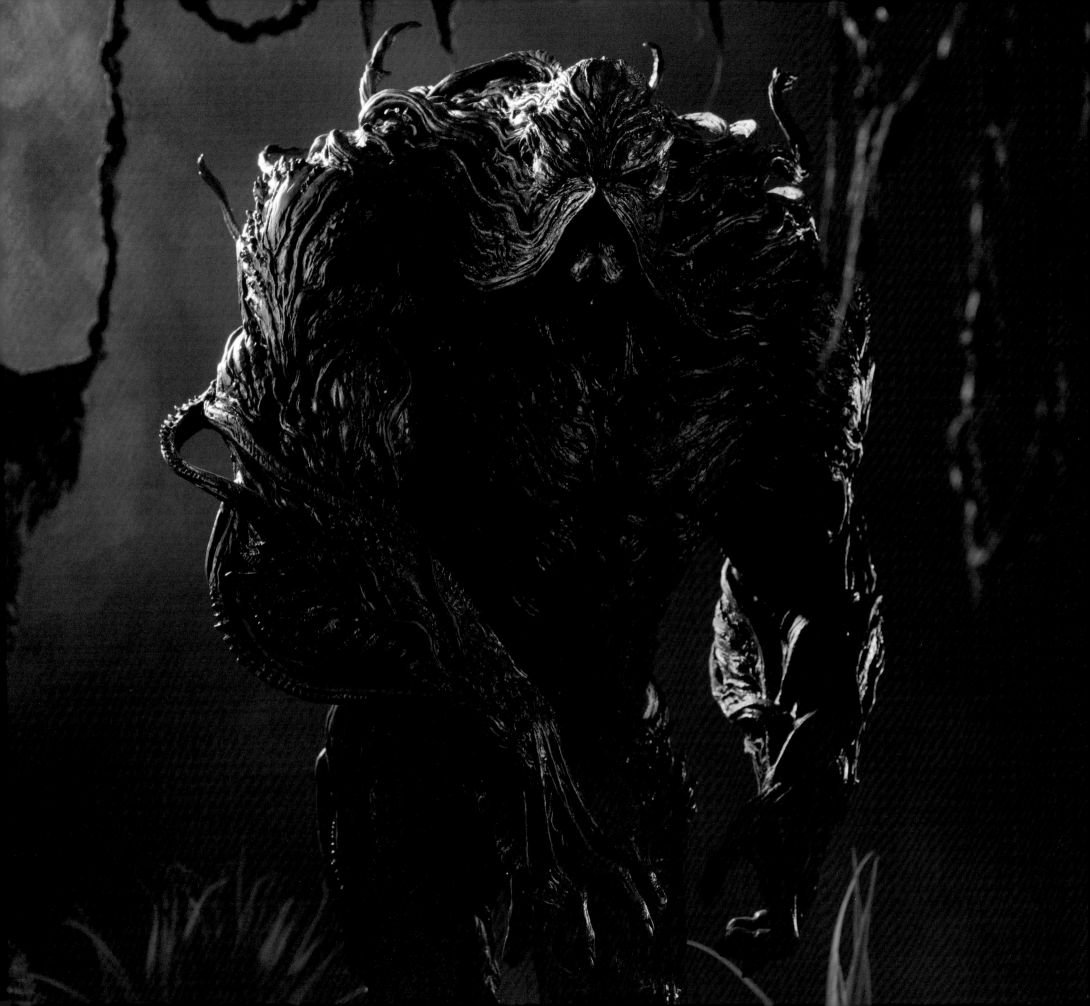

SWAMP THING
MAQUETTE

I am a ghost out of time. Condemned to a moment that is far beyond the world of clocks and calendars and the rhythms of nature. —Swamp Thing, *Swamp Thing* #87 (1989)

Dr. Alec Holland was developing a bio-restorative formula in his top-secret laboratory in the Louisiana bayous when the young scientist was murdered by criminals. But from the very spot where Alec Holland's body fell, a new life-form—the Swamp Thing—arose. The hulking, powerful Swamp Thing soon discovered he could control all forms of plant life and vowed to use these abilities to protect both humanity and the environment—usually from each other.

The towering Swamp Thing Maquette captures the size and scale of the self-described "muck-encrusted mockery of a man" as he emerges from the depths. Every detail, from the smallest leaf to the largest vine, is painstakingly rendered, and sculptor Paul Komoda considers the maquette one of his crowning artistic achievements. "I'll just say that it took as long as needed, which was a considerable portion of the year," the sculptor laughs. "It was indeed a labor of love, and that being said, it thoroughly kicked my ass on several occasions.

"Mostly they were technical issues," says Komoda. "Looking back, the armature I built was structurally ludicrous and would self-destruct inside the sculpture during the night, then would require invasive surgery the following day."

Among the biggest technical challenges for Komoda was getting his materials to cooperate at the massive scale at which he was sculpting. "I was using Super Sculpey®, which above a certain scale goes rogue, and unless it's properly anchored, the weight of it will wrench it right off from whatever understructure you have set up. With a bit of creative jackhammering, I got it under control and could indulge myself, aesthetically speaking."

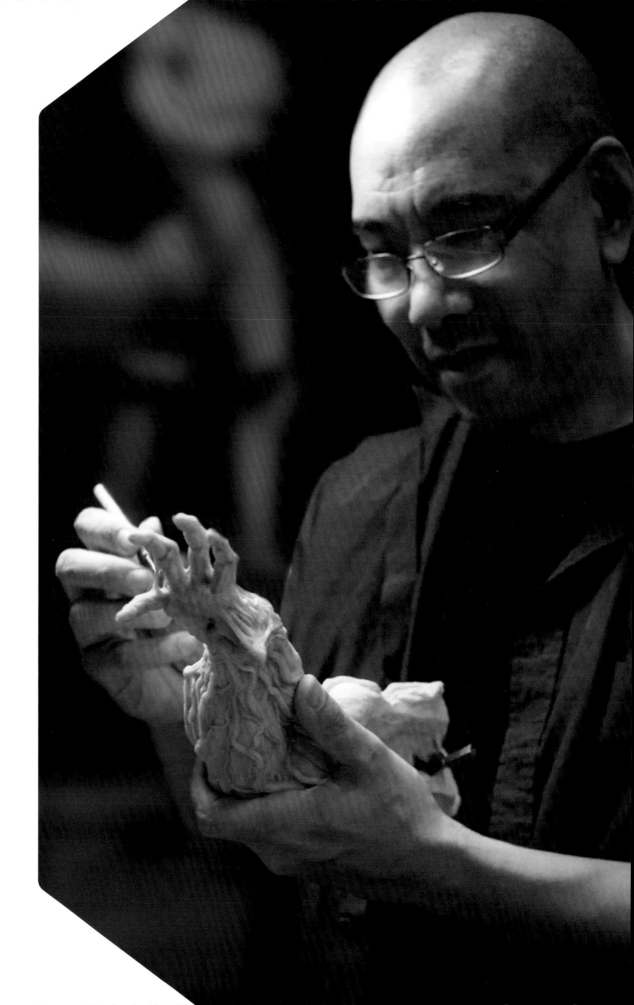

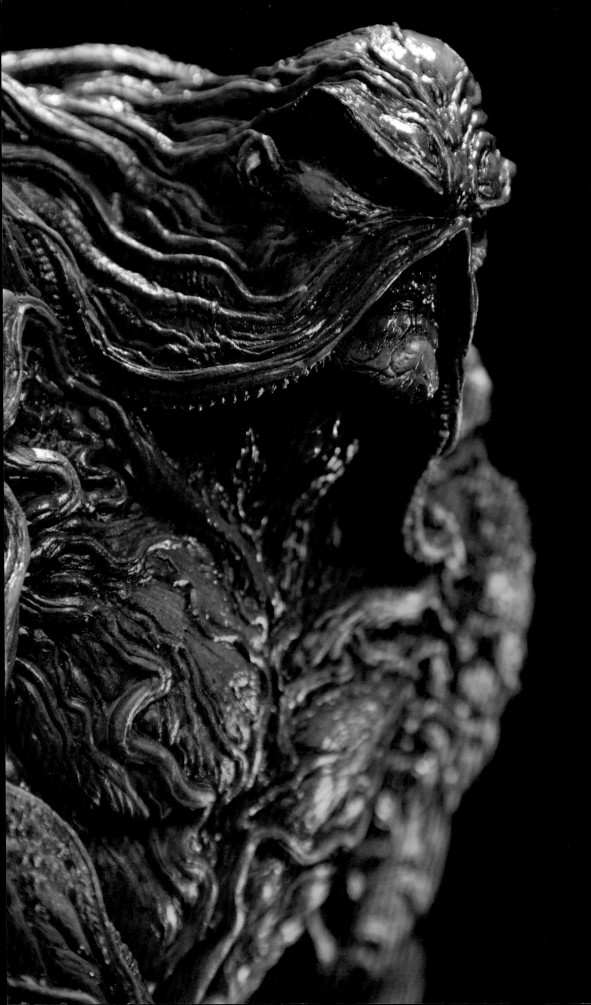

DETAILS

Each element of Swamp Thing, from the largest roots to the smallest leaves, is lovingly rendered by Paul Komoda, who left no detail to chance. "I am a bit of an obsessive when it comes to sculpting biological detail, which runs counter to the 'less is more' sensibility I apply to my illustrated work," notes Komoda. "One of my biggest inspirations is the eighteenth-century wax anatomical display at La Specola at the Museum of Natural History in Florence, Italy. . . . I wanted to imbue the sculpture with a similar visceral feeling of exposed muscles, interwoven with the gnarled and tuberous plant growth."

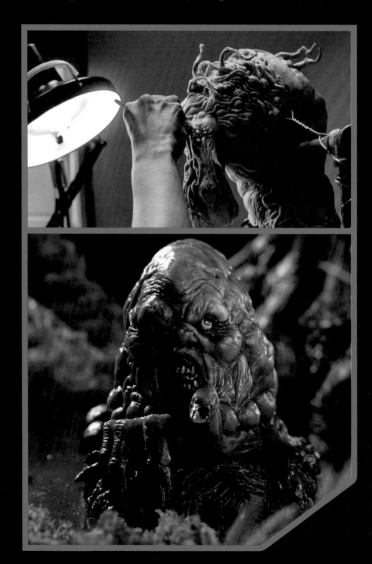

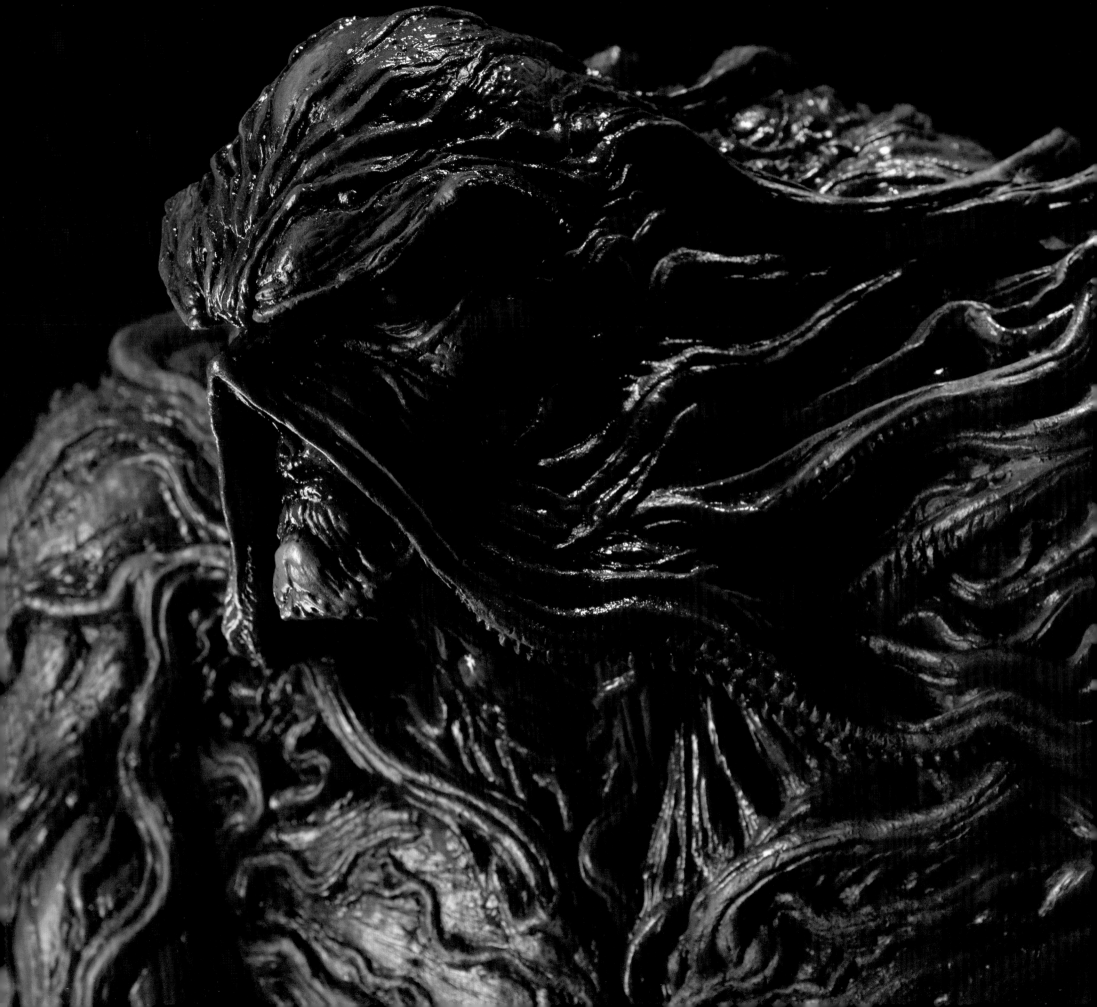

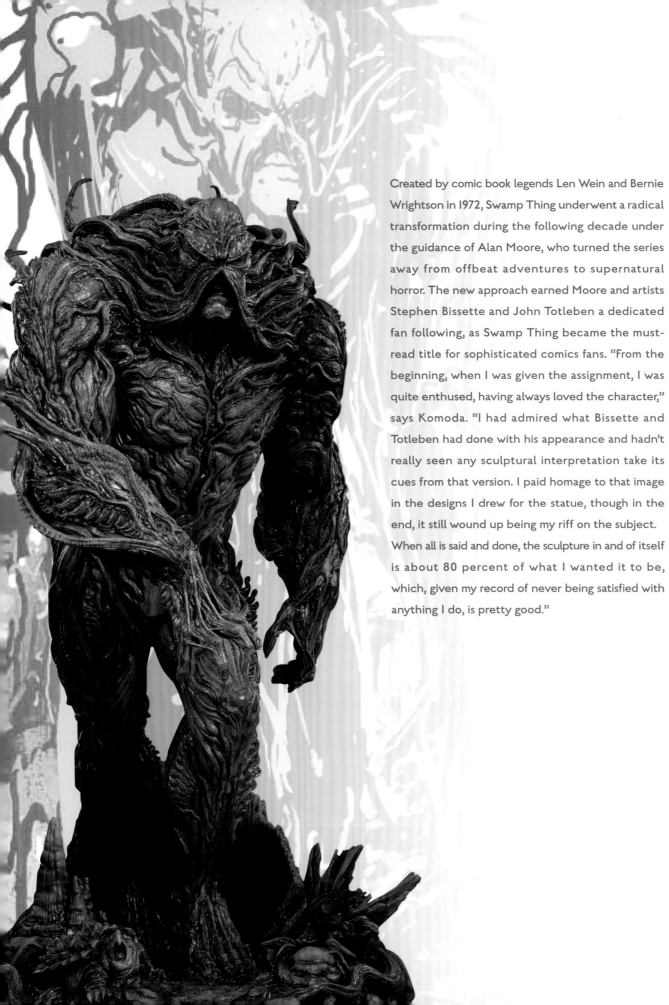

Created by comic book legends Len Wein and Bernie Wrightson in 1972, Swamp Thing underwent a radical transformation during the following decade under the guidance of Alan Moore, who turned the series away from offbeat adventures to supernatural horror. The new approach earned Moore and artists Stephen Bissette and John Totleben a dedicated fan following, as Swamp Thing became the must-read title for sophisticated comics fans. "From the beginning, when I was given the assignment, I was quite enthused, having always loved the character," says Komoda. "I had admired what Bissette and Totleben had done with his appearance and hadn't really seen any sculptural interpretation take its cues from that version. I paid homage to that image in the designs I drew for the statue, though in the end, it still wound up being my riff on the subject. When all is said and done, the sculpture in and of itself is about 80 percent of what I wanted it to be, which, given my record of never being satisfied with anything I do, is pretty good."

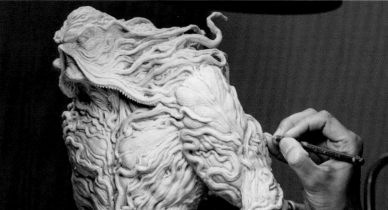

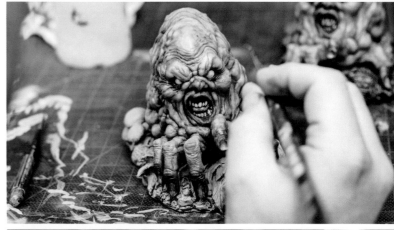

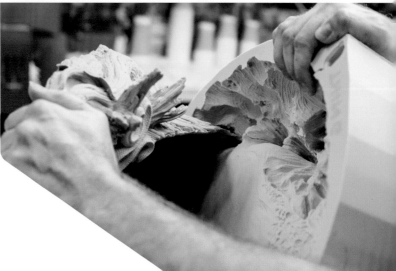

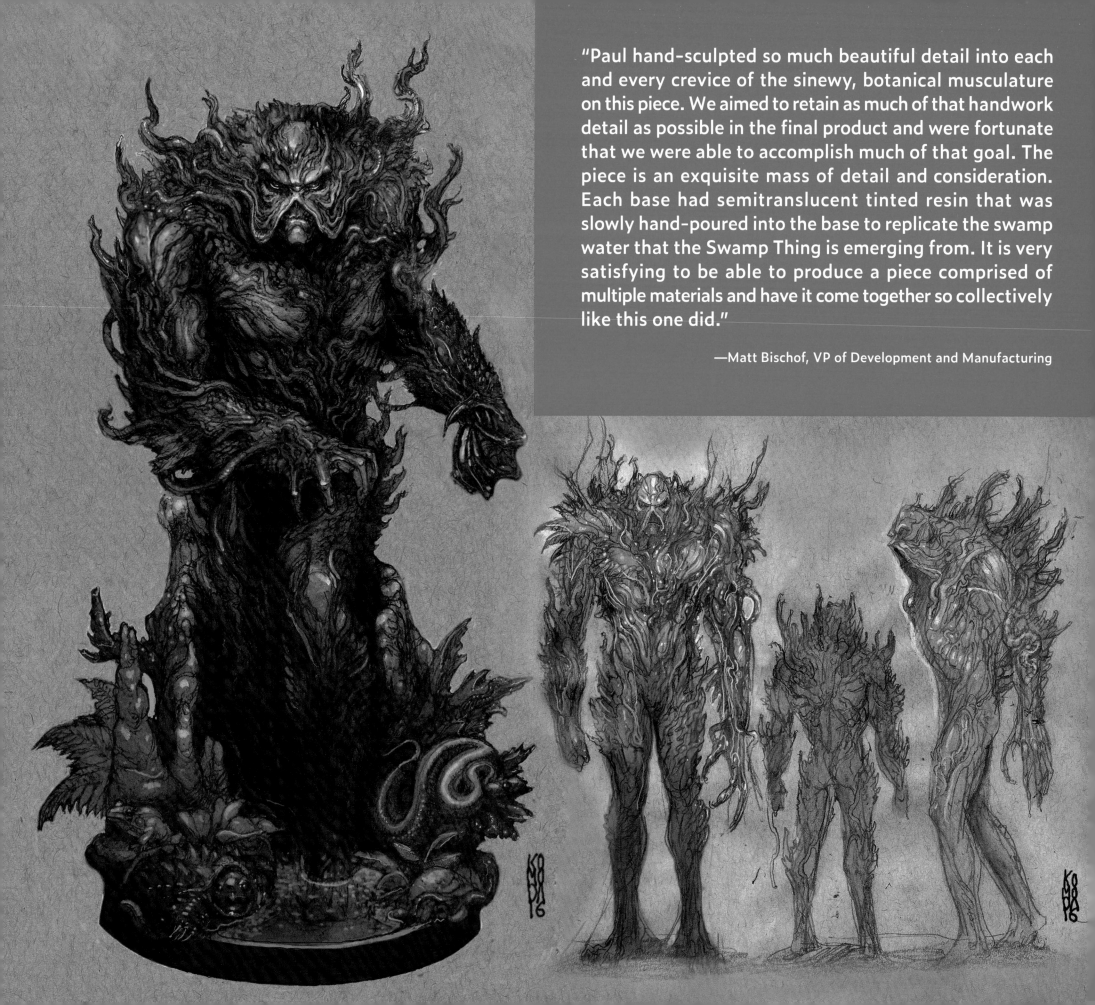

"Paul hand-sculpted so much beautiful detail into each and every crevice of the sinewy, botanical musculature on this piece. We aimed to retain as much of that handwork detail as possible in the final product and were fortunate that we were able to accomplish much of that goal. The piece is an exquisite mass of detail and consideration. Each base had semitranslucent tinted resin that was slowly hand-poured into the base to replicate the swamp water that the Swamp Thing is emerging from. It is very satisfying to be able to produce a piece comprised of multiple materials and have it come together so collectively like this one did."

—Matt Bischof, VP of Development and Manufacturing

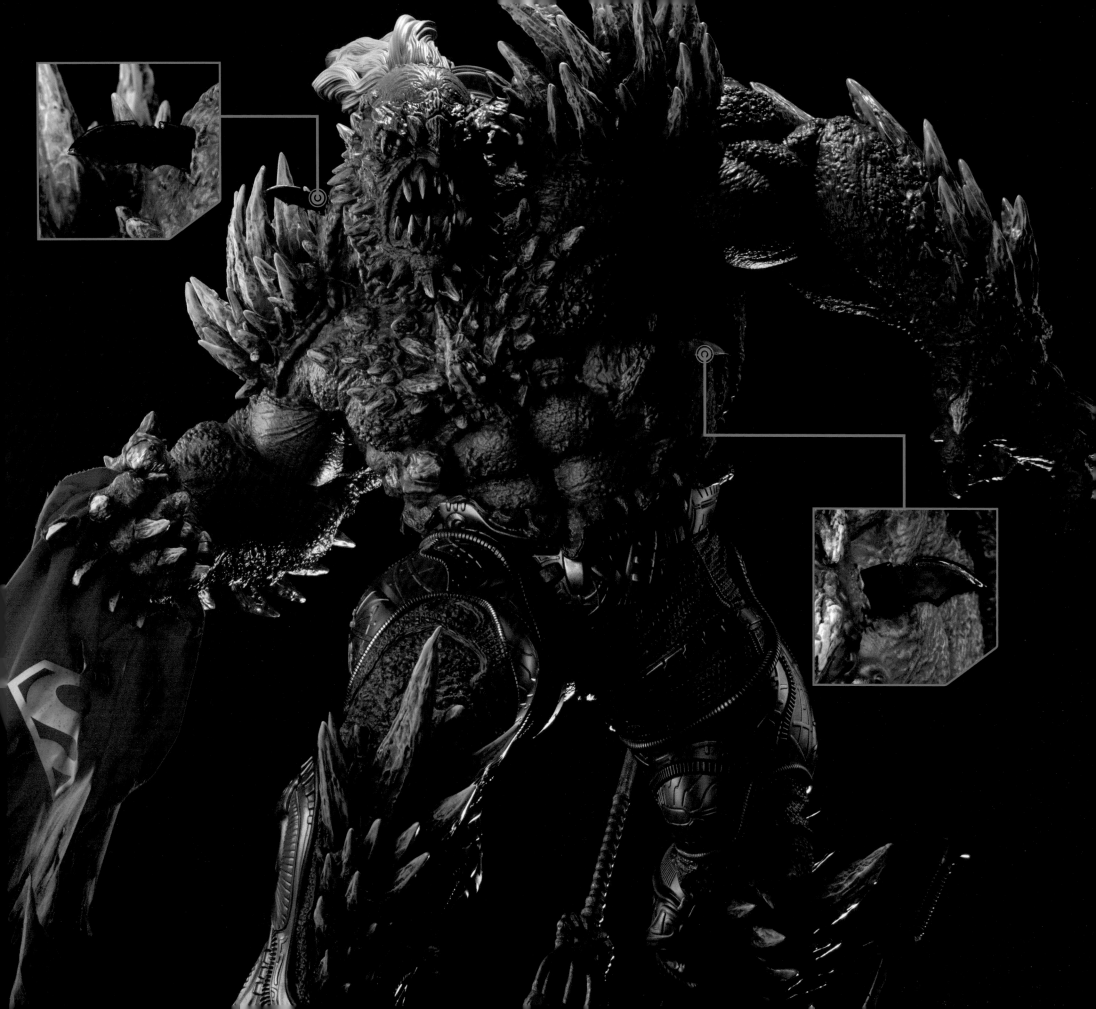

DOOMSDAY
MAQUETTE

I've always been here, and I'll always be here.
—Doomsday, *Superman/Wonder Woman #9 (2014)*

No character made a greater impact on the DC multiverse right out of the gate than the mindless engine of destruction known as Doomsday, who laid waste to the entire Justice League, the city of Metropolis, and Superman himself in an epic battle that seemingly claimed the lives of both Doomsday and the Man of Steel.

Superman eventually recovered, as did the nigh-indestructible Doomsday, who would return time and time again to threaten Superman and bring death and destruction to all who stand in his way.

Sideshow's Doomsday Maquette stands a monstrous 26.5 inches tall, capturing the raw fury of Superman's ultimate foe. This fearsome statue depicts a triumphant Doomsday astride a rubble environment base littered with trophies from the valiant heroes who have fallen in his wake, including Wonder Woman's sword, Aquaman's trident, Batman's cowl, and Green Lantern's ring.

While some artists shy away from crafting horrific monsters like Doomsday, others can't wait for the opportunity to bring life to DC's most dastardly villains. "I tend to get the scarier type characters thrown my way, because my background has been so much of this type of work," observes painter Casey Love. "Monsters are my first passion in my personal work. I find the darker characters to be a lot more fun to work on. To me the darker side of things is far more interesting than the light—the more monster the better."

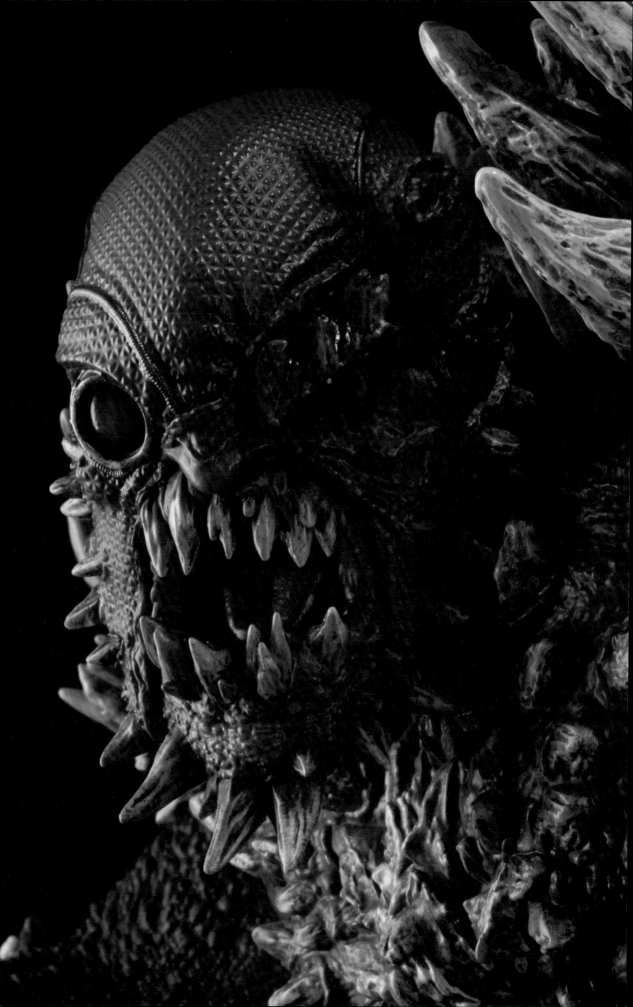

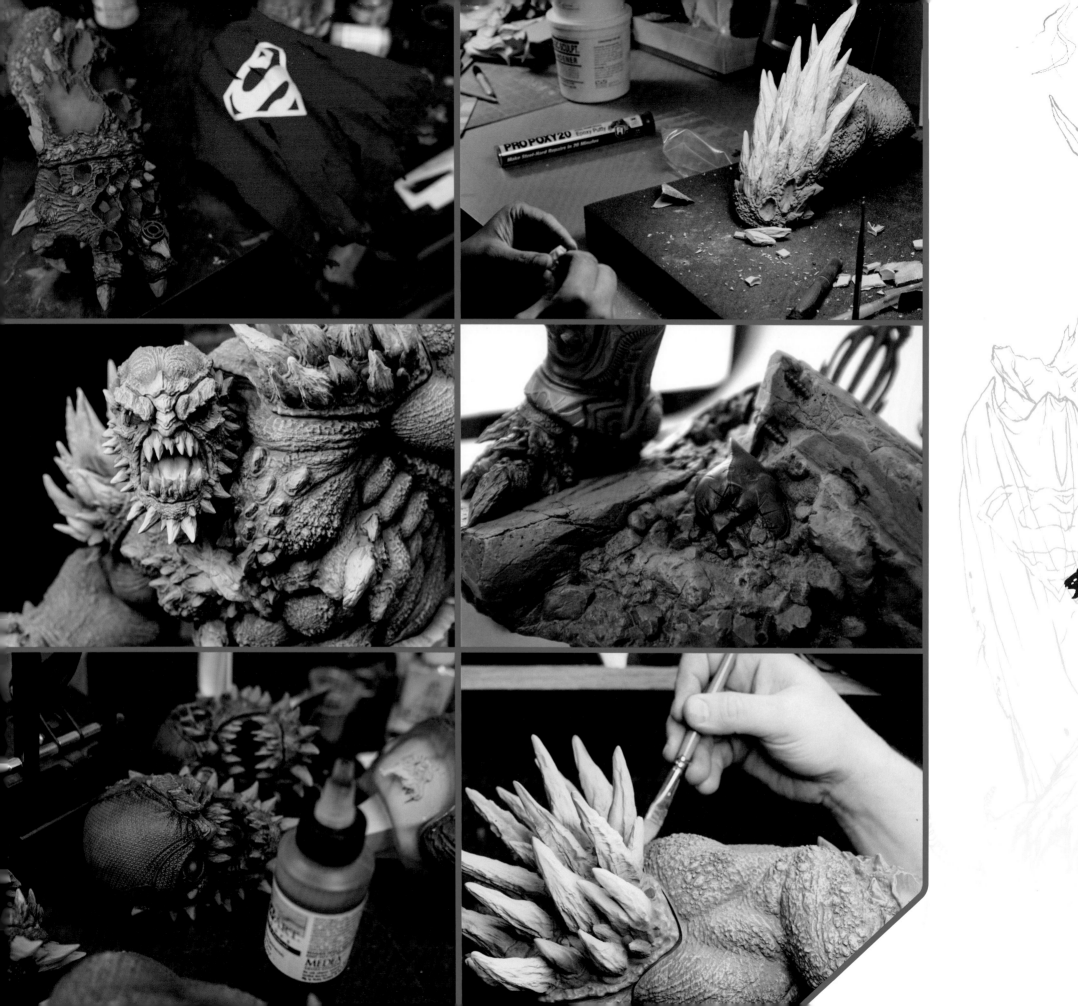

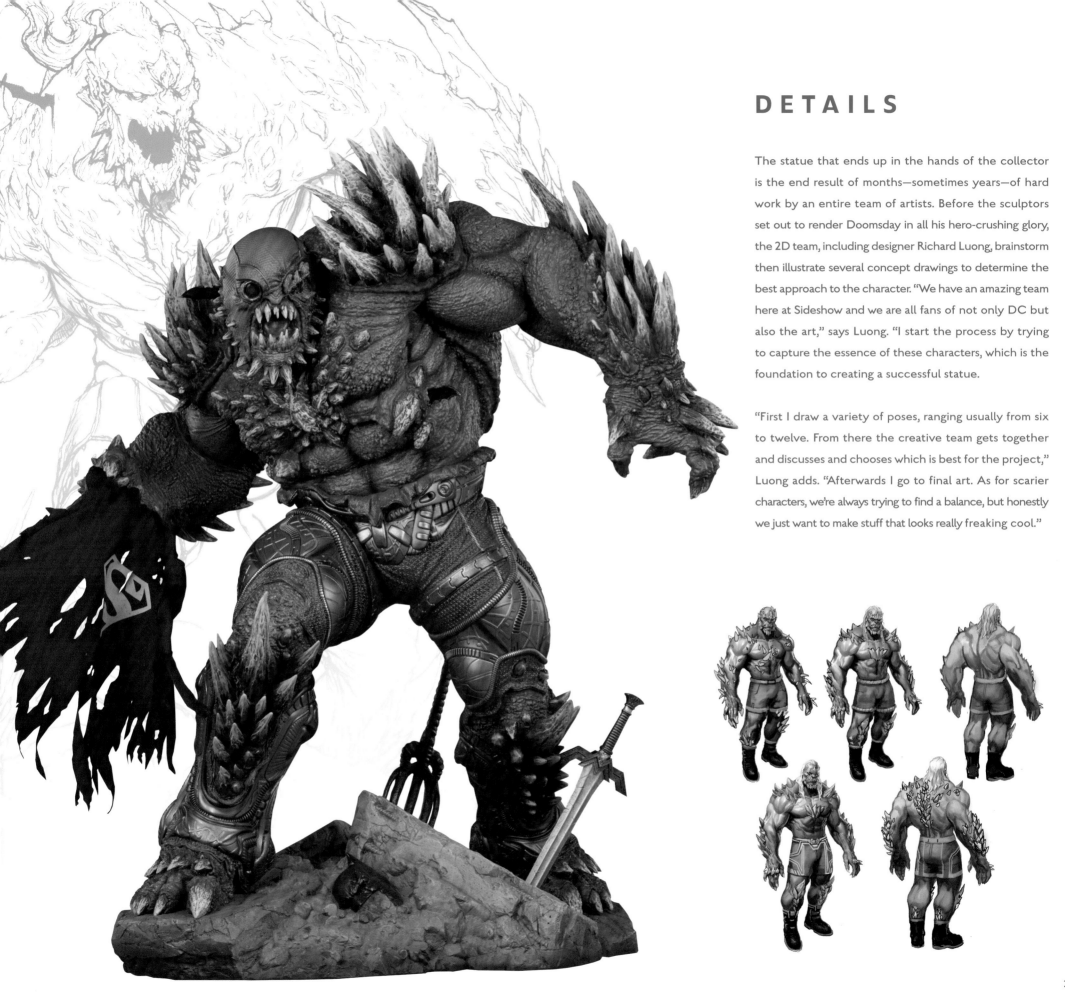

DETAILS

The statue that ends up in the hands of the collector is the end result of months—sometimes years—of hard work by an entire team of artists. Before the sculptors set out to render Doomsday in all his hero-crushing glory, the 2D team, including designer Richard Luong, brainstorm then illustrate several concept drawings to determine the best approach to the character. "We have an amazing team here at Sideshow and we are all fans of not only DC but also the art," says Luong. "I start the process by trying to capture the essence of these characters, which is the foundation to creating a successful statue.

"First I draw a variety of poses, ranging usually from six to twelve. From there the creative team gets together and discusses and chooses which is best for the project," Luong adds. "Afterwards I go to final art. As for scarier characters, we're always trying to find a balance, but honestly we just want to make stuff that looks really freaking cool."

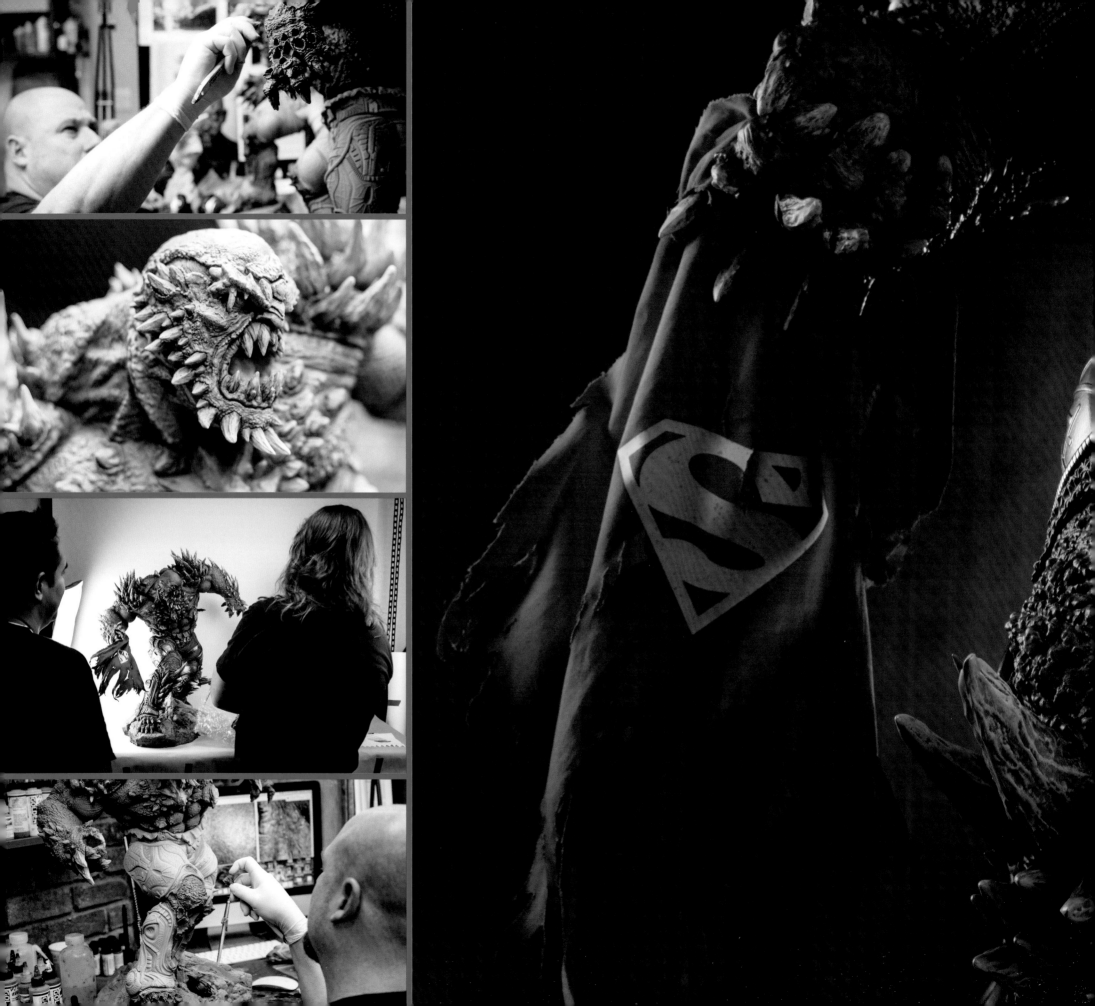

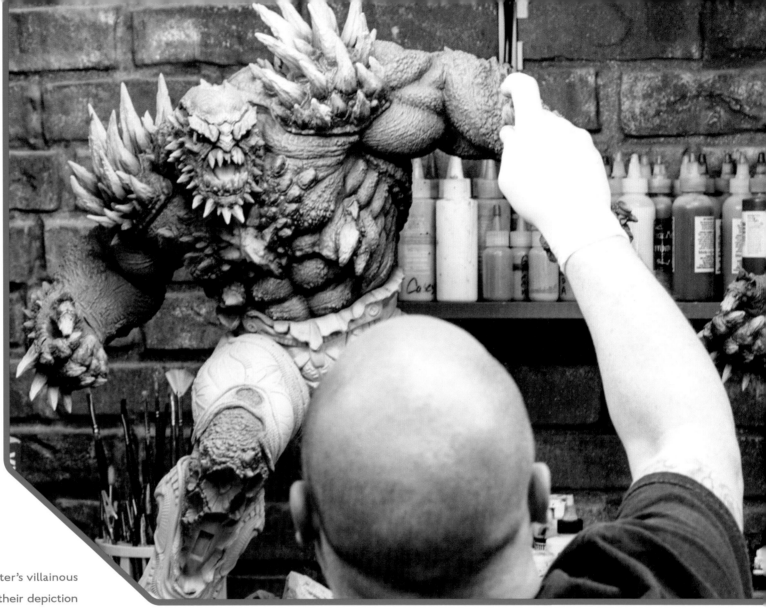

The epic scale of Doomsday, along with the character's villainous pedigree, inspired the creative team to go all out in their depiction of the ultimate killing machine. "There's always some extra fun to be had with creating these larger-than-life characters—Doomsday is a freakin' beast!" exclaims costume fabrication manager Tim Hanson. "It's no surprise we have a lot of fun adding all sorts of details throughout the many phases of production. The sculptor, Martin Canale, is masterful at not only giving these characters an undeniably epic presence and style but also adding a tremendous amount of fanciful details.

"I truly love the exclusive alternate hooded portrait. It's a great nod to the character's first appearance," adds Hanson. "Although my part in the project was minimal, I had a fun time designing the destroyed and tattered version of Superman's cape . . . hugely inspired by the famous Superman #75 [the culmination of the famous Death of Superman story line]."

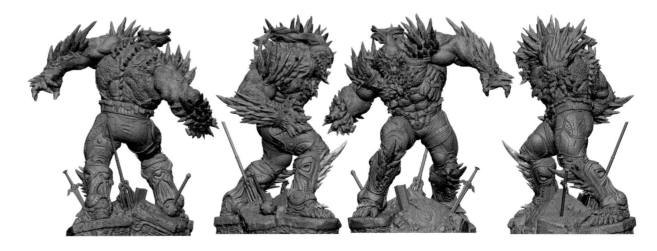

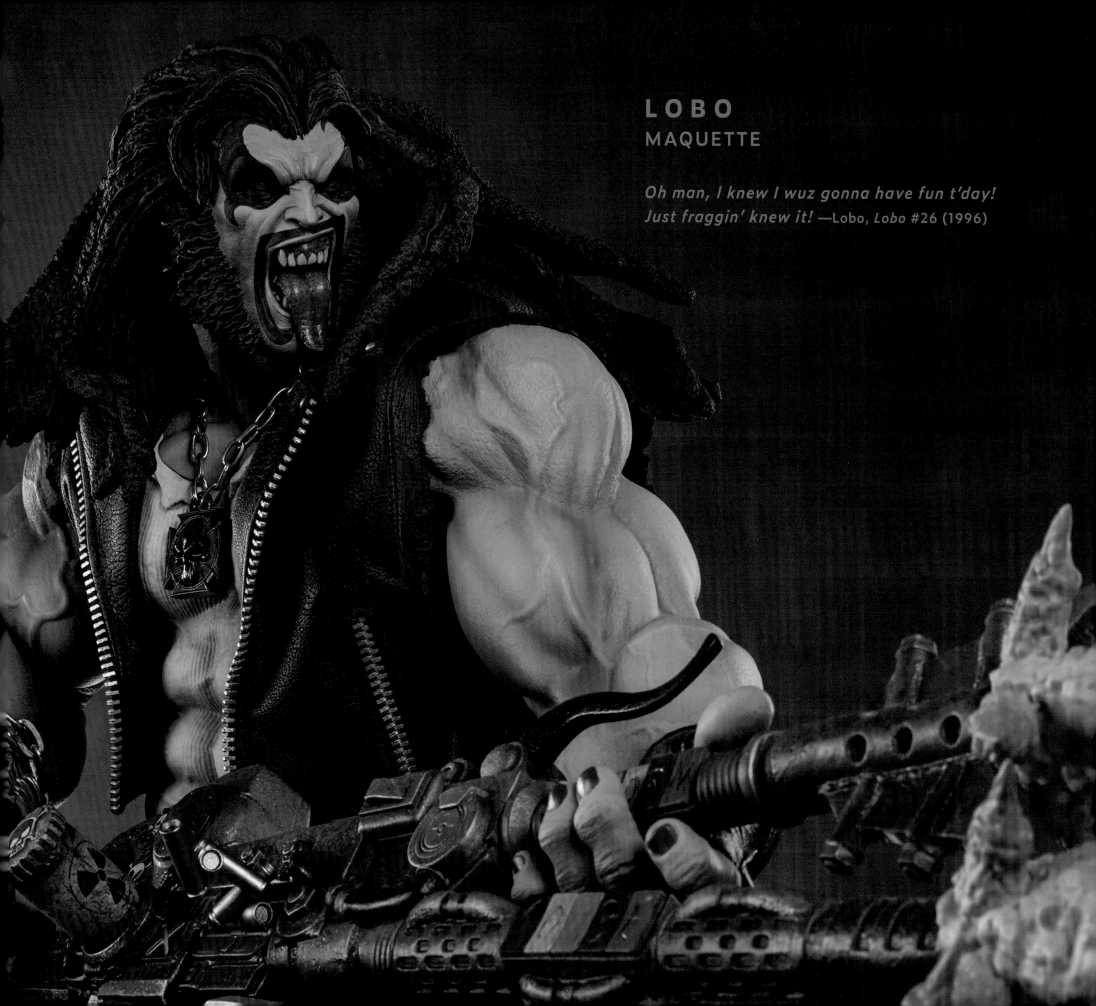

LOBO
MAQUETTE

*Oh man, I knew I wuz gonna have fun t'day!
Just fraggin' knew it!* —Lobo, *Lobo #26* (1996)

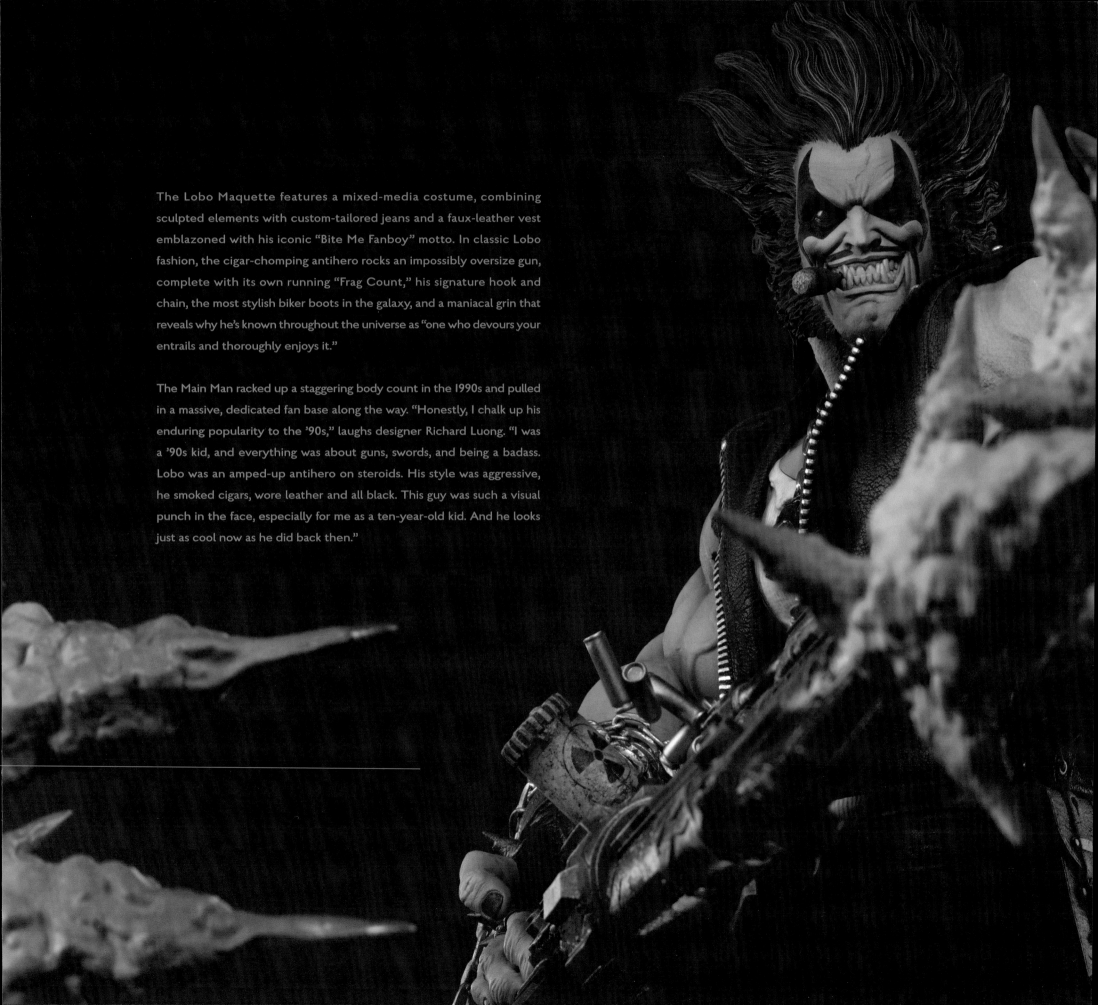

The Lobo Maquette features a mixed-media costume, combining sculpted elements with custom-tailored jeans and a faux-leather vest emblazoned with his iconic "Bite Me Fanboy" motto. In classic Lobo fashion, the cigar-chomping antihero rocks an impossibly oversize gun, complete with its own running "Frag Count," his signature hook and chain, the most stylish biker boots in the galaxy, and a maniacal grin that reveals why he's known throughout the universe as "one who devours your entrails and thoroughly enjoys it."

The Main Man racked up a staggering body count in the 1990s and pulled in a massive, dedicated fan base along the way. "Honestly, I chalk up his enduring popularity to the '90s," laughs designer Richard Luong. "I was a '90s kid, and everything was about guns, swords, and being a badass. Lobo was an amped-up antihero on steroids. His style was aggressive, he smoked cigars, wore leather and all black. This guy was such a visual punch in the face, especially for me as a ten-year-old kid. And he looks just as cool now as he did back then."

DETAILS

Lobo was strictly a minor character when he was introduced in the pages of DC's *The Omega Men* in the early 1980s, but when he was reinvented as an over-the-top, ultraviolent intergalactic bounty hunter in the early '90s, he became an immediate fan favorite. His brash attitude made him one of DC's signature characters of that unforgettable decade. Capturing that larger-than-life persona was crucial to the team who crafted the Lobo Maquette.

"Lobo is another all-out-crazy character to create. It has to be ballsy and over the top and should bring a smile to your face just looking at it," laughs costume fabrication manager Tim Hanson. "For our second go at Lobo—the first being our Lobo Sixth Scale Figure—we went for a badass intergalactic bounty hunter engaged in some alien-blasting. I loved the look of the torn leather vest and weathered jeans with the red stripe and white stars, inspired by the artwork from the '90s.

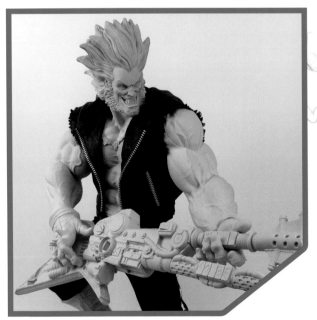

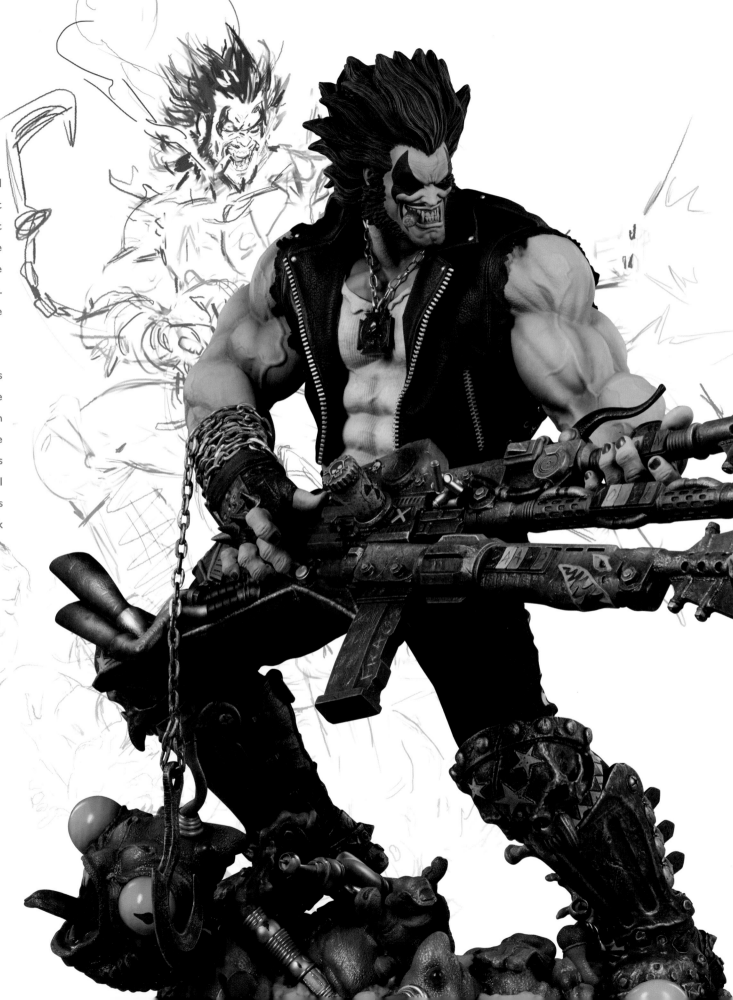

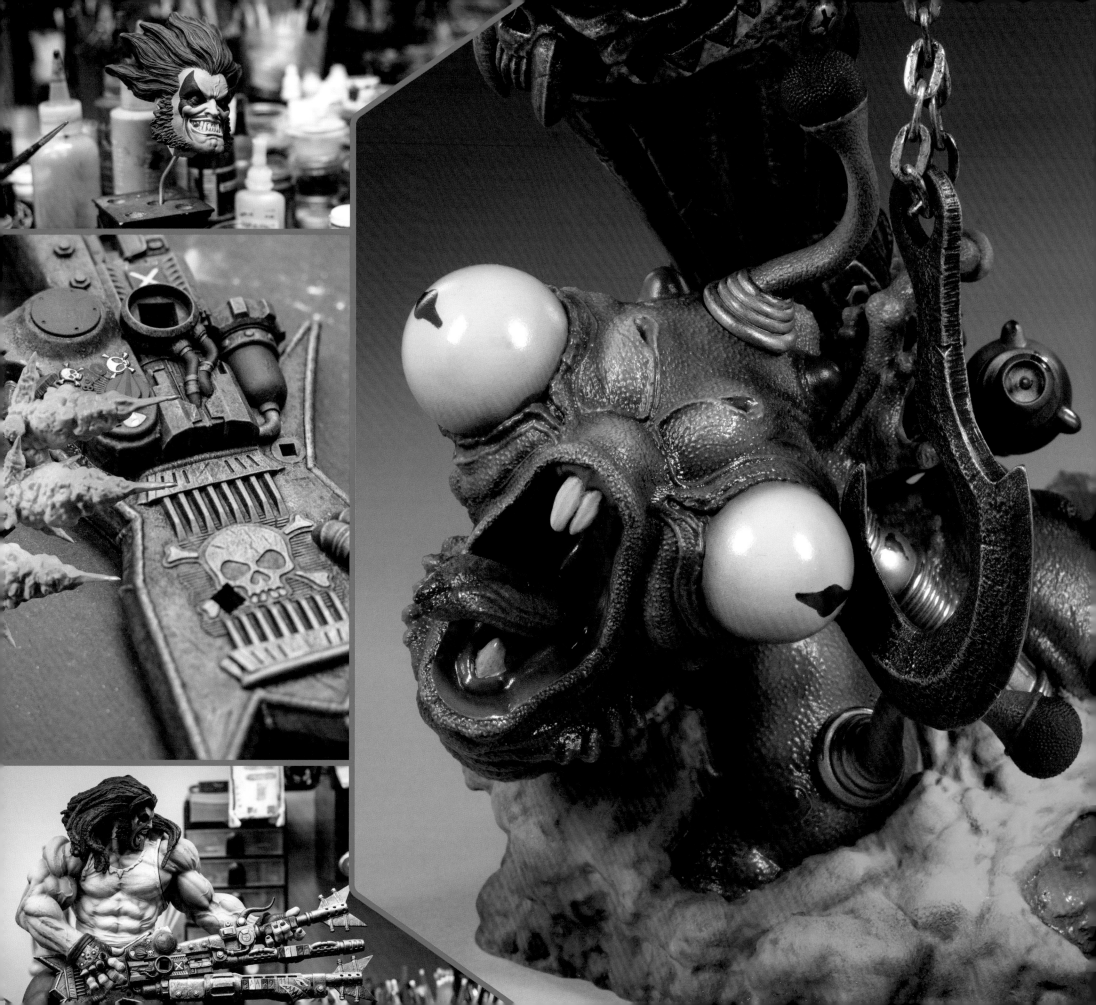

"A huge bonus was getting another chance at making that awesome patch on his back," Hanson adds. "This time, we made it an actual embroidered patch, where it was previously printed on canvas. The large metal zippers and real chains add just the right touches for the Main Man."

Although Lobo's super-strength and ability to heal from any injury already make him one of the most dangerous men in the galaxy, the Main Man packs one of the deadliest arsenals around, from his legendary hook and chain to his massive custom blaster. "That ridiculously awesome triple-barrel guitar blaster was a huge focus on this piece," says Tim Hanson. "I remember seeing the artwork early on and wondering how that would translate into 3D . . . once I saw the final product, it did not disappoint! There's so much to take in with all the dials, knobs, and colorful keys to the kill-count 'Frags' etched in. But my favorite detail might be the bullet casings ejecting from the chamber."

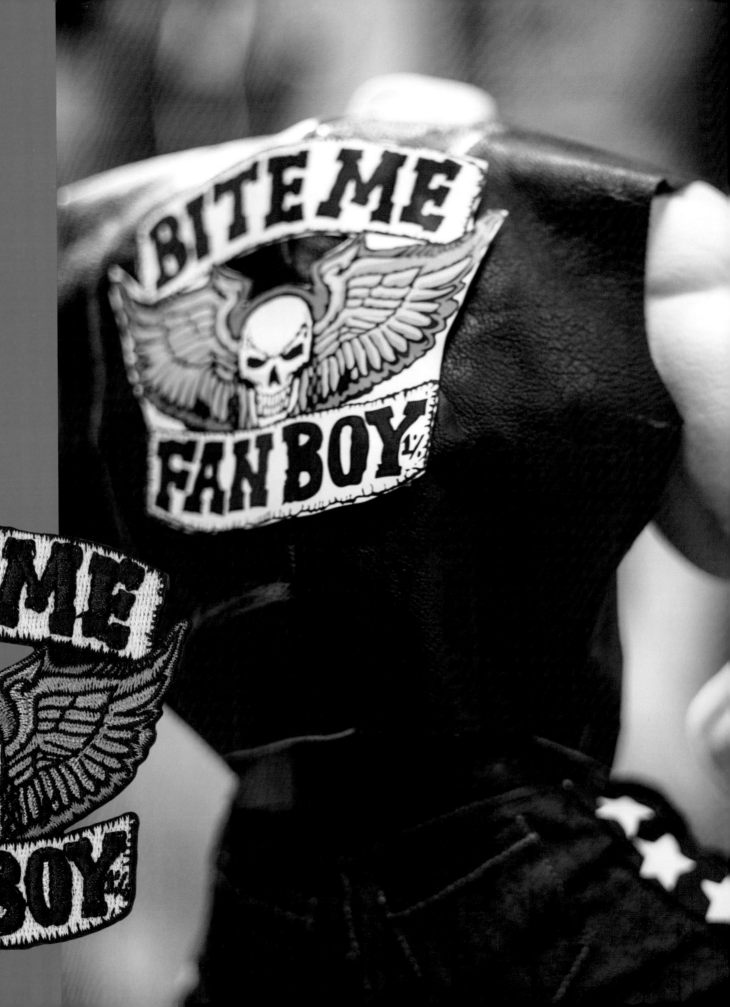

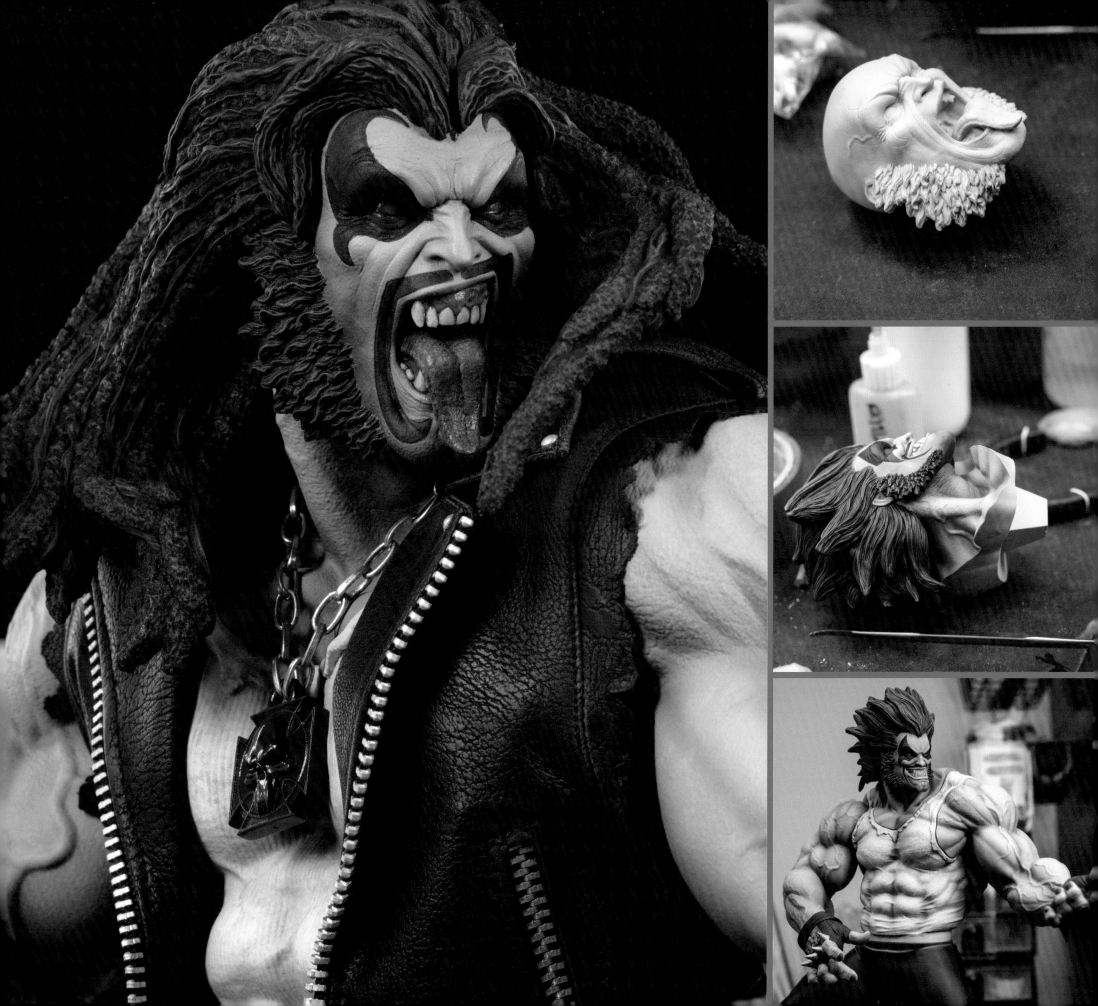

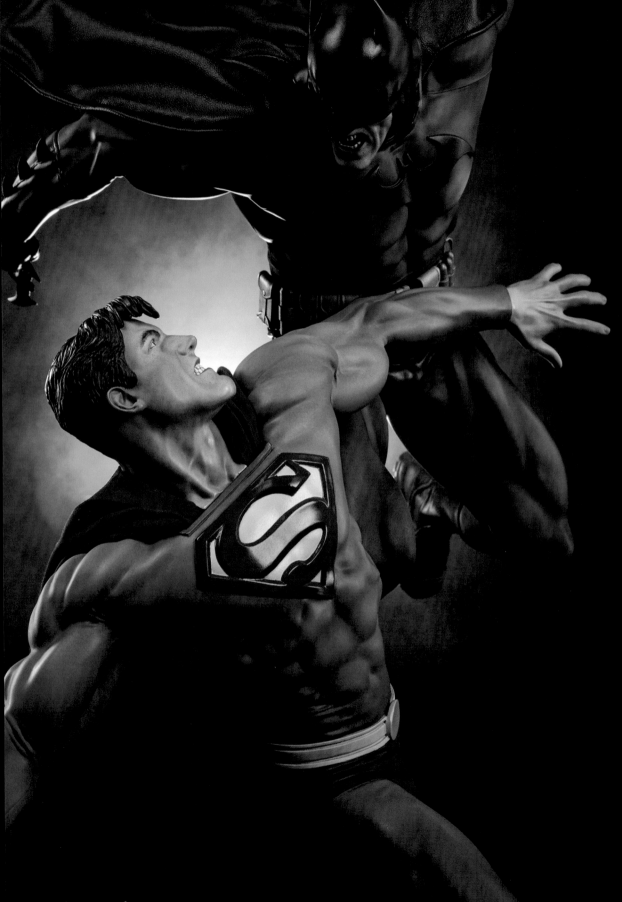

SUPERMAN VS. BATMAN

DIORAMA

It's way past time you learned what it means to be a man. —Batman, *Dark Knight Returns* #4 (1987)

For most of their shared history, Batman and Superman have been part of the World's Finest team, saving the DC multiverse from evildoers time and time again. But through the years, notably in the classic comic books *Batman: The Dark Knight Returns* and *Kingdom Come*, that friendship has been pushed to its limits due to ideological differences between the Big Two and their crime-fighting methodologies.

Sideshow's Superman vs. Batman Diorama depicts the ultimate showdown between the Man of Steel and the Dark Knight in the midst of Superman's Fortress of Solitude.

The resin Superman vs. Batman Diorama features two highly detailed, sculpted Super Heroes. Superman, dressed in his classic, primary-colored outfit, winds up with a powerful punch as the shadowy, fearless Batman prepares a counterattack, armed with a Batarang and a Kryptonite ring. This 23-inch-tall diorama is painstakingly crafted, and its deluxe sculptural elements are complemented by tailored fabric capes with internal wiring for custom posing options.

Irresistible force meets immovable object, winner take all.

DC fans have debated for decades which hero would come out on top in an all-out, no-holds-barred battle between Superman and Batman—and designer Richard Luong doesn't expect this sculpture to put that topic to rest. "We really wanted to make sure that neither one of them looked like they had the upper hand here," says Luong. "These are two of the most iconic characters ever created, so our goal was to make them locked in a pose where each was about to give their full impact. The viewer can imagine the epic action that is about to occur."

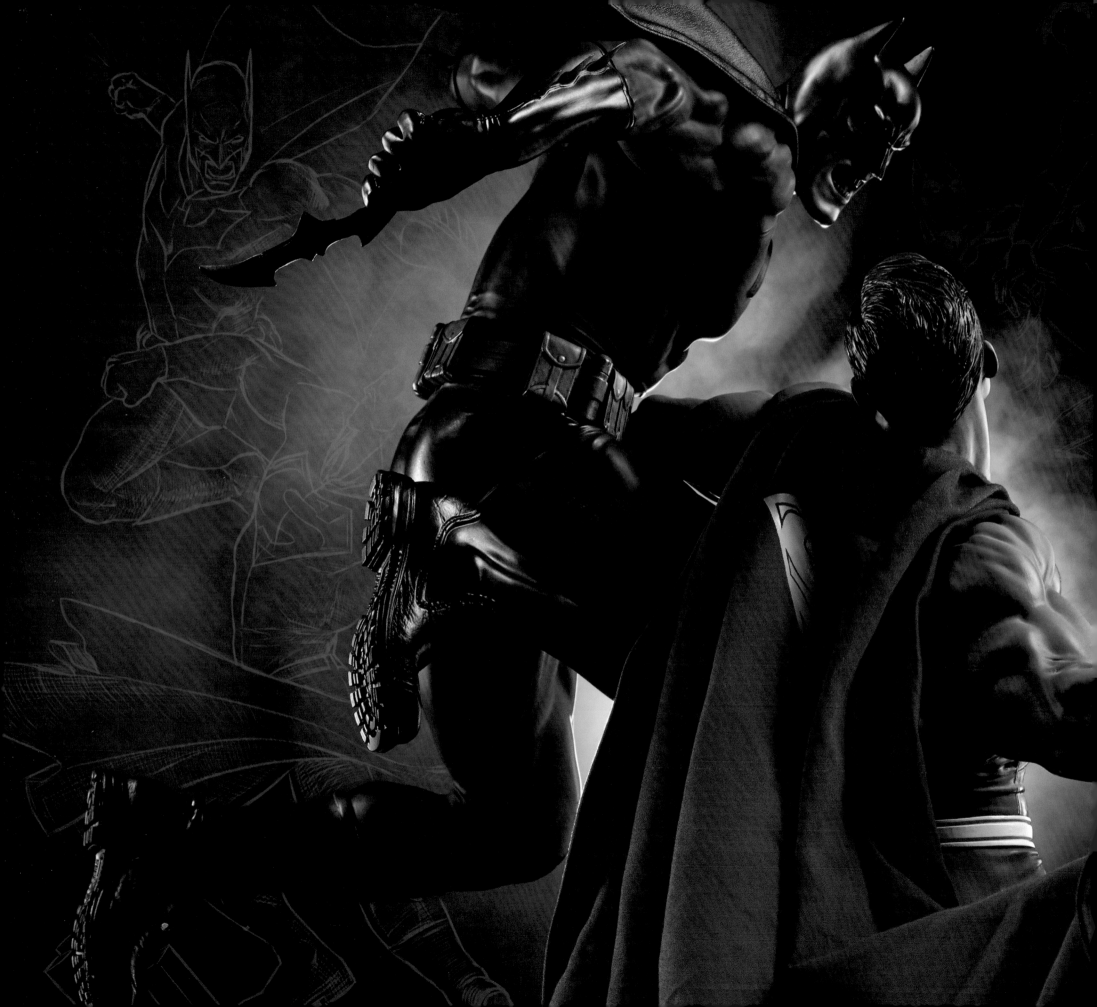

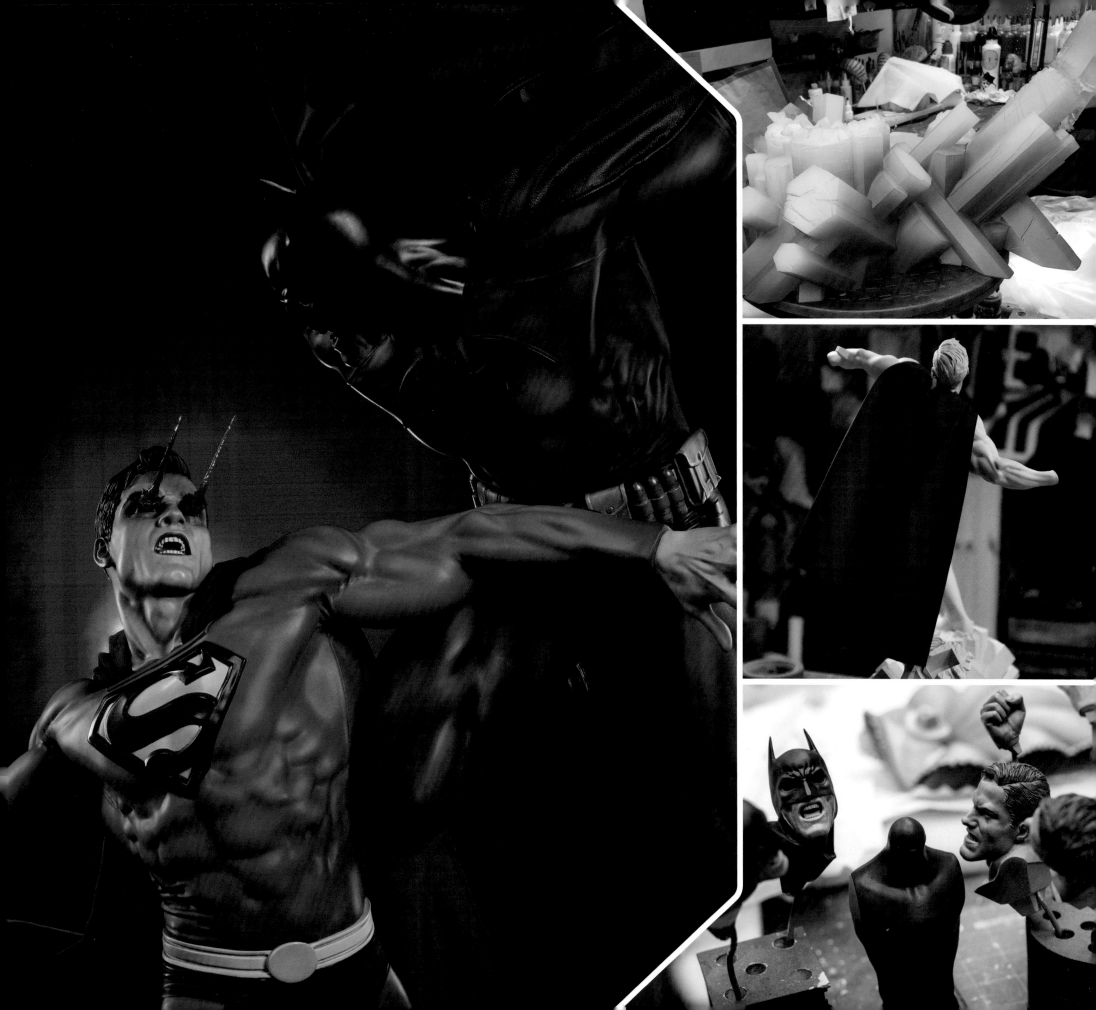

DETAILS

Staging the epic confrontation required something special, according to sculptor Steve Lord. "When thinking of laying out the fight scene for Superman vs. Batman, I wanted something different than the 'almost ready to punch each other' scenario," says Lord. "Flipping the scene where Superman is on the ground and not flying was the first change. Second was I really wanted contact between them, so we were trying to come up with scenarios where there was contact but neither one was getting beat down. Third change was we really wanted to break Superman's signature stoic look, so we have him grimacing and yelling, which makes him more human."

The nigh-invulnerable Man of Steel takes a head-on approach in battle, while master tactician Batman is willing to use everything in his bag of tricks to level the playing field. "Having Batman knee Superman in the back was a good way to show contact, while both were displayed evenly for the most part and not one of them was getting clobbered," says Lord. "Another concern when sculpting a group, especially, is that it has to look good in all angles. We worked hard to get the twisting and movement right, so when looking at the piece at any angle there was something interesting going on."

The resulting diorama is a study in contrasts, with the champion of truth and justice locked in mortal combat with the Dark Knight. Painter Bernardo Esquivel played up that dichotomy with stunning results in the final sculpture. "It was exciting to find the right balance of real-world and comic book feel to this piece," says Esquivel. "Using bright colors for a comic book feel but at the same time adding some weathering effects and different finishes for real-world feel."

"The design team and paint team worked hard to get a good balance for each character," Esquivel adds. "The design team establishes the main color scheme, then I build on that, mixing and laying down colors to match what has been approved. We go back and forth until we find the right balance. It's a collaborative effort, and it's nice to see the end result of our teamwork."

The design, sculpture, and painting are only part of the process involved in bringing a completed piece like the Superman vs. Batman Diorama to collectors worldwide. The Mold and Cast Department must be able to replicate the design team's work before a piece can be put into production. "Mold and Cast is actually a couple of different departments combined into one," notes Sideshow's Jeremy Williams. "We handle 3D print cleanup, mold and cast, as well as a good amount of general quality control. Once a project is sculpted, digitally for the most part, it gets sent out for 3D printing. Although the 3D printers have gotten pretty good over the years, the printed parts still require a good amount of cleanup to get them to the quality we need, and that's where our department comes in. We clean the build lines off each printed part, adding any textures or fidelity that didn't translate from sculpt to print.

"After we clean a project we can start molding and casting it. The process starts by building a box around each part and pouring silicone around it to make a mold," adds Williams. "Once the mold catalyzes, we can pour up a casting using polyurethane resin. We typically cast up three or four copies of each statue: one paint copy, which gets sent to our manufacturer for reference; one prototype copy, which stays at Sideshow to compare to factory samples; and one tooling master, which gets sent to the manufacturer to make their molds from. If the project requires any fabric costuming, like the Superman vs Batman Diorama, we cast a fourth copy for Cut and Sew, which handles the costuming."

STATUES

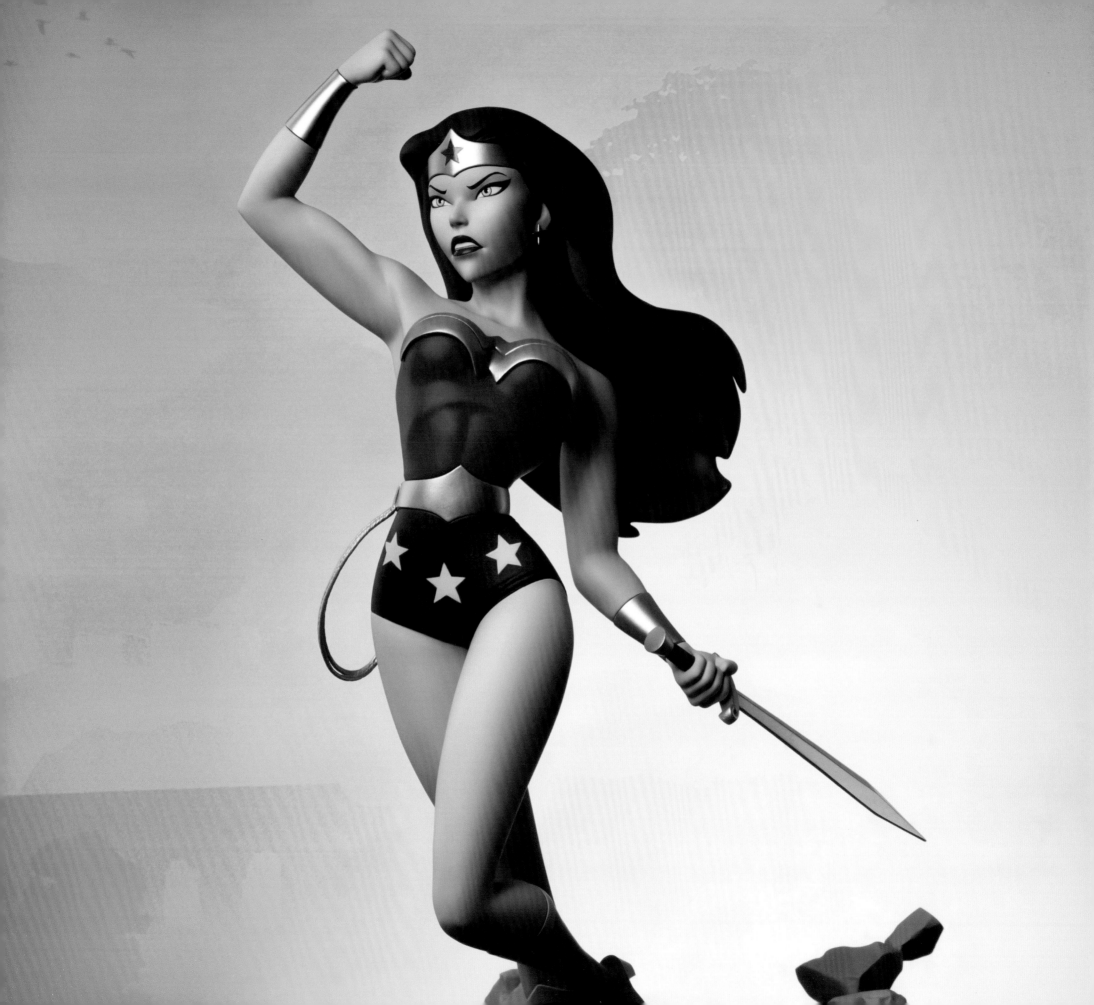

"IF THE POLICE EXPECT TO PLAY AGAINST THE JOKER, THEY'D BETTER BE PREPARED TO BE DEALT FROM THE BOTTOM OF THE DECK!"
—THE JOKER, *BATMAN* #1 (1940)

STATUES

One aspect of Sideshow's vast output that is often taken for granted is the sheer range of artistic styles showcased by the modern-day renaissance studio.

The scope of the studio's talent is perhaps most apparent in Sideshow's DC Artist Series statues. The series, spotlighting Stanley 'Artgerm' Lau, gave a visionary artist free rein to reimagine three of DC's most celebrated sirens—Catwoman, Harley Quinn, and Poison Ivy—as high-fashion icons designed to appeal to lovers of retro art as well as connoisseurs of contemporary collectibles.

It's impossible to imagine a more severe counterpoint to the glamour of the Artgerm statues than the Gotham City Nightmare Collection. Batman and The Joker, two of the world's most famous comic book characters, are twisted and transformed by darkness into macabre, funhouse mirror distortions of themselves. The Gotham City Nightmare Collection allowed Sideshow artists, led by designer Paul Komoda, to cut loose, get creative, and above all, have fun with an original creation unlike anything they'd produced under the DC license before.

Sideshow's prowess with radical reinventions of DC icons is matched by its skill in creating faithful renditions of classic characters. A striking line based on some of the most beloved and critically acclaimed television cartoons of all time—*Batman: The Animated Series*, *Superman: The Animated Series*, and *Justice League*—provided the inspiration for a third new series of statues. Although these iconic characters have been immortalized as toys and deluxe sculptures before, Sideshow's innovative designs and premium quality put a bold new face on them, bringing the animated aesthetic to a new level of artistic achievement.

"Our ethos includes a strong mandate toward originality in how we present well-known characters," says Sideshow CEO Greg Anzalone. "Can we take DC heroes and villains and present them as folks know them, but do so in a way that includes our thumbprint, our spin, our interpretation? For me the answer has always been a resounding yes and is one of the reasons why we stand out with what we do."

Three design teams. Three dramatic visions. Three astounding series.

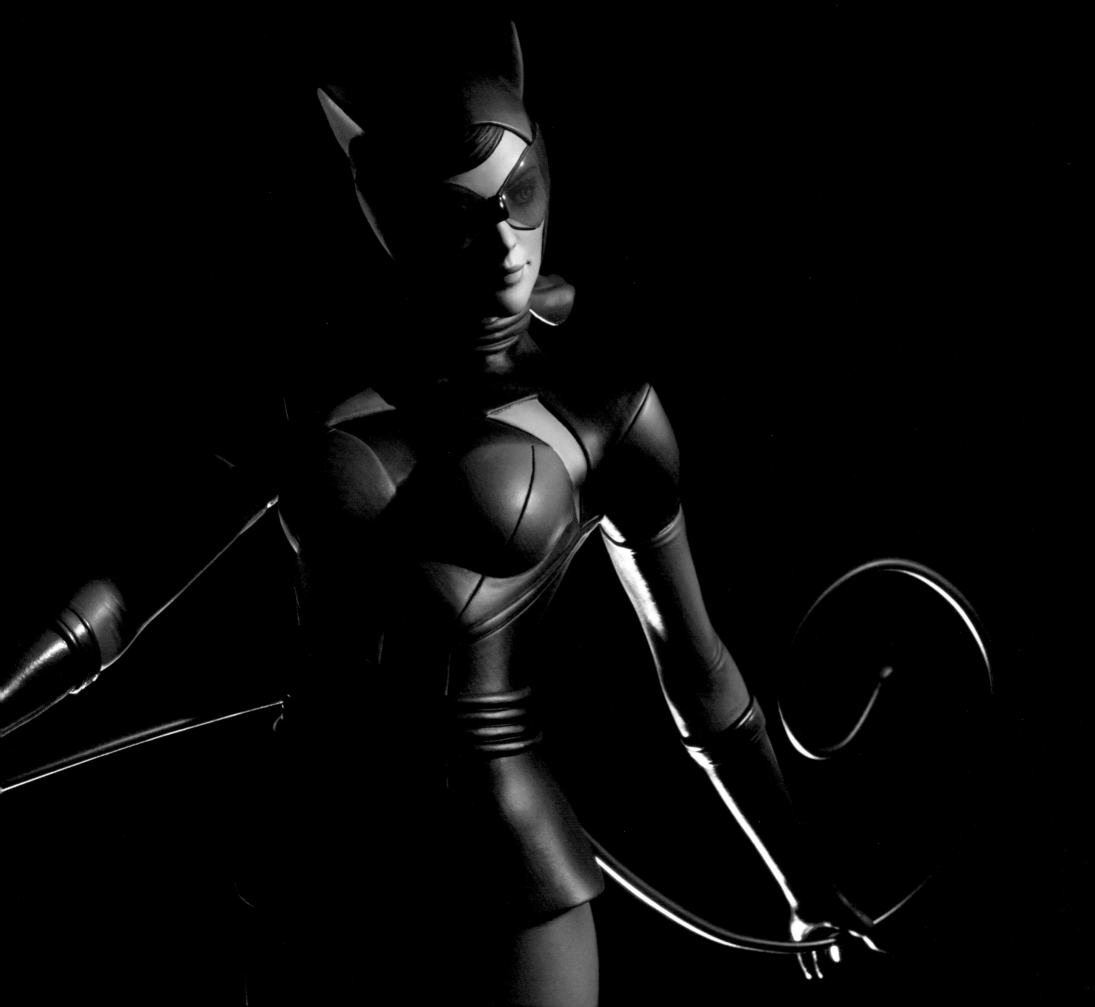

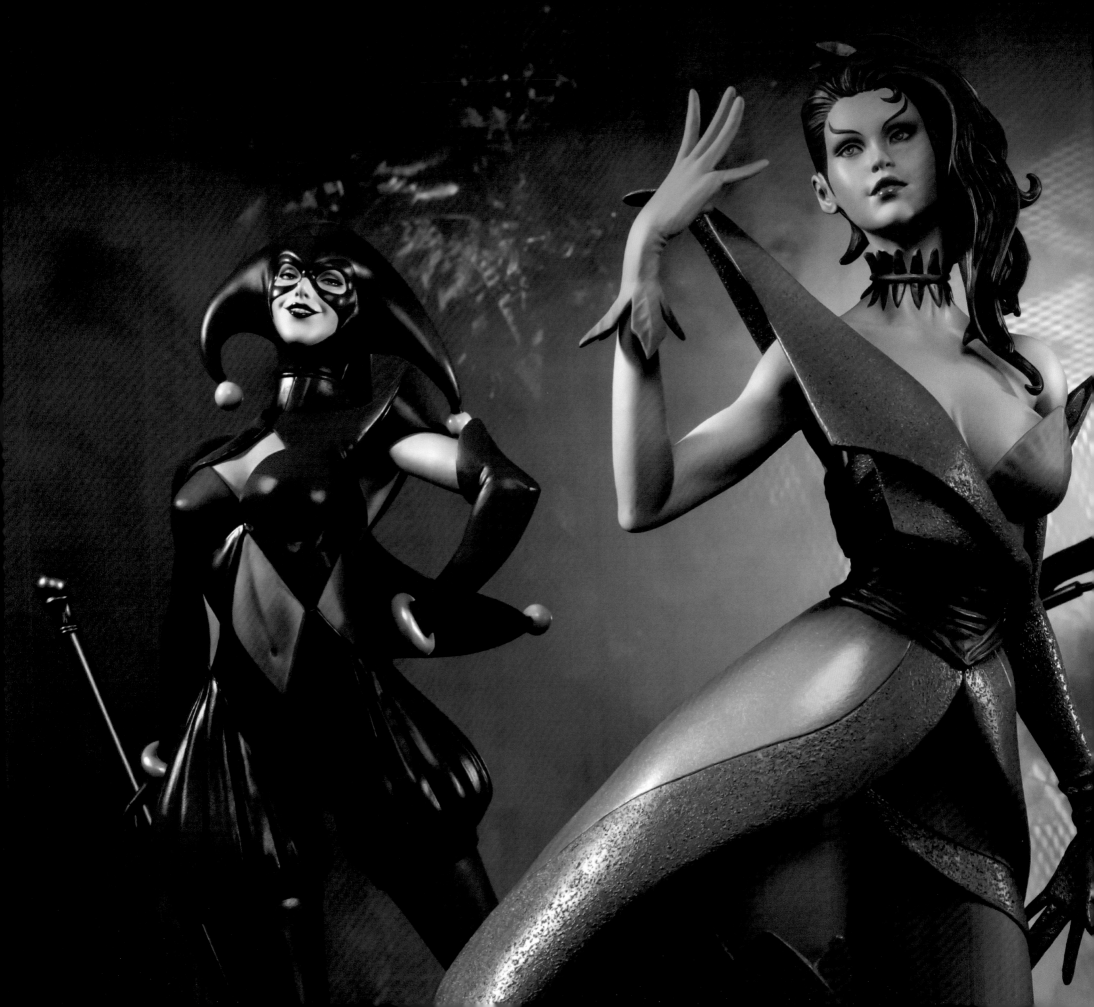

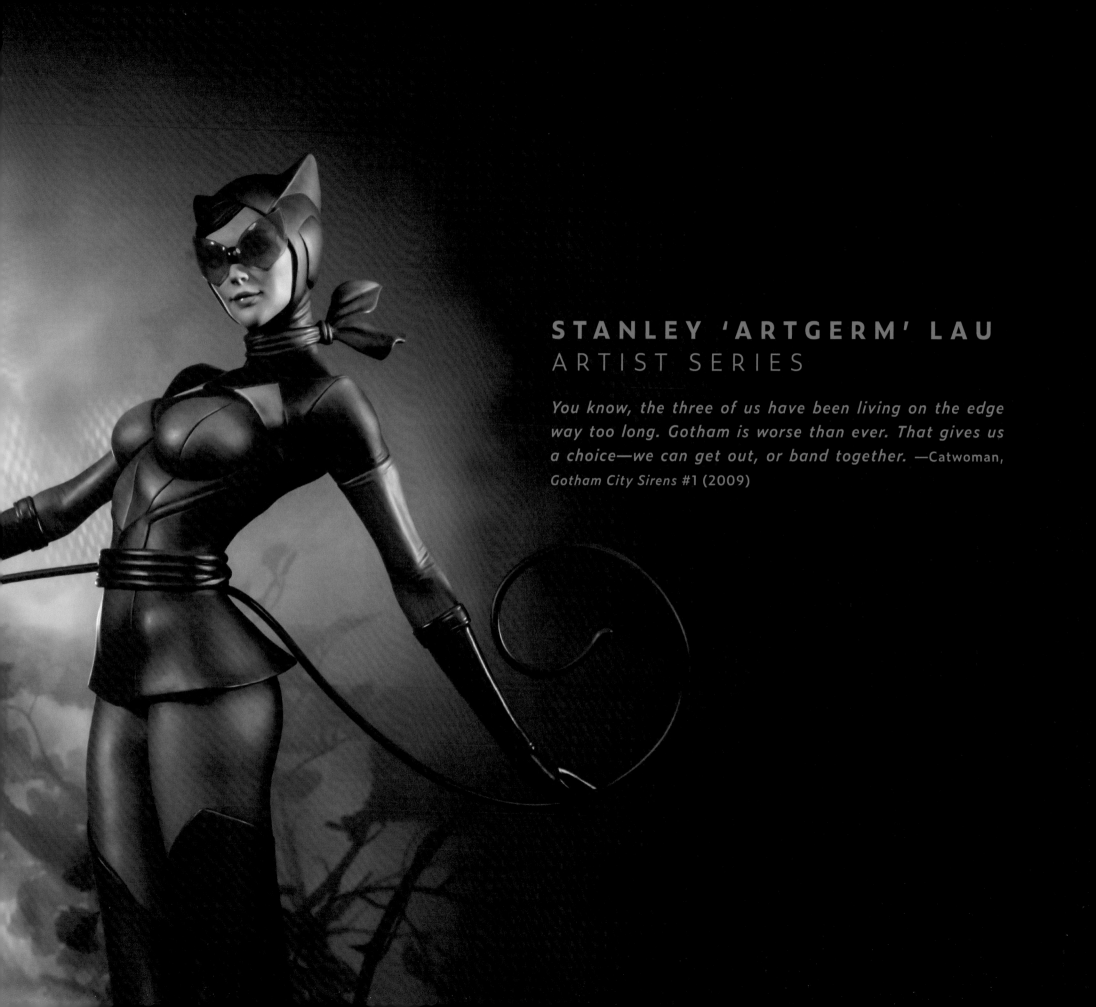

STANLEY 'ARTGERM' LAU
ARTIST SERIES

You know, the three of us have been living on the edge way too long. Gotham is worse than ever. That gives us a choice—we can get out, or band together. —Catwoman, *Gotham City Sirens* #1 (2009)

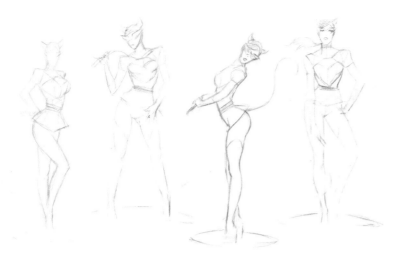

The Bad Girls of Gotham City—Catwoman, Poison Ivy, and Harley Quinn—take the stage in a series of statues by visionary designer Stanley 'Artgerm' Lau. This titanic trio, known collectively as the Gotham City Sirens, are reimagined by Lau as high-fashion icons, as he and Sideshow bring a fresh new take on three of the most compelling members of Batman's Rogues Gallery. His fun, stylish reinventions bring a bold perspective on these classic characters, from Catwoman's retro-future cat burglar outfit to Poison Ivy's elegant formalwear to Harley Quinn's head-turning carnival outfit.

"I always believe that art is a lifestyle, and I'm living in it," says Lau. "Being able to bring something that I have in mind to life through a piece of art—to me, that is magical." Hailing from Hong Kong, Stanley Lau is a designer and concept artist who has brought his own signature blend of Eastern and Western art styles to the worlds of video games, illustration, and comic books. Known commonly as Artgerm, he has garnered great acclaim for his bold visual style and earned an ever-growing fan base of collectors and admirers.

Lau's vibrant artwork certainly gave the team plenty of inspiration to bring these fashionable figures to life with attitude and flair. "Over time, I've worked on a few Stan Lau statues, and he has a very particular color style that he uses, so we wanted to make sure that we captured that," says painter Kat Sapene. "In all of these, you'll notice that they have a specific direction that the light is coming from. We wanted to find a direction that was flattering to all the pieces that really accentuated their faces and would give them a three-dimensional and realistic look."

Art director David Igo adds, "This project was all about evolving these iconic rogues in a new and unique direction with Stanley and his passion for fashion design, and the team really came together to support and meet that goal. Each of the vixens has [her] own distinctions, but their fashion styles and colors really complement one another when they're all presented together. Stanley's designs have really popped out of his artwork and come to life."

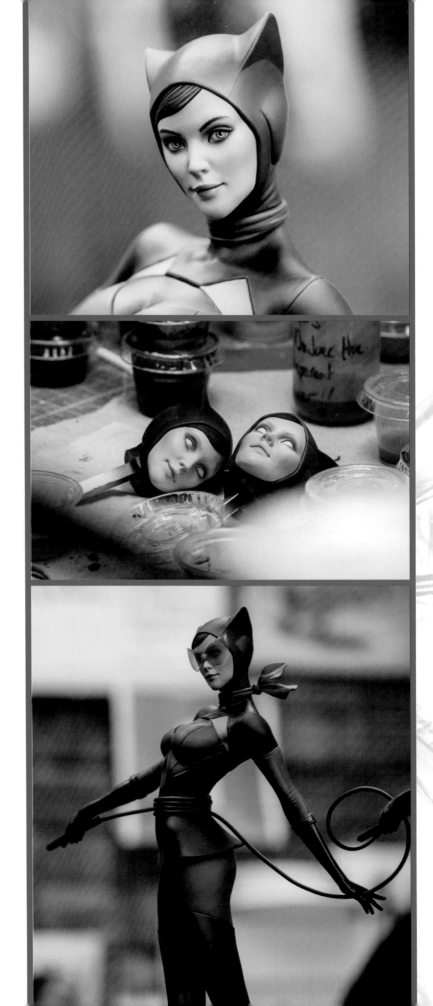

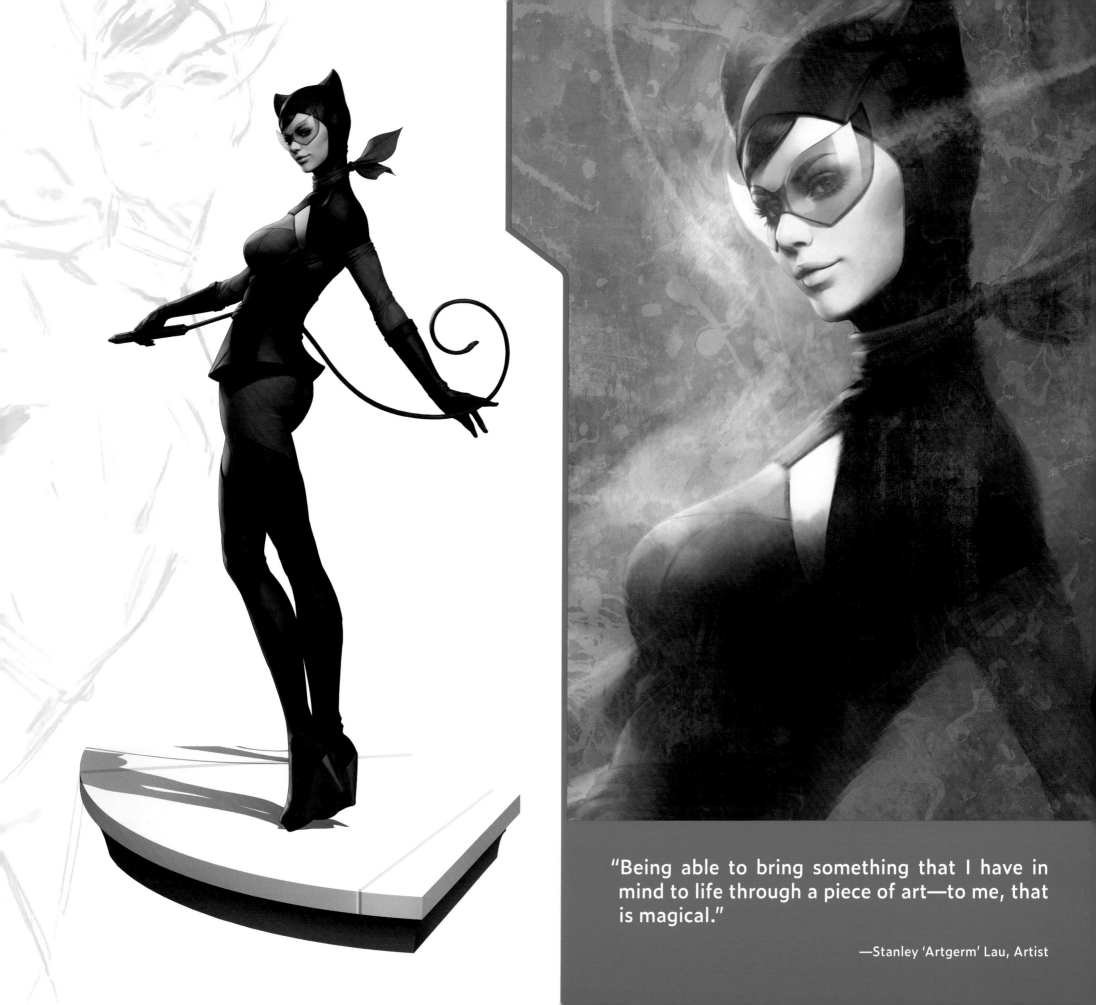

"Being able to bring something that I have in mind to life through a piece of art—to me, that is magical."

—Stanley 'Artgerm' Lau, Artist

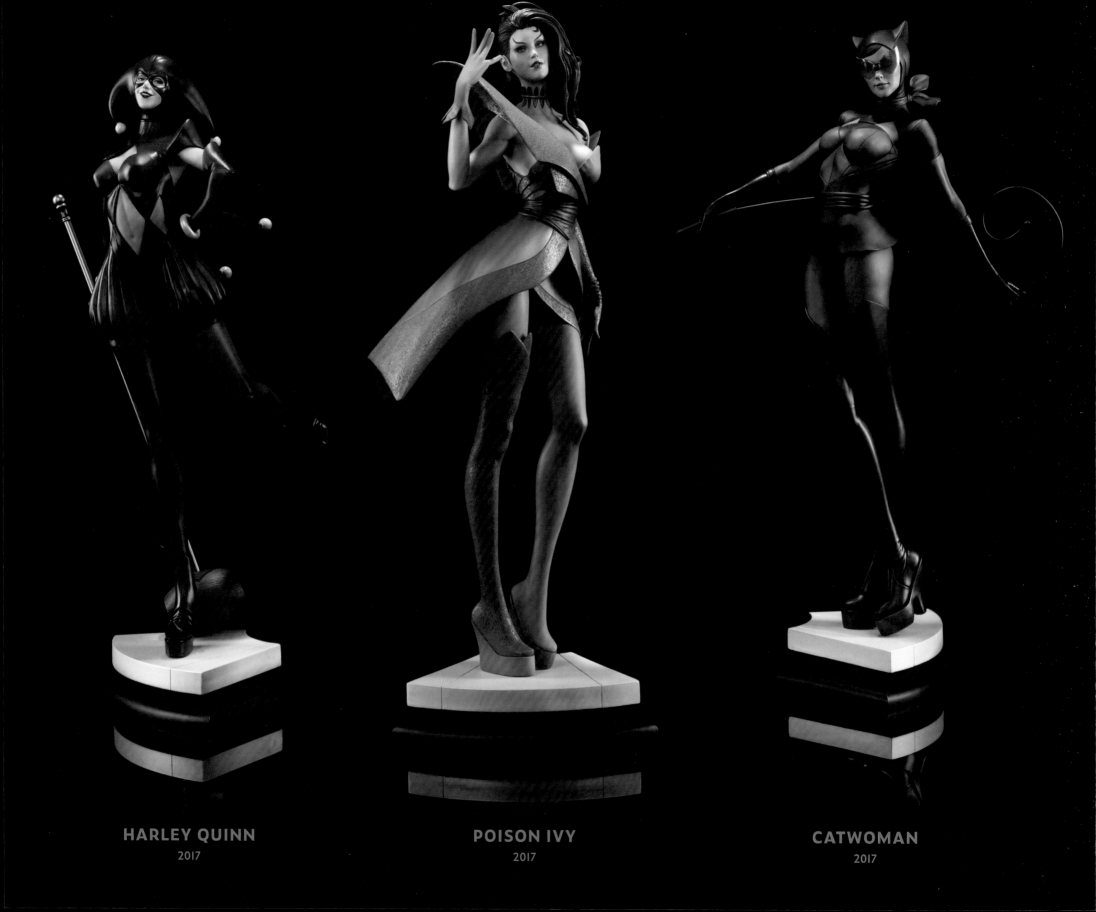

HARLEY QUINN

2017

POISON IVY

2017

CATWOMAN

2017

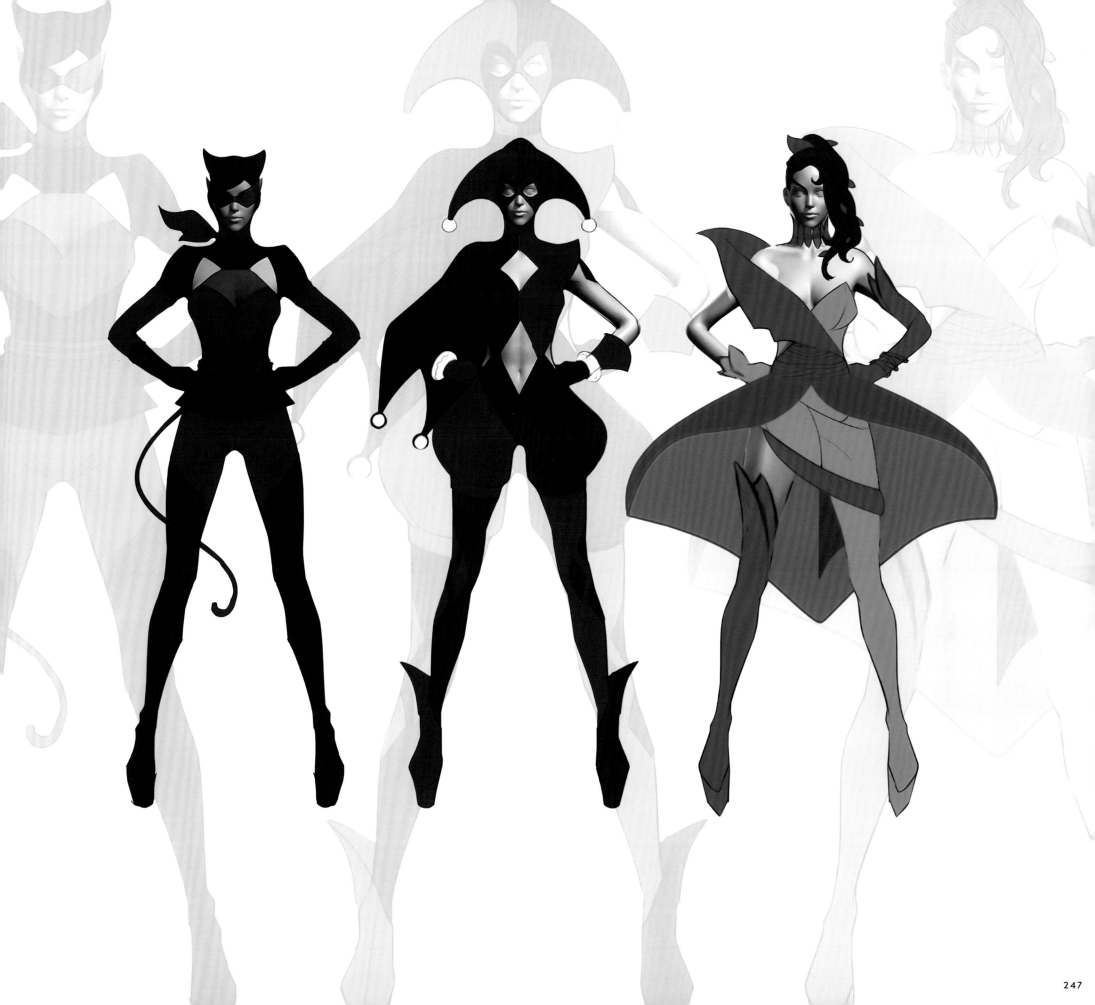

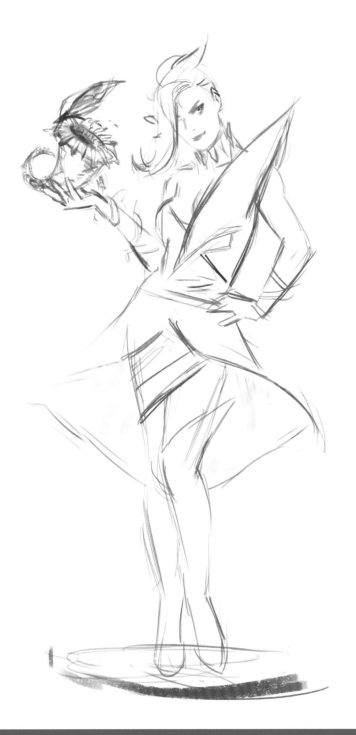

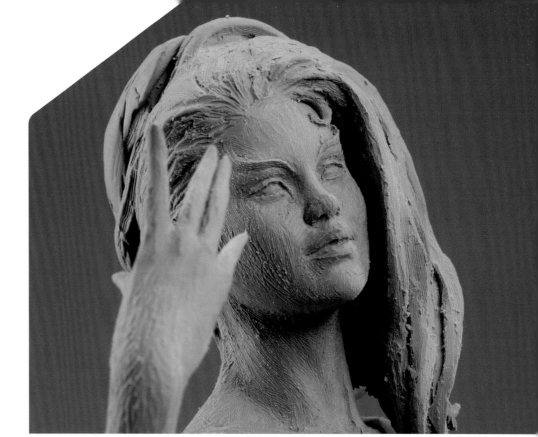

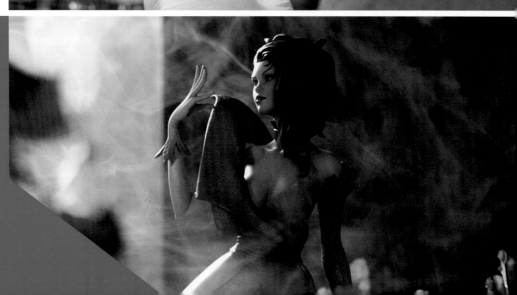

"When I first saw the collection, my mind instantly went to *Project Runway*. I love how elaborate those photographers got with staging sets on the runway. So I tried my take on that with these ladies, which was a whole lot of fun."

—Jeannette Villarreal Hamilton, Photography
Manager and Photographer

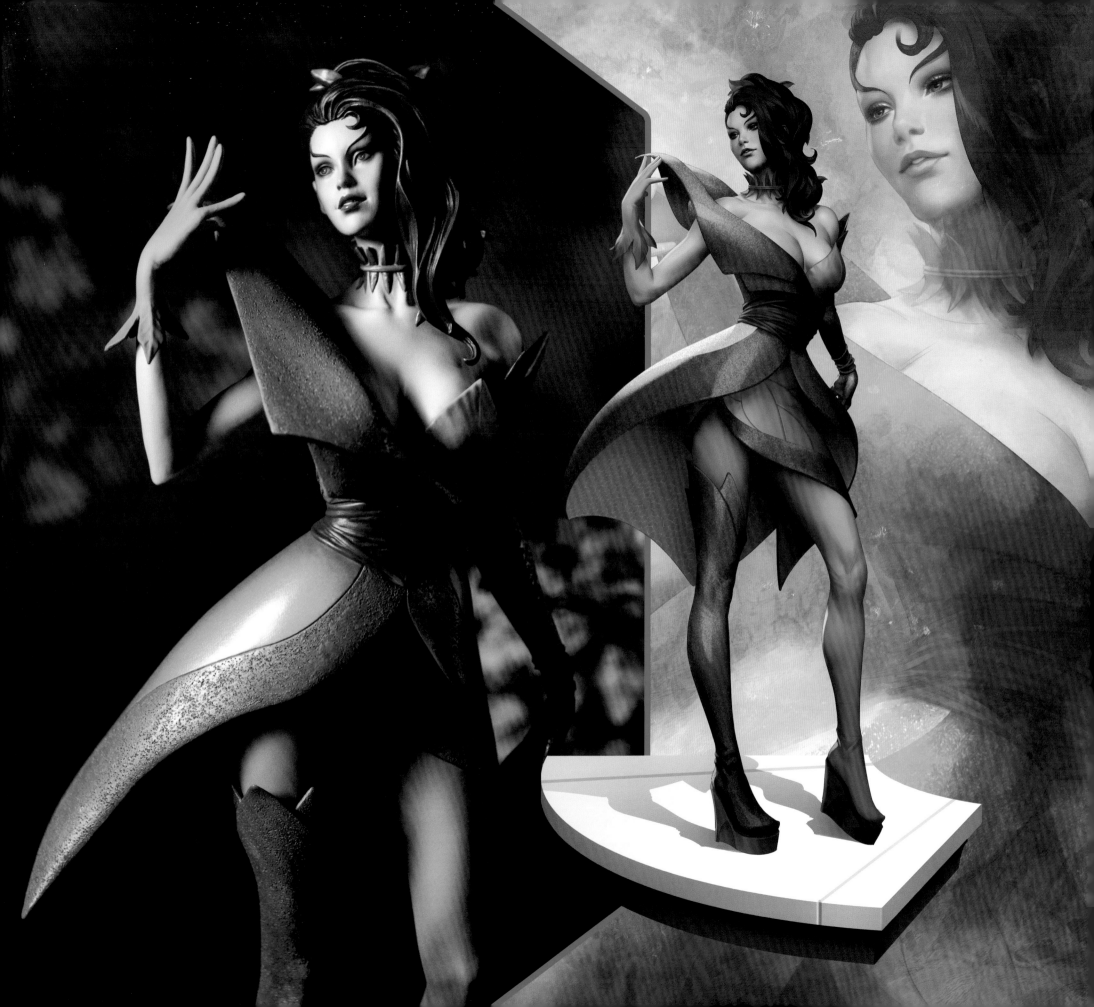

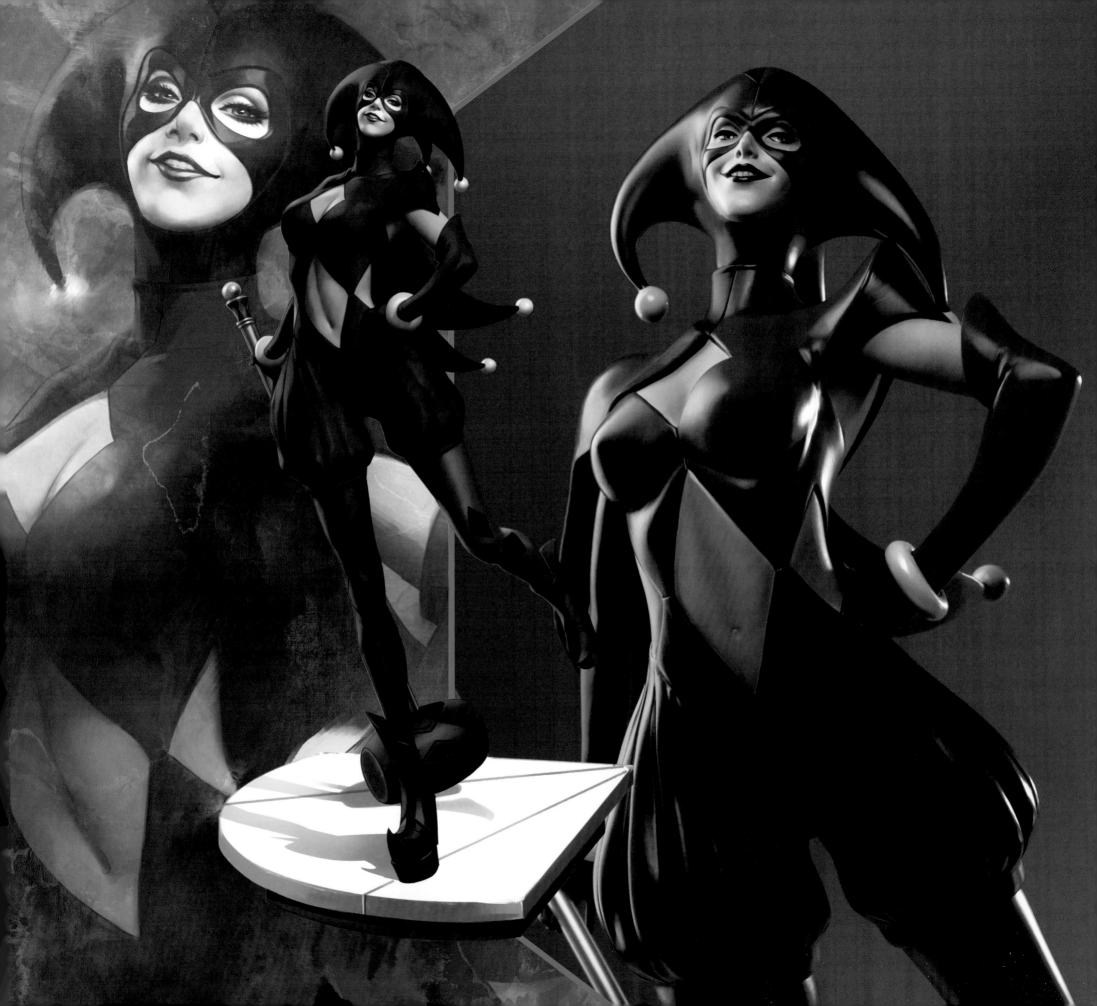

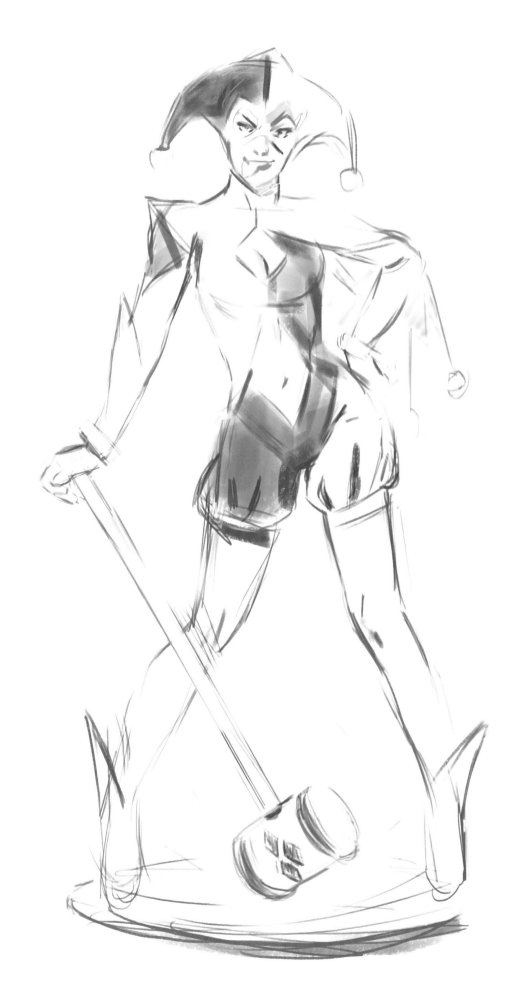
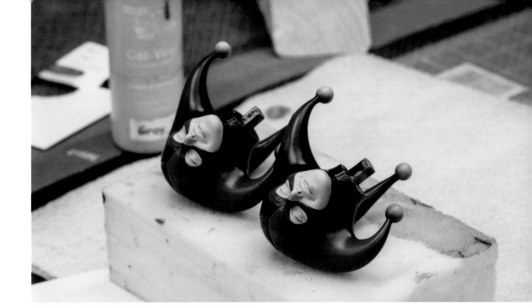
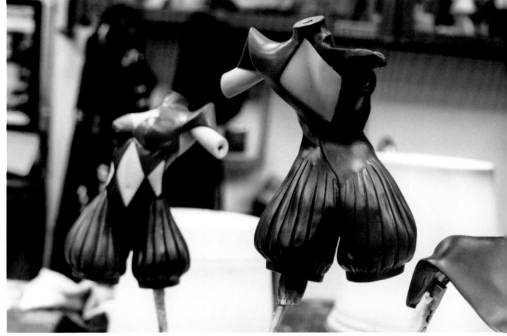

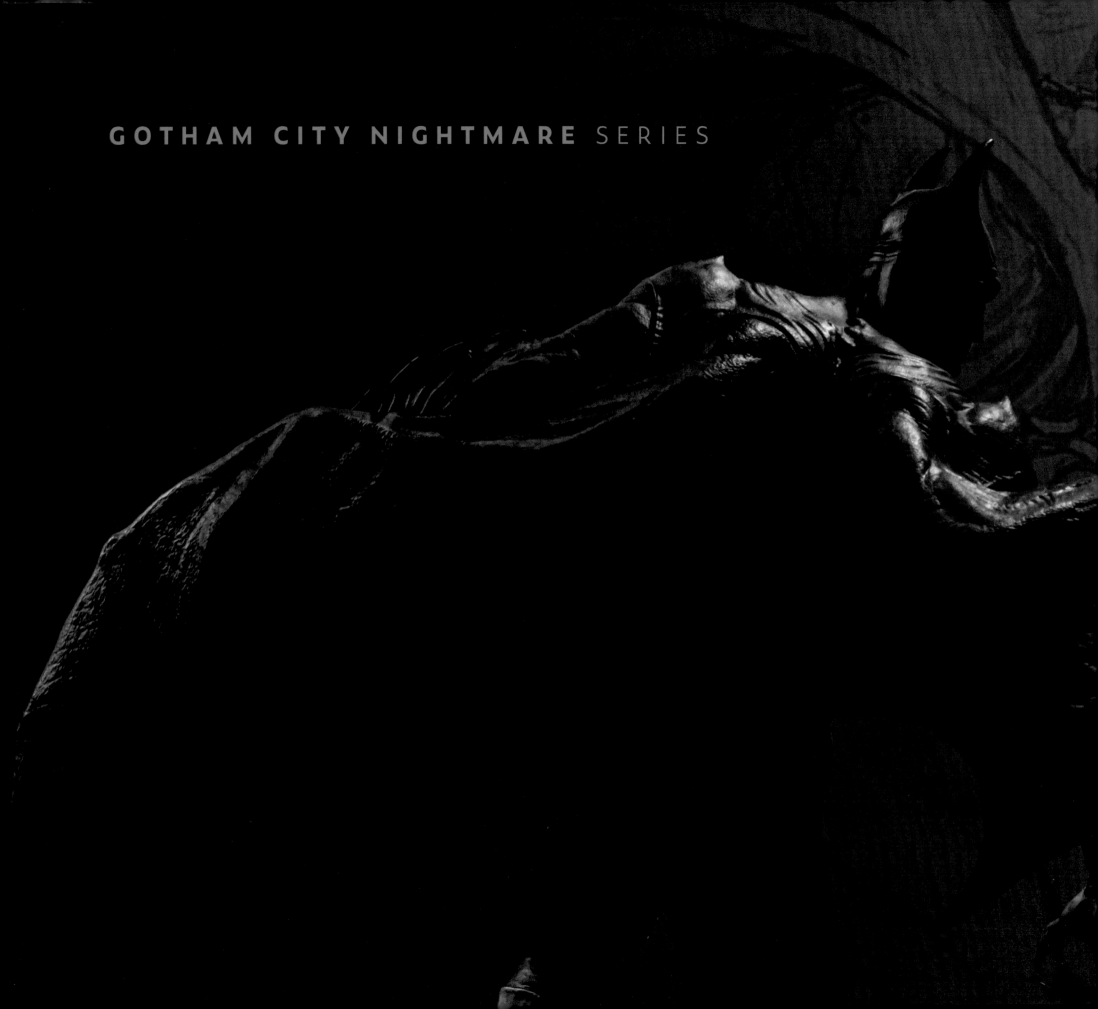

GOTHAM CITY NIGHTMARE SERIES

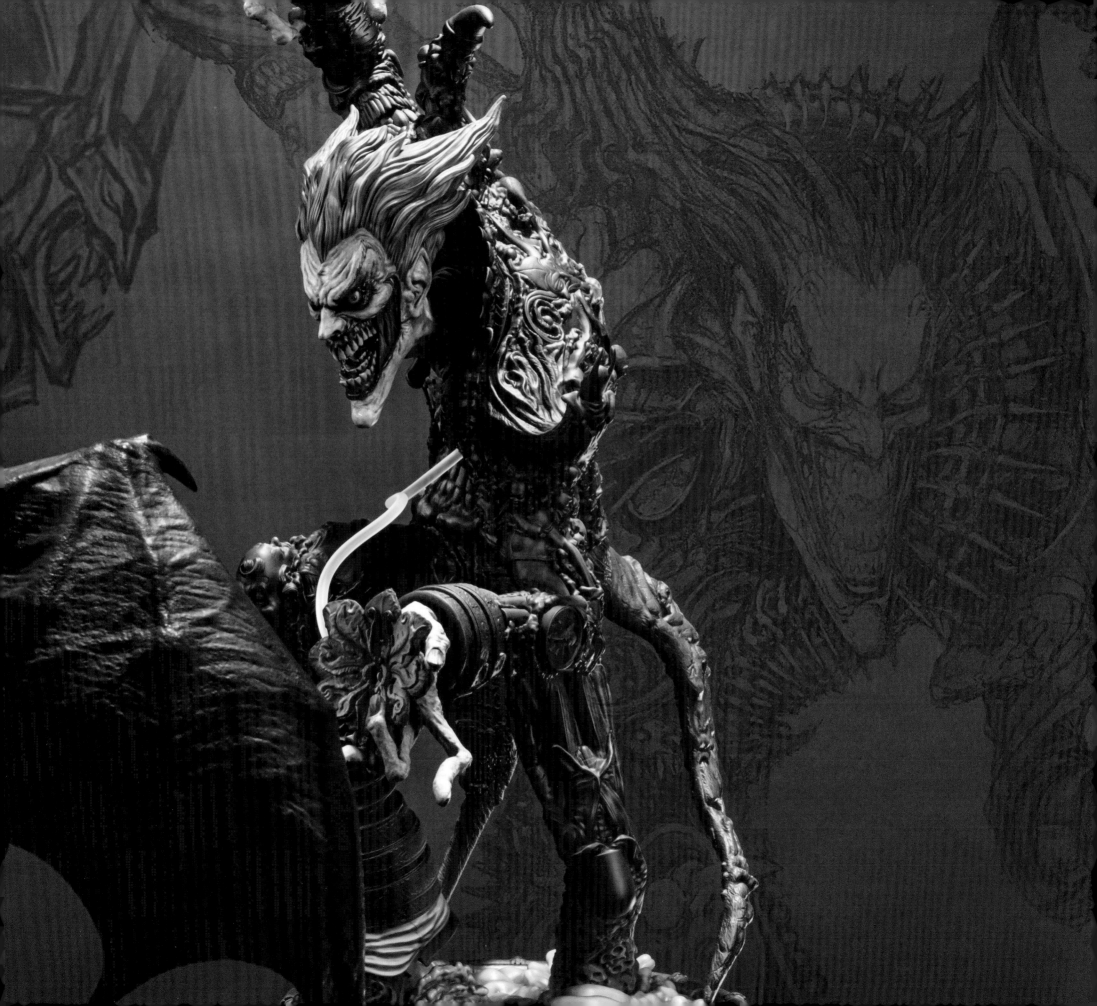

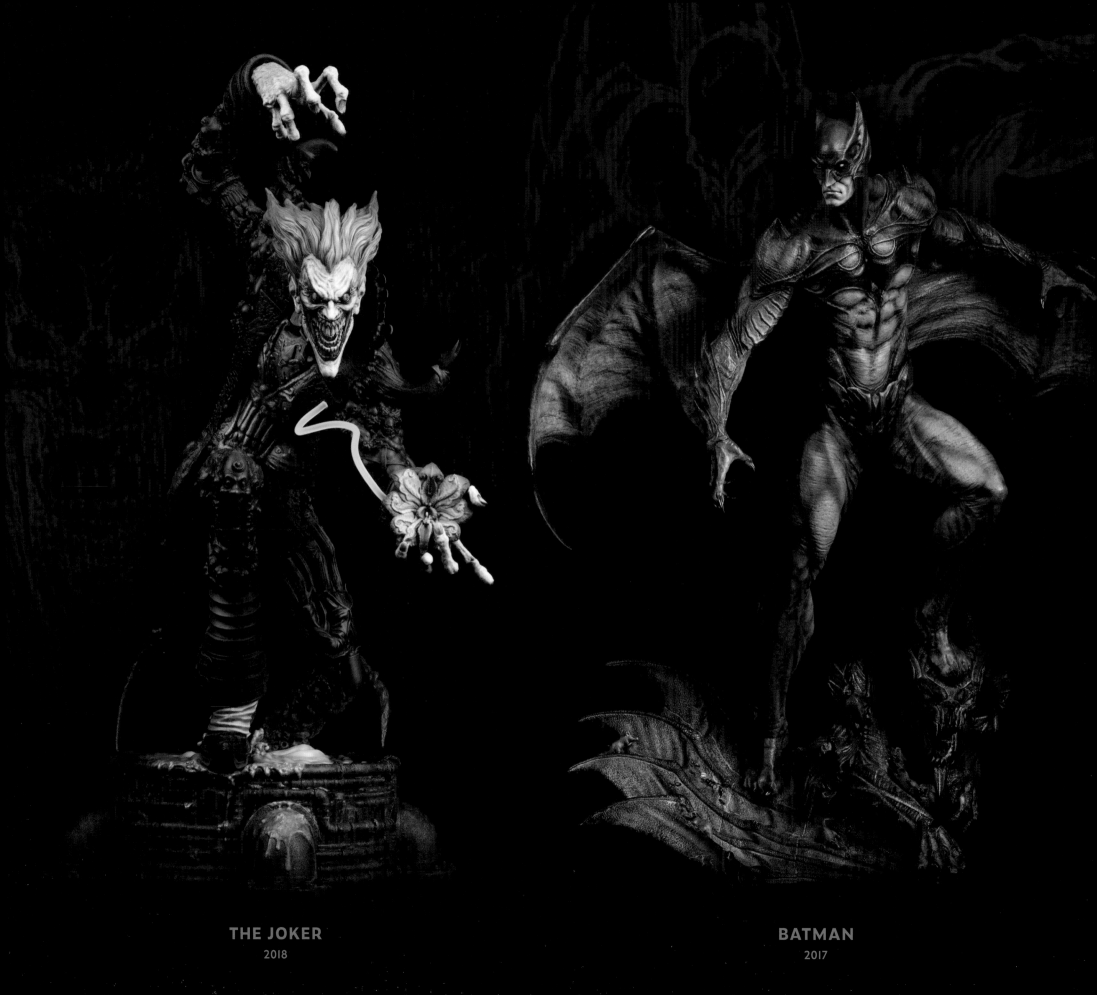

THE JOKER

2018

BATMAN

2017

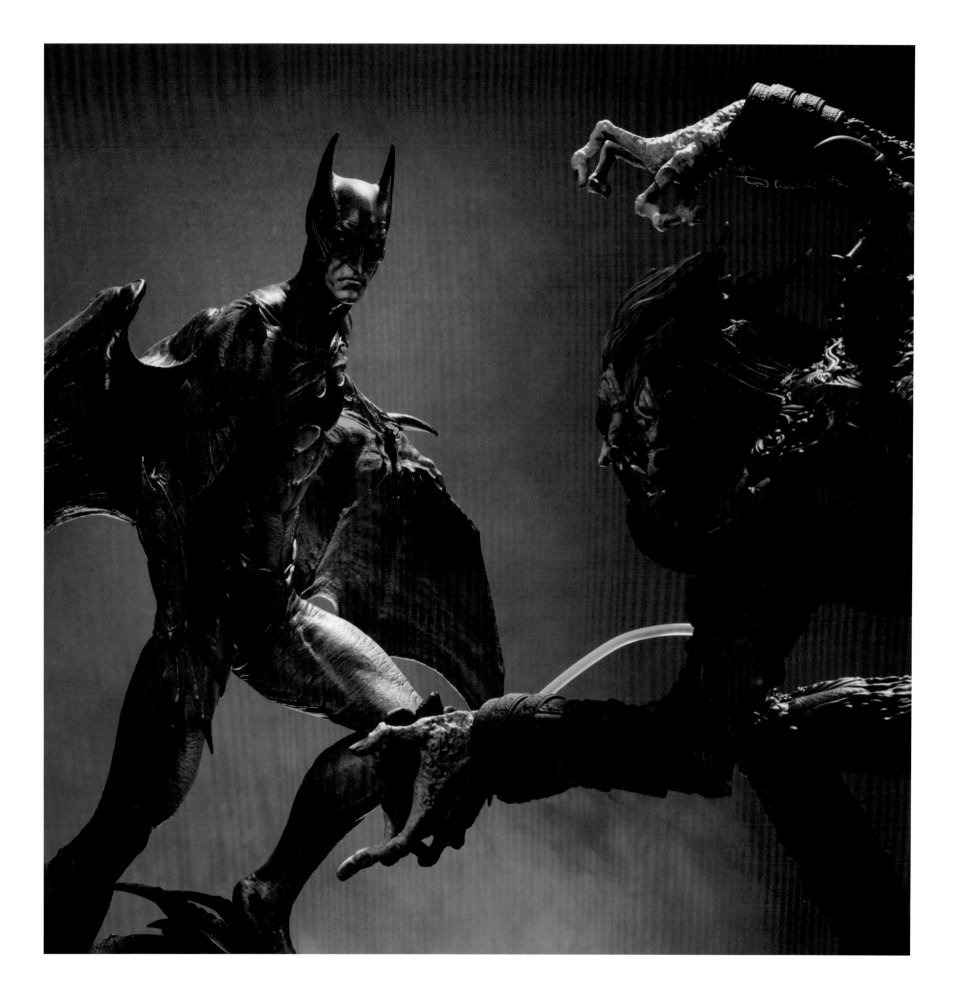

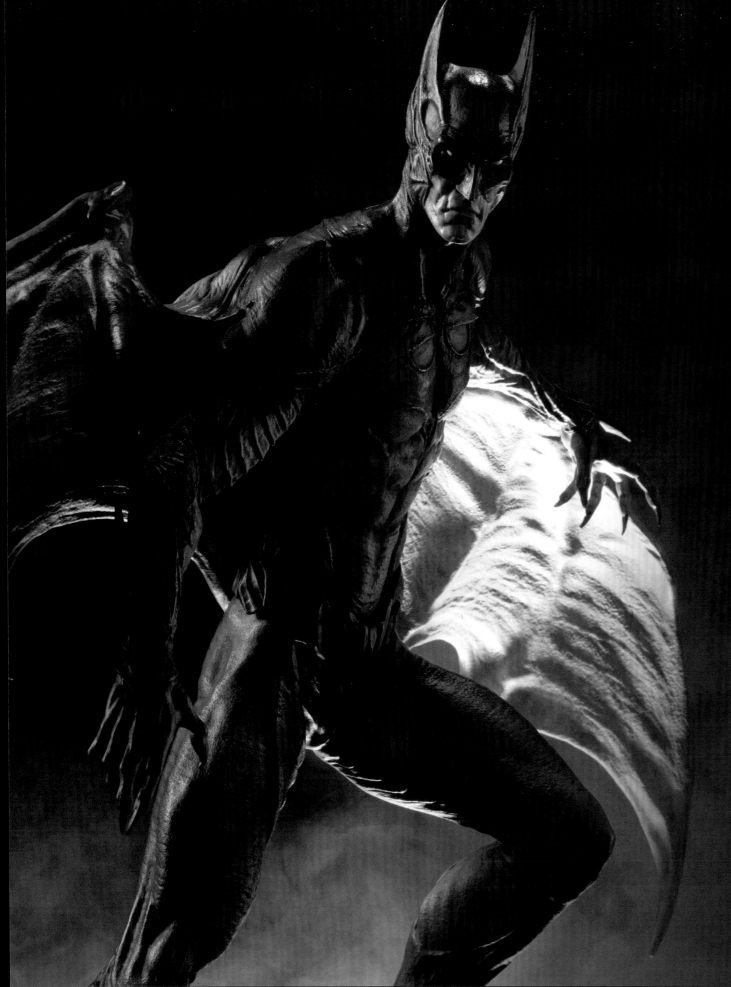

BATMAN
GOTHAM CITY
NIGHTMARE

Sometimes it's only madness that makes us what we are. —Batman, *Batman: Arkham Asylum* #1 (1989)

He is the night and the nightmare.

Sideshow's Gotham City Nightmare Collection presents a Dark Knight unlike any before, a twisted, fearsome Batman who strikes terror into the hearts of the guilty and the innocent alike. In creative director Tom Gilliland's words, "out of the obscurity comes this vigilant force of justice, but it's not a knight in shining armor—it's the lord of darkness."

This chilling incarnation of Gotham City's guardian is as much bat as man, a sinister hybrid that is truly the stuff of nightmares. "I think what keeps characters like Batman and The Joker enduring is that they're giving form and voice to things that have been swimming around, inchoate, in the plasma pool of darker dreams for generations," says designer Paul Komoda. "Though Batman's our protagonist, we can still relate to much of the heavier, more somber emotions that drive him. And through The Joker we can inhabit the skin of one who embodies every writhing, shrieking impulse under the surface of our 'normal' exterior and allow an aspect of our inner lives to run riot."

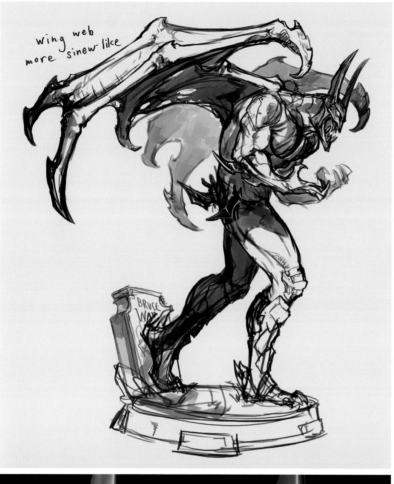

wing web
more sinew-like

BRUCE
WAYNE

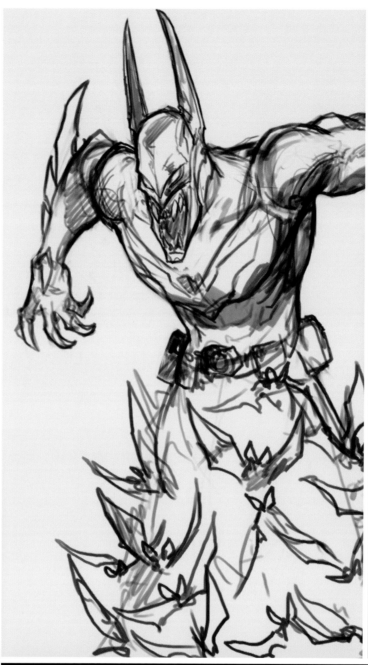

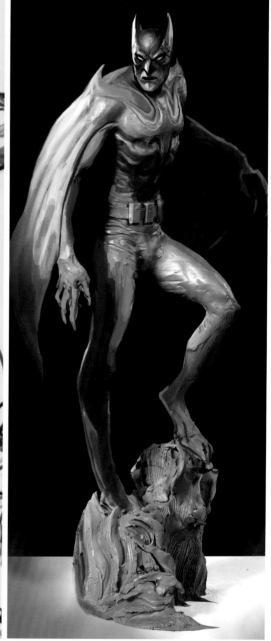

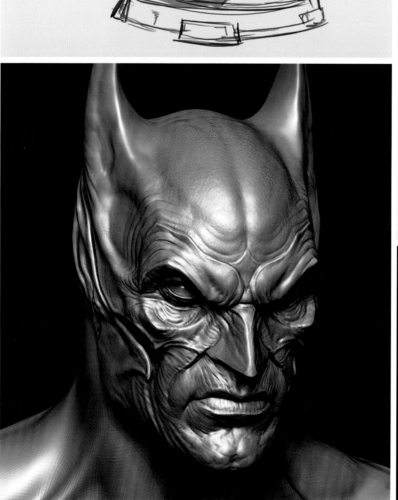

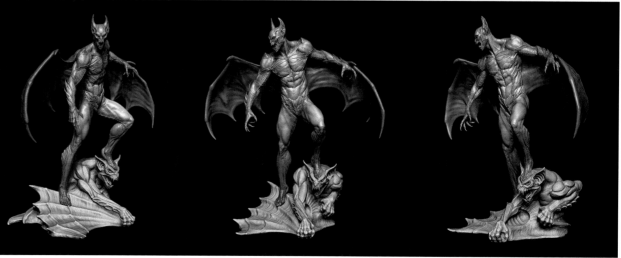

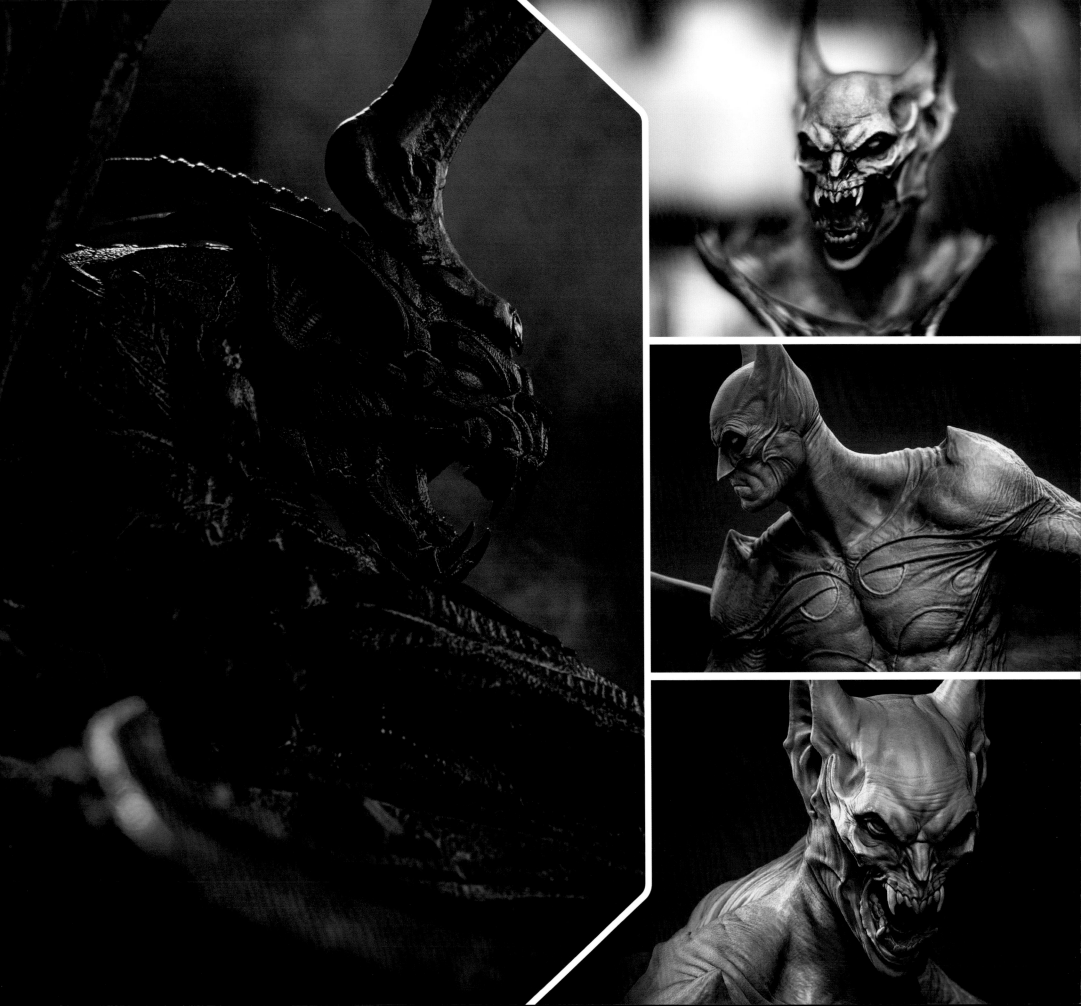

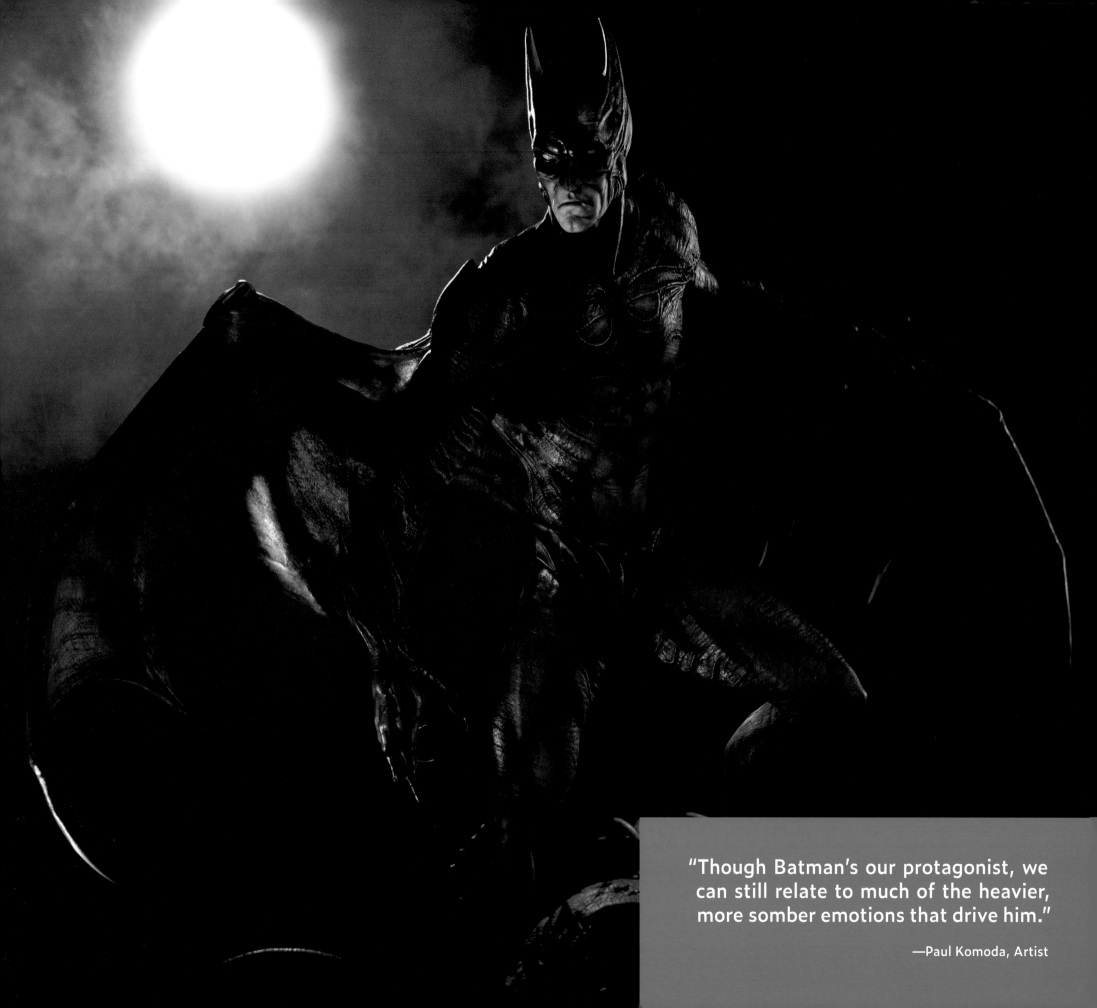

"Though Batman's our protagonist, we can still relate to much of the heavier, more somber emotions that drive him."

—Paul Komoda, Artist

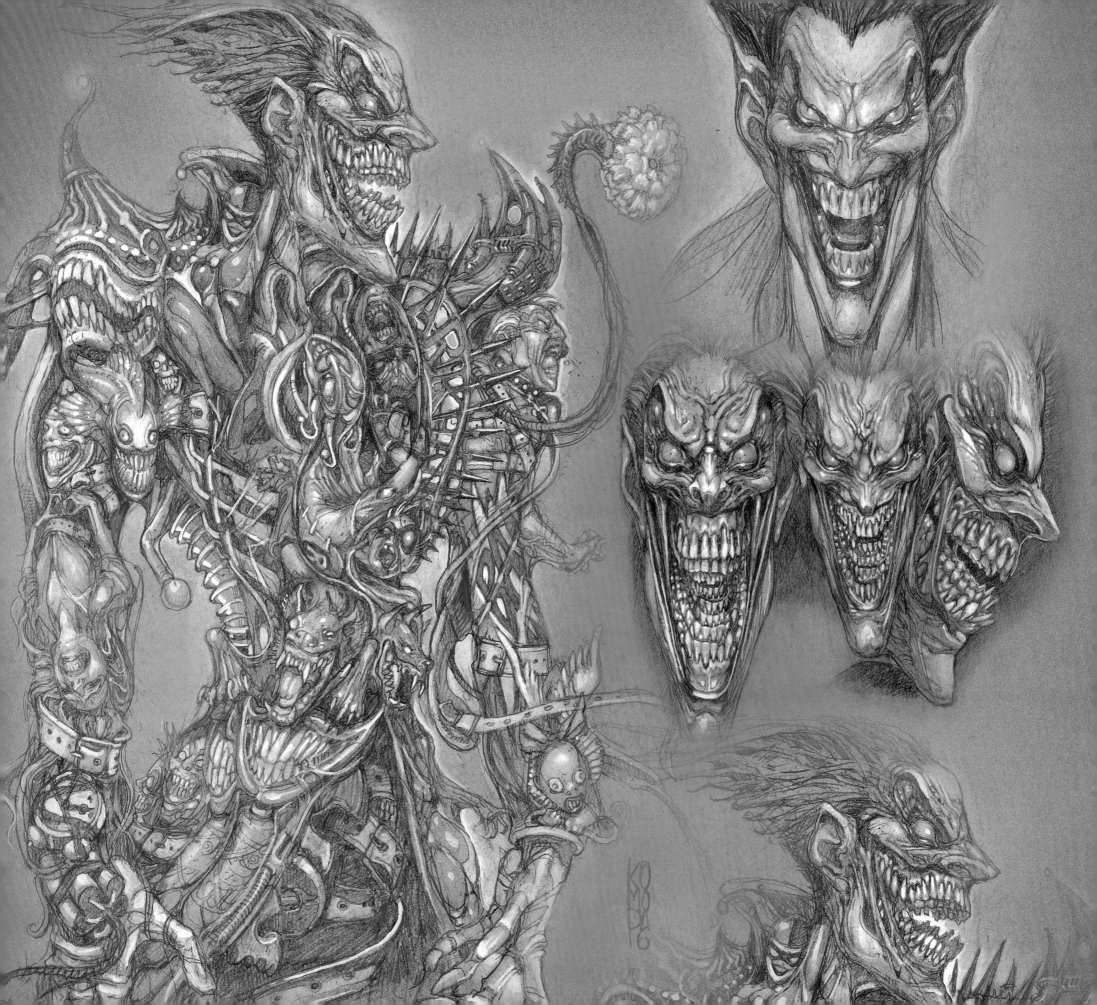

THE JOKER
GOTHAM CITY NIGHTMARE

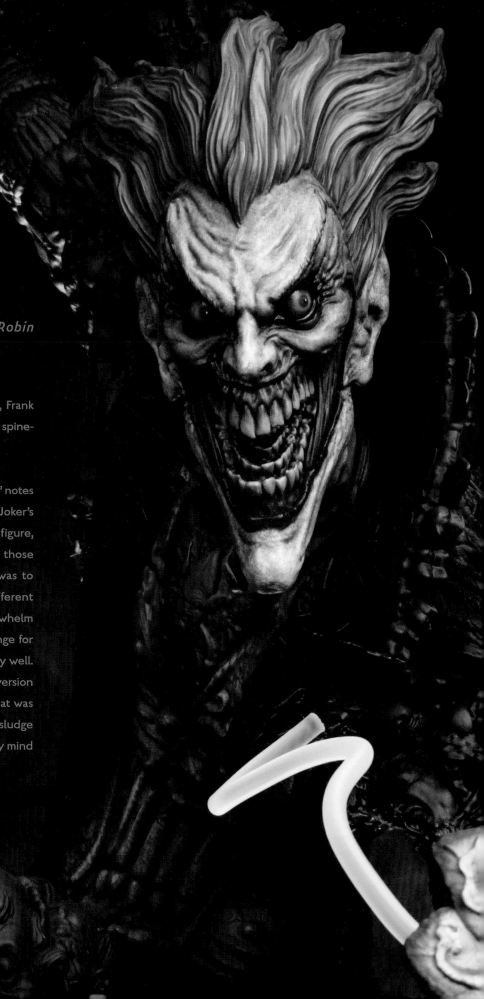

I'm not mad at all! I'm just differently sane! —The Joker, *Batman and Robin #13, (2010)*

Perhaps the only person more terrifying than the Gotham City Nightmare Batman is that world's version of The Joker, the living embodiment of the very worst that city has to offer. "We took the insanity of The Joker and made his entire makeup a tableau of bas-relief Easter eggs of his entire existence," creative director Tom Gilliland explains.

One of Sideshow's most ambitious statues to date, The Joker: Gotham City Nightmare embraces the Clown Prince of Crime's nihilistic philosophy from the seminal graphic novel *Batman: The Killing Joke*: "All it takes is one bad day to reduce the sanest man alive to lunacy." The Joker's wardrobe serves as an "organic collage of all the elements of The Joker's life and his character intermeshed into his body," notes designer Paul Komoda.

Secrets from the villain's past, including references to Harley Quinn and the Red Hood, the Joker fish, Arkham Asylum, and the Ace Chemical factory as well as homages to comic creators Jim Lee, Frank Miller, and others, are hidden throughout this spine-tingling sculpture.

"This was a creepy, and tricky, figure to paint," notes painter Kat Sapene. "There's so much of The Joker's history told in the reliefs that are all over the figure, but at the same time we didn't want all of those painted individually. Tom Gilliland's idea was to use very dramatic painted lighting with different colors to bring out the reliefs but not overwhelm the statue. It was mentally a bit of a challenge for me, but in the end I think it turned out really well. Still creepy, but that's the character and the version of the character we were going for. Once that was done, I had a blast painting the icky green sludge and rusty base for The Joker; easier to get my mind around that."

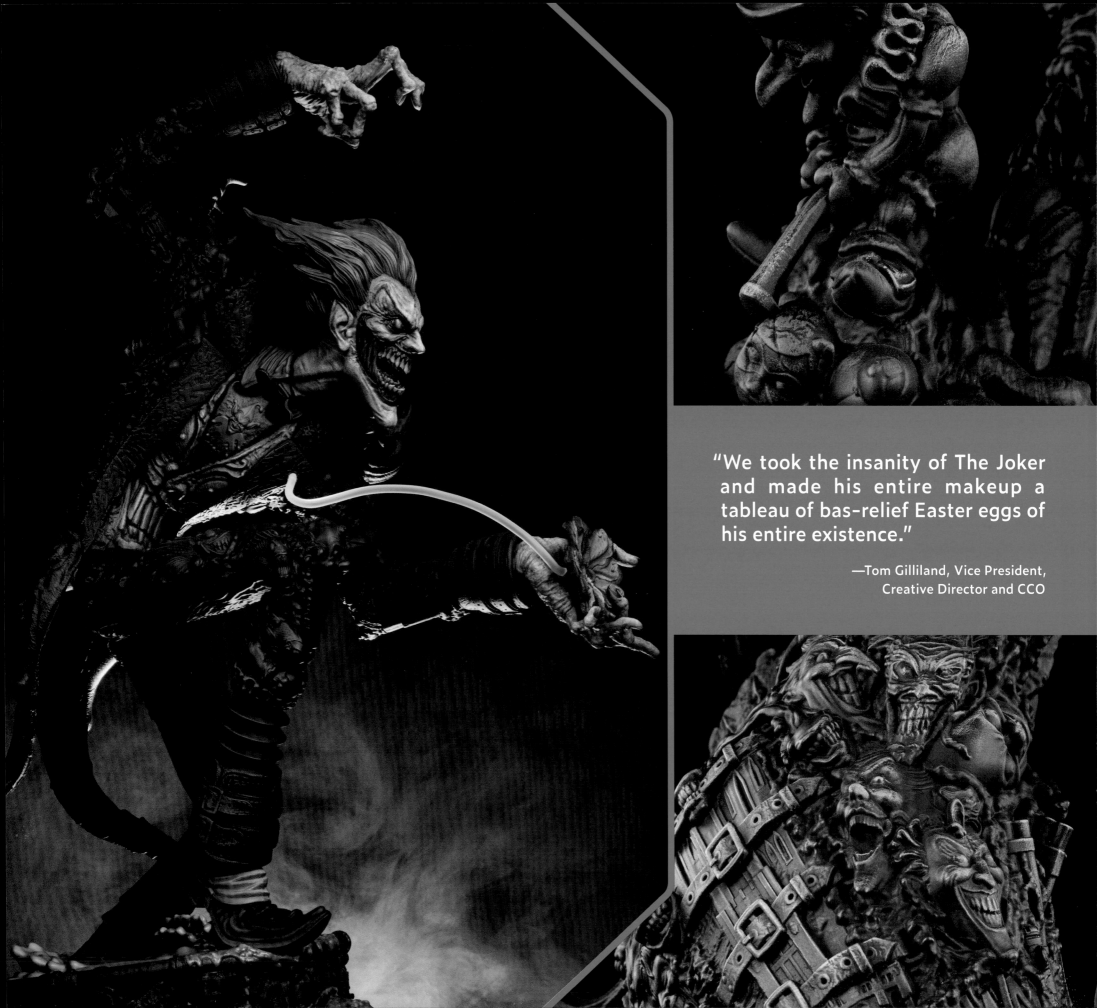

"We took the insanity of The Joker and made his entire makeup a tableau of bas-relief Easter eggs of his entire existence."

—Tom Gilliland, Vice President, Creative Director and CCO

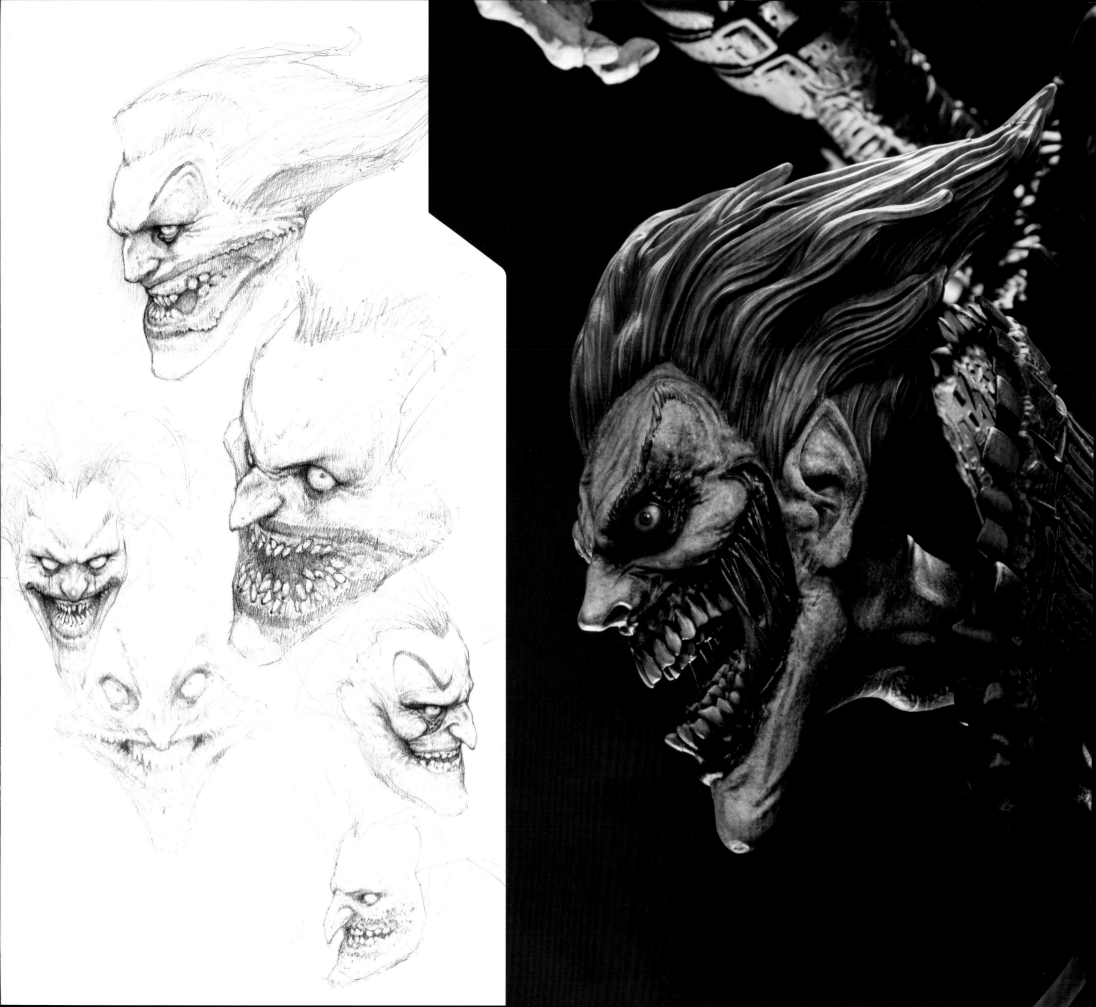

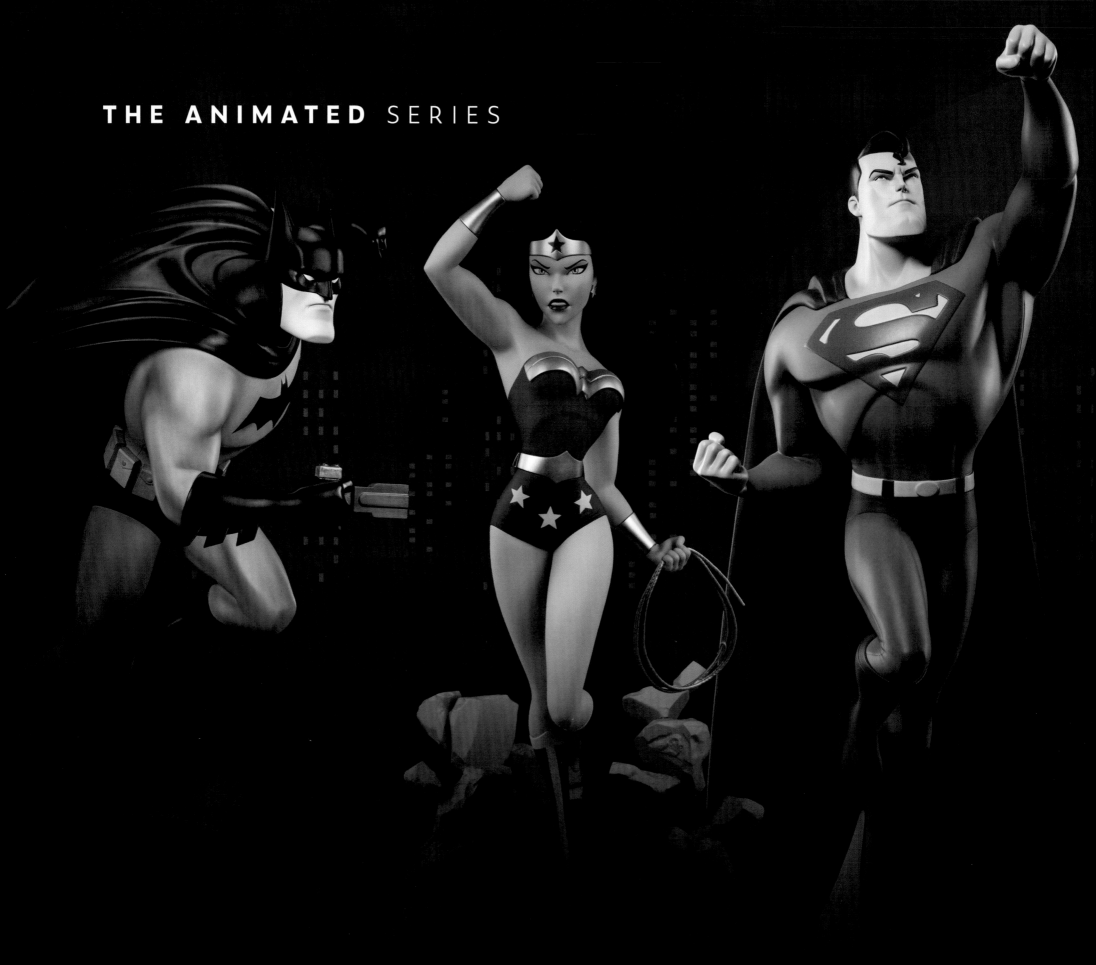

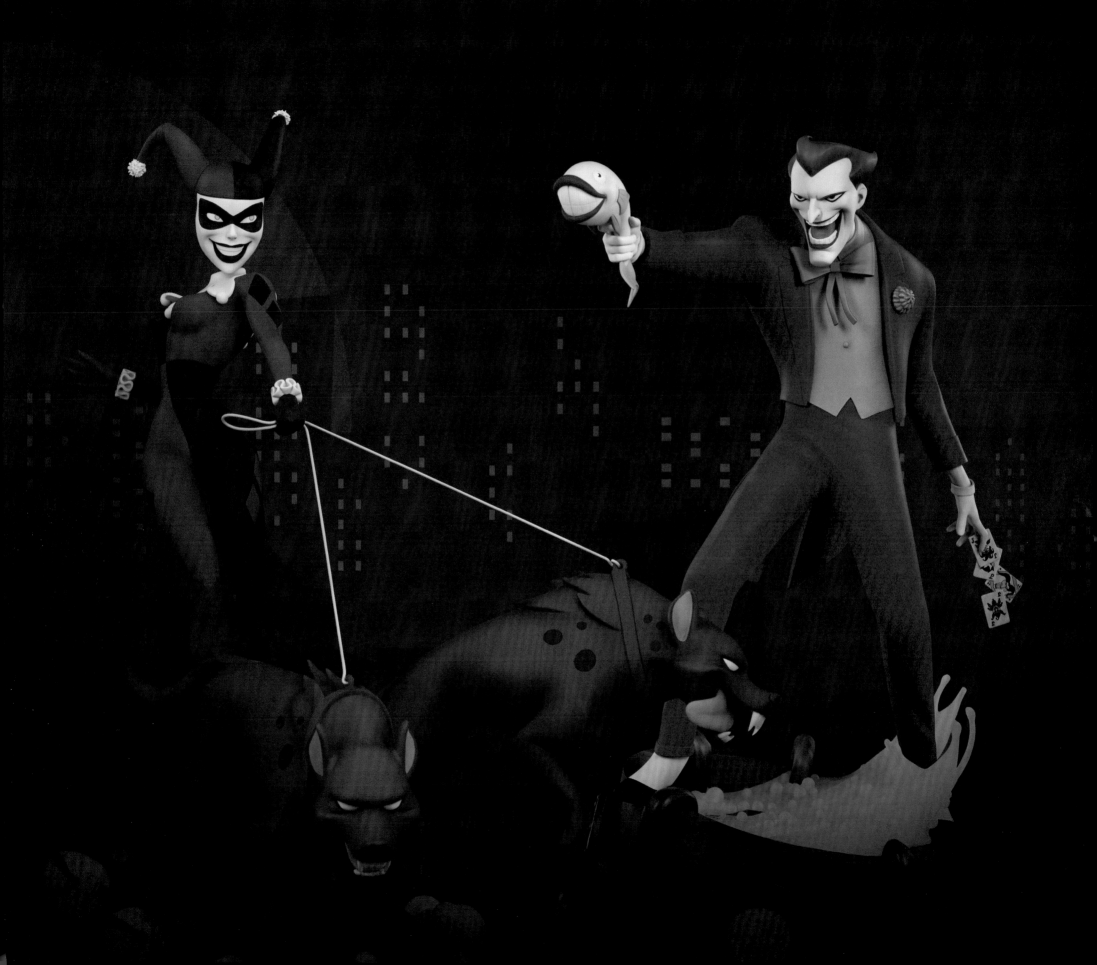

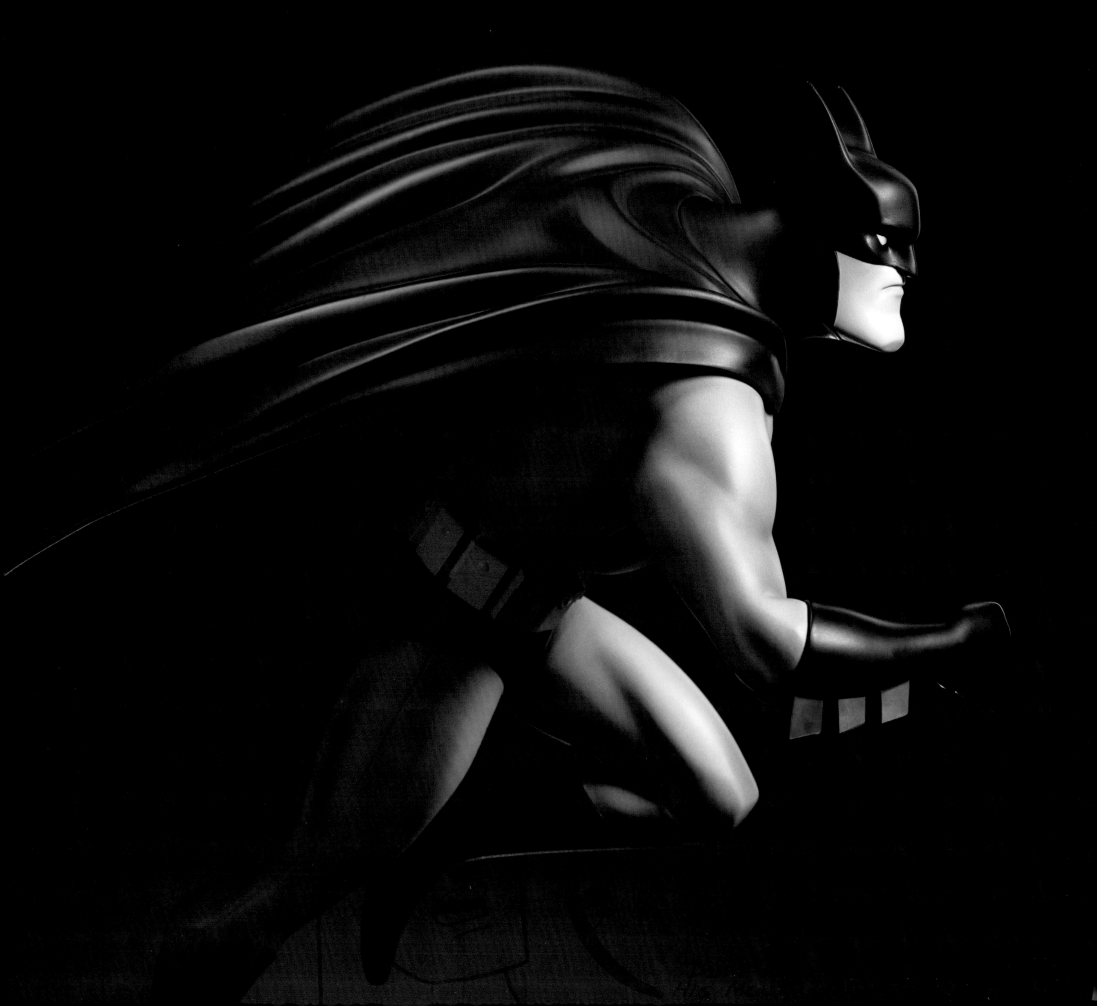

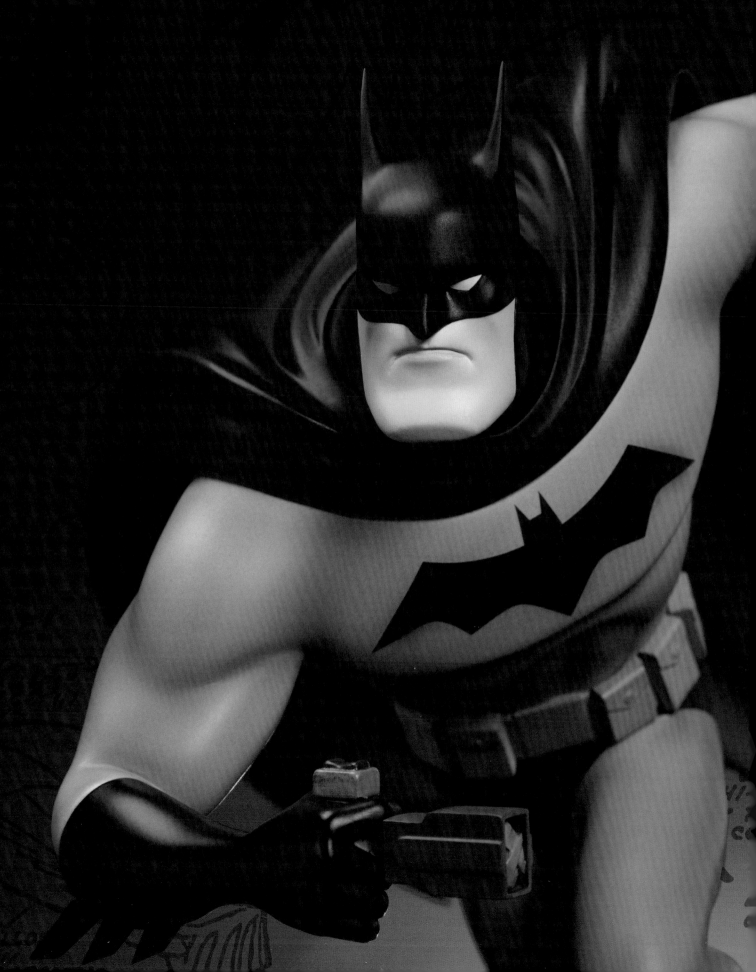

BATMAN
THE ANIMATED SERIES

I'm an equal-opportunity crime fighter! —Batman, "The Cat and the Claw," Part II, *Batman: The Animated Series* (1992)

Appropriately enough, Sideshow launched its Animated Series Collection with the Dark Knight, whose critically acclaimed *Batman: The Animated Series* revolutionized television animation and became a cornerstone of Warner Bros. Animation's DC Universe. Drawing inspiration from the iconic *Batman: The Animated Series* and *The New Batman Adventures*, designer Ian MacDonald captures the dynamic motion and grim determination of the Caped Crusader as he races into action to defend the streets of Gotham City.

Batman's sculpted costume is stylized to capture the movement and the striking silhouette of the World's Greatest Detective. Sideshow's Exclusive Edition of the Batman statue includes an alternate right hand holding a grapple gun, the perfect piece of tech for traversing the urban Gotham City setting.

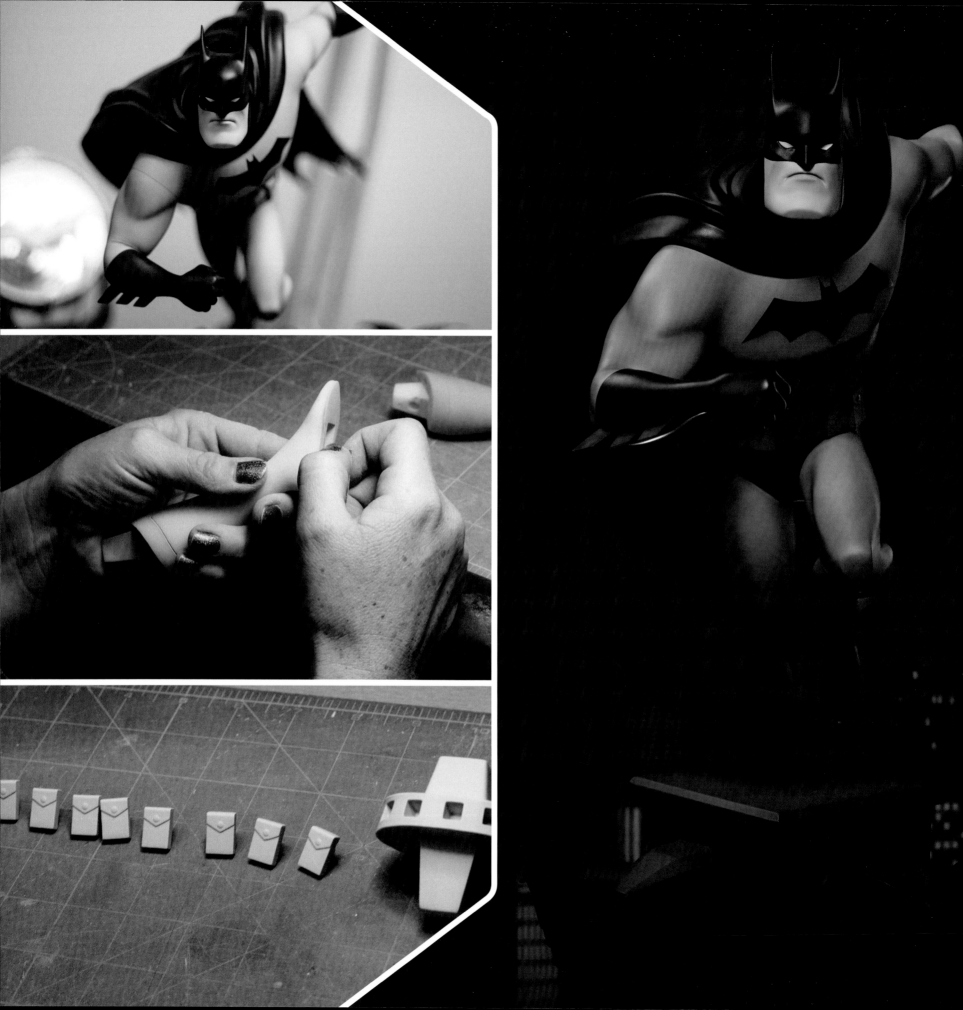

DETAILS

"It was very exciting to work on the DC Animated Series figures," gushes painter Kat Sapene. "I was in my mid-to-late teens when *Batman: The Animated Series* was on, and I loved it. I would watch it every day after school. The stories were great, and I loved that it all took place at night. The detailed backgrounds really helped give the series an old, gritty texture."

Sapene continues, "When Kevin Ellis and I were talking about this line, we both thought it would be great to try and give the bases that same texture. I just had to figure out how to do it. Holly Knevelbaard painted the first figure, Batman, but we had her just paint the base with solid colors. Then when the project came in, I played around with the bases and added layers of speckling that gave us the gritty feel we were looking for. Holly took it from there and incorporated the technique in the other statues she painted. She did a great job, and they turned out fantastic."

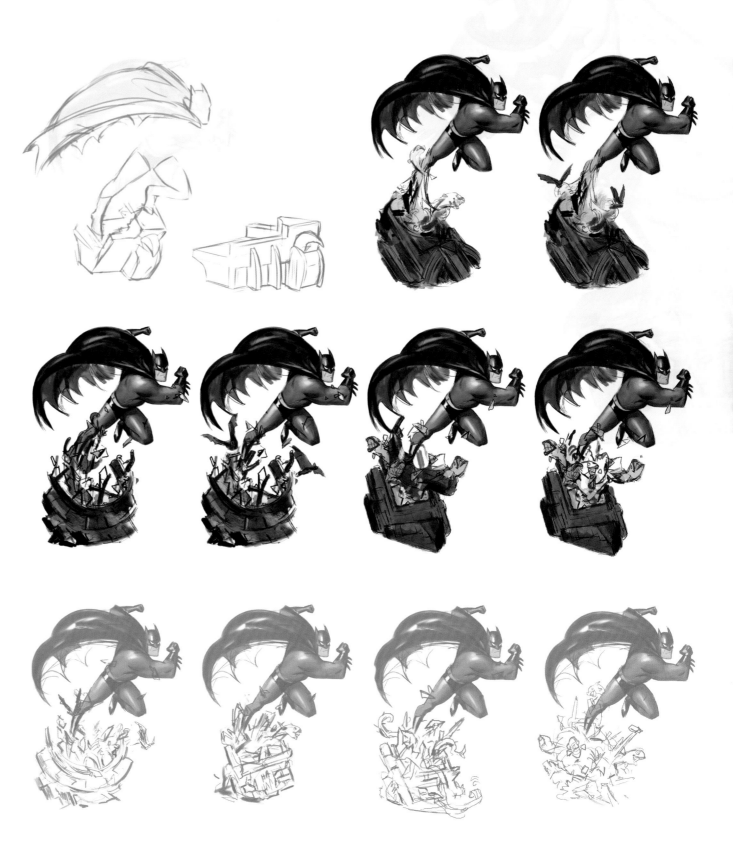

EXCLUSIVE
EDITION
BASE ART

COLLECTOR
EDITION
BASE ART

PACKAGING

Batman: The Animated Series is acclaimed as one of the greatest television cartoons ever produced, and its bold design and iconic imagery have influenced generations of artists and storytellers. Finding a new approach to such a celebrated, popular cartoon for Sideshow's Animated Series Collection packaging proved to be an interesting challenge, according to graphic designer Jennifer Garrett. "There is always an element of added pressure for any Sideshow product; in every aspect you want to live up to what people love and remember about a particular character, even down to the packaging," says Garrett. "We want the visual representation to be true and want the packaging and the artwork on the bases to be an extension of the character."

"In this particular line, we had the added bonus of some assets and inspiration from our Sideshow media team, who had released a trailer for the Animated Series line," Garrett adds. "They created some stunning visual motion graphics inspired by the title sequence of the series, which in turn excited us for the packaging artwork as well. The series aesthetic is very art deco, dark, and gritty, so we tried to keep those same aspects in the packaging artwork and base artwork."

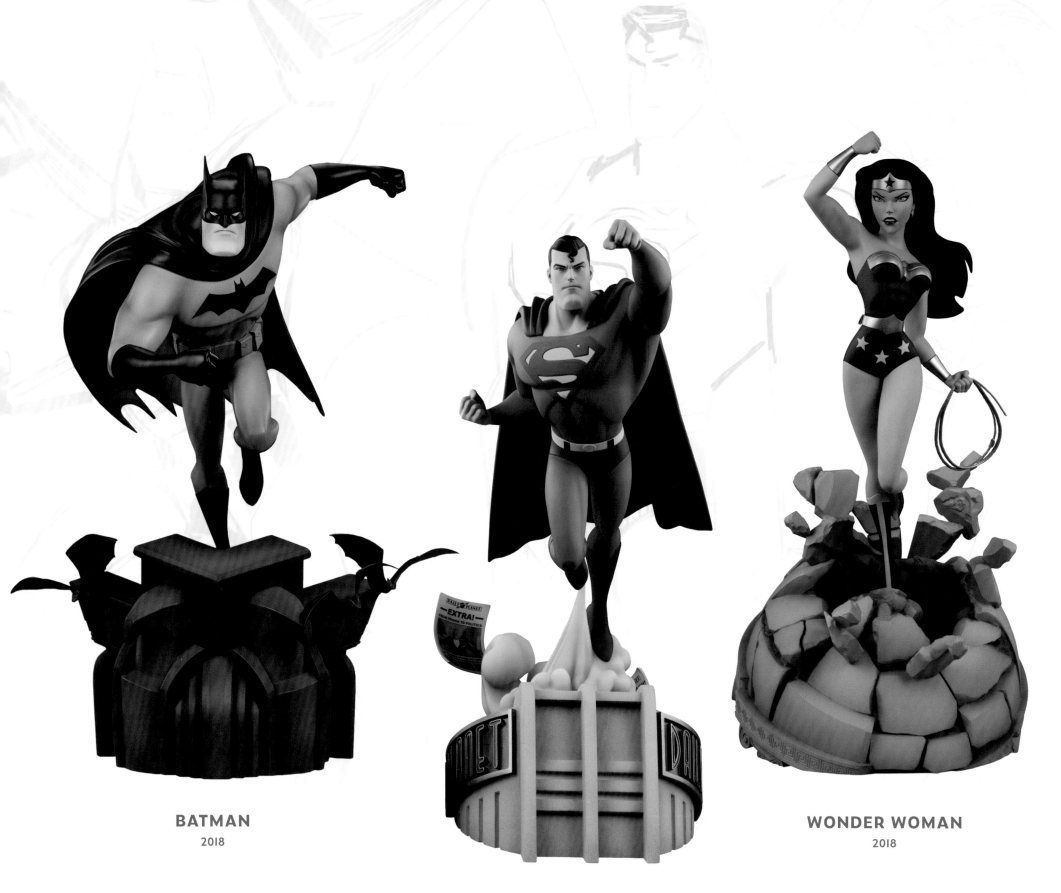

BATMAN

2018

SUPERMAN

2018

WONDER WOMAN

2018

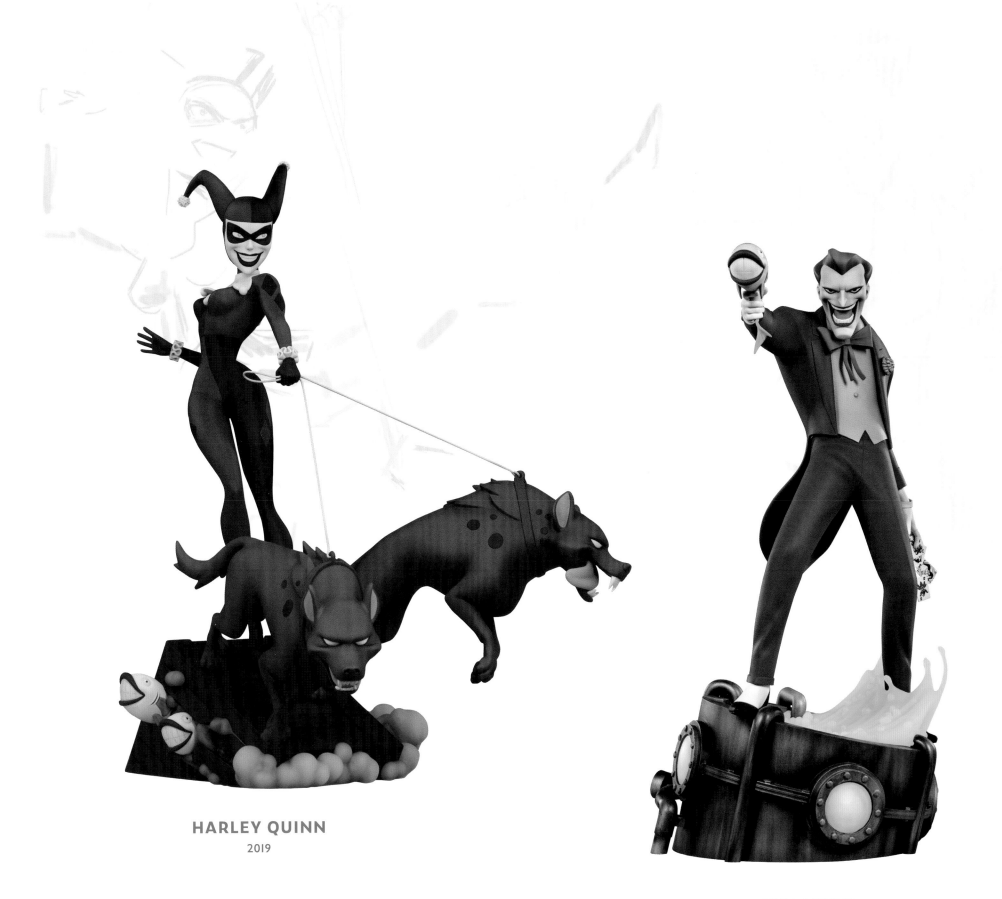

HARLEY QUINN

2019

THE JOKER

2019

SUPERMAN
THE ANIMATED SERIES

I won't have vigilantism in my town.
—Superman, "World's Finest," *Superman: The Animated Series* (1997)

With the success of *Batman: The Animated Series,* it was only a matter of time before the creative team set its sights on the Man of Steel—Superman.

This bright, stylized statue captures the Last Son of Krypton as he takes flight off the roof of the Daily Planet Building, ready to serve and protect his beloved city of Metropolis. Adorning the dynamic design of the statue are three *Daily Planet* newspapers—complete with breaking news—caught up in Superman's wake as he flies into action.

Superman's iconic design brings the world's first Super Hero to life as he once again prepares for his never-ending battle for truth and justice.

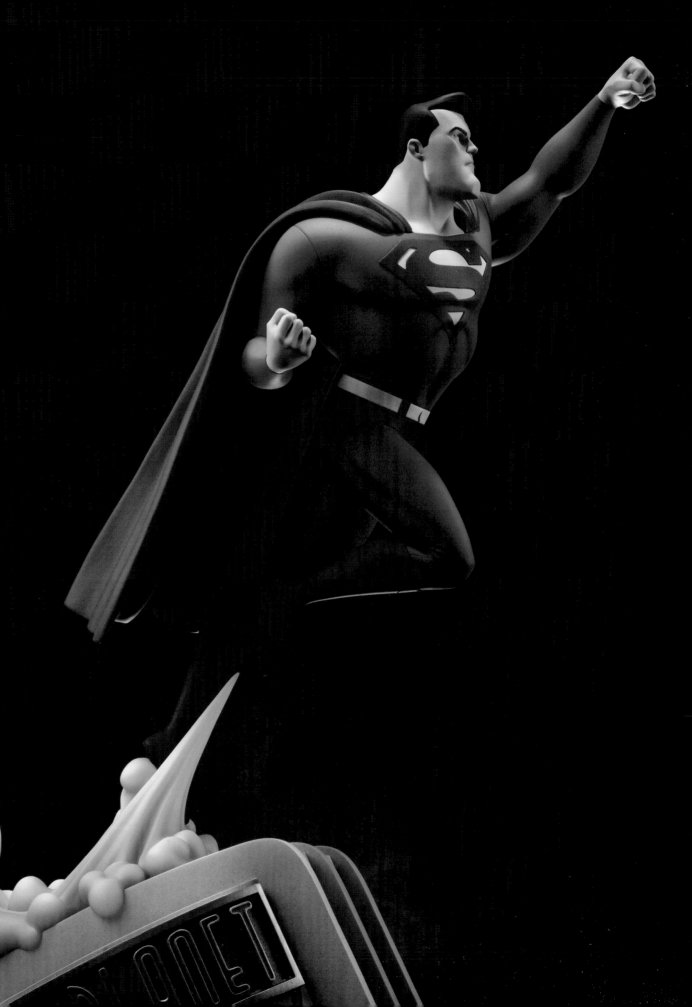

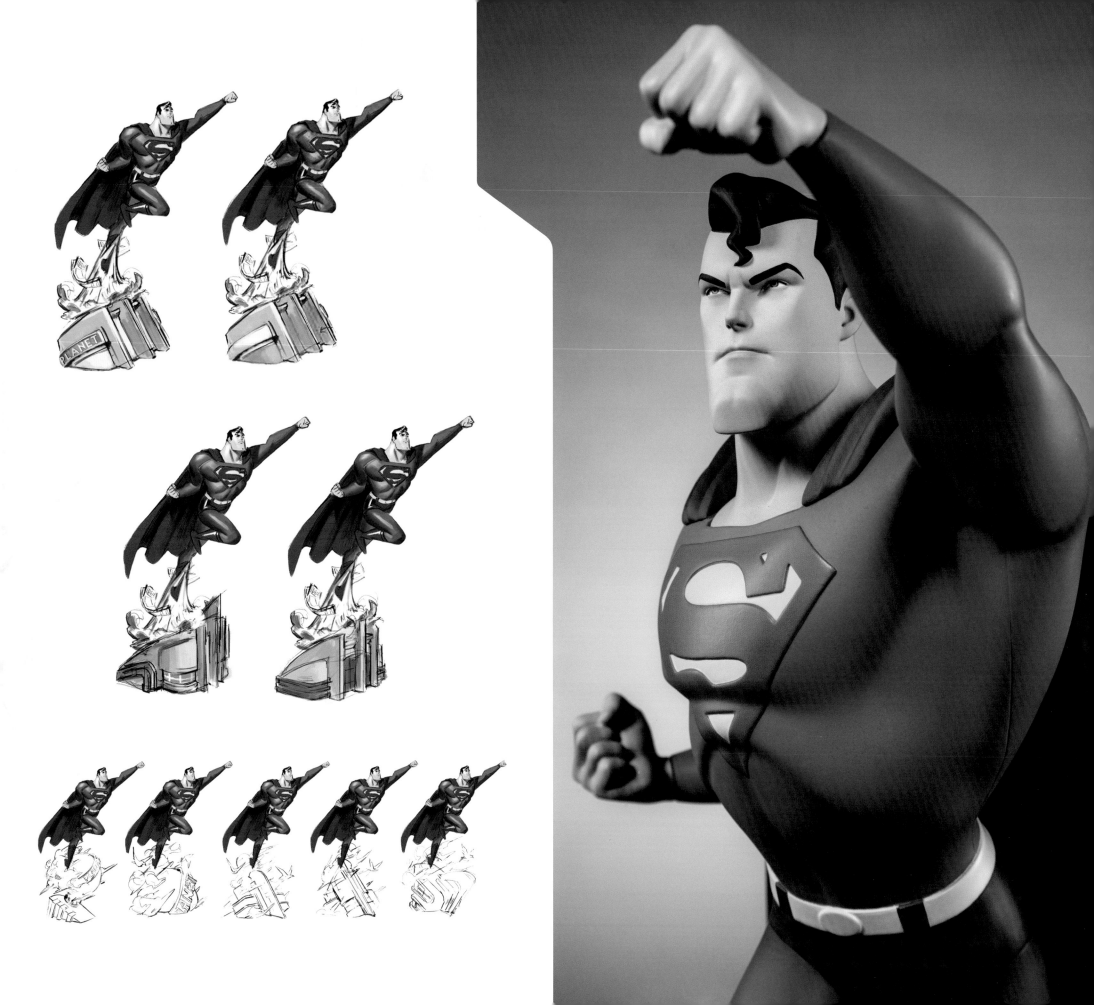

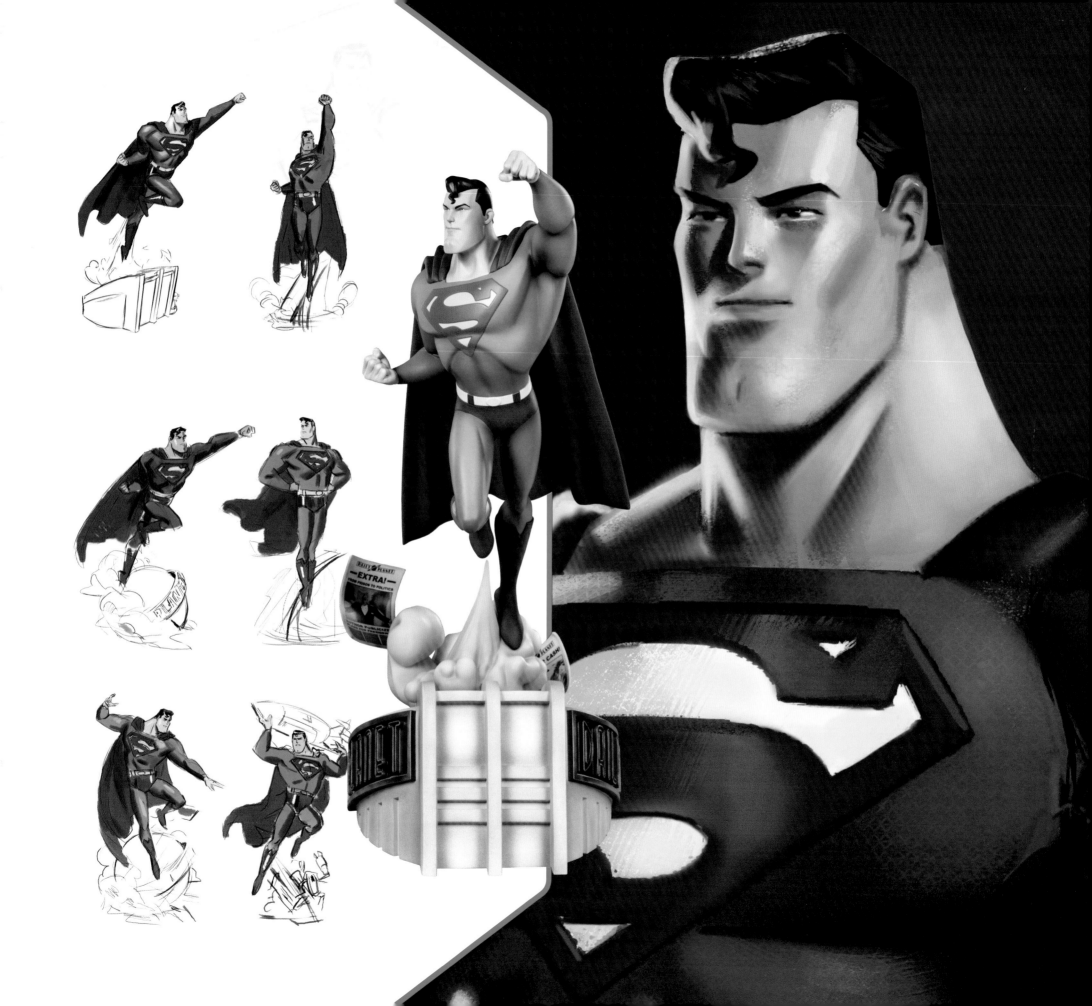

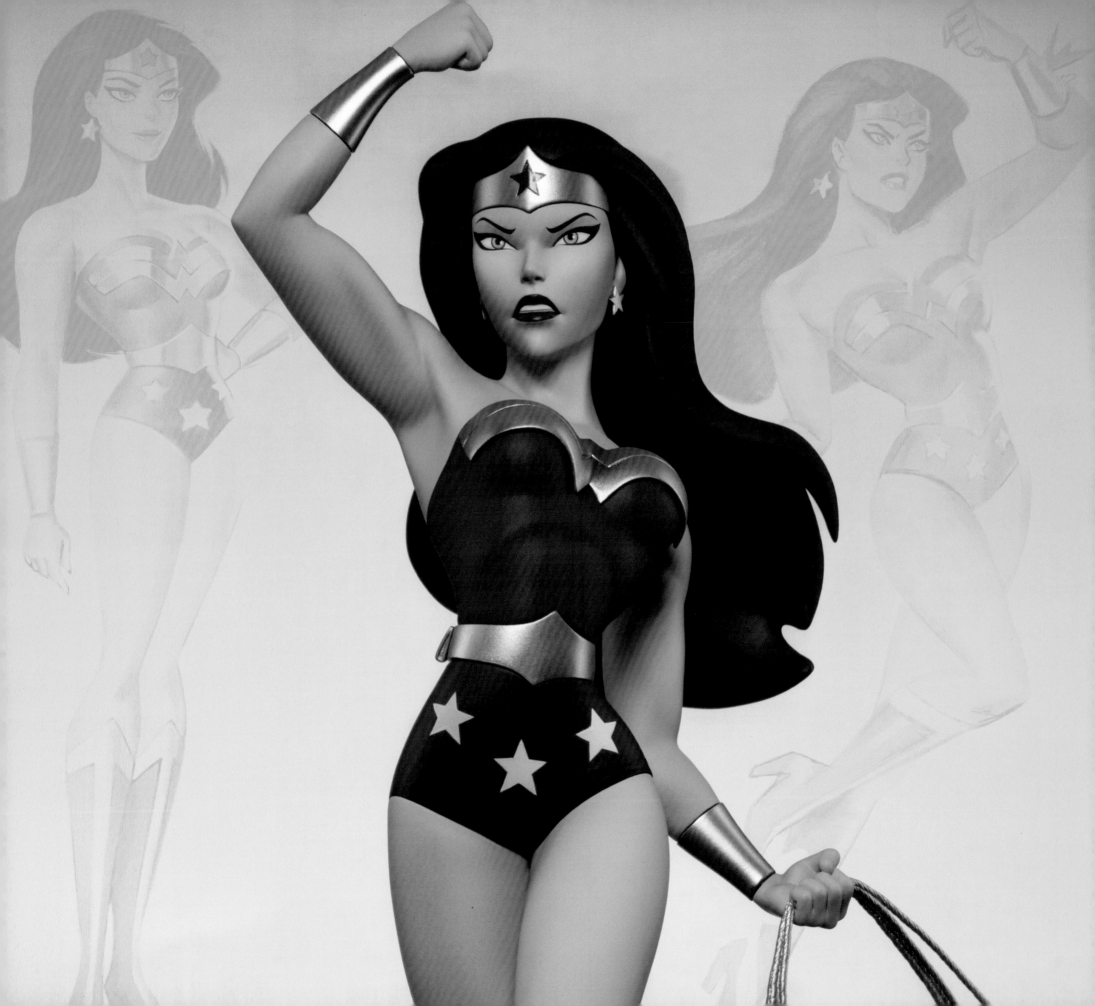

WONDER WOMAN
THE ANIMATED SERIES

I am Diana, Princess of the Amazons!
I won't be denied! —Wonder Woman, "Paradise
Lost," *Justice League* (2002)

Wonder Woman joined the DC Animated Series Collection
lineup as a founding member of the Justice League, a team
composed of the World's Greatest Super Heroes, and the
universe would never be the same.

The Amazon Warrior races into action in this dynamic DC statue
as Diana of Themyscira bursting through a Temple of Athena
base, leaving a pile of rubble in her wake. Sideshow's collectible
depicts the most iconic, celebrated version of Wonder Woman,
sporting her classic red, white, and blue uniform, golden armor,
tiara, bracelets, and Lasso of Truth—ready to fight injustice in
all its forms!

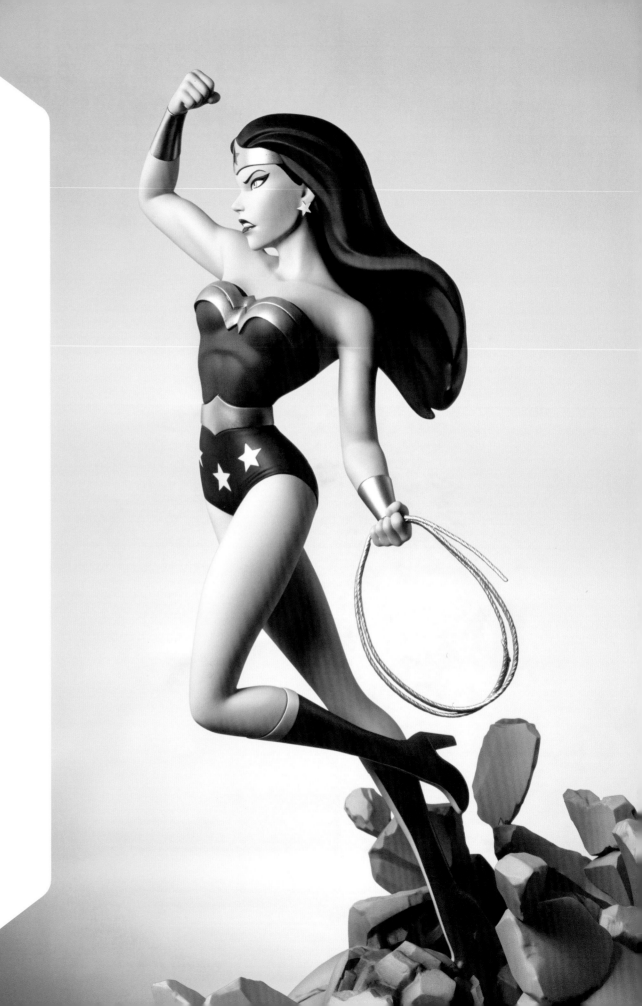

DETAILS

Although the animated version of Wonder Woman has been adapted into toys and smaller scale figures before, Sideshow's statue brings a new level of artistry to the DC icon. "I think the difference between those earlier renditions and Sideshow's version is attention to detail and quality," says painter Holly Knevelbaard. "From a painter's point of view, even though it seems cartoony and therefore more simple, there was a lot of attention to detail."

The simplicity of the character's design makes rendering it surprisingly complex, Knevelbaard notes. "These statues aren't painted as just flat colors," she explains. "There is subtle—and occasionally not so subtle—shading and highlighting that straddles the line between a more cartoony cell shaded style and the way a more realistic style piece would be painted, as well as forced lighting that really makes the piece pop. This gives it the feel of the cartoon but allows it to be more detailed than cartoon colors typically are."

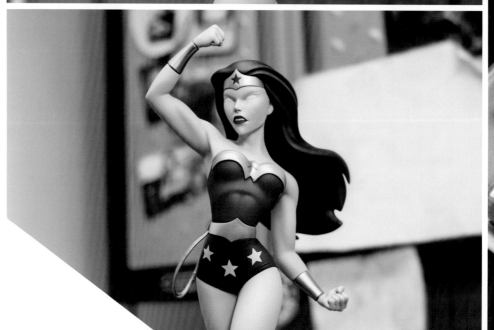

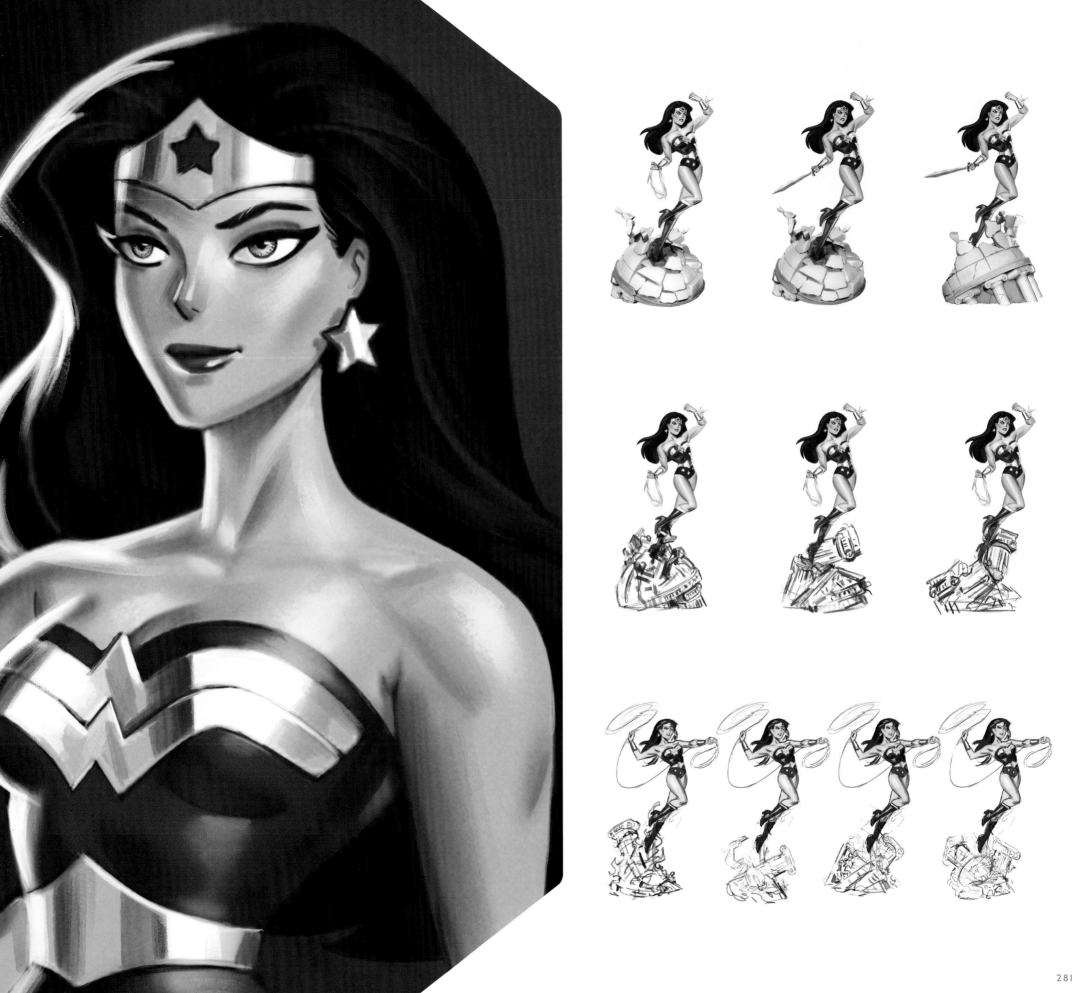

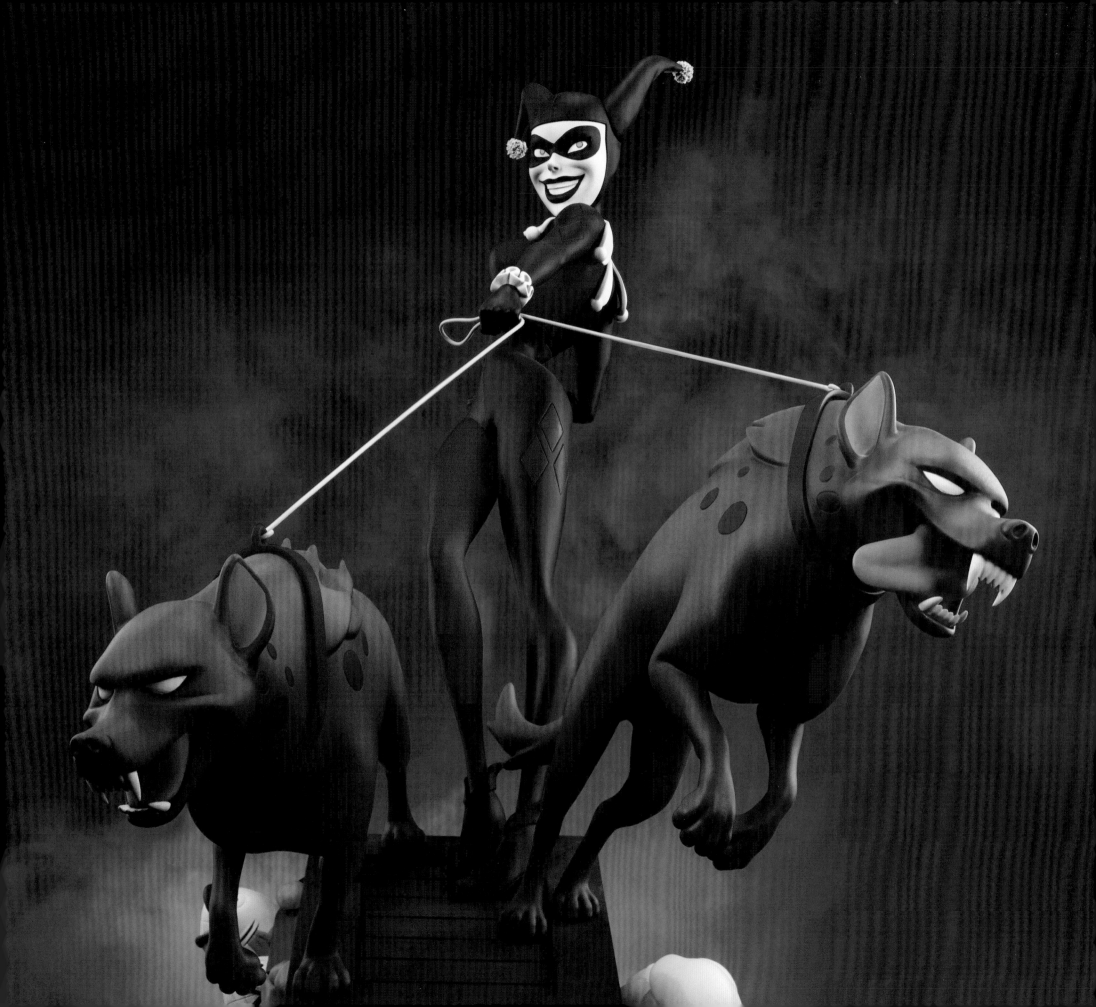

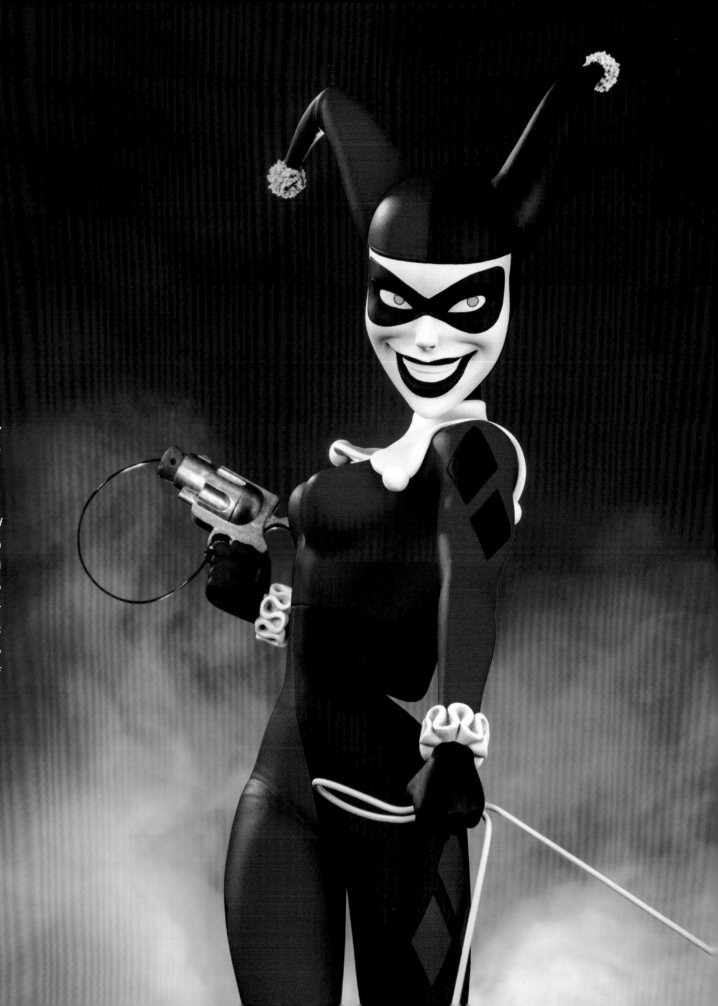

HARLEY QUINN
THE ANIMATED SERIES

Babies! Play nice with your new chew toy. —Harley Quinn, "Harley's Holiday," *Batman: The Animated Series* (1994)

The breakout star of *Batman: The Animated Series* was introduced as The Joker's sidekick in an episode called "Joker's Favor," as writer Paul Dini and artist Bruce Timm sought to add some spice to The Joker's crew. With her Brooklyn accent and her wicked sense of humor, creators and fans couldn't help but fall for Harley Quinn, who would go on to rival—and maybe even surpass—the popularity of her beloved "Mistah J."

DETAILS

Gotham City's Maid of Mischief is ready for a night on the town, as the madcap adventurer takes her darling hyenas, Bud and Lou, out for a stroll. Harley ramps down a crate bursting with Joker fish and laughing gas in a delightful nod to one of the most popular episodes of *Batman: The Animated Series,* based on a classic *Detective Comics* story line. Just as much attention to detail went into Harley's classic costume, with its trademark diamond-cut patterns and the animated motion of her jester's hood.

It's no surprise that many of the biggest fans of DC's animated programs went on to become creative professionals themselves, including Sideshow sculptor Matt Black. "When the animated projects came up, I was more than willing to try a new take on these amazing projects," he notes. "I think Harley is my favorite out of the five that I got to work on. She looks like she is having a blast. The rest are snapping into action, and she is having a lovely stroll with her hyenas!"

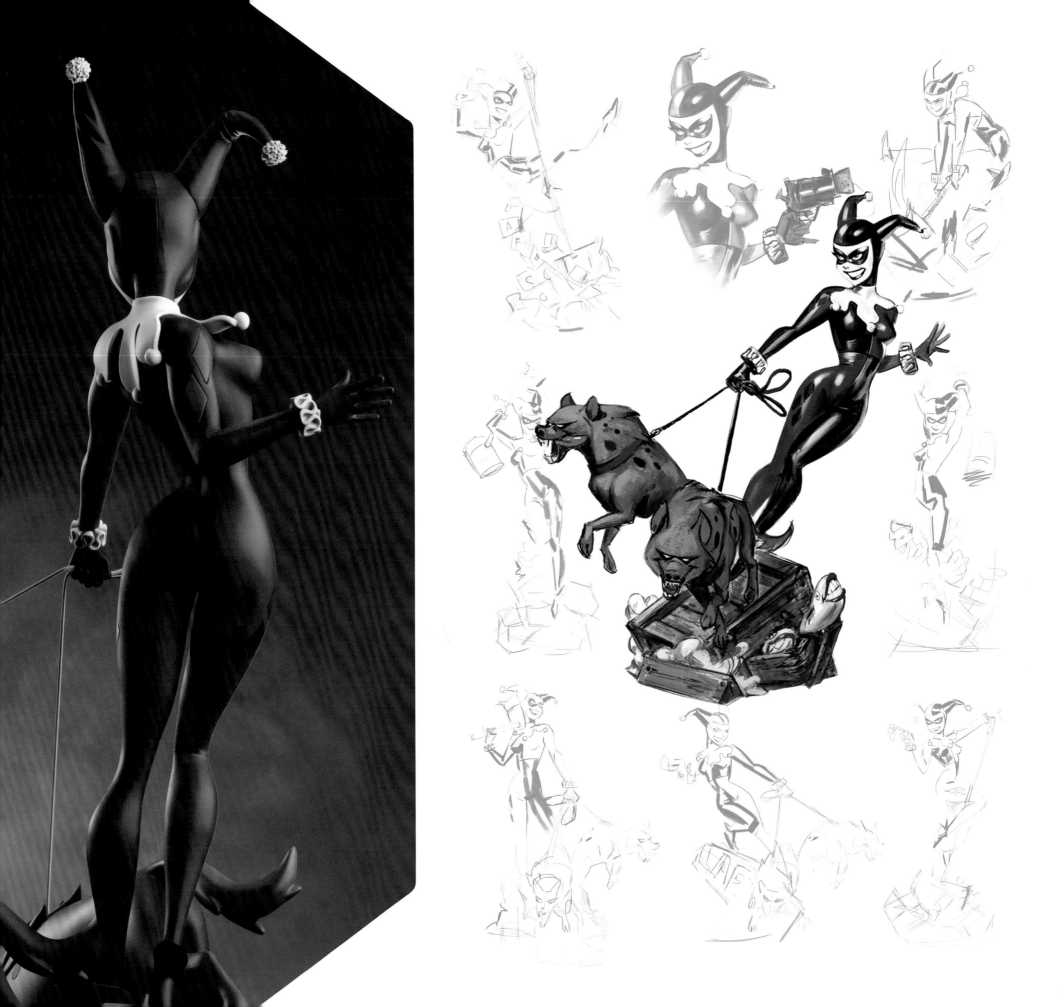

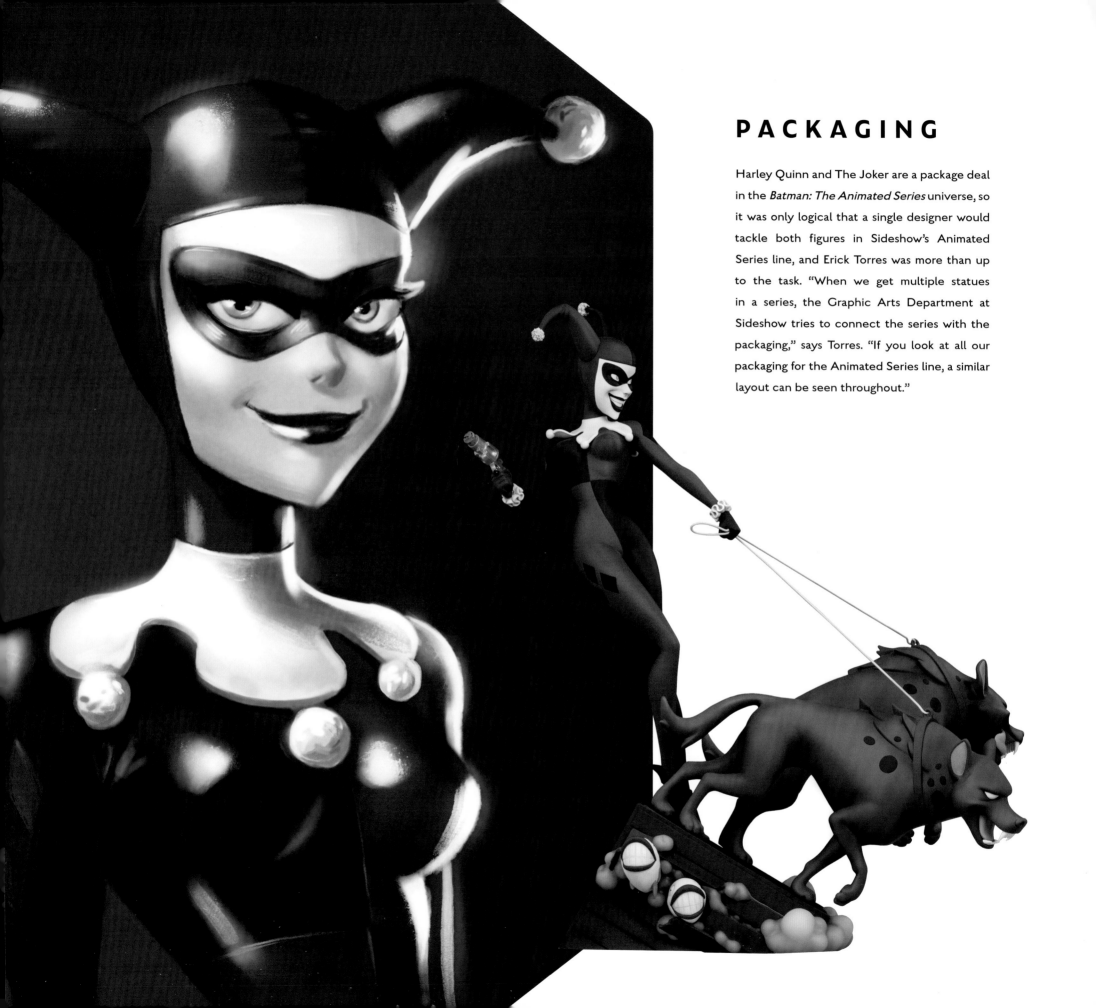

PACKAGING

Harley Quinn and The Joker are a package deal in the *Batman: The Animated Series* universe, so it was only logical that a single designer would tackle both figures in Sideshow's Animated Series line, and Erick Torres was more than up to the task. "When we get multiple statues in a series, the Graphic Arts Department at Sideshow tries to connect the series with the packaging," says Torres. "If you look at all our packaging for the Animated Series line, a similar layout can be seen throughout."

**COLLECTOR
EDITION
BASE ART**

**EXCLUSIVE
EDITION
BASE ART**

"I really like the design of the Harley Quinn statue. It captures the character very well and draws a connection to our Joker statues as well with the smiling fish at her base. I decided to use the diamond suit element on her costume to draw inspiration for the packaging. You can see the diamond suit angles and patterns throughout the box."

—Erick Torres, Graphic Designer

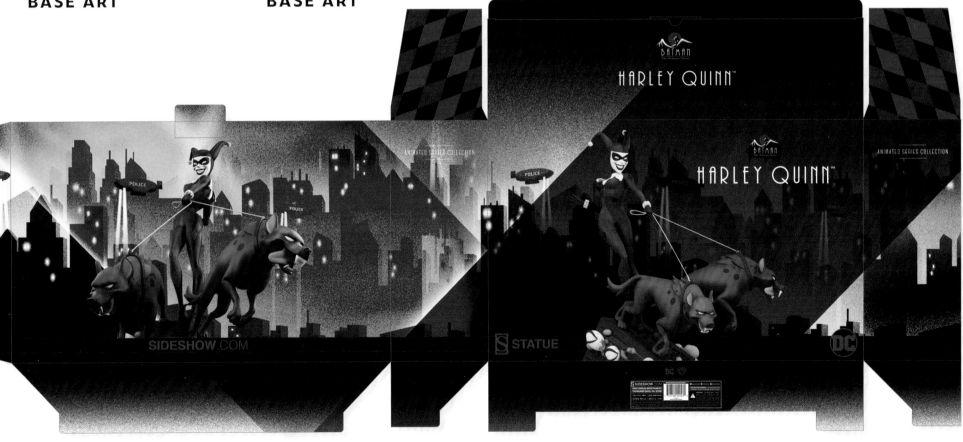

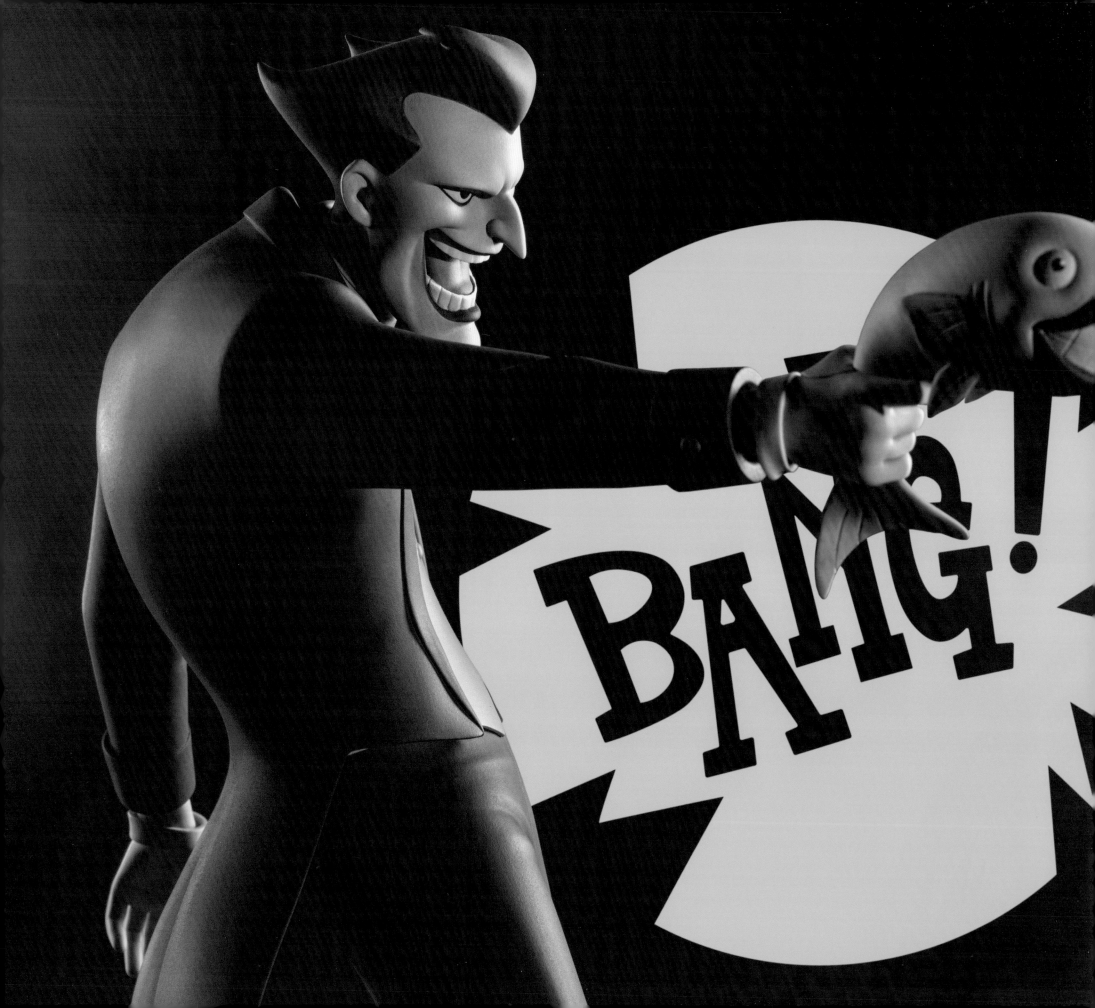

THE JOKER
THE ANIMATED SERIES

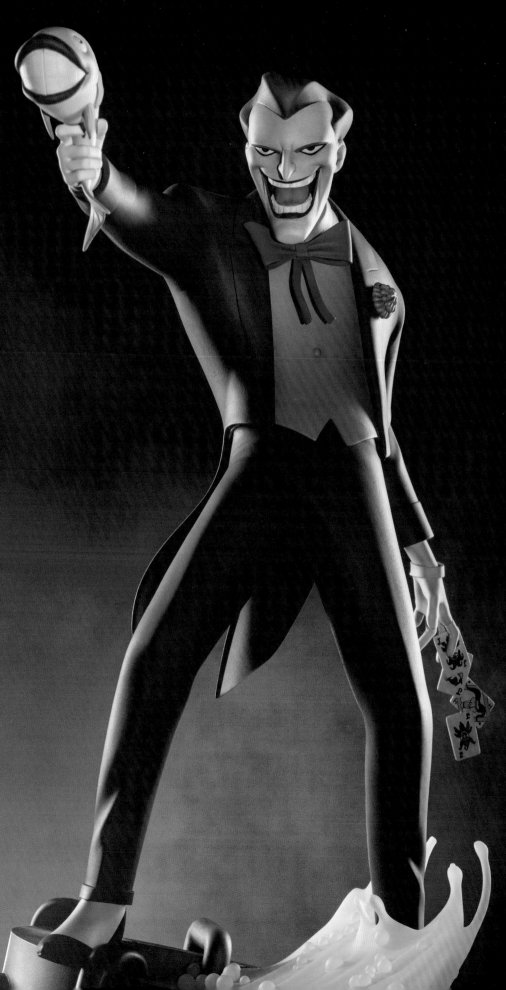

Without Batman, crime has no punch line.
—The Joker, "The Man Who Killed Batman," *Batman: The Animated Series* (1993)

No villain in Batman's Rogues gallery has had the staying power, tenacity, and sheer panache of the Clown Prince of Crime, The Joker. Despite his comical appearance, this diabolical criminal mastermind is chaos personified and is by far the most dangerous villain the Dark Knight has ever faced.

Sideshow's stylized statue captures the suave insanity of this iconic criminal as he stands atop a toxic vat of noxious green chemicals threatening to spill over. In one hand, he holds a maniacally grinning fish, while his other hand drops a variety of villainous Joker playing cards into the acid below. His sculpted costume, painted in his signature color scheme, makes The Joker a portrait of sophistication as he prepares to deliver yet another killer punch line.

"It's a very collaborative effort to create our products; lots of back and forth," says painter Kat Sapene. "The Paint Lead for a project is usually brought in pretty early in the sculpt process. This is so that the sculptor has someone they can go to if they have any questions about how something is going to paint up. Or sometimes the Paint Lead will see something that would work better in paint if it were done slightly differently. Oftentimes too, a sculptor will have suggestions for paint about color or materials or textures. Everyone brings different ideas to the table, which really adds to the final direction of a piece."

BANG!
FLAG PISTOL
DECAL

VILLAINOUS JOKER FACE CARDS

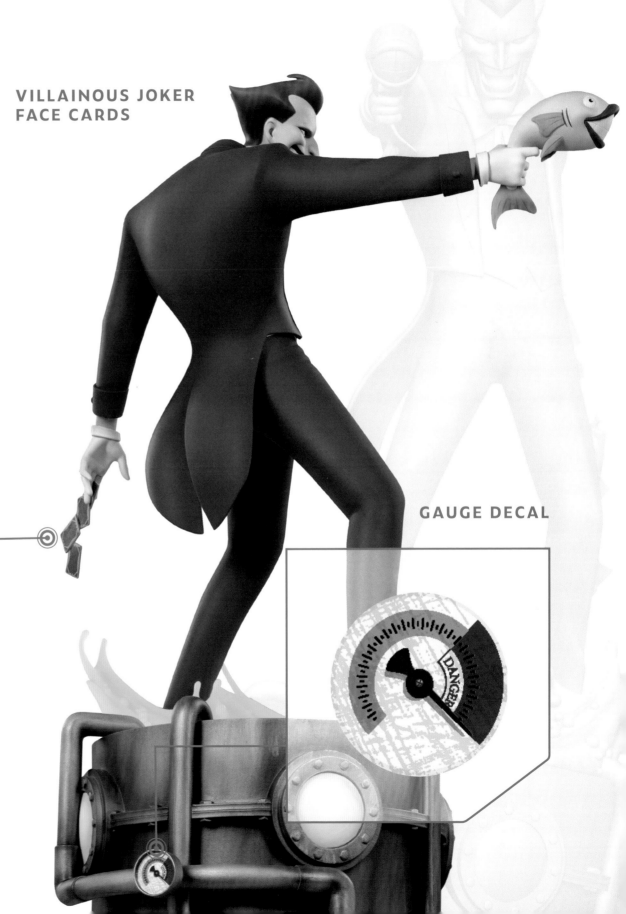

GAUGE DECAL

COLLECTOR
EDITION
BASE ART

EXCLUSIVE
EDITION
BASE ART

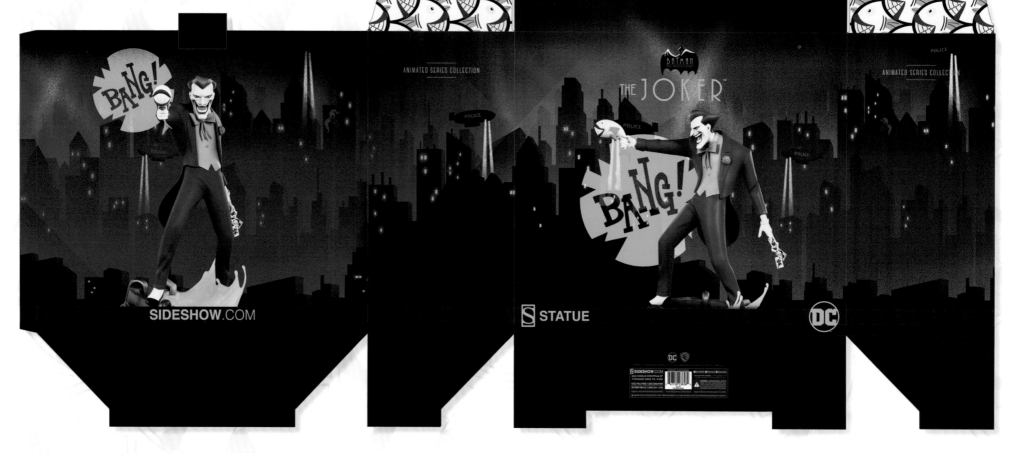

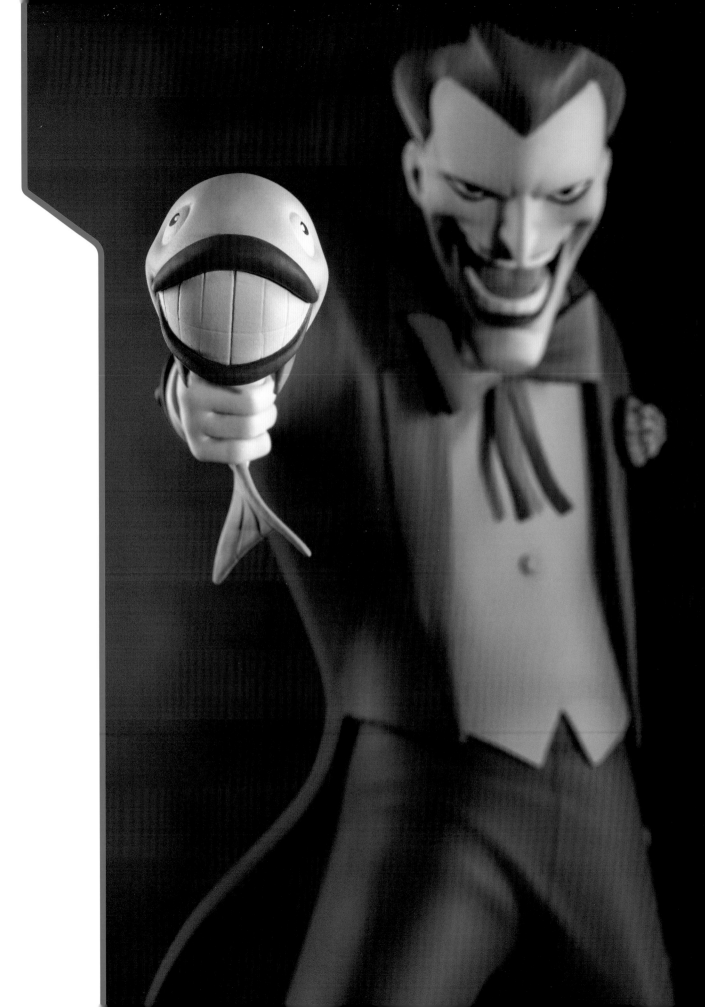

PACKAGING

Many members of the Sideshow creative team are die-hard fans of *Batman: The Animated Series,* and they jumped at the chance to bring their own talents to Gotham City. Graphic designer Erick Torres is well aware of the show's legacy, but he welcomed the opportunity to create the packaging for the Animated Series statue of The Joker. "I grew up watching this version of The Joker," says Torres. "Because of this, it wasn't intimidating at all for me. In fact, I had a lot of fun designing this package because of all the amazing art in the animation."

"I really love the pattern element I came up with that is located on the inner flaps," Torres adds. "I drew inspiration from the smiling fish sculpt on the figure itself and from the classic Joker episode 'The Laughing Fish.' The pattern can also be found on the bottom of the figure on the base art. And the base art really connects the figures to our packaging."

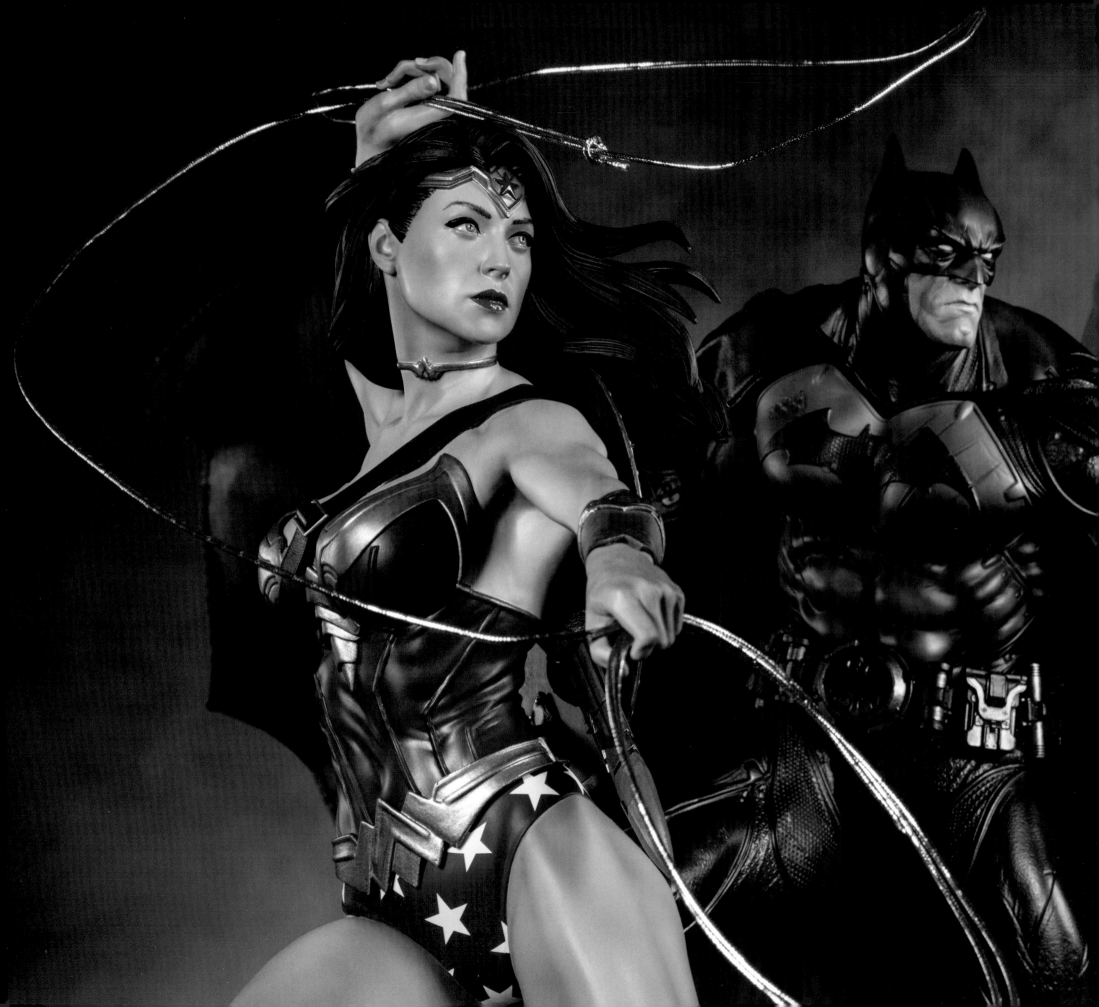

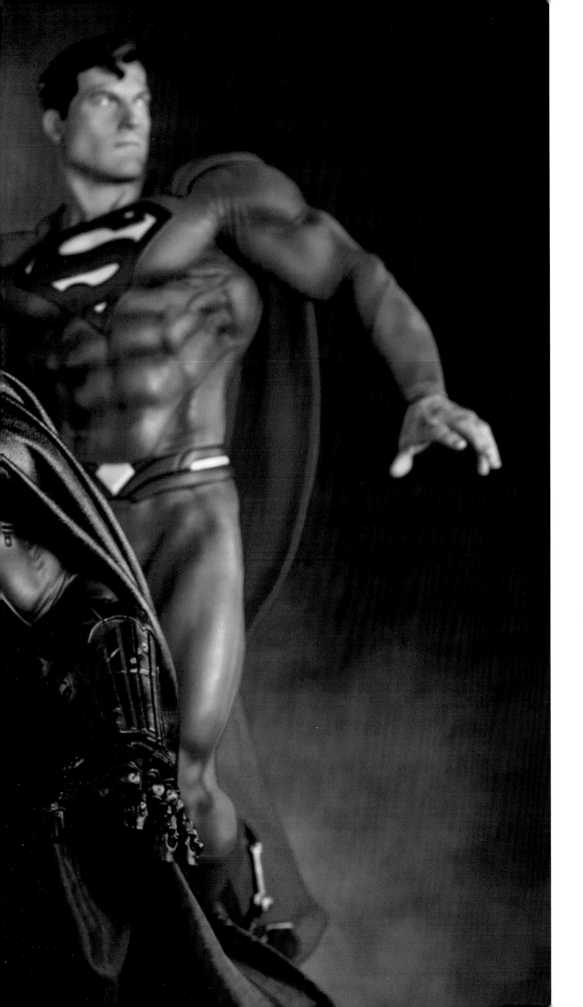

AFTERWORD

You'll believe a man can fly. —*Superman: The Movie* tagline (1978)

For nearly a century, the heroes of DC not only have entertained us but have inspired us.

"We are adrift without heroes," says Sideshow CEO Greg Anzalone. "Those characters that lift, inform, excite, and inspire us to be better versions of ourselves are valuable commodities in nearly all cultures around the world. While these DC heroes may be extreme examples, they are nonetheless relatable and capable of reflecting something back to us that adds meaning to our own work and purpose."

From the original comic books by a host of creative talent to the modern cinematic blockbusters that thrill audiences around the world, from homemade fan art to the high-end craft of Sideshow, the DC multiverse expands outward every day, limited only by our imaginations.

INSIGHT
EDITIONS

PO BOX 3088
SAN RAFAEL, CA 94912
INSIGHTEDITIONS.COM

Library of Congress Cataloging-in-Publication
Data available.

ISBN: 978-1-64722-135-5

INSIGHT EDITIONS

Publisher: Raoul Goff
President: Kate Jerome
Associate Publisher: Vanessa Lopez
Creative Director: Chrissy Kwasnik
Associate Editor: Holly Fisher
Editorial Assistant: Harrison Tunggal
Managing Editor: Lauren LePera
Senior Production Editor: Elaine Ou
Senior Production Manager: Greg Steffen

Also available from Sideshow Collectibles and
Insight Editions:

*Capturing Archetypes Volume 3: Astonishing
Avengers, Adversaries, and Antiheroes*

Court of the Dead: The Chronicle of the Underworld

Shadows of the Underworld Graphic Novel

Inside the Sideshow Studio

Sideshow: Fine Art Prints

2630 CONEJO SPECTRUM ST.
THOUSAND OAKS, CA 91320
SIDESHOW.COM

SIDESHOW COLLECTIBLES

Creative Director
Tom Gilliland

Book Concept
Greg Anzalone

Design and Photography
Adam Codeus
Andrea Mendoza
Andrew McBride
Cassie Fuertez
Erick Torres
Jeannette Villarreal Hamilton
Jennifer Garrett
Jessica Miranda
Katie Simpson
Margaux Piñero
Nathan Lewis

This publication would not be possible without the creative
ambition and endless toil of the creative forces behind the
Sideshow Collectibles Design and Development Teams.
Spread far and wide the world over, our teams consist of
artisans from the United States, Europe, Argentina, Canada,
Korea, Singapore, and China. It is with great pride and honor
that we say thank you to all those creative spirits that have
played in our orchestra. Special thanks to Andrew Farago and
Kevin Conroy.

To learn more about the studio's environments, the talented
artists, and the unique Sideshow creative process, check out
the behind-the-scenes videos at Sideshow.com.

ROOTS OF PEACE REPLANTED PAPER

Insight Editions, in association with Roots of Peace, will plant
two trees for each tree used in the manufacturing of this book.
Roots of Peace is an internationally renowned humanitarian
organization dedicated to eradicating land mines worldwide
and converting war-torn lands into productive farms and
wildlife habitats. Roots of Peace will plant two million fruit and
nut trees in Afghanistan and provide farmers there with the
skills and support necessary for sustainable land use.

Manufactured in China by Insight Editions

10 9 8 7 6 5 4 3 2 1

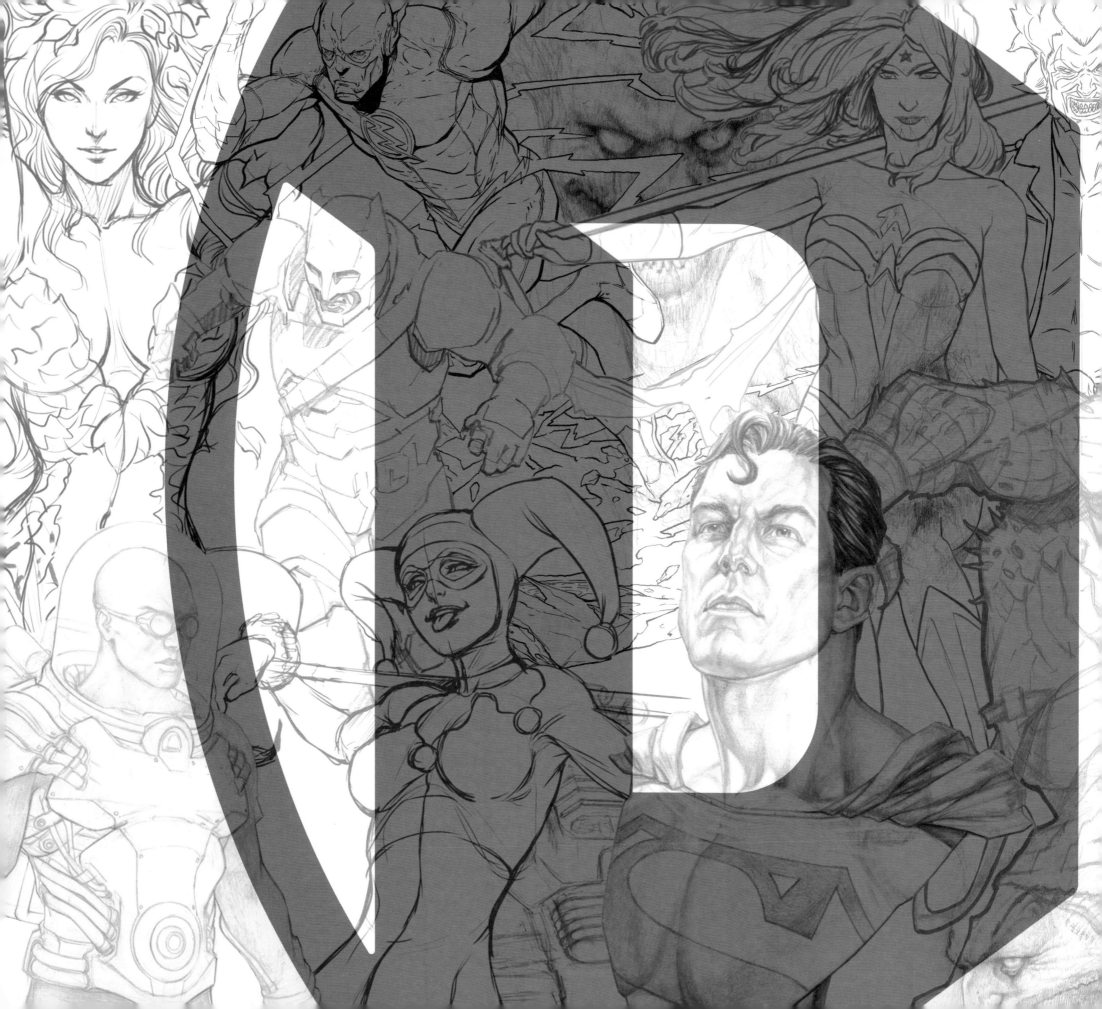